TIMOR RUNGURANGA

A photographic journey through Timor-Leste

davidpalazón

TIMOR RUNGURANGA
A photographic journey through Timor-Leste

A photobook by David Palazón
8 x 10 in (220 x 250 mm)
344 pages | 280 images (252 colour & 28 b/w)
ISBN: 9781367559110

The editor is extremely grateful for the contributions of the following writers, artists and photographers: (in alphabetical order) Abe Barreto, Agio Pereira, Ahimsa-ka Satya, Alberto Fidalgo, Alessandro Boarccaech, Alfeo Pereira, Andrew Henderson, Bernardino Soares, Daniel Simião Schroeter, Danilo Afonso-Enriques, Elena Tognoli, Enrique Alonso, Ester Piera Ester Züecher, Gibrael Dias Carocho, Grinaldo Fernandes, Hector Hill, Iñigo Ballester, Isabel Boavida, Jake VDVF, Jean-Christophe Galipaud, Jen Shyu, Joanna Barrkman, John Martires, Josh Trindade, Karen Reidy, Kelly Silva, Kim Dunphy, Kirsty Sword Gusmão, Larissa Almeida, Leilana Quinger, Licinio Martins Lopes, Lucas Serrao Lopes, Luke Monsour, Madalena Barreto, Manuel Casal Aguiar, Mara Bernardes de Sá, Marcelina Osolio, Margarida Bandeira de Lima, Maria Ceu Lopes Federer, Maria Madeira, Mariano Gonçalves, Masanori Nagaoka, Megumi Yamada, Mireia Clemente, Naldo Rei, Nelson Turquel, Nuno da Silva, Patrick Walsh, Philip Yampolsky, Rebecca Kinaston, Rick Shearman, Risza Lopes da Cruz, Rogerio Lopes, Rosália Madeira Soares, Simão Barreto, Sofia Miranda, Sula Sendagire, Tony Fry and Victor de Sousa.

The contributing articles have been published in their original language (English, Tetun, Portuguese, Indonesian, Italian, French, Spanish). Should English not be the original language, a translation has been additionaly added by the author. Proofread by Karen Reidy. Set in Dosis, an open source font designed by Edgar Tolentino and Pablo Impallari.

First edition, July 2016. Published in association with Arthropology[Lab]. Printed-on-demand in the USA and distributed worldwide by Blurb Books (www.blurb.com/b/7181097-timor-runguranga). A special collectors' edition (ISBN: 9781367551268) is available from Amazon.com.

Second revised edition (1000 copies), December 2016. Published and distributed exclusively in Timor-Leste by Timor Aid (www.timoraid.org). The views expressed in this book are those of the contributing authors and do not necessarily reflect the views or policies of the publisher. The designations employed and the presentation of materials in this book do not imply the expression of any opinion whatsoever on the part of the publisher. Printed by Prolong Press in China.

Copyright © 2016 by David Palazón, Timor-Leste. All rights reserved. The author asserts his moral right to be identified as the author, editor and designer of this book. The copyright of the writing and photographic contributions are held by the respective authors/owners. No part of this publication may be reproduced, distributed, or transmitted in any form or by any means, including photocopying, recording, or other electronic or mechanical methods, without the prior written permission of the author, except in the case of brief quotations embodied in critical reviews and certain other noncommercial uses permitted by copyright law. For permission requests, please write to the author on the email below.

A selection of images by David Palazón are available as open edition single prints in different sizes and qualities. For more information, please visit the Timor Runguranga Collection at Saatchi Art (www.saatchiart.com).

Cover image: Du'u Kai.

www.davidpalazon.com
david@davidpalazon.com

Facebook > Timor Runguranga
Instagram > davidpalazon.photography
Saatchiart.com > collections > Timor Runguranga

*'From the moment I picked your book up until I laid it down,
I was convulsed with laughter. Someday I intend reading it.'*

Groucho Marx

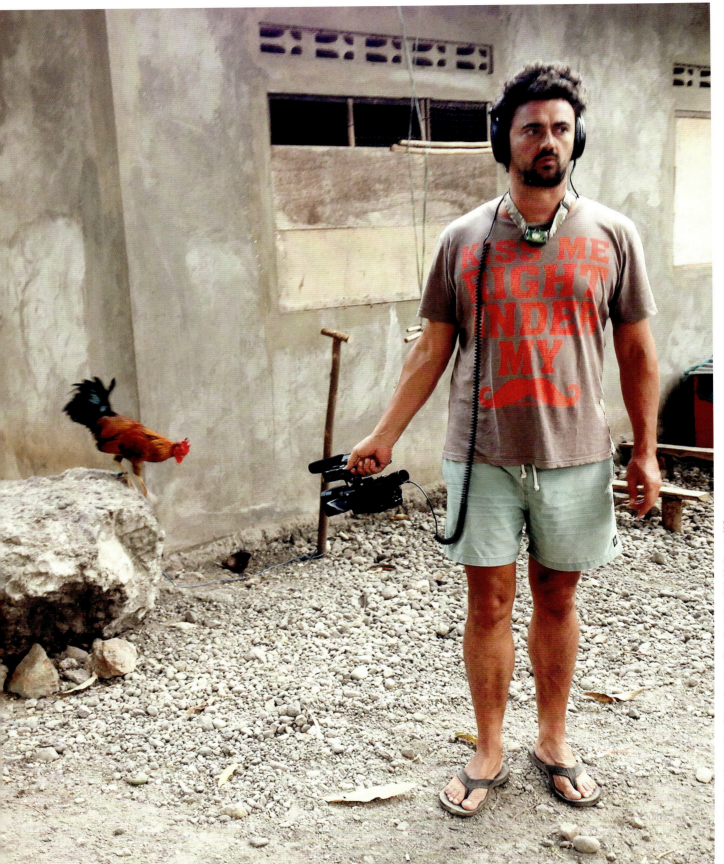

000 | Incidental documentation. Photograph courtesy of the author. © Karen Reidy, Vila Maumeta, 2015.

KONLISENSA[1]
David Palazón

On Februay 11th 2008 I remember receiving an email from my friend Ricardo, an avid reader of geography and politics, informing me that José Ramos-Horta, Nobel Peace Laureate and former President of Timor-Leste had been shot in an assasination attempt. Coincidentally, a few days earlier, I had visited Ricardo in my hometown of Barcelona and told him about the idea of quitting London for Timor-Leste. He was slightly worried that I was not quite sure where I was going or knew much about the recent history of the country. A few months later I gave up my job at the University of the Arts London, gave away most of my belongings, handed over my clients, and called a halt to my relationship with Elena. I jumped on a plane and landed in Dili in early July.

I initially went to Timor to work as a volunteer, mentoring design and filmmaking to a group of young artists, but as one thing leads to another, three months later, I curiously found myself flying with a Russian pilot on a UN helicopter while making a peace-building documentary with the very same Ramos-Horta. That was one of many episodes that I accidentally, incidentally stumbled across while working and living in the remote half-island nation of Timor-Leste for almost eight years.

My work as an artist takes aim at exploring the boundaries of the human condition, and Timor-Leste, without doubt prompted me with a vast amount of opportunities to learn much about the lives of others, and consequently about my own. From volunteer arts mentor to government advisor, I had the pleasure to work across the full spectrum of creative practices, mentoring young adults through the years and help them achieve self-employment in the creative industries, designing multilingual books and exhibitions, directing and producing some of the first indigenous, international award-winning documentaries coming out of the country, curating exhibitions, art directing and managing all sorts of events, working with all kinds of artists, artisans and international researchers in a quest to document the arts and culture—both tangible and intangible—,as inspirational vehicles for the development of this young nation.

Countless times I travelled from Dili to some of the most remote parts of the country to find unspoilt beauty and wonder as you would find a rough, uncut gem at the edge of the world. Somehow, my experience of working in the districts felt strikingly more honest and pure than being in the capital. Regardless of where I went, most people I met were kind, receptive and would always embrace me as one of their own. The experience of working in Dili, was a totally different story, often it felt like a postcolonial, *malae* [2] infused, coconut cocktail, laced with a dash of nonsense, frustration, confusion, and contagious laughter mixed into a *runguranga* [3] film, scripted by the Max Brothers and performed by the Monty Phyton.

The school of Timor-Leste has taught me many things, most of which would be impossible for me to explain in words, so instead, I decided to make this photobook, and share with you some of my observations about the odd and the not so obvious across the country. In the process of selecting and editing the photographs, I realised my experience was mostly shaped by the many people I had met throughout all these years, and therefore I decided to invite those who were interested to become contributors to this unique piece of artwork.

I am covinced feelings are more important than facts, so I hope this publication might spark enough sentiments of curiosity to its readers (and viewers) so they decide to explore this remarkable young nation, as I did.

To end, I wish to dedicate this book to Karen, my *defactopastafarian* partner, not only for her encouragment and support over the last year to help me realise this book, but most importantly, for the love and laughter that binds us together.

1. *Konlisensa* is a word of Portugese origins (*com lisensa*) generally used as a way of making oneself noticed, for example, as a way of proceeding to interrupt a talking audience but also as a formal introduction in traditional ceremonies and official openings. It is also commonly used when someone needs to pass through a group of people generally unaware of blocking a public pathway or corridor; the individual will acknowlegde his action by passing through slightly bent, while pointing forward the right hand as the aiming direction—almost like in an Egyptian painting—while pronuncing the word '*Konlisensa*' (Excuse me!). **2.** *Malae* is an a noun commonly used to describe a foreign person, generally outside of the Malay archipelago region. **3.** *Runguranga* is an adjective which meaning swings between 'uproar' or 'disturbance' to 'in a mess' or a 'messy' situation or place; it is perhaps this last significance that makes Timorese people grin like a Cheshire cat when the word *runguranga* is pronounced.

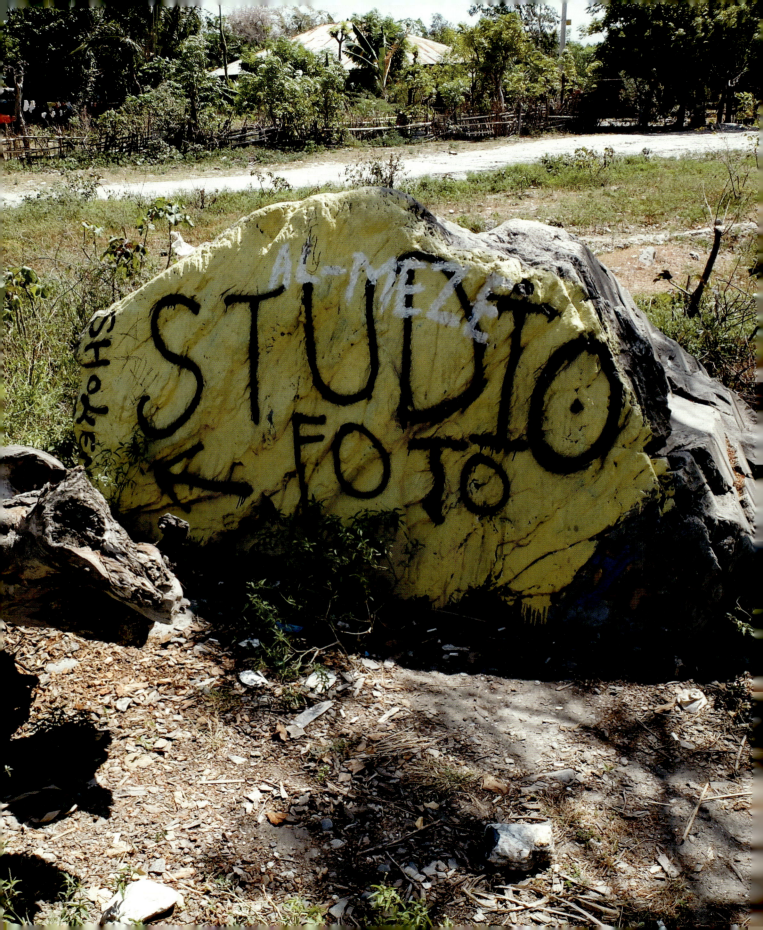

CONTRIBUTING WRITERS

12	SIMPLE PAST	Leilana Quinger
20	REMEMBERING THE PAST IN THE PRESENT	Andrew Henderson
26	SOBRE PENSAR DEMAIS	Larissa Almeida
32	CLOSURE	Kirsty Sword Gusmão
53	FOOTBALL TEAMS	Agio Pereira
55	COCONUT THIRST	Rebecca L. Kinaston
60	UNIVERSOS DISTANTES: TIMOR-LESTE ENTRE DÍLI E AS ALDEIAS	Sofia Miranda
66	INAN: BEE-MATAN, SULI LORON, SULI KALAN	Abé Barreto Soares
72	LET ME SPIN YOU A YARN	Joanna Barrkman
77	AS GUARDIÃS DA TRADIÇÃO	Rosália E. M. Soares
84	O TAIS	Rosália E. M. Soares
90	BONECA DE ATAÚRO	Ester Piera Züecher Camponovo
100	GAUA SURI	Maestro Simão Barreto
108	TIMOR OAN	Danilo Lemos Henriques
120	SALT WATER CROCODILES	Alberto Fidalgo
130	PAÍS TROPICAL COM GENTE DENTRO	Madalena Salvação Barreto
148	SA'ET HEHATA, SA'ET PERANI, SILENT TESTEMUNHAS ATAÚRO NIAN	Maria Ceu Lopes Federer
160	EMA DEHAN SIRA BULAK	Kiki Kakashi
171	FOUND IN TRANSLATION	Daniel Simião
177	I GALLI DI AUDIAN	Elena Tognoli
184	TRADICIONAL COMTEMPORÂNEO	Maria Maderia
192	THE STORY OF KELBELI & MANU-TASSI	Lucas Serrão Lopes
199	GETTING LOST	Nuno da Silva
203	HAKILAR NUUDAR EMA	Naldo Rei
210	SIRA FIAR ADAT	Enrique Alonso-Población
216	JUSTINO VALENTIM†	Amy Stevenson
219	SUNG POETRY IN SUAI	Philip Yampolsky
230	SAFEGUARDING CULTURAL DIVERSITY	Masanori Nagoka
234	FUHUK IHA BATAR LARAN	Hector Hill
237	HOMEWORK	Marcelina Warubua Osolio
240	KARAU	Jean-Christophe Galipaud
256	LULIK: VALOR NUKELO TIMOROAN NIAN	José (Josh) Trindade
272	REGRESSO AO PARAÍSO	Manuel Casal Aguiar
276	LEGADO DISTANTE E FRÁGIL	Isabel Boavida
289	MAU DUA†	John Martires
293	DIMENSÕES VISÍVEIS E INVISÍVEIS	Mara Bernardes de Sá
300	PEDIR PERMISO	Mireia Clemente
311	WALKING UP GOLGOTA	Pat Walsh
317	O DESENVOLVIMENTO, A MODERNIDADE E O PUDIM DE LEITE	Margarida Bandeira de Lima
324	EMA BO'OT	Leilana Quinger
328	SO WHAT IS IT ABOUT TIMOR-LESTE?	Tony Fry
333	CHALLENGES	Alessandro Boarccaech
336	OBRIGADA, EM TIMOR-LESTE E A TIMOR-LESTE	Kelly Silva
342	ACKNOWLEDGEMENTS	

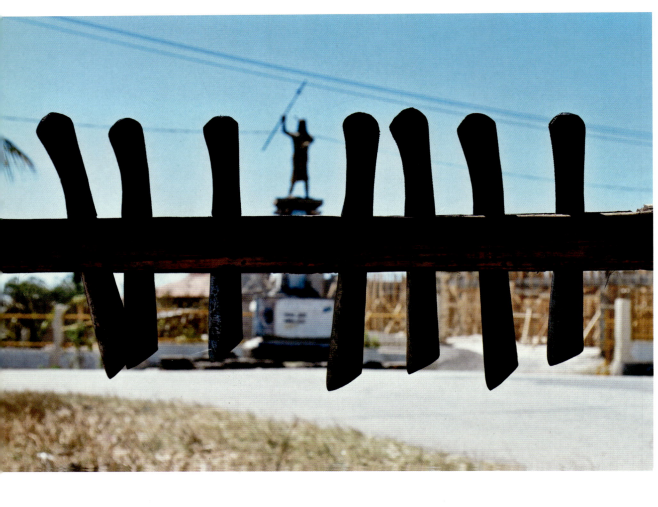

003 | Distant warrior. © David Palazón. Baucau, 2009.

004 | Welcome. © David Palazón. Tasitolu, 2014.

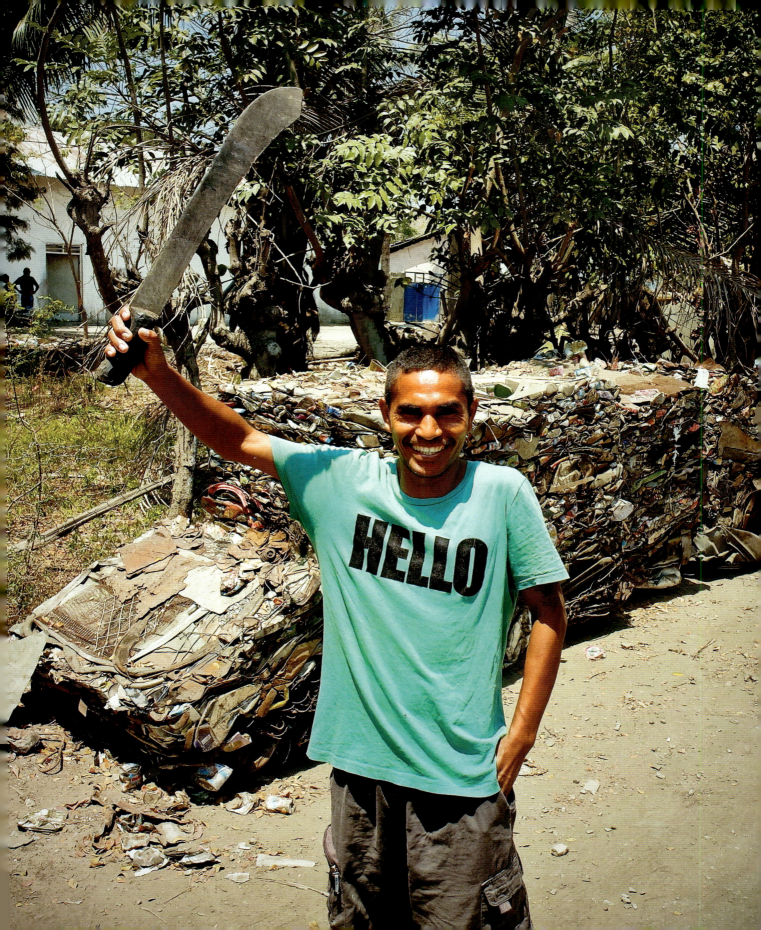

SIMPLE PAST
Leilana Quinger | English teacher

As a teenager I spent years obsessing about the independence movement in Timor-Leste and had cried, a high school Amnesty International volunteer, genuine tears of joy when that little country got to be it's own state. When a man who I hero-worshipped from afar got to be President and was actually a good person. We don't think these things will actually happen in our own lifetimes.

Even so, when I visualized Timor-Leste, directly before I went, I forgot to include the nation state. I spent my days both literally and mentally googling mountains, crystal water teeming with migrating sea mammals, big Catholic churches with charming chipped paint jobs and markets over-flowing with Pacific style root vegetables.

I didn't google institutions, or ministries, or ambassadors.

What I got, landing in Dili, was all of the above, including bureaucracy to make an Indian blush and a ludicrous embassy to house ratio along the best real estate of Dili. Including the very recent history. Including the most violent versions of the modern nation state, the shocks of which were still reverberating in my classrooms.

Teaching the past simple, I would innocently ask a room full of government Ministers: 'Where were you ten years ago? Twenty years ago?'

The examples in the text book were: 'I was at university' or 'I was at primary school, learning to read.' My students, middle-aged, kind and glad to be there, would think and count back on their fingers.

'20 years? Oh, haha, I was in the jungle ... killing soldiers ...'

The class would erupt into laughter and the student who spoke would break into a brief, flashing grin before swallowing it and watching carefully for my reaction.

How could I react? I would smile, always, and say something like 'Huh! Wow!' Then I would let the silence hang, leave room to add details—they often wanted to.

I learned, through my years in Asia, to smile and even laugh when hearing of trauma. It is expected.

And, here in Timor, albeit more Pacific than Asian, my students would gather around their tables—campfire style—eyes dancing and nervous grins blinking between serious pronouncements—and tell me about hiding in the jungle. Tell me about giving birth in the jungle. Tell me about the food one can grow in the jungle.

Right now it's dry season though, so you can't imagine. They'd add. When it's raining, it gets really dense up there.

Outside, we'd drive our motorbikes away in the dust; the mountains above bare, the embassies fortress-like, flags snapping in the wind.

005 | Looking back. © David Palazón. Beloi, 2015.

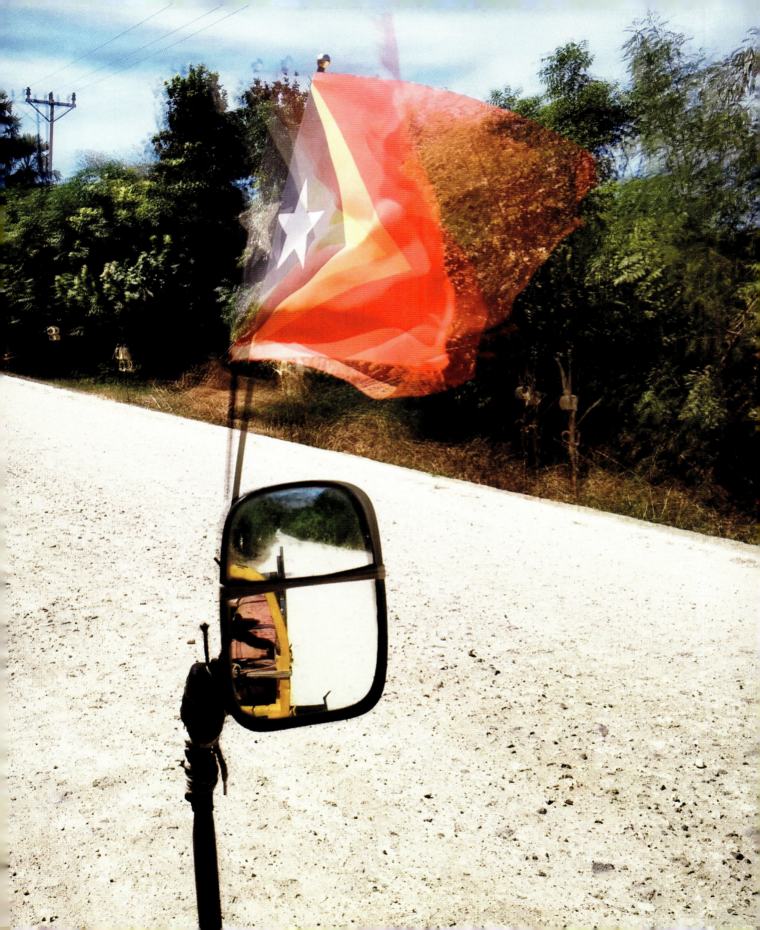

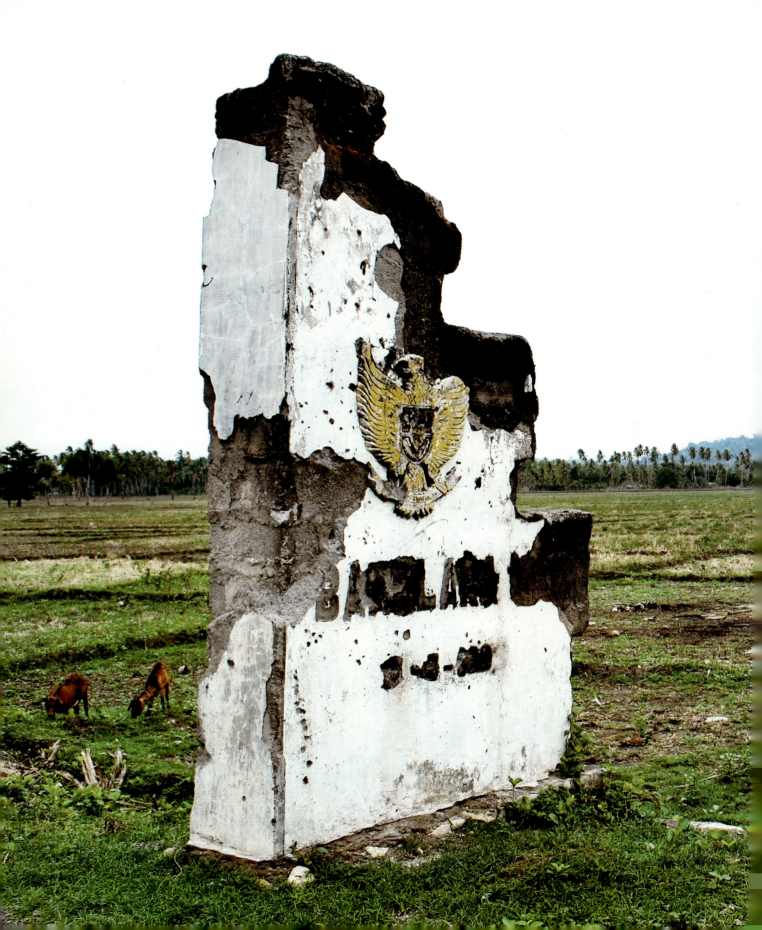

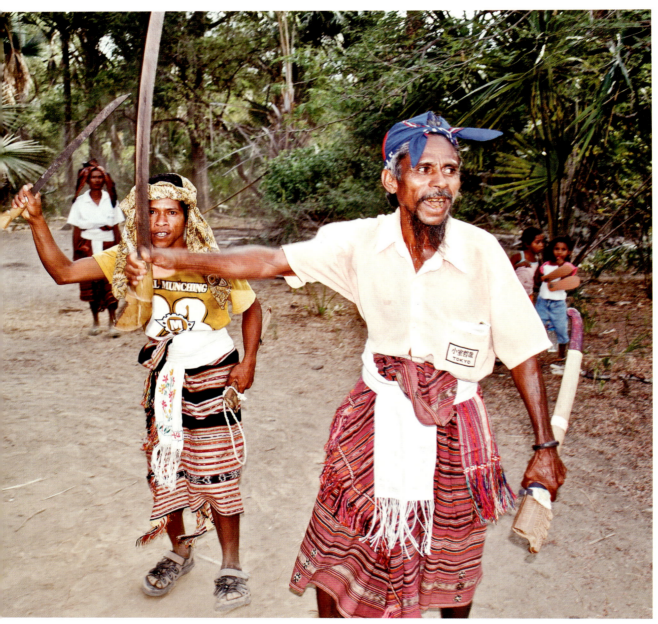

007 | Dancing with swords. © David Palazón. Lakore, 2009.

008 | Gunman with moustache. © Elena Tognoli. Manatuto festival. 2010.

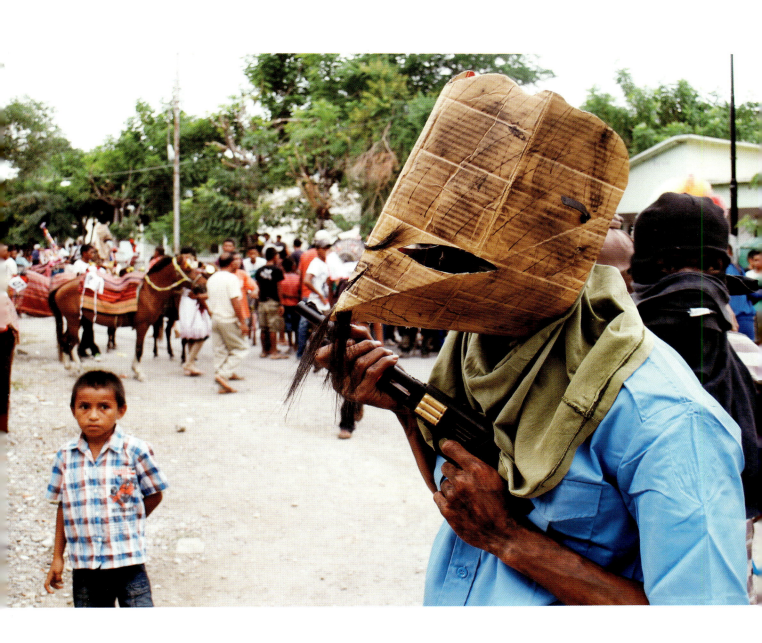

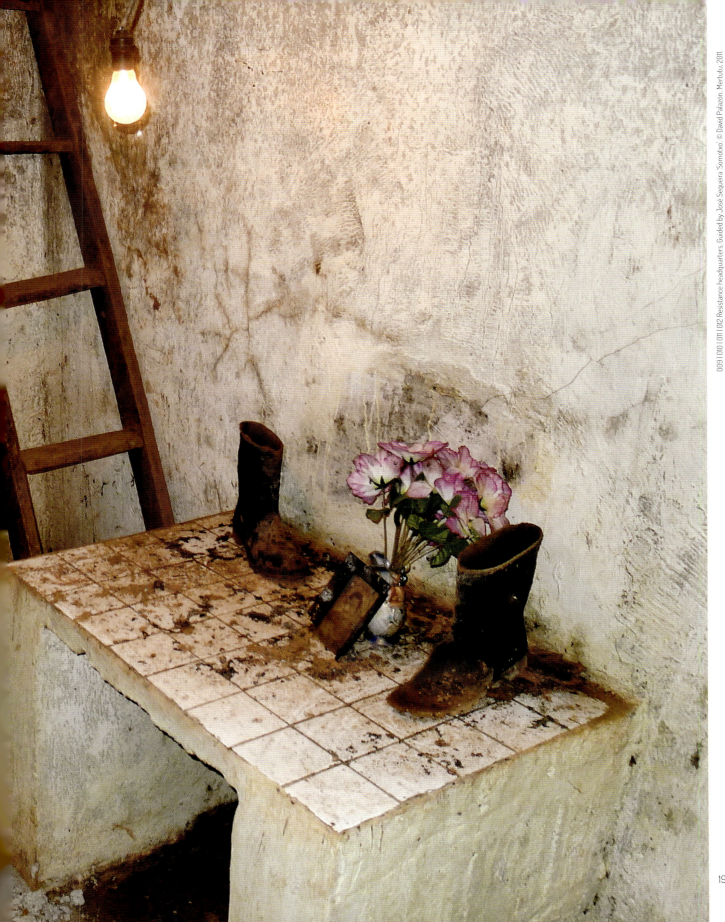

REMEMBERING THE PAST IN THE PRESENT
Andrew Henderson | Programme Specialist, Memory of the World

How the past is remembered, represented and commemorated in the present appears to be more and more of a concern of the government in Timor-Leste. The Nicolau Lobato monument, inaugurated in 2014, is one such example of this. Located strategically on the highway to the Dili airport, the statue of Timor-Leste's first President holding an M16 rifle, is a powerful representation of the role of the guerrillas, and veterans, many of whom currently hold positions of power in government, in the struggle for Timor-Leste's independence.

This focus on state led 'memory' projects raises questions about the political aspects of remembering the past in the present. What aspects of the past are considered worth preserving and celebrating and by whom? What stories are left untold and why?

The archive of the CAVR (Truth and Reconciliation Commission) is one collection that offers an alternative window to view Timor-Leste's past, outside of simply focusing on the role of the armed resistance. The archive contains records from the 1970s to the post-independence period from public hearings, community recommendations, court files, victim statements and interviews with people involved in the resistance.

This collection is of national significance and can play an important role in sharing the stories of occupation and resistance from a range of perspectives including women, youth, and other groups.

Much work is also being done by the Max Stahl Audio Visual Archives to document the 'memories', or oral histories, of people who expe-rienced events first hand, as well as preserving audiovisual records from the pre and post independence periods. This important archive was acknowledged by UNESCO as being of significance to not only Timor-Leste, but the wider international community through the Memory of the World (MoW). This UNESCO program aims to promote the preservation and access to documentary heritage globally.

According to the international panel of experts that assessed the archive, it holds international significance as 'Timor-Leste is the first nation to liberate itself through the power of audiovisual images, contributing to radical changes by enabling people to speak directly to each other and to the world.'

Many other significant collections exist in Timor-Leste. The records of the referendum of 1999 held in the National Archives are just one such example. The preservation of such collections, and increasing access to them for use by students, academics, and the general public, can be valuable for the work of reexamining and reinterpreting Timor-Leste's past in new holistic, exciting and inclusive ways.

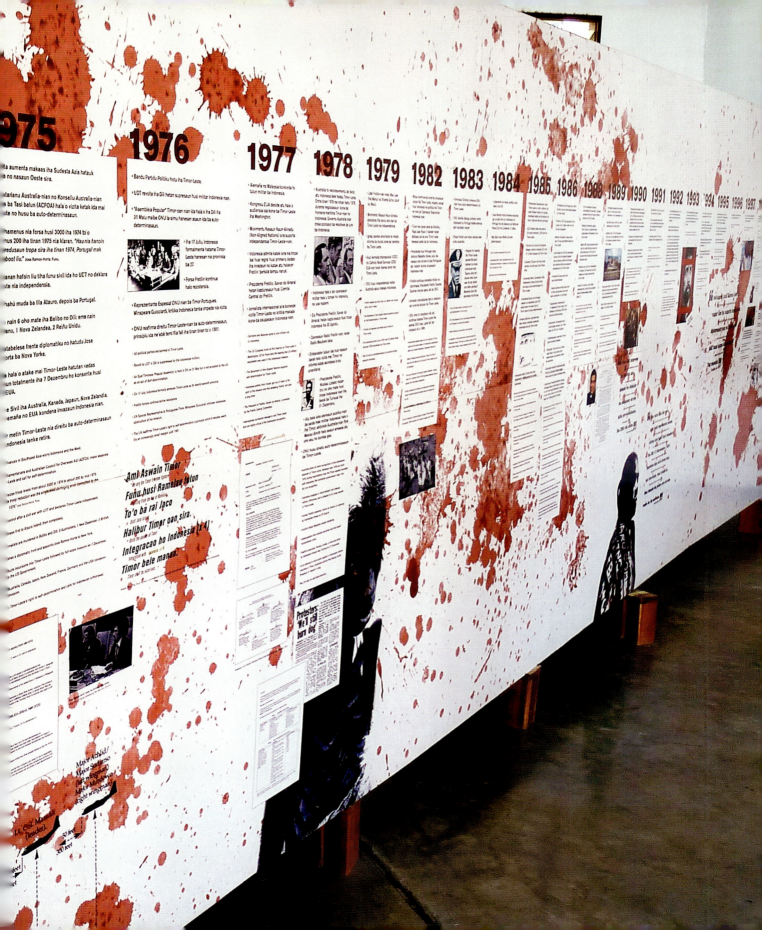

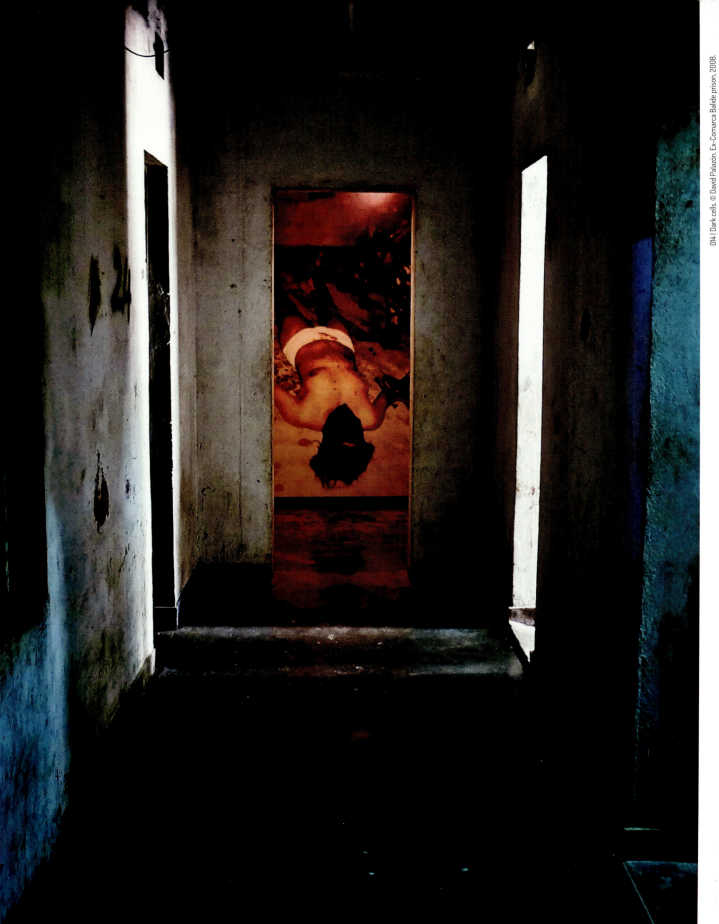

014 | Dark cells. © David Palazon. Ex-Comarca Balide prison, 2008.

015 | Torture series. Photograph courtesy of the author. © Bernardino Soares. Dili, 2011.

016 | Spyhole. © David Palazón. Maubutar cell (Ex-Comarca Balide prison), 2008.

017 | Missing target. © David Palazón. Baucau, 2008.

SOBRE PENSAR DEMAIS
Larissa Almeida | Especialista em comunicação

Em 2012, lembro de ler em um jornal que alguém de Lecidere havia cometido suicídio. Entre as razões, tentava explicar o jornalista, estava *nanoin barak*—que literalmente significa "pensar demais". É bem provável que ele tenha usado essas palavras para explicar o que seria depressão, talvez porque o termo até então não era de conhecimento amplo ou não possuía tradução. Se existia tradução ou não, nunca soube. Embora triste, preferi ficar com a beleza melancólica da união de duas palavras que viraram uma certa poesia em minha memória.

De vez em quando penso (demais) nas misteriosas trilhas xistenciais, seja através dos questionamentos sobre o propósito da vida ou sobre as cruéis incertezas dela. De forma constante, toma forma no meu pensamento a lembrança de Timor-Leste e de seu calendário onde a chama fluida das velas marcam o compasso da memória. É através do brilho delas que a imagem dos mártires volta ao pensamento dos que perderam amigos e entes queridos para que hoje essa jovem nação fosse livre.

Hanoin barak faz lembrar a resistência desses homens e mulheres que resistiram às garras da morte para que hoje soubéssemos da dimensão de suas histórias. É bem possível que *hanoin barak* também se aplicasse, naquele contexto, de pensar muito (e bem) antes de reagir às provocações inescapáveis dos opressores impiedosos. Era como se o pensar cuidadosamente fosse uma forma de guardar a identidade que os unia enquanto povo, para que ele fisicamente se transformasse em um grito tão logo houvesse liberdade. A independência chegou, a reconstrução começou e a vida continua com a sabedoria de que as dores daquela época não muito distante ajudaram a pensar e a formar a nação de hoje.

ABOUT THINKING TOO MUCH
Larissa Almeida | Communication specialist

In 2012, I remember reading in a newspaper that someone had committed suicide in Lecidere. *Hanoin barak*—which literally means 'thinking too much'—was among the reasons the journalist gave. It is very likely that he used those words to describe the meaning of 'depression', because at the time perhaps the term was not widely used nor did it have a translation. I never found out if there was a translation for it. Sadly enough, I preferred to stay with the melancholic beauty of two words that sparked a certain poetry in my memory.

Once in a while I think (too much) in mysterious existential trails, either through questions about the purpose of life or about the cruelty of her uncertainties. It constantly takes shape in my mind the remembrance of Timor-Leste and its calendar of perpetual candle flames. It is through the glowing of these flames that the image of martyrs appears to those who have lost their friends and loved ones, so this young nation can be free today.

Hanoin barak reminds me of the resistance of the men and women who fought from the jaws of death, so that today we can know the dimensions of their stories. It is quite possible that *hanoin barak* was also applied in that context, about thinking too much before reacting to the inescapable provocations of ruthless oppressors. As if this careful thinking was the way to keep their unified identity as people, becoming a physical scream heard until freedom was to be found. Independence came, reconstruction began and life went on accompanied by the not too distant painful wisdom that helped to think and shape today's nation.

018 | Santa Cruz massacre remembrance day. Photograph courtesy of the author). © Bernardino Soares, Santa Cruz, 2014.

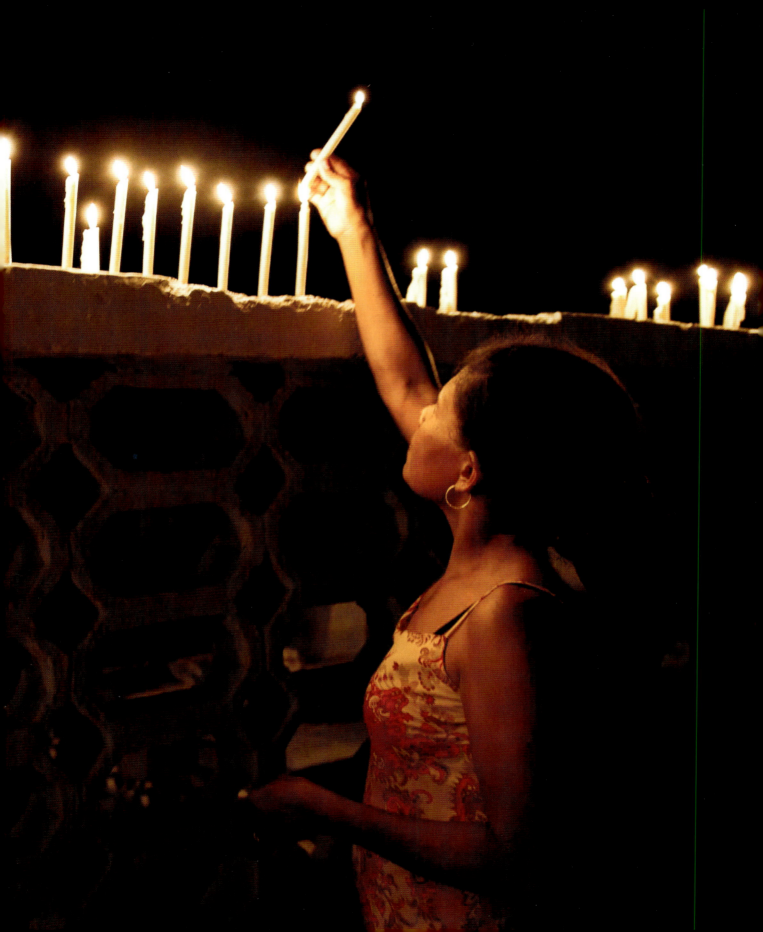

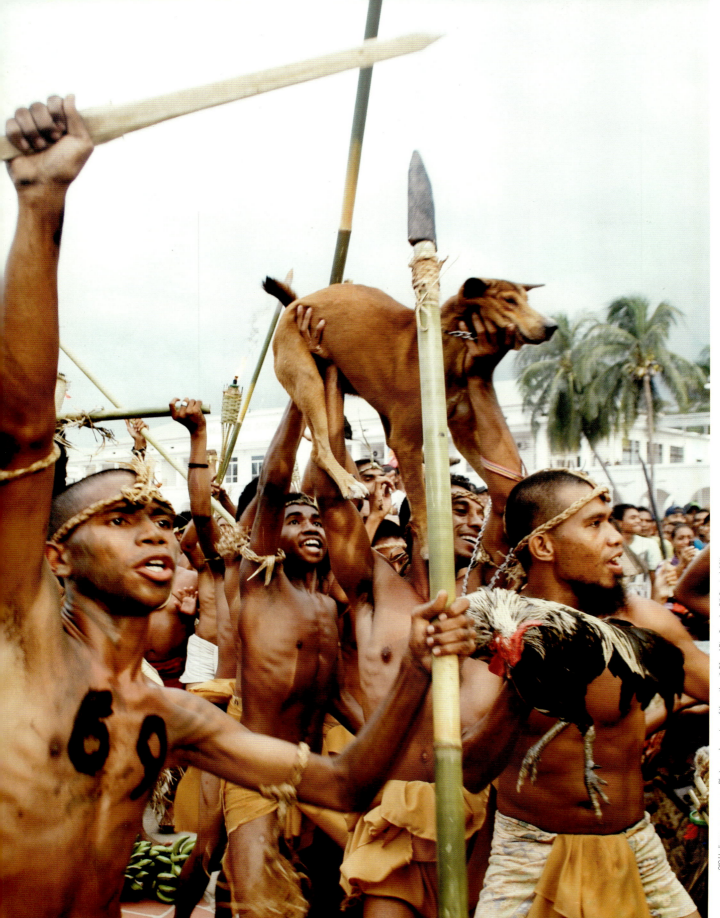

019 Indigenous runguranga. Photograph courtesy of the author. © Gibrael Dias Carocho. Dili Carnival, 2011.

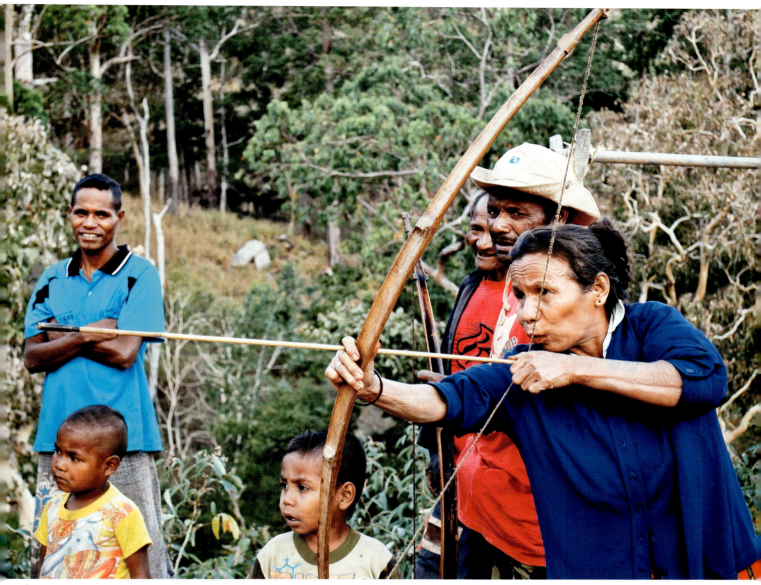
020 | Female archer. © David Palazón. Ilimanu, 2009.

021 | You've been targeted. © David Palazón. Venilale. 2010.

022 | Window display. © David Palazón. Venilale. 2010.

CLOSURE

Kirsty Sword Gusmão, AO | Goodwill Ambassador for Education, Democratic Republic of Timor-Leste | President, Alola Foundation

On the road between Dili and Aileu, at the dusty (or muddy, depending on the time of year) turnoff to the seminary of Dare, is a memorial. It's just a slightly weathered bronze plaque set into a slab of concrete by the side of the road and overlooked by most of those who pass here. Amongst those who shuffle by the plaque daily are old women bent double with their baskets of fruit and vegetables for sale in the markets of Dili, and the school children of Fatunaba Primary School. These kids are learning each day in a place steeped in history, atop a treasure chest of relics which are testimony to a love and friendship born of war.

The original monument, dedicated by members of the 2/2nd and 2/4th Commando Associations in 1969, consisted of an in-ground swimming pool and fountain and was intended as a resting place for travellers passing through on their way to and from Dili. It was a gift from the Australian diggers to the people of Timor-Leste for the life-saving support they provided to the Commandos between 1941 and 1942 in the course of Japan and Australia's occupation of then Portuguese Timor. Australian war historians are loath to describe Australia's landing of troops on Timor as an invasion or occupation, but in fact this is what it was. Portuguese Timor was a neutral country during the war, and would not have attracted the ruthless attention of Japan that it did if it hadn't been for the presence of Australian troops. The war on Timor island cost the lives of between 40,000 and 60,000 East Timorese civilians. Only 40 Australians perished.

In 2008, the freshwater swimming pool was filled in and the Fatunaba Primary School built on top of it. There was literally no other piece of flat land available on these picturesque slopes overlooking Dili. Besides, due to land slippage and resulting leaks, the pool was unable to hold significant quantities of water, other than puddles in which mosquitoes bred.

The over 300 students who file into the school's classrooms each day are most likely unaware of the significance of the site on which they are being educated as Timor-Leste's new generation of nation builders and leaders. It was my hope when I established the Museum and Café here at the Memorial site that the children of the area would grow up with a strong sense of pride in the monumental sacrifices made by their forebears, a pride infused not with anger or resentment but with admiration and wonder at the power of friendship and solidarity which blossomed between the Australian diggers and their brave East Timorese helpers.

Such a friendship, that of Private John 'Paddy' Kenneally and his friend, Rufino Correia, is celebrated in pictures at the Dare Memorial Museum. Irish-born Paddy joined up for active service in the Australian army in 1941, to fight 'for Australia, not the King'. Perhaps it was Paddy's experience at a young age of the sectarian violence associated with British occupation of Ireland that was to turn him into a fierce campaigner against Indonesia's illegal annexation of Timor-Leste. For years he railed against Australia's complicity with the Indonesian armed forces in the genocide being played out in the territory. He passionately and emotionally reminded Australian politicians of the debt of honour owed to the people of Timor-Leste for the human tragedy wrought upon them by a war they had nothing to do with.

Paddy sadly passed away just a month before the refurbished memorial and the new museum and primary school were inaugurated on 25 April 2009. He continued, however, right up until his death to refer to the site as a 'memorial to betrayal.' Of course, he was referring to the original betrayal which saw Australian soldiers depart the shores of Timor island, leaving behind the thousands of mainly young Timorese who had helped them, knowing they were unlikely to survive Japan's swift and brutal retaliation. Many diggers went to the grave never having experienced closure over the guilt and trauma left by that abandonment.

But then the betrayals kept mounting up, the next being Australia's *de jure* recognition of Indonesia's illegal 24-year occupation of the territory.

It is perhaps just as well that Paddy has been saved the pain and disillusionment of Australia's most recent betrayal, that of its refusal to negotiate a seabed boundary with Timor-Leste. When I think of how important it is to Timor-Leste's sovereignty to close that 344 km gap in the maritime border it shares with Australia, I think not so much of which country will claim the lion's share of oil and gas resources in the Timor Sea. I think more of the children of Fatunaba and their understanding of their nation's history and future in relation to Australia. Will it be one imbued with the gentle spirit and stories of friendship and mutual respect of the Fatunaba memorial and museum, or one tainted by the greed and short-sighted notions of 'national interest' of Australia's political leaders?

http://darememorialmuseum.com
http://www.gfm.tl/

023 | Read between the lines. © David Palazón. Ferry to Ataúro, 2015.

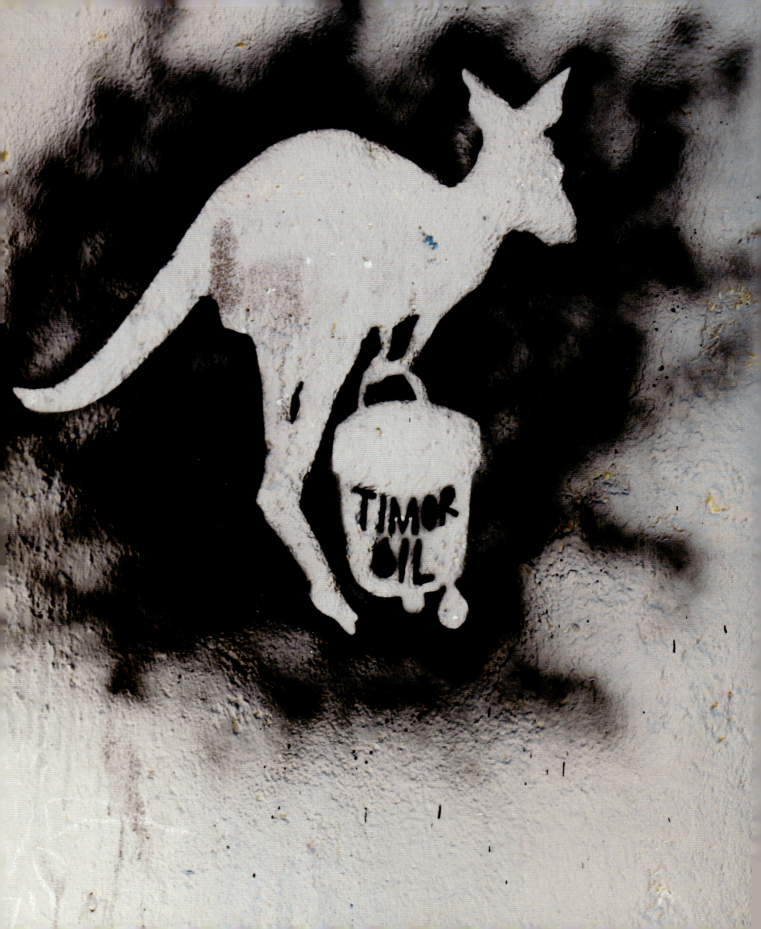

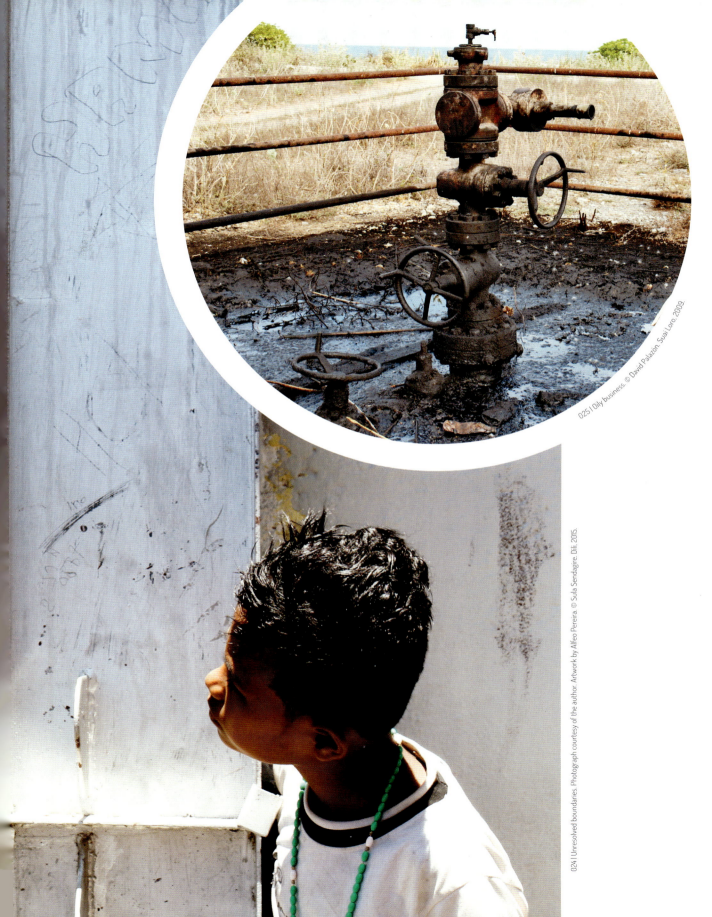

025 | Oily business. © David Palazón. Suai Loro, 2009.

024 | Unresolved boundaries. Photograph courtesy of the author. Artwork by Alfeo Pereira. © Sula Sendagire. Dili, 2015.

35

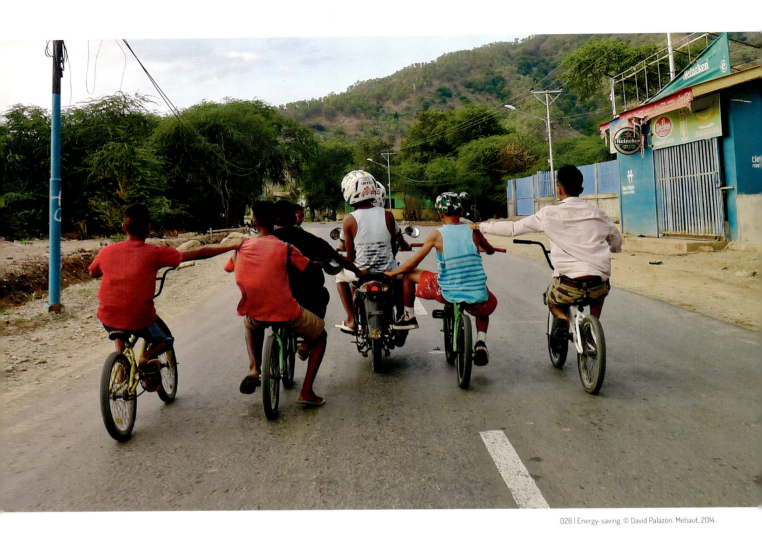

026 | Energy-saving. © David Palazón. Metiaut, 2014.

027 | Travelling infection. © David Palazon. Maliana. 2013.

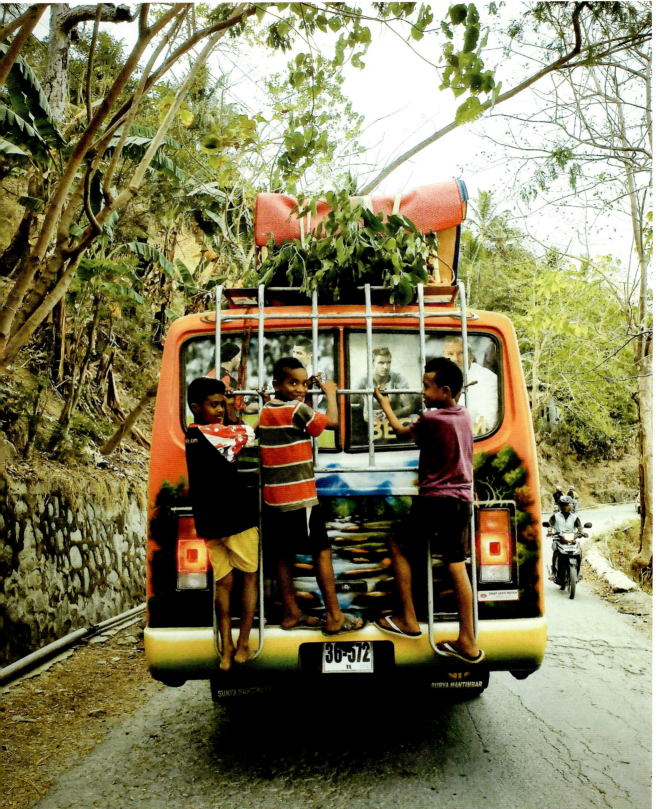

028 | Freeride. © David Palazón. Dare. 2014.

030 | 031 | Boy racers. © David Palazón. Viqueque, 2009.

032 | Onomatopoeia. © David Palazón. Dili, 2014.

033 | See you on the other side. © David Palazón. Viqueque, 2010.

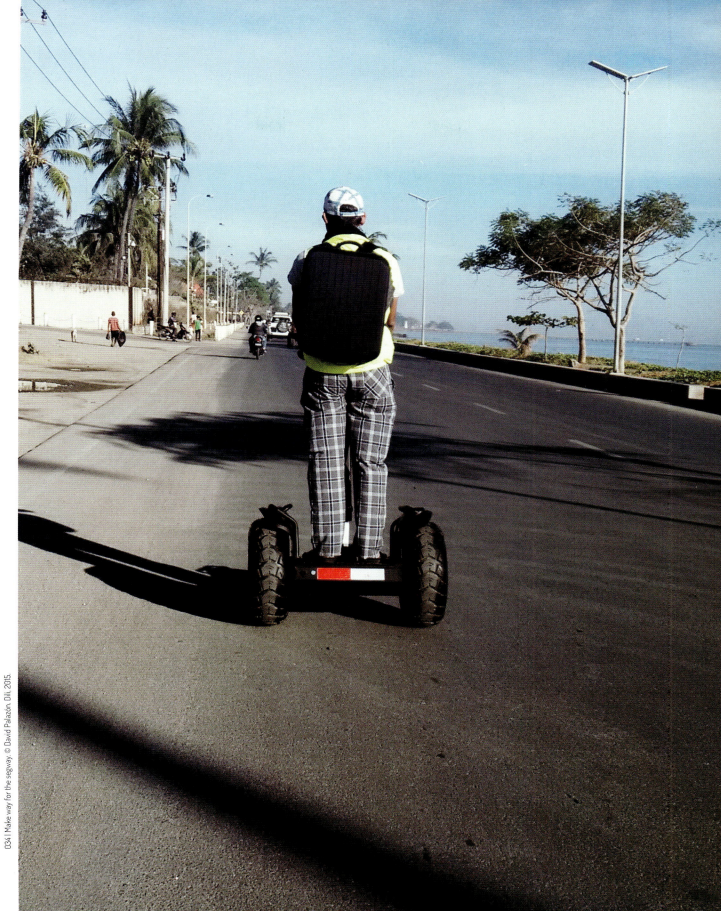

034 | Make way for the segway. © David Palazón. Dili, 2015.

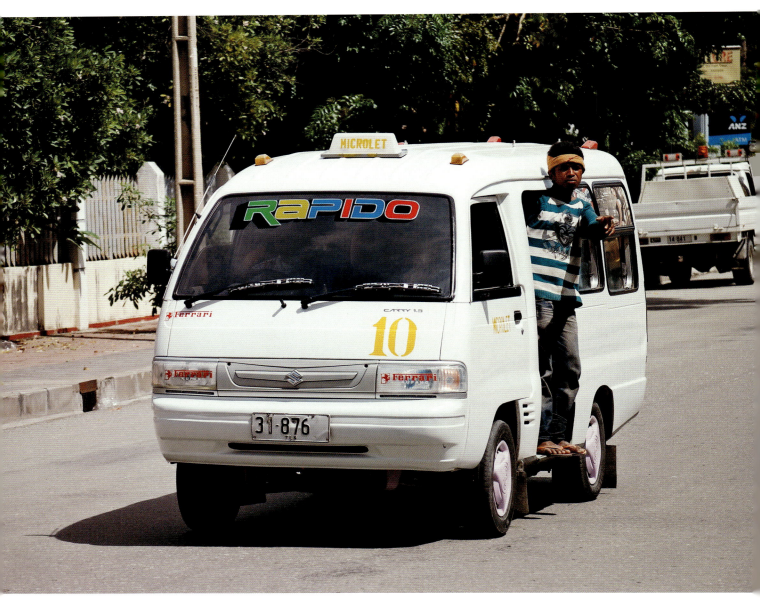

035 | *Rapido* (fast) *microlet*. © Gibrael Dias Carocho. Dili, 2012.

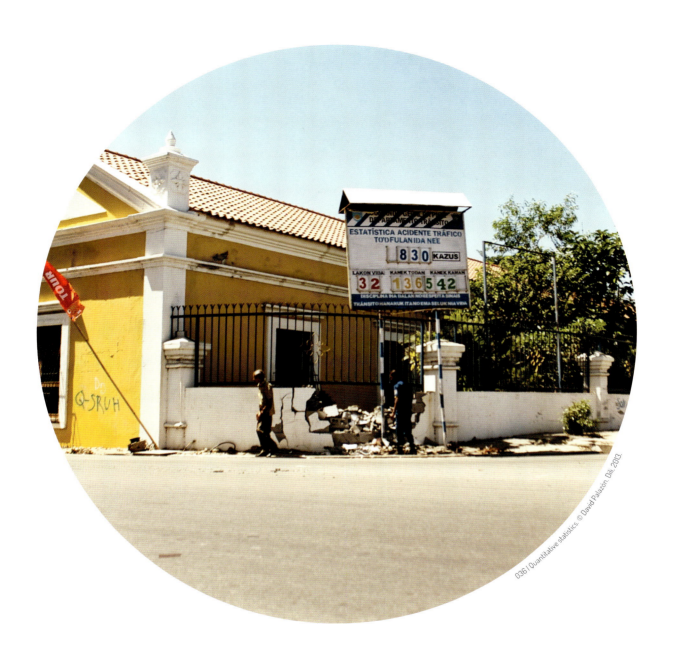

036 | Quantitative statistics. © David Palazón. Dili, 2003.

037 | Free parking space. © David Palazón. Camansa, 2014.

038 | Pole position. © David Palazón. Tibar, 2008.

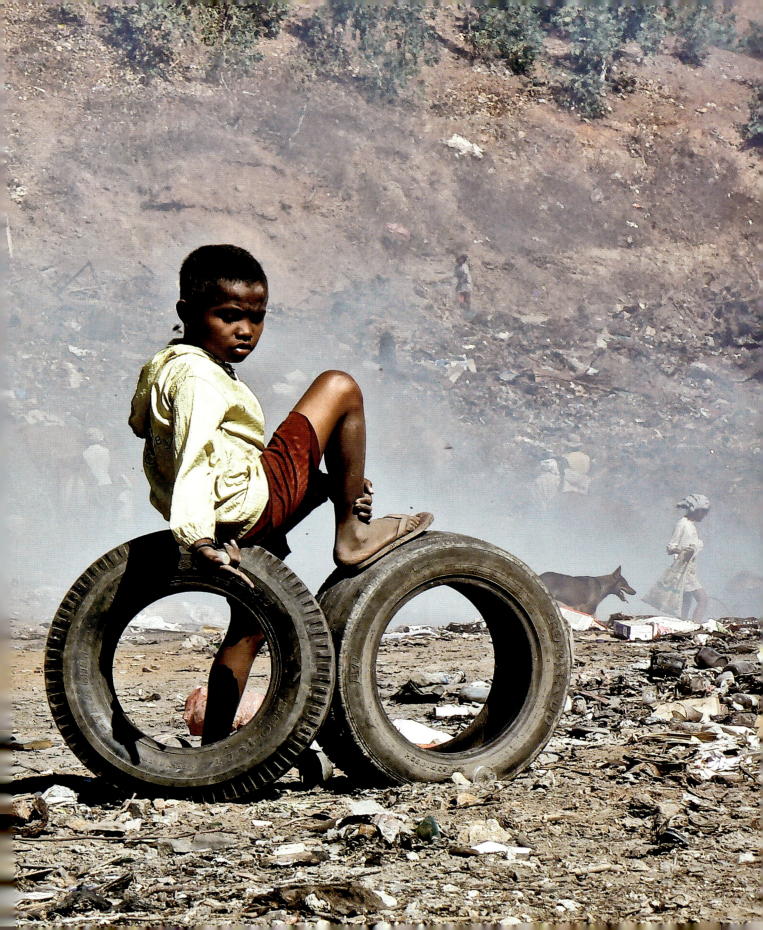

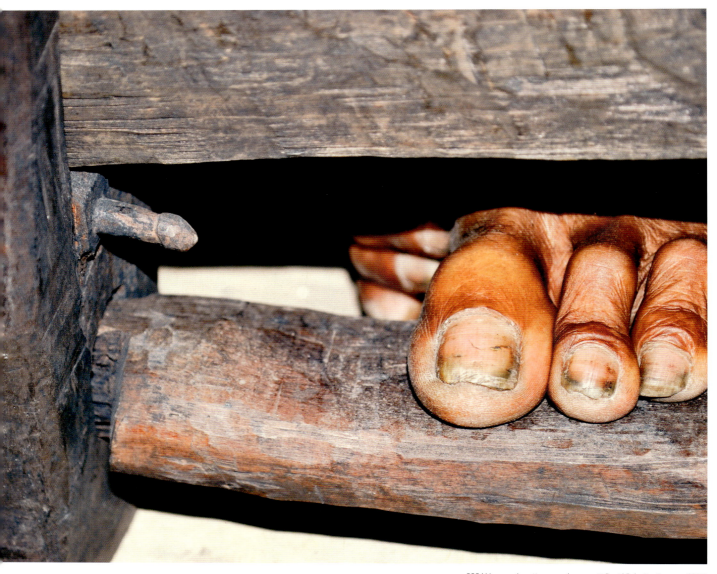

039 | Man-made cotton mangle press. © David Palazón. Oecusse, 2009.

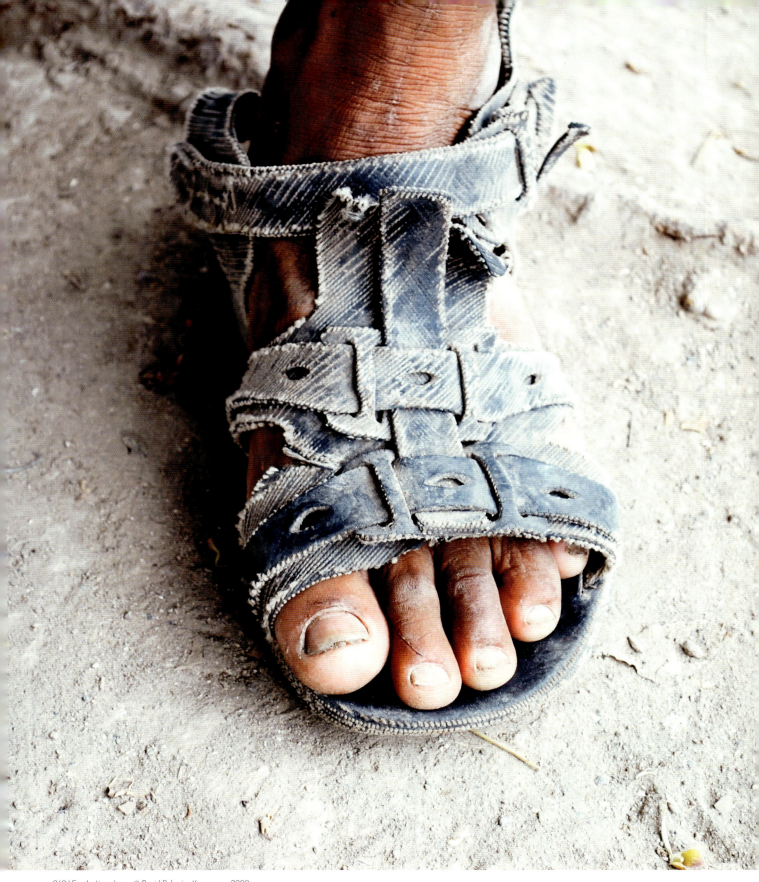

040 | Everlasting shoes. © David Palazón. Kamanasa, 2009.

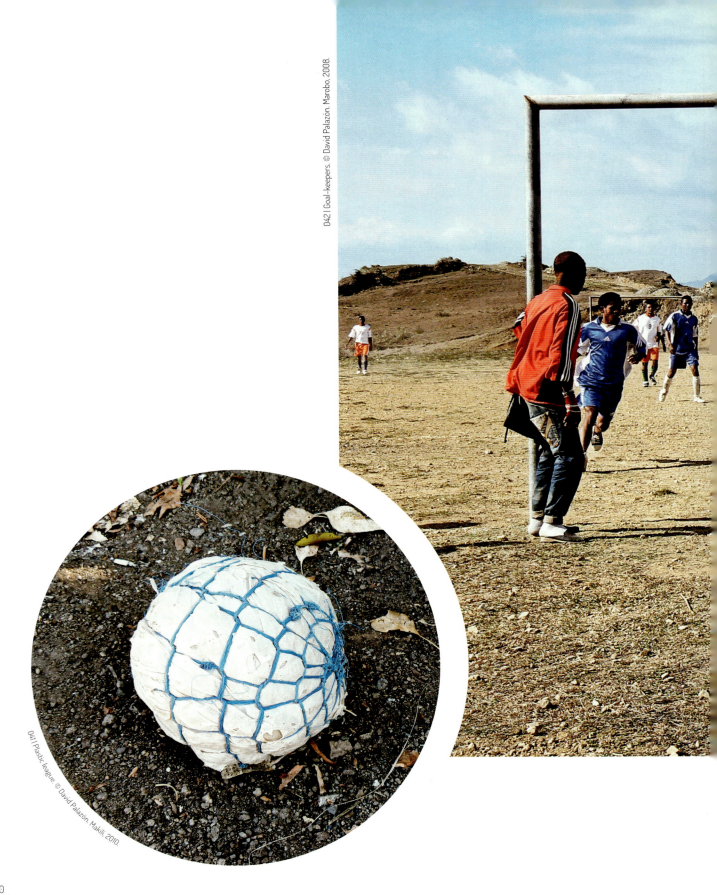

042 | Goal-keepers. © David Palazón. Marobo, 2008.

041 | Plastic league. © David Palazón. Makili, 2010.

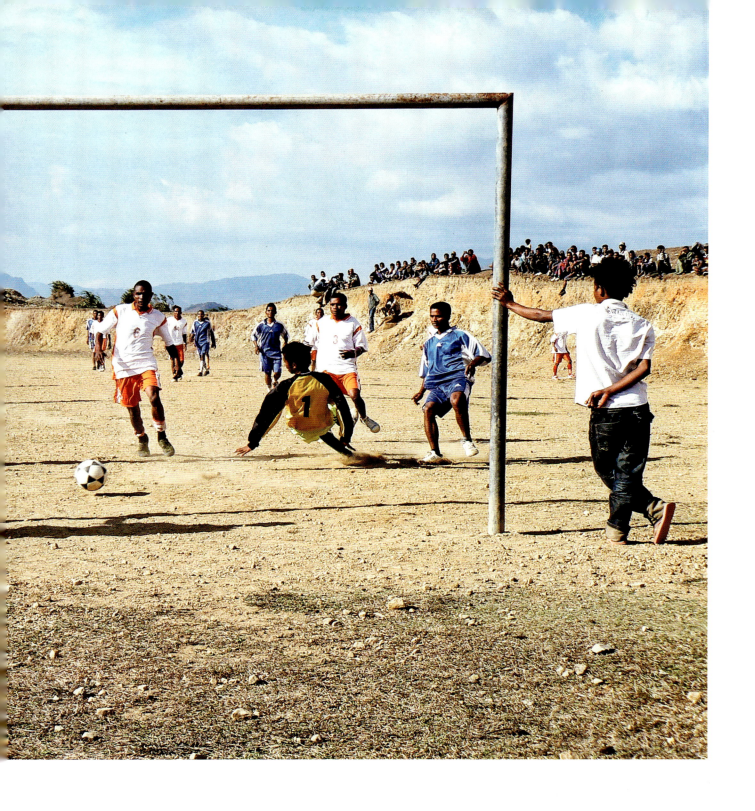

043 | Headless player. Photograph courtesy of the author. © Rogerio Lopes. Maubisse, 2011.

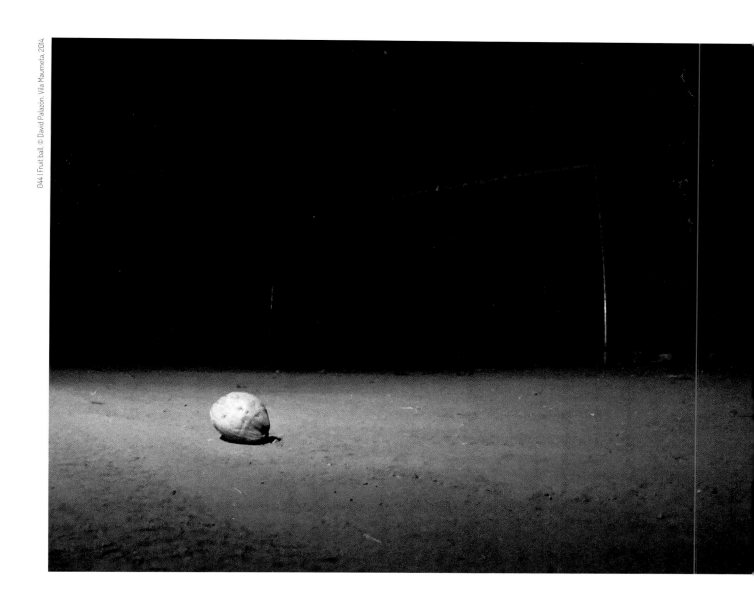

044 | Fruit ball. © David Palazón. Vila Maumeta, 2014.

FOOTBALL TEAMS
Agio Pereira | Politician

'Runguranga' was a name we used for a football team in Lisbon, when we used to play in the cup organised by refugees. Back in those days it was a politically sensitive environment—some refugees from Timor were anti-Fretilin and our team was pro-Fretilin, so the 'runguranga' football team also became a political issue.

Some anti-Fretilin refugees tagged our team: "you see ... their team's name 'runguranga' ... means they are here to destroy us". We originally thought about the meaning for our team's name simply as a 'disorganised' team, but somehow the political influence led them to see 'runguranga' as a team focusing on destroying the cohesion of pro-UDT refugees.

COCONUT THIRST

Rebecca L. Kinaston | Archeologist

From June through October the island of Ataúro is dry, very dry. During this time grasslands cover its entirety like a shaggy brown coat interspersed with eucalypts and palm trees. On the west coast of the island there are no roads. The three villages that are spread along this coastline are only accessible by a narrow walking path or from the sea, usually by small dugout outrigger canoes, or larger wooden boats with outboard motors. The southern-most village is known as Maker, from which a two hour walk along a rocky volcanic path brings you to the sweeping golden bay and sandy paths of Atekru. The trail heads north past a large, breezy one room schoolhouse where one can either follow the beach at low tide around massive tumbled black boulders or, at the impassable high tide, follow the tenuous inland trail to Adara, a picturesque forested village with neatly swept paths where the famous women free divers of Timor-Leste live. The path continues along the coastline to a small fishing hamlet consisting of a few thatch huts, freshly hewn dugout canoes, and sinewy nets strung from the trees. Here one turns inland and begins the vertical scramble up the limestone cliffs to the village of Arlo.

A metal pipe, about three centimetres in diameter, snakes along beside the path, through grasslands and forests, over large volcanic rocks, up and down every incline, reaching a near vertical zenith on its final leg to Arlo. In places the pipe is bandaged with rubber, in others it is patched with metal, and a few leaks spring out here and there. The purpose of the pipe is to transport the water that originates high in the mountainside above Maker, the only reliable freshwater source in the area, to the parched villages to the north. When coming from one of the other, drier villages, Maker appears to be a veritable waterworks; lush gardens, wells, and free flowing taps. In the next village, Atekru, the water is only turned on for three hours a night, but this may vary on a daily basis. In Adara, there are regular complaints about the reliability of the water. In Arlo, the villagers say the taps have never worked. These taps sit in a central position in the village, a teasing memorial of the time the government wanted to help these farmers and fishermen but then laid a pipe so small and impossible that God himself could not will water inside it up a limestone cliff.

In the scorching heat of the day the only respite comes from the humble coconut, a tree that enabled people to live on these lands for millennia. The smack of the lips and sigh of thirst quenching relief that involuntarily accompanies the lowering of the empty shell makes it seem like every coconut the locals drink is their first, not their thousandth. Maybe this satisfaction also comes with the reliability of coconuts; one just needs to plant more.

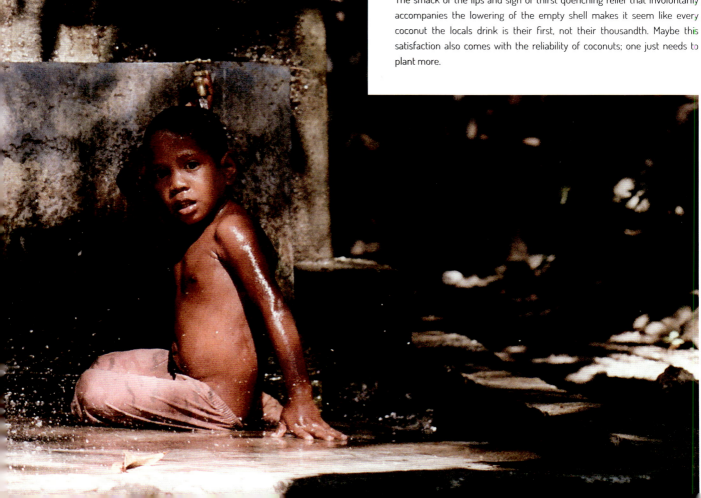

046 | Piping. © David Palazón. Makili. 2015.

047 | Bottled up. © David Palazón. Taibessi. 2014.

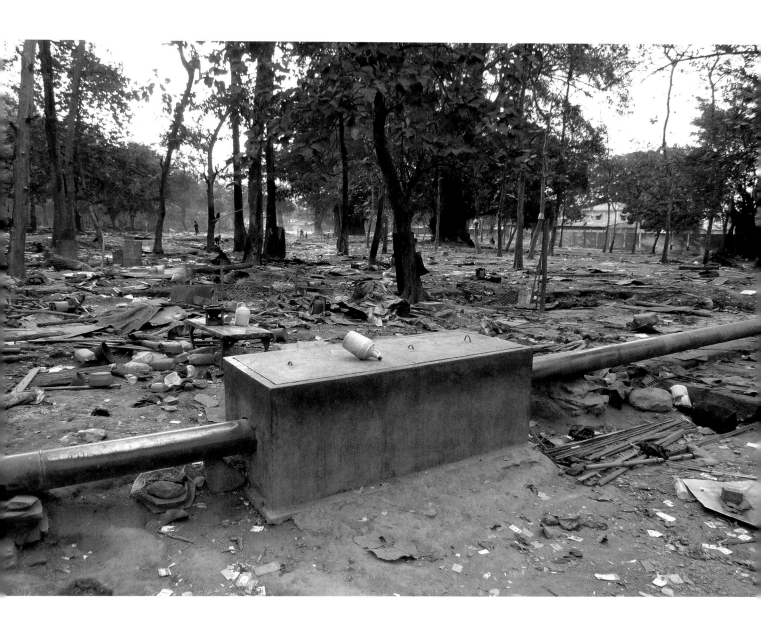

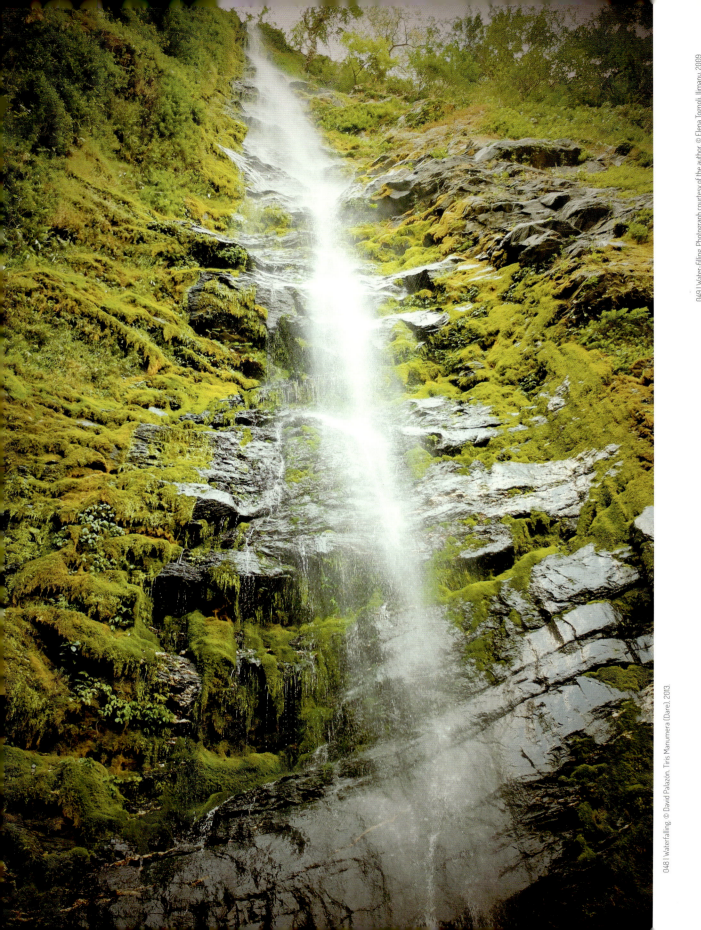

048 | Waterfalling © David Palazón. Tiris Manumera (Dare), 2013.

049 | Water-filling. Photograph courtesy of the author. © Elena Tognoli. Ilimanu, 2009

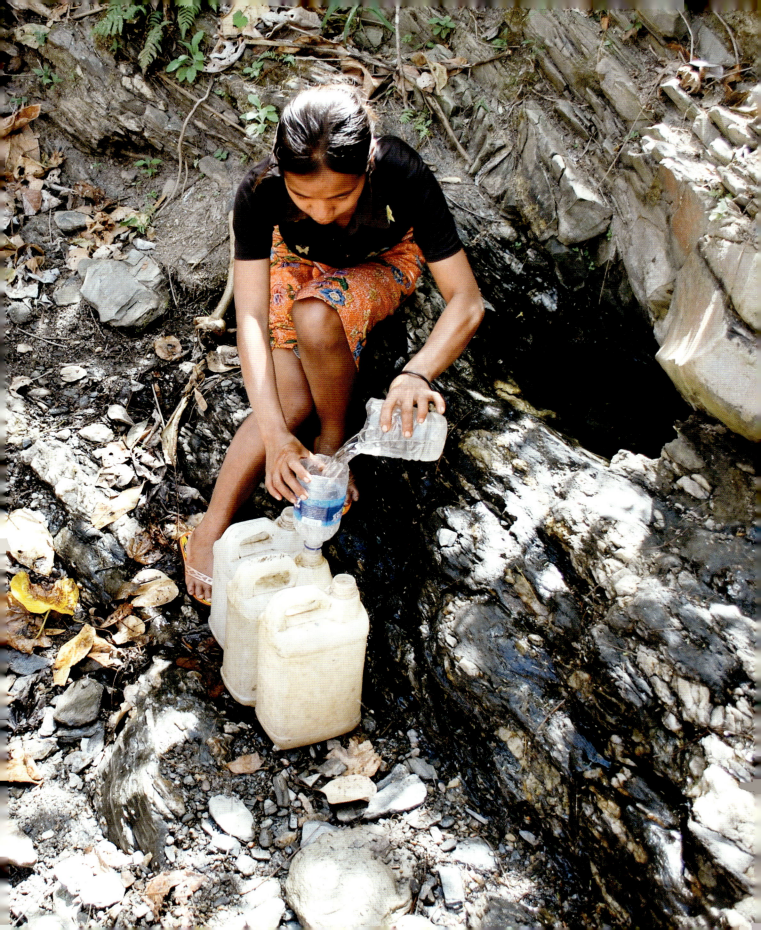

UNIVERSOS DISTANTES: TIMOR-LESTE ENTRE DÍLI E AS ALDEIAS
Sofia Miranda | Antropóloga

Timor-Leste é um país de contrastes e contradições. À primeira vista sobressaem as diferentes paisagens, características fisionómicas e socioeconómicas da população ... Contudo, um olhar mais atento evidencia também diferenças fortemente marcadas em termos regionais e, sobretudo, entre a capital e o resto do país.

De um modo geral, assiste-se à existência de um grande fosso entre dois níveis/mundos: Díli—o centro do poder, onde são elaboradas as políticas e tomadas as decisões—e o resto do país—o mundo dos distritos, dos sucos e aldeias. A comunicação entre ambos é difícil e, por vezes, inexistente, razão pela qual as populações rurais desconfiam cada vez mais de tudo o que vem de Díli, queixando-se de estarem cansadas de criar faltas expectativas. Este tipo de críticas estende-se aos governos, mas também às agências internacionais e ONG, que fazem vários estudos e promessas, mas concretizam pouco. Em paralelo, as informações sobre programas e apoios disponibilizados nem sempre chegam aos principais interessados, as comunidades ao nível dos sucos e aldeias; quando chegam, estas tendem a sentir-se perdidas e/ou abandonadas no meio da máquina burocrática do Estado—não sabem a quem se dirigir para pedir informações, ajuda ou para entregar propostas; quando se dirigem aos sítios/entidades corretas queixam-se de não obterem qualquer resposta ... Tudo isto contribui para o aumento do descrédito perante aquilo que vem de Díli e do poder central, simbolizado pelo Governo e é agravado pelos níveis de escolaridade geralmente baixos.[1]

Como consequência ou em reação ao cenário descrito, a população tende a adotar uma postura pouco proactiva e dependente do exterior, em especial do Governo do qual exigem tudo, desde casa, a alimentos, dinheiro para pagar os estudos dos filhos ou para contratar pessoas que ajudem nos trabalhos agrícolas, a que compre os produtos locais. Em contrapartida, as iniciativas locais para, por exemplo, formar grupos são poucas e, na maioria dos casos, resultam da sugestão ou iniciativa de pessoas ou organizações exteriores à comunidade.

1. De acordo com os resultados dos Censos 2010, para além de uma elevada taxa de analfabetismo (34% da população com seis anos nunca frequentou a escola e a percentagem de pessoas que nunca frequentou a escola aumenta com a idade), dos 38% da população timorense compostos por estudantes, a maioria (57,1%) frequenta o ensino primário e essa percentagem vai diminuindo à medida que se avança no ciclo de ensino, até chegar aos 4,6% que frequentam o ensino universitário. Proporcionalmente, vão aumentando o abandono escolar e as disparidades reginais e ao nível do género.

WORLD'S APART: TIMOR-LESTE BETWEEN DILI AND THE VILLAGES
Sofia Miranda | Anthropologist

Timor-Leste is a country of contrasts and contradictions. At first glance, the landscapes stand out, alongside the physiognomic and socio-economic characteristics of the population ... However, a closer look shows strongly marked differences in regional terms and, above all, between the capital and the rest of the country.

Broadly speaking, we witness the existence of a wide gap between two worlds: Dili—the center of power, where policies and decisions are prepared and taken—and the rest of the country—the world of the districts, *sucos* and villages. The communication between them is difficult and sometimes non-existent, which is why people from the rural communities are increasingly distrustful about all that comes from Dili, complaining of being tired of unfulfilled expectations. Such criticism extends to governments but also to international agencies and NGO's, which make many promises, studies and projects, but little materializes. At the same time, information on available programs and support do not always reach the main stakeholders, people from the communities at the *suco* and village level; when information does reach them, they tend to feel lost and frustrated in the middle of the bureaucratic machinery of the state—they do not know where to look or whom to turn to for information, help or proposal delivery; when they go to the correct places/entities they complain that often they don't even receive an answer ... All this contributes to an increased sense of disbelief towards everything that comes from Dili and the central power symbolized by the Government which is aggravated by the generally low levels of education.[1]

As a consequence or in reaction to the described scenario, the population assumes little proactive posture and remain dependent from the outside, in particular to the Government from which they acquire everything, from homes, to buying their local products, food, money to pay their children's studies and so on, in an endless list of demands. On the other hand, local initiatives to form working groups or undertake some kind of work/project to improve the living conditions of the community, almost always result from the initiative or suggestion of persons or organizations external to the community itself.

1. In accordance with the results from the 2010 Census, in addition to a high rate of illiteracy (34% of the population over six years old never attended school and the percentage of people who never attended school increases as age progresses), of the 38% comprised of students, the majority (57,1%) attended primary school and this percentage decreases as the student advance in the education cycle, to end up reaching 4,6% who attended university education.

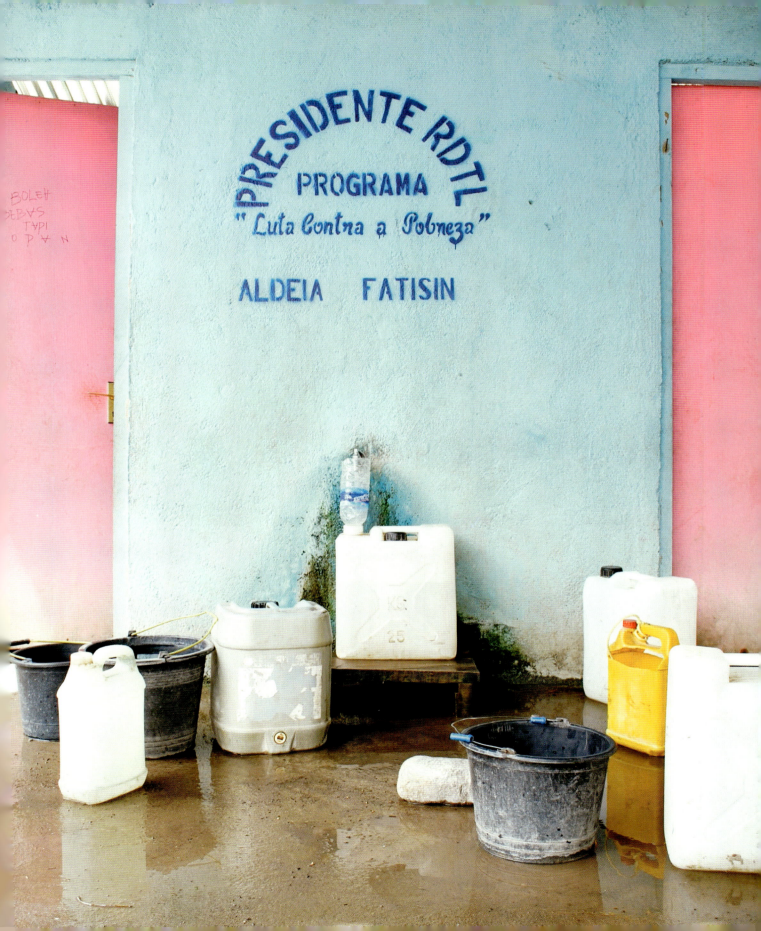

É então visível a necessidade de criação de mecanismos para o estabelecimento de uma comunicação efetiva e mediação entre estes dois universos tão próximos geograficamente, mas ao mesmo tempo, tão distantes, sendo que ambos integram a mesma jovem Nação. Esta será uma das formas de quebrar esta barreira de isolamento em que ainda se encontra a maioria do país e, simultaneamente, um meio para contrariar a "fuga" massiva para a capital, sobretudo da população mais jovem.

Therefore, there is a clear need to create mechanisms for establishing effective communication and/or mediation between these two worlds so close geographically, but at the same time, so far apart, always bearing in mind that both are part of the same young nation. This may be one of the ways to break this isolation barrier that persists in most of the country and, simultaneously, can be a means to reduce the massive 'exodus' to the capital, especially among the younger population.

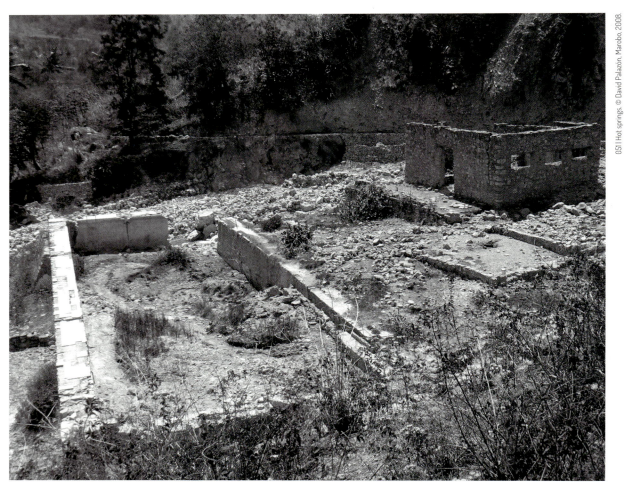

051 | Hot springs. © David Palazón, Marobo, 2008.

052 | Freshwater pooling. © David Palazón, Baucau, 2015.

053 | After-school bus. © David Palazón. Baucau, 2010.

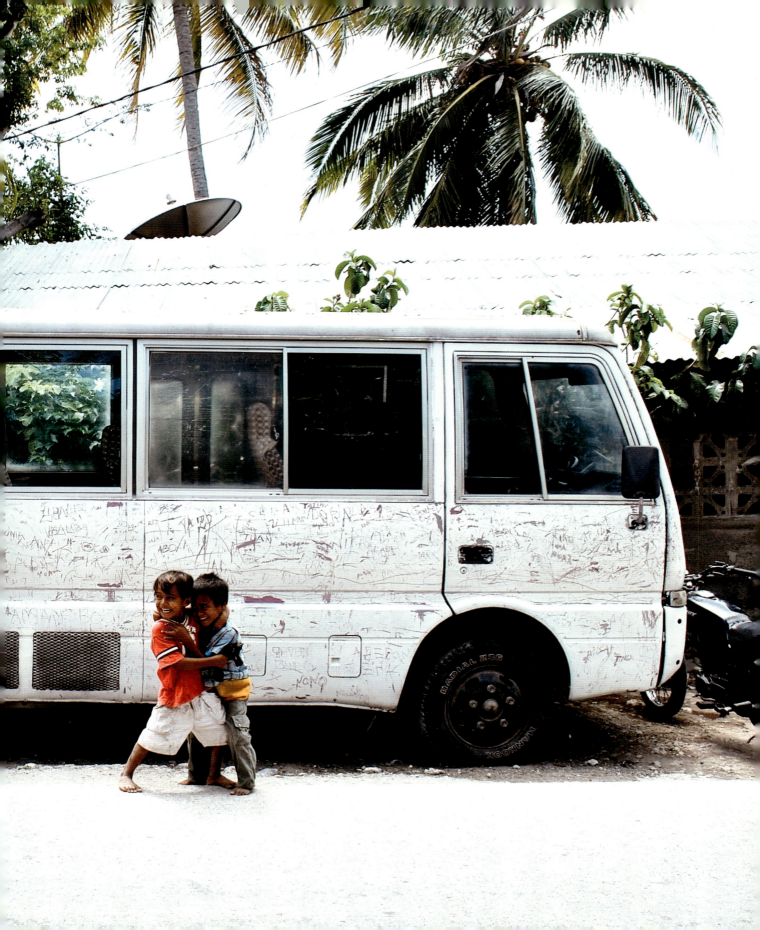

INAN: BEE-MATAN, SULI LORON, SULI KALAN
Abé Barreto Soares | Poeta

Ko'alia kona-ba inan, la seluk, la leet, ita ko'alia kona-ba ita-nia hun, ita ko'alia kona-ba ita-nia abut rasik.

Se karik lahó inan nia prezensa, oinsá maka ita bele mosu, oinsá maka ita bele eziste, no bidu ho laran haksolok iha ita-nia planeta Rai nia palku leten, no rai-fehan sira?

Hamutuk ho ita-nia aman sira, ita-nia inan doben, kous hasai ita ho laran no neon tomak, hosi Nai Maromak nia kadunan, ho neras domin. Nia kous ita, nia lori ita mai hatuur tan iha abad mundu rai klaran ne'e nian. Nia la kole, foti matan, hateke ita buras, nia la kole haree ita, lolo ita-nia dikin, rani iha fatin-fatin.

Inan nia terus, ita sura labele. Inan nia kole, inan nia kosar-been, ita selu labele, to'o deit ita tama fali ba rai kuak, alias filafali ba rai rahun.

Hanesan inan ida-ne'ebé tau ita iha mundu rai klaran, nia la husu buat barak mai ita. Hanesan inan ida-ne'ebé terus barak tiha ona mai ita, nia husu deit, atu ita hato'o hikas fali ita-nia domin tomak ba nia. Hanesan inan ida-ne'ebé fó an tomak ba mate atu sosa ita-nia moris, bainhira nia tanis, nia hakarak tebes duni atu ita la baruk, hamaran lisuk nia matan-been maka suli.

Inan nia domin, domin rohan-laek! Inan nia domin, domin lalehan. Inan nia domin, domin hori otas, domin hori wain nian kedas.

Inan sira nu'udar bee-matan, ne'ebé suli loron, suli kalan. Bee matan oan ne'e mós, moos nabilan tebes, no furak la halimar. Kanek bubu sira-ne'ebé ita iha, ho bee, ita buka atu tuhik. Kanek bubu sira-ne'ebé ita iha, ho bee, sei sai di'ak.

Ho domin tomak ne'ebé nia hato'o mai ita, nia kria armonia, ho domin tomak ne'ebé nia haklaken, nia kria dame, ho domin tomak ne'ebé nia haburas, nia kria hakmatek iha ita-nia uma kain laran.

Inan nia prezensa iha mundu rai klaran, ho frajilidade tomak ne'ebé nia iha, nia fó sai nia lian. Nia lian: lian osan-mean, nia lian: lian laran-maus, nia lian: lan laran-dodok, dala barak hananu beibeik, iha espasu lia-loos nian mak sublime.

MÃE: UMA FONTE, FLUINDO DE DIA E NOITE
Abé Barreto Soares | Poeta

Falando sobre a mãe, não é nenhuma dúvida de que falamos sobre as nossas próprias raízes, nossas próprias origens.

Se não tivesse havido a presença de uma mãe, como poderíamos aparecer e existem, e dançar com alegria em cima dos palcos do nosso Planeta Terra?

Junto com os nossos pais, as nossas amadas mães levou-nos com um manto de amor do palácio de Deus de todo o coração. Ela pegou e nos trouxe para a selva do mundo. Ela não estava cansado de ver-nos florescer, e também ela não estava cansado de ver-nos alargar os nossos galhos e pousar em todos os lugares.

Não podemos medir em todo o sofrimento de uma mãe. Não podemos recompensar a favor de uma mãe em tudo até morrer, até que nos tornemos pó novamente.

Como alguém que nos deu à luz no mundo, ela não nos pede para muitas coisas. Como alguém que sofreu muito para nós, o que ela só pede é toda a nossa oferta de amor para ela. Como alguém que tem dado toda a sua vida quando nos dando à luz, ela realmente quer-nos a não ser preguiçoso em enxugando as lágrimas quando ela chora.

O amor de uma mãe é um amor interminável. O amor de uma mãe é um amor celestial. O amor de uma mãe é o amor de tempos imemoriais.

As mães são como fontes, fluiram de dia e noite. A água dessas fontes é cristalina, e são muita bonita. As feridas inchadas que temos podem ser massageados com a água de nascente. As feridas inchadas que temos serão curado pelo seu poder mágico.

Com todo o amor que elas nos oferecem, as mães criam harmonia, com todo o amor que elas se espalharam, as mães criam a paz, e com todo o amor que elas promovem, as mães criam tranqüilidade dentro de cada lar.

A presença da mãe em nosso mundo com toda a fragilidade que ela tem move-a para proferir a sua voz. A voz dela é uma voz de ouro. A voz dela é uma voz suave. A voz dela é uma voz compassivo, muitas vezes cantando no espaço da verdade sublime.

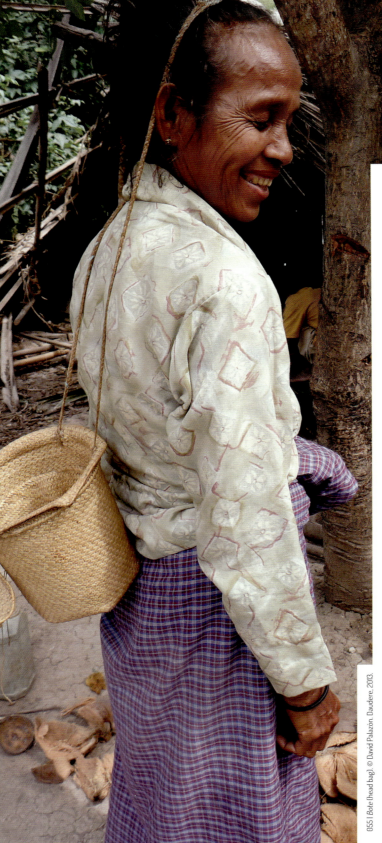

MOTHER: A SPRING, FLOWING DAY AND NIGHT
Abé Barreto Soares | Poet

Speaking about mother, it is no doubt that we speak about our own roots, our own origins.

If there had not been the presence of a mother, how could we appear and exist, and dance with joy on the stages of our Planet Earth?

Along with our fathers, our beloved mothers took us with a blanket of love from the palace of God wholeheartedly. She took and brought us to the jungle of the world. She was not tired of seeing us flourish, and also she was not tired of seeing us extend our twigs and perch everywhere.

We cannot measure all the suffering of a mother. We cannot return the favour of a mother until we die, until we become dust again.

As someone who bore us into the world, she does not ask us for many things. As someone who suffered a lot for us, what she only asks is our whole offering of love back to her. As someone who has given all her life when bearing us, she really wants us not to be lazy in drying her tears when she cries.

The love of a mother is an endless one. The love of a mother is a heavenly one. The love of a mother is the love of time immemorial.

Mothers are like springs, flowing day and night. The water of those springs is crystal clear, and very beautiful. The swollen wounds we have can be massaged with the spring water. The swollen wounds we have will be healed by its magic power.

With all the love they offer us, mothers create harmony, with all the love they spread, mothers create peace, and with all the love they foster, mothers create tranquillity within every household.

A mother's presence in our world with all the fragility she has, moves her to utter her voice. Hers is a golden one. Hers is a soft one. Hers is a compassionate one, often times singing in the space of sublime truth.

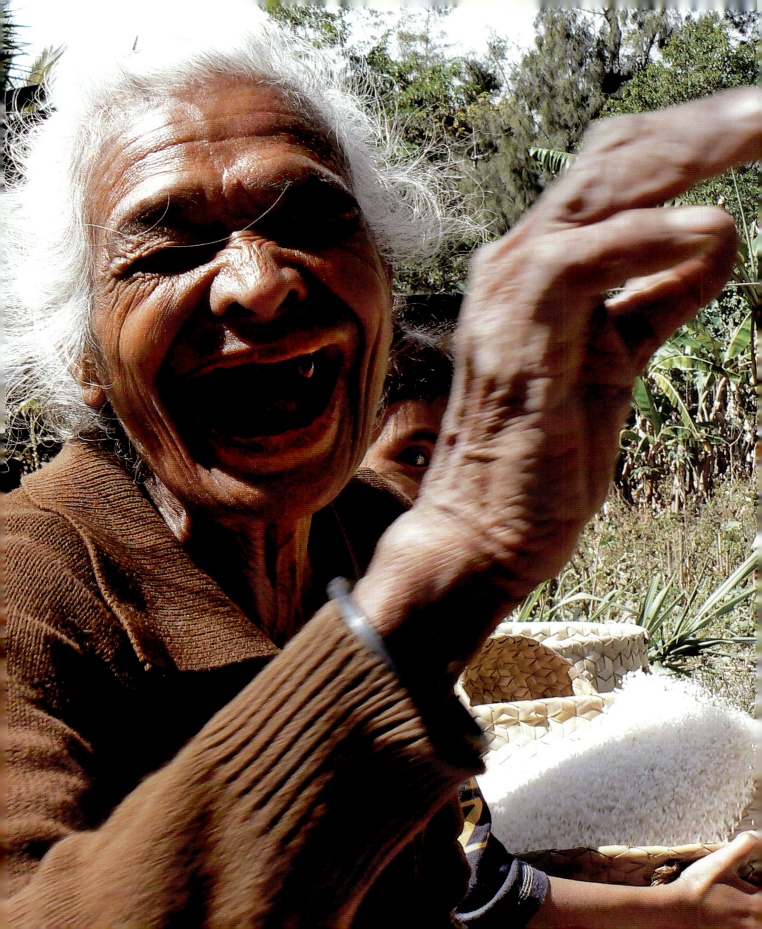

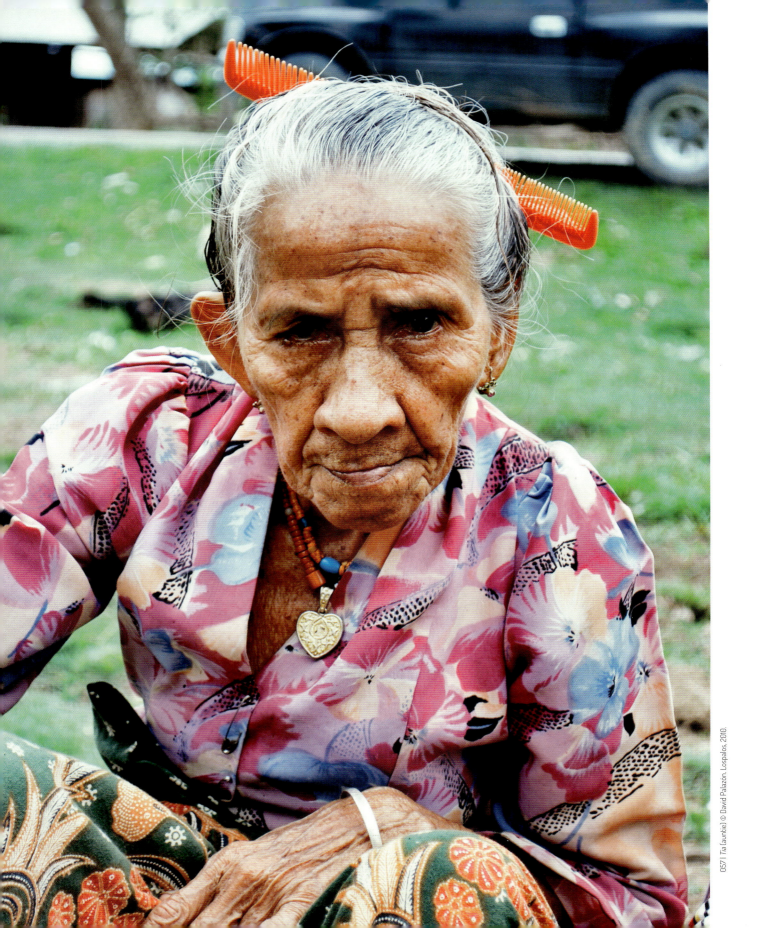

057 | *Tia Auntie* © David Palazón. Lospalos, 2010.

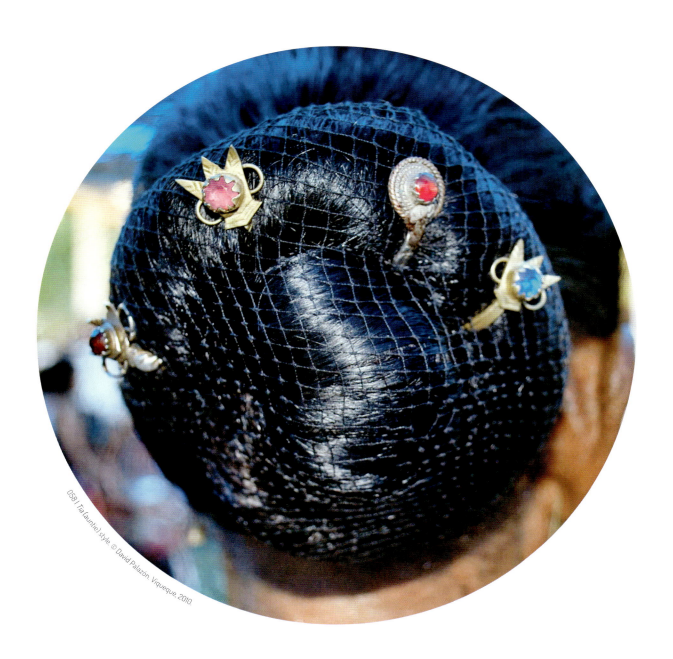

058 | Tia (auntie) style. © David Palazón. Viqueque, 2010.

LET ME SPIN YOU A YARN [1]

Joanna Barrkman | Curator

How long is this ball of yarn? Or should I say 'how long is this ball of commercially spun undyed cotton yarn'? That is of course different from a ball of hand spun undyed cotton yarn but let's not get bogged down in details. This ball of cotton, placed in the right hands will be transformed. It will be dyed in various hues to create a modern design or customary pattern passed down from earlier generations and then it will be woven on a backstrap loom, using any number of complex techniques to create a cloth, known in Timor-Leste as *tais*, T.

The warp yarns will be wound onto the loom and can be likened to the 'bones' that form the 'skeleton' or 'backbone' of the *tais*. The weft yarns will be woven across the warp, over and under repeatedly. So the warps yarns can be liken to the 'muscles' of the cloth. It seems appropriate to use these anthropomorphic metaphors to describe a *tais*, in keeping with the Timorese predilection to classify objects and experiences into dualistic categories such as visible and invisible, mundane and sacred, inner and outer, light and dark, masculine and feminine.

Of course, *tais* is 'feminine', a counterpart to metal, which is 'masculine'. However, many a young Timorese boy has assisted his mother or grandmother as she beings the process of threading up the loom. Actually using a ball of yarn and a coconut dish (please see the photo on the right!) the warp thread is wound onto the loom. This process is a two-person task ... passing the dish around the rods at the extremities of the loom. So little hands, boys or girls, come in handy to assist with this task. If *amaa* or *avo* need assistance, with care and patience this ball of cotton will be unraveled into the skeleton of their next *tais*. Every child who has passed the cotton ball around the loom appreciates the time and effort required to make a *tais*. A ball of cotton in a coconut shell triggers fond memories of mothers, aunts and grandmothers.

The family compound is where women customarily weave; inside the inner domain. Between cooking, caring for children and the elderly and tending their garden they spend their time seated on the ground weaving. Maybe a child is soon to marry, or an order from a neighbour or relative has been received. Alternatively, this ball of yarn, once woven may be destined to be added to the family's store of *tais* ready 'for the future', when a family member dies or a new baby arrives. Either way, in the inner domain Timorese women weave balls of yarn into cloths creating metaphorical skins, to wrap around and encase their families. Every Timorese *tais* begins with a simple ball of cotton. Depending on the skill, patience and ingenuity of the weaver it will be transformed into a cloth—aesthetically it maybe garish and crooked or beautiful and even. Whatever the case, a *tais* will clad you, it will keep you warm as you sleep and tell others where you are from. A hand-woven cloth of unimaginable function and value all begins with a simple ball of yarn. Just be careful not to drop it! Create with it what you will!

059 | Yarning. © David Palazón. Suai Loro, 2009.

—
1. In my country of origin, Australia, a 'yarn' is a story or tale. 'To spin a yarn' suggests a tale, possibly one that is exaggerated.
—
Joanna Barrkman is a curator and co-editor of the book *Textiles of Timor: island in the woven sea*, UCLA Press, Los Angeles, 2014. She has researched and published extensively on Timorese textiles since 2003 and has even woven a few cloths over the years. Joanna has developed collections of *tais* in Timor-Leste and at the Museum and Art Gallery of the Northern Territory, Darwin Australia. She is currently the Curator at Charles Darwin University Art Collection and Art Gallery and a doctoral candidate at the Australian National University. She had the pleasure to work with David Palazón and together they shared several adventures in the quest to document the arts and material culture in Timor-Leste. *A luta continua David!*

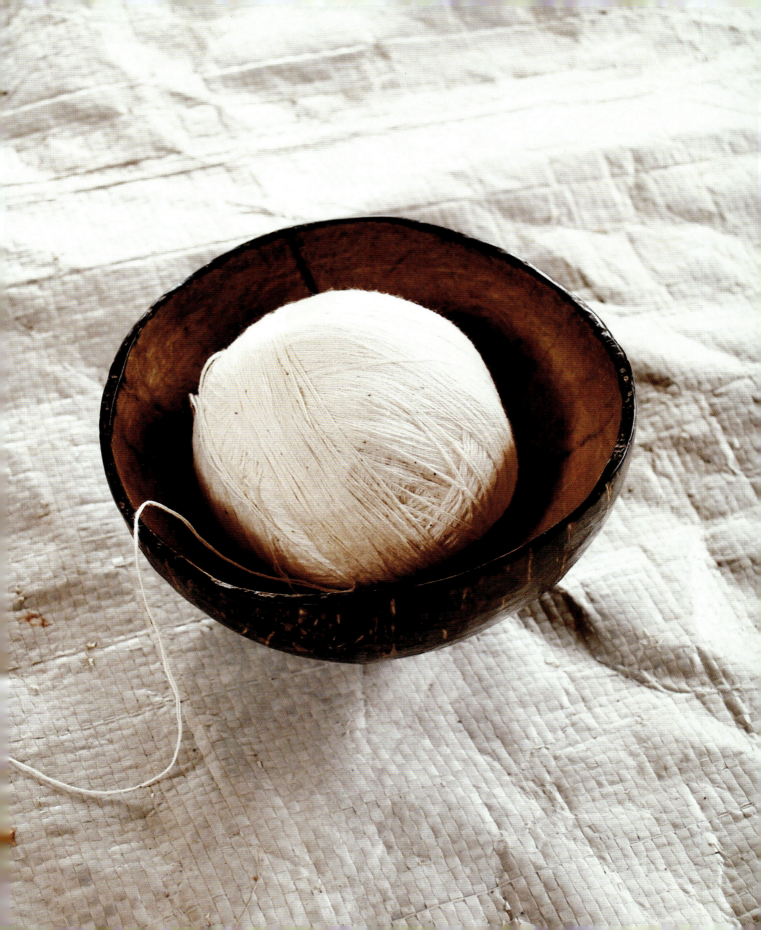

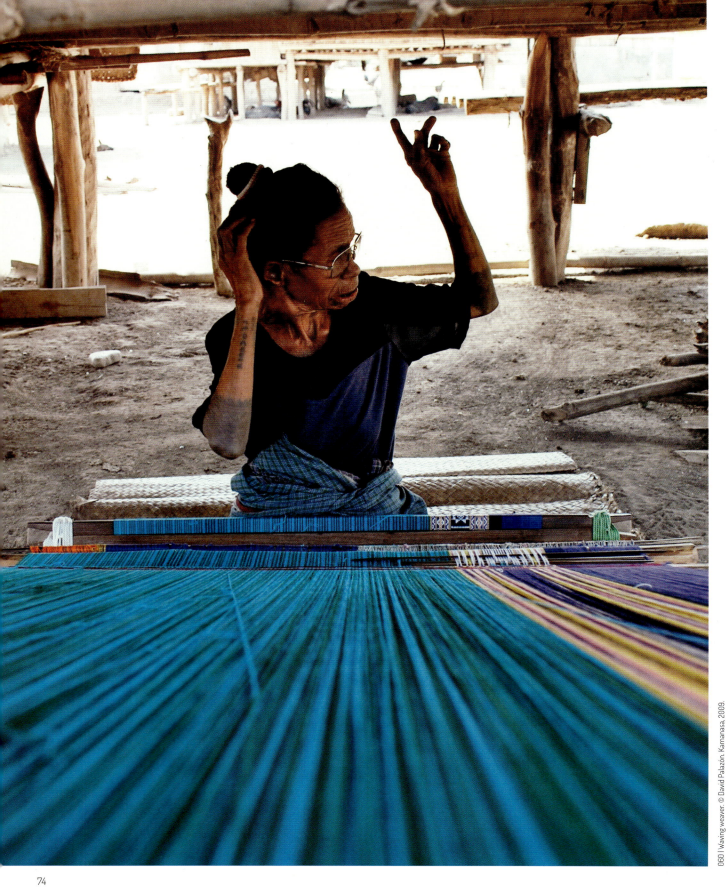

060 | Waving weaver. © David Palazón. Kamanasa, 2009.

061 *Dulan kabas* (spinning cotton). © David Palazón. Daudere, 2013.

75

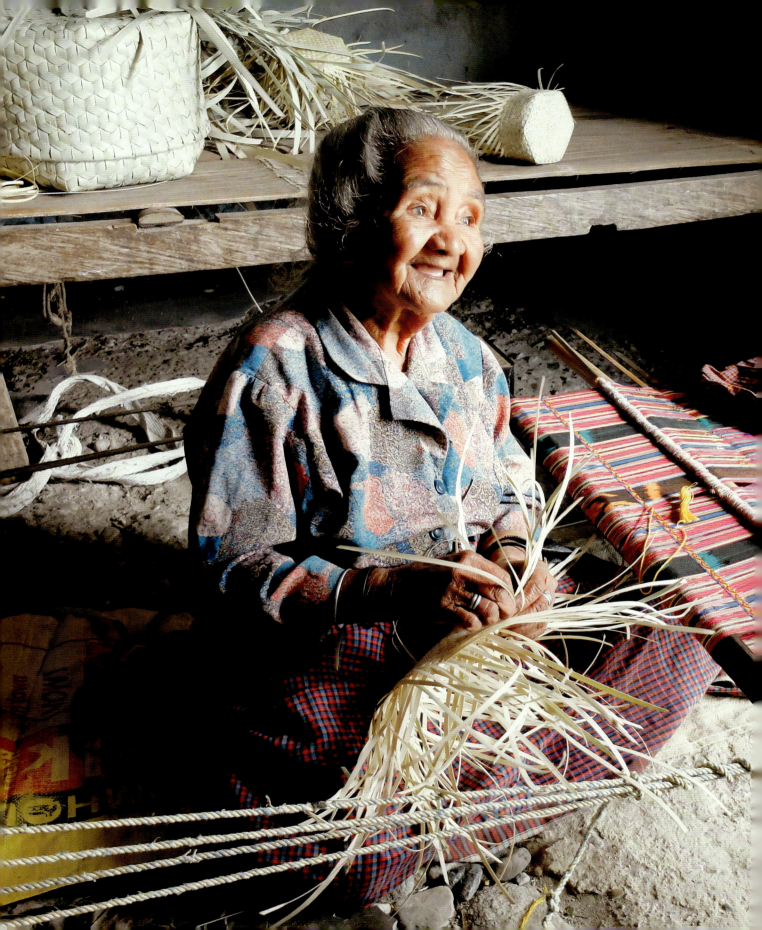

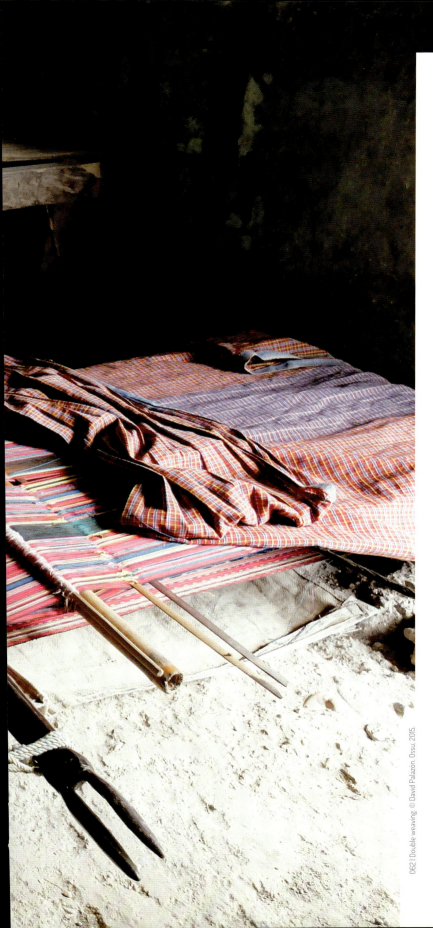

0621 Double weaving © David Palazón. Ossu, 2015.

AS GUARDIÃS DA TRADIÇÃO
Rosália E. M. Soares | Pesquisadora

Runguranga, sabaraut, nakarakat, arbiru
A vida nos campos, nas aldeias de Timor,
Onde a liberdade é farta
Onde a identidade do povo repousa.

Nas aldeias, nos campos, do pequeno Timor
Nas tardes da vida quotidiana,
As mulheres curvadas debaixo duma *uma lulik*
Tecendo a sua tradição.

De geração a geração, o fio da tradição se repassa
Da avó à mãe, da mãe à filha, da filha à neta.

Para alguns,
 É runguranga o som do *atis*
 É *sabaraut* o tear, *atis*
 É *nakarakat* o fio do *futus*
 É *arbiru* a mulher que cria o *tais*.

Verdadeiras estafetas da tradição!
Sem nome, sem homenagem,
São elas as tecedeiras do *tais*.
São elas as guardiãs da tradição timorense.

GUARDIANS OF TRADITION
Rosália E. M. Soares | Researcher

Runguranga, sabaraut, nakarakat, arbiru
Life in the fields, in the villages of Timor-Leste
Where freedom is sated
Where the identity of the people lies.

In the villages, in the fields, of tiny Timor-Leste
In the afternoons of everyday life
Women bent under an *uma lulik*
Weaving their tradition.

From generation to generation, the tradition passes
Grandmother to mother, mother to daughter,
daughter to granddaughter.

For some,
 Runguranga is the *atis* sound
 Sabaraut is the loom, *atis*
 Nakarakat is the *futus*' thread
 Arbiru is the woman who creates *tais*.

True messengers of tradition!
Without name, nor tribute
They are the weavers of *tais*
They are the guardians of Timorese traditions.

063 | Domestic attire. © David Palazón. Suai Loro, 2010.

064 | Family signature. © David Palazón. Suai Loro, 2009.

065 | *Cruz jovem* (youth cross) parade. Photograph courtesy of the author. © Bernardino Soares, Dili, 2015.

066 | Double layered. © David Palazón. Viqueque, 2010.

81

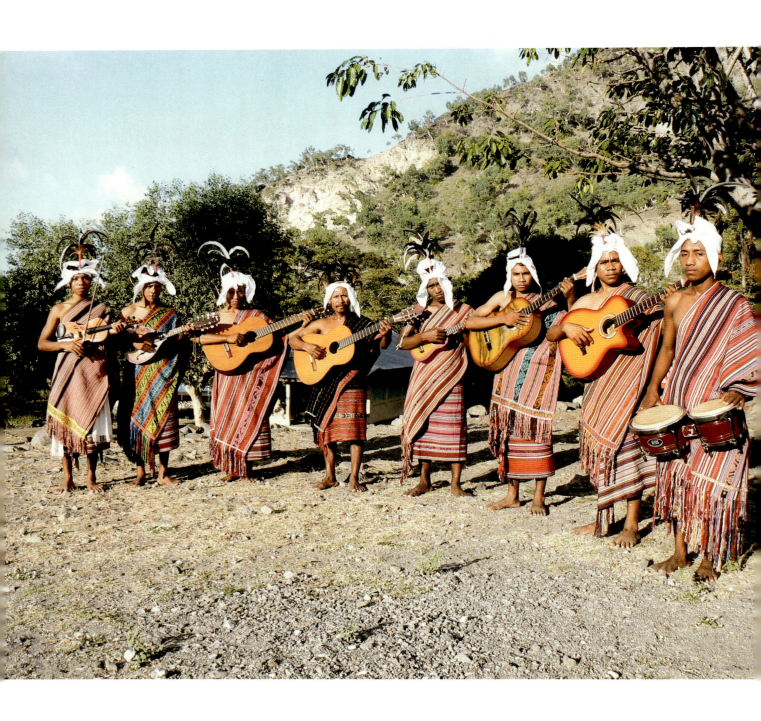

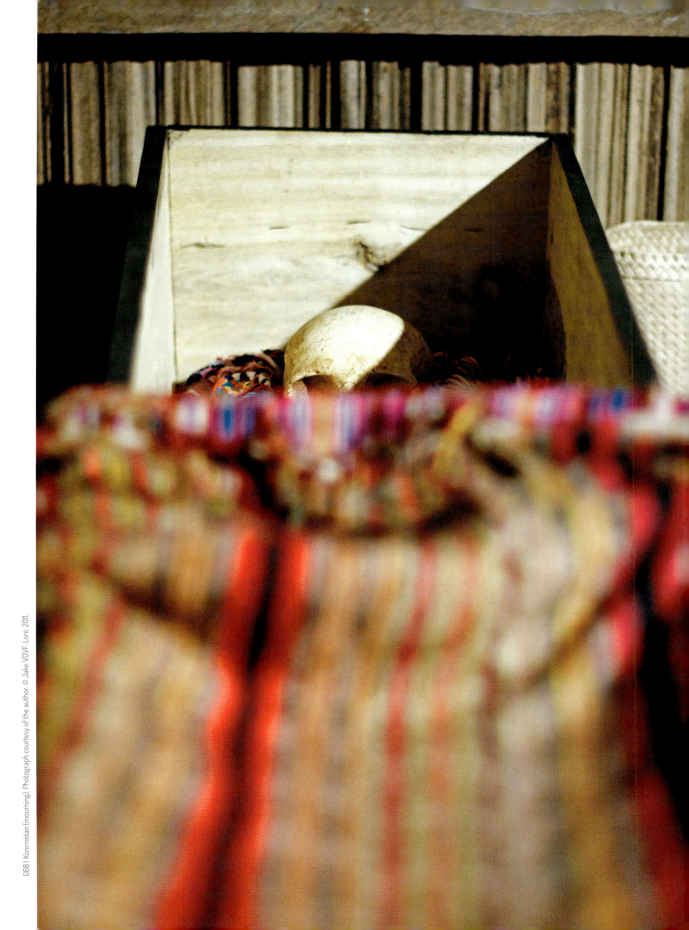

067 | *Troupe*. © David Palazón, Makili, 2009.

068 | *Koremetan* (mourning). Photograph courtesy of the author. © Jake VDVF, Loré, 2011.

O TAIS
Rosália E. M. Soares | Pesquisadora

Como noutros lugares no mundo, Timor também produz o seu têxtil tradicional: o TAIS (T), Têxtil de características específicas e únicas, rico em referencias culturais, que nos seus padrões e técnicas, transporta a herança cultural e patrimonial dos antepassados dos grupos etnolinguisticos timorenses como os: *Kemaks, Bunaks, Makasaes, Fatalukos, Fehan*, etc …

Construída em forma rectangular—*tais mane*—para uso masculino e, em forma tubular—*tais feto*—para uso feminino, os *tais* desempenham uma função importante na vida sociocultural dos timorenses, sendo um poderoso indicador do seu estatuto social, identidade familiar e importância do linhagem. Numa sociedade alargada como a timorense, o *tais* é um poderoso símbolo da identidade cultural das suas comunidades, tanto no estrangeiro como em Timor sendo usado ritualmente desde a nascença até à morte, em cerimónias familiares, particulares, religiosas, públicas e governamentais e com importância central e muito relevante nos vários rituais animistas específicos das diversas culturas etnolinguisticas, que na sua diversidade completam a identidade cultural de Timor-Leste.

Com padrões variados, incluindo muitas riscas coloridas e intercaladas por barras de desenhos e técnicas características das diversas culturas de origem das suas tecelãs, o *tais* é produzido num tear de cintura denominado *atis*, que permite à tecelã, com o corpo, controlar a tensão da urdidura para a tecelagem resultar num alto nível de qualidade. Desde tempos imemoriais que após a colheita da flor de algodão e usando os métodos tradicionais transmitidos de avó a neta, o algodão é preparado para ser fiado e tingido usando receitas transmitidas de geração em geração que usam os recursos locais que a natureza disponibiliza. Hoje em dia, em consequência da grande disponibilidade de fios de produção industrial, este saber ancestral já só se encontra em áreas rurais e remotas, sendo preferencialmente usado para produzir *tais* de grande valor patrimonial a serem usados em cerimonias da maior importância cultural.

Sem diminuir o seu valor cultural, o *tais* modernizou-se, adaptou-se a novas funções, outros usos e ganhou nova e ainda maior visibilidade através da intervenção de designers e artesãos que se dedicam a explorar, criativamente, toda a potencialidade de transformação e adaptação do *tais* a novos produtos com valor comercial.

Produzidos principalmente pelas mulheres que habitam em áreas rurais, que assim garantem a proteção, promoção e divulgação de todo este património, o *tais* multiplicou as suas possibilidades, e com o contributo criativo de estilistas e artesãos, reforçou o potencial de rendimento dos muitos grupos estabelecidos que assim garantem a sobrevivência familiar e, muito importante, a educação das suas crianças.

Esperamos que este desenvolvimento e os demais, venham favorecer as tecelãs no seu árduo trabalho de produção deste têxtil de forte tradição e identidade patrimonial por forma a garantir o prestigio e preponderância desta manifestação cultural.

TAIS
Rosália E. M. Soares | Researcher

Like in other parts of the world, Timor also has its traditional textiles, the *tais*. Beautiful fabrics with specific characteristics, unique but also rich in information inside their own patterns and signs with traces of the Timorese ancestry, ethnic groups like the *kemaks*, the *bunaks*, the *makasaes*, the *fatalukos*, the *fehan*, etc …

Presented in rectangular shape—*tais mane*—for men and in tubular shape—*tais feto*—for women, these textiles play an important role in the cultural tradition of Timorese people. It functions like a symbol of social status, the identity of the family or clan. *Tais* are one of the most important symbols of cultural identity. In Timorese society, whether domestically or overseas, from their moment of birth to death, in private or public, government ceremonies, in traditional and religious rituals, *tais* have always had their place and mark the cultural identity and presence of the people of Timor-Leste.

Colored-striped, interspersed with line designs and techniques of many origins as weavers from each of district, *tais* are produced in a traditional loom called *atis*, a back loom secured with belts, in which weavers forge the textile controlling the pressure of the threads at the back. Since the old days, when cotton was harvested, weavers used to prepared the yarns following ancient natural recipes shared between weavers from generations to generations. Nowadays, with the wide availability of commercial yarns, this traditional knowledge is reduced to rural and remote areas and mainly destined to produce *tais* of extraordinary value for ceremonies or traditional rituals.

Without diminishing their cultural value, the development of *tais* has evolved and adapted to new functional uses, overall gaining a wider visibility through the intervention of creative work by designers and artisans exploring the full potential transforming and adapting *tais* into new products of commercial value.

Tais are produced mainly by women in rural areas, guaranteeing therefore the promotion and protection of their patrimony. Nowadays, with the creative contribution of stylists and artisans, the possibilities have reinforced the manufacturing potential for established groups, not only securing income for their household, but most importantly, an education for their children.

We hope these and future developments will benefit the weavers in their hard work manufaturing these textiles that carry strong traditions and identity heritage, and consequently guaranteeing the uniqueness and importance of this cultural tradition.

069 | Music for your eyes. © David Palazón. Kaitia, 2009.

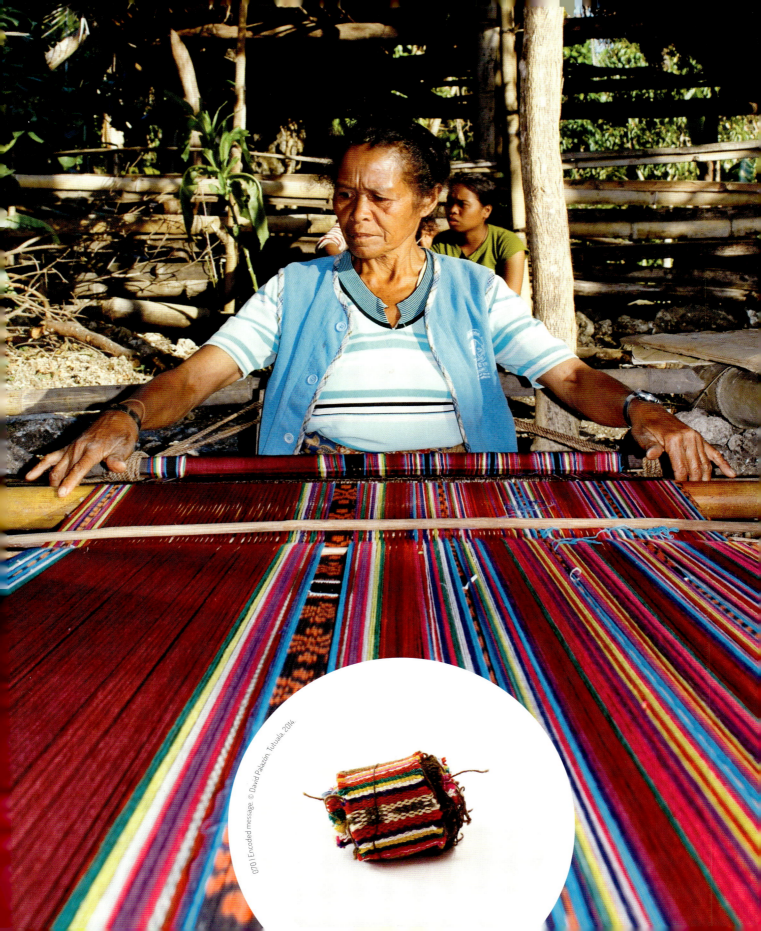

070 | Encoded message. © David Palazón. Tutuala 2014.

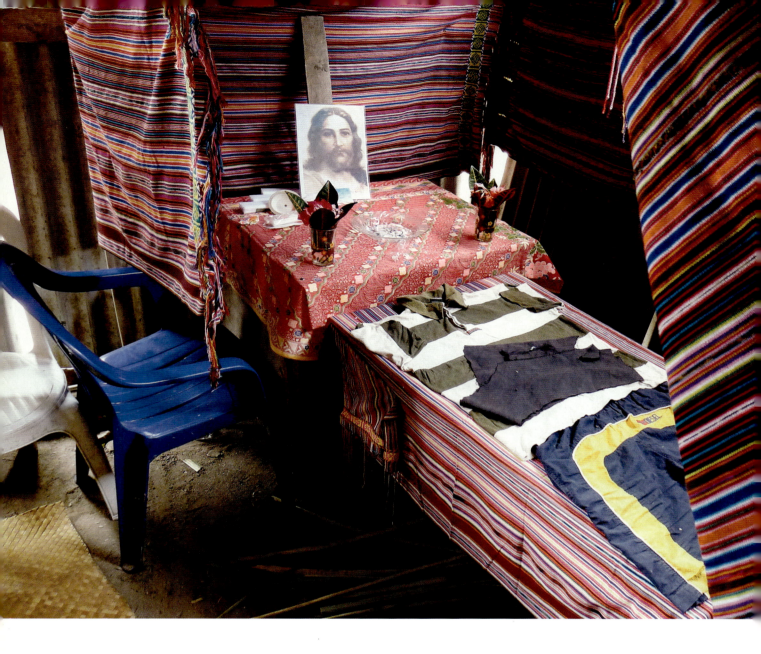

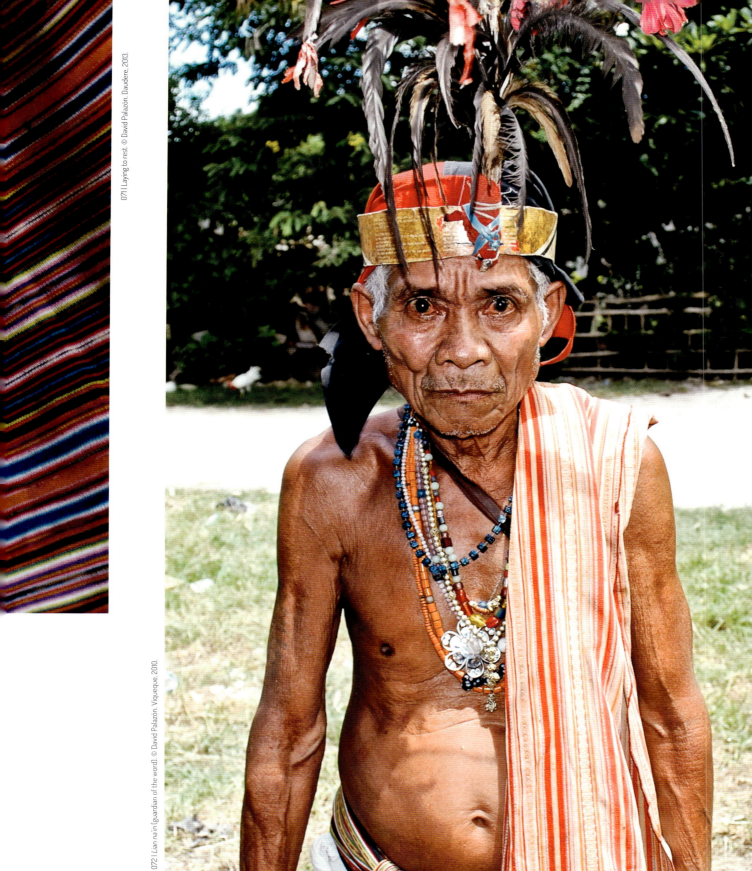

071 | Laying to rest. © David Palazón. Daudere, 2013.

072 | *Lian na'in* (guardian of the word). © David Palazón. Viqueque, 2010.

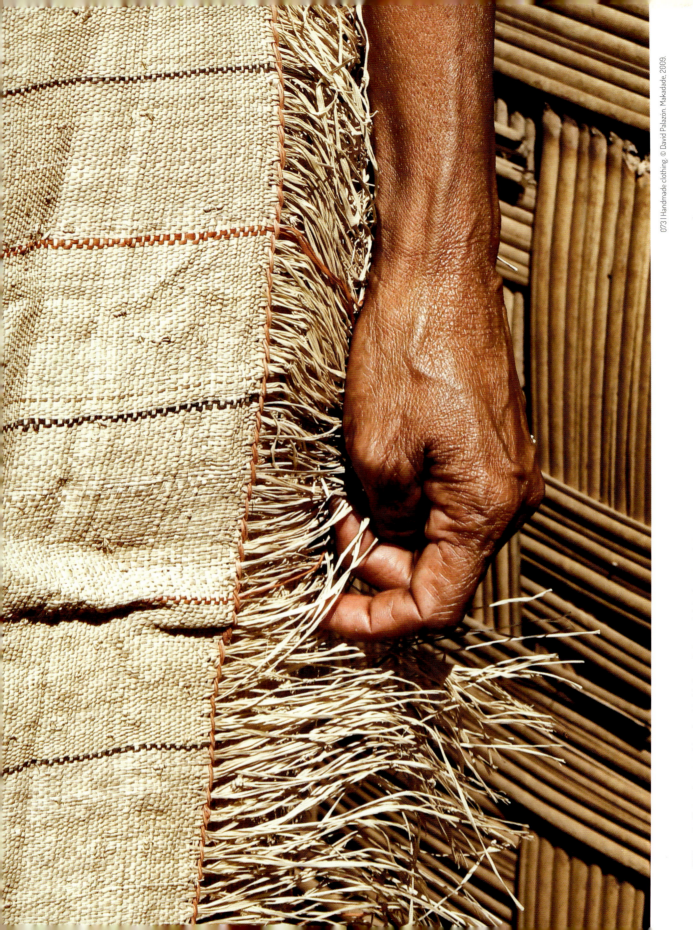

073 | Handmade clothing. © David Palazon. Makadade, 2009.

074 | Innovation. Photograph courtesy of the author. Artwok by Boneca de Ataúro. © Sula Sendagire. Ataúro, 2015.

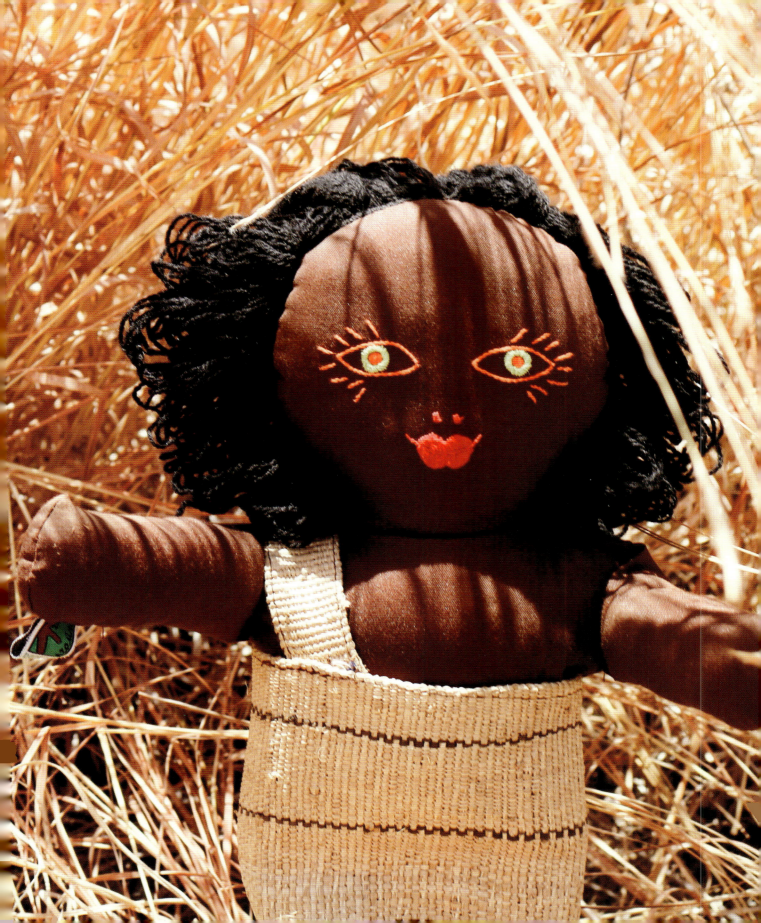

BONECA DE ATAÚRO
Ester Piera Züecher Camponovo | Artista

A "Boneca" é uma boneca de pano nascida na ilha do exílio, que atravessou o mar e muitas fronteiras para viajar por todo o mundo.

É um lugar mágico, onde nascem preciosos objectos de desejo.

É um lugar onde as mulheres encontram o seu espaço, a sua dignidade, a sua independência económica.

É uma marca, actualmente muito conhecida.

A "Boneca" é uma fábrica de conhecimentos partilhados: técnicos, humanos, de relação, de comércio; conhecimento de sonhos cumpridos e sonhos por cumprir.

É um lugar para mulheres de qualquer idade. As mulheres mais velhas trazem prudência, experiência, paciência; as mais jovens trazem alegria e vontade de futuro.

É um lugar onde mulheres analfabetas encontram um espaço de aprendizagem; e onde as que têm escolaridade partilham o seu conhecimento com a maioria.

A "Boneca" é uma cooperativa onde o orgulho de ganhar a vida com as próprias mãos é alimentado.

A "Boneca" é um farol para outras mulheres de Ataúro, que querem crescer e trabalhar com dignidade.

ATAÚRO'S DOLL
Ester Piera Züecher Camponovo | Artist

The 'Boneca' is a rag doll born on the island of exile; a doll that crossed the sea and many borders to travel around the world.

It is a magic place where precious objects of desire are born.

It is a place where women find their space, their dignity and their economic independence.

It is a brand, quite renowned by now.

The 'Boneca' is a factory of shared knowledge: technical, human, relational, commercial; a knowledge of fulfilled dreams and dreams to fulfil.

It is a place for women of any age. Elderly women bring prudence, experience, patience; younger ones bring joy, and desire for the future.

It is a place where illiterate women find a space to learn; and where literate ones share their knowledge with others.

The 'Boneca' is a cooperative where the pride of earning a living with your own hand is nurtured.

The 'Boneca' is a beacon for other Ataúro women, who wish to grow and work with dignity.

BONECA HUSI ATAÚRO
Ester Piera Züecher Camponovo | Artista

"Boneka" ne'e buat ne'e boneka hena ne'ebé moris iha illa eziliu nian; boneka ne'ebé hakur tasi no illa barak hodi la'o hadulas mundu.

Buat ne'e iha fatin májiku ida iha ne'ebé objetu folin boot ne'ebé ita hakarak moris ba.

Buat ne'e fatin ida iha ne'ebé feto sira hetan sira nia fatin, sira nia dignidade, no sira nia ekonomia ne'ebé independénsia.

Buat ne'e hanesan marka, ne'ebé ema barak koñese iha oras ne'e daudaun.

"Boneka" ne'e hanesan fábrika ida ba hafahe matenek: tékniku, kona ba relasaun umanu sira, komersiál; no koñesimentu ida kona ba mehi ne'ebé tuir ona no ba mehi ne'ebé seidauk.

Ida ne'e fatin ba feto sira hosi kualkér otas. Feto ho idade boot fó protesaun, esperiénsia, pasiénsia; feto ho idade ki'ik fó alegria, no iha mehi ba futuru.

Ida ne'e fatin iha ne'ebé feto analfabetu hetan sira nia fatin atu aprende; no iha ne'ebé hirak ne'ebé alfabetizadu hafahe sira nia koñesimentu ba sira hotu.

"Boneka" ne'e hanesan kooperativa ida iha ne'ebé orgullu ba tusan kona ba hela ho ita boot nia liman rasik mak sei hakiak.

"Boneka" ne'e hanesan faról ahi ba feto Ataúro sira seluk ne'ebé hakarak atu moris no servisu ho dignidade.

075 | Closet of wonders. Artwork by Boneca de Ataúro. © David Palazón. Vila Maumeta, 2009.

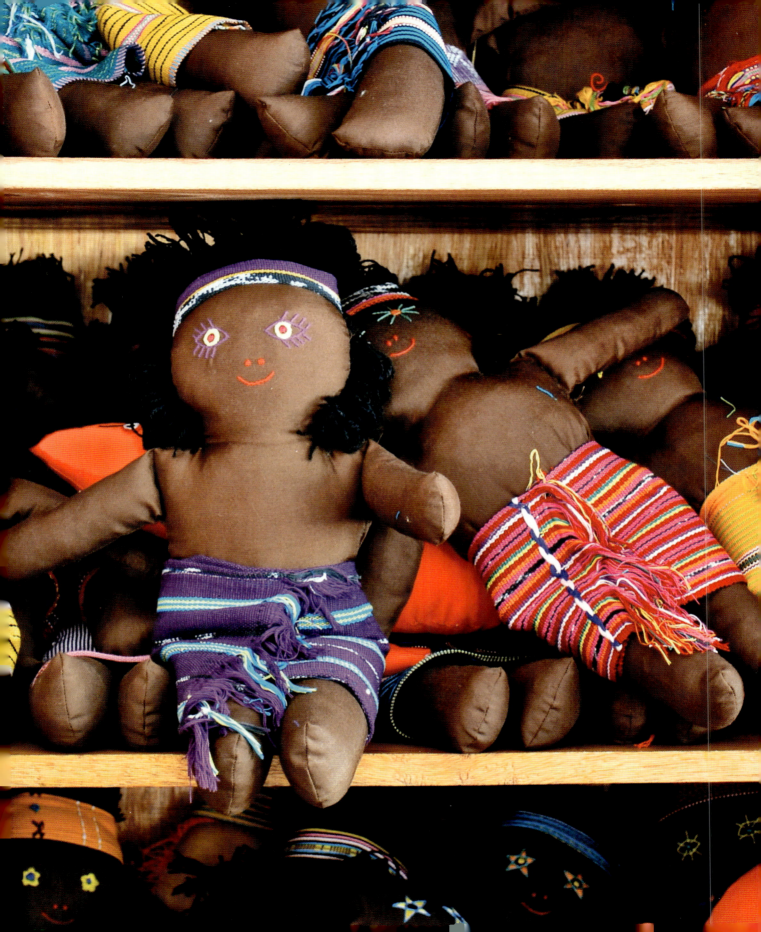

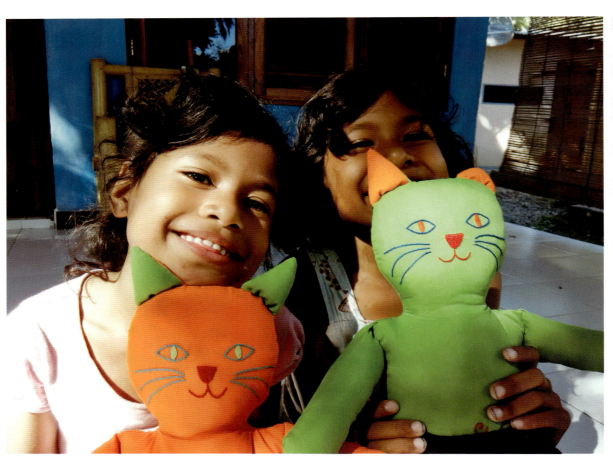

076 | Copycat. Artwork by Boneca de Atauro. © David Palazón. Bidau Santana, 2015.

077 | Boneca de Atauro's fashion show. Photograph courtesy of the author. © Luke Monsour. Dili, 2011.

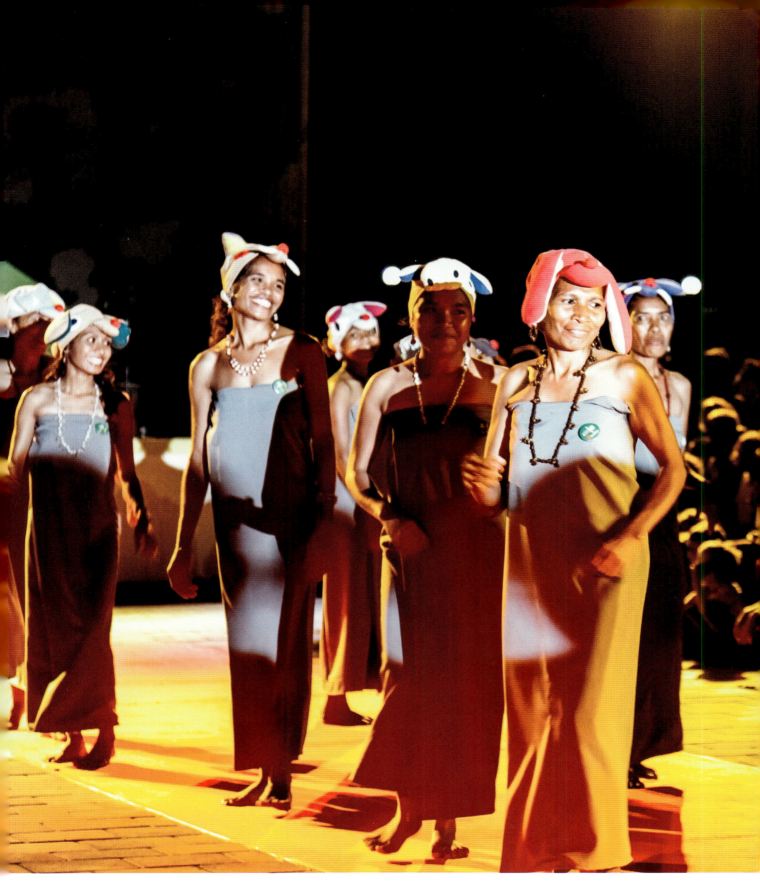

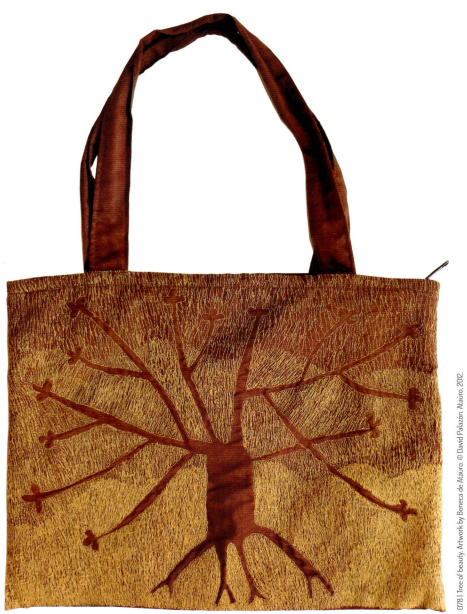

078 | Tree of beauty. Artwork by Boneca de Ataúro. © David Palazón. Ataúro, 2012.

079 | Sacred tree. © David Palazón. Dare, 2013.

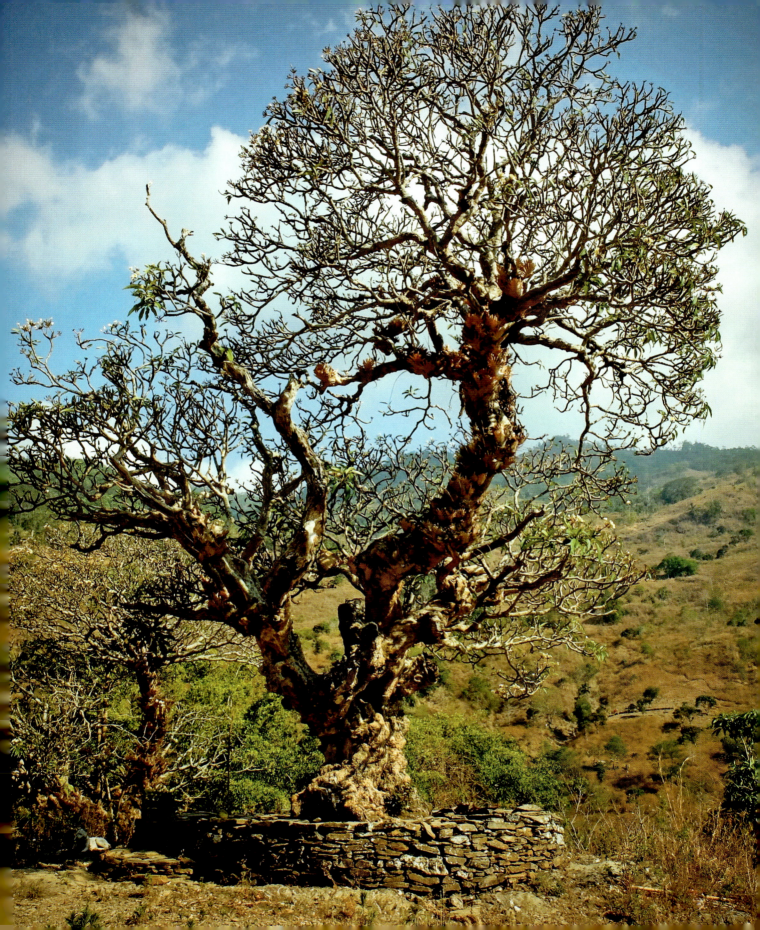

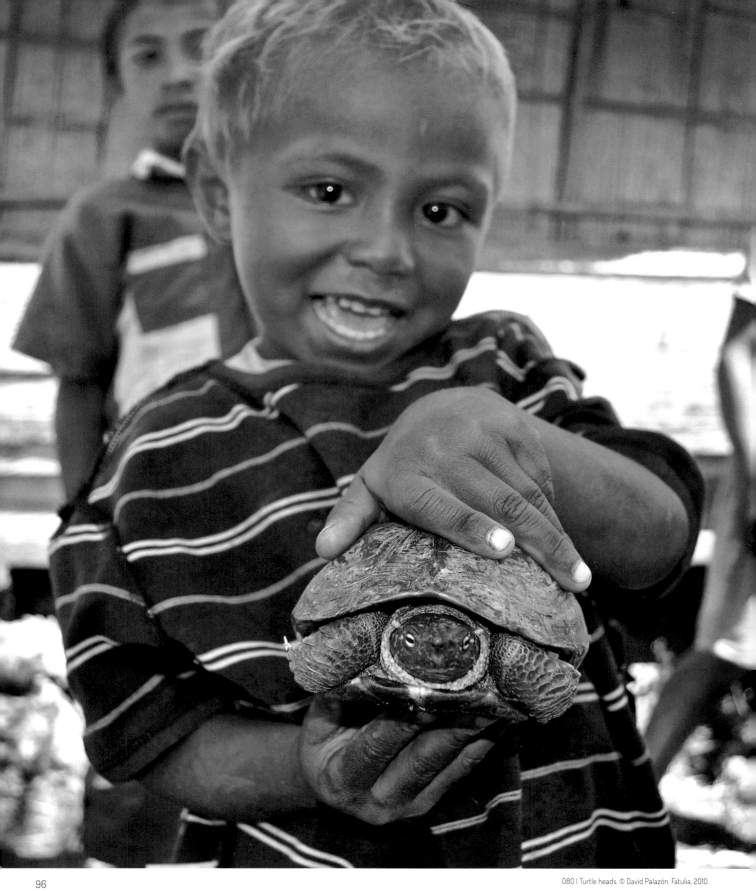
080 | Turtle heads. © David Palazón. Fatulia, 2010.

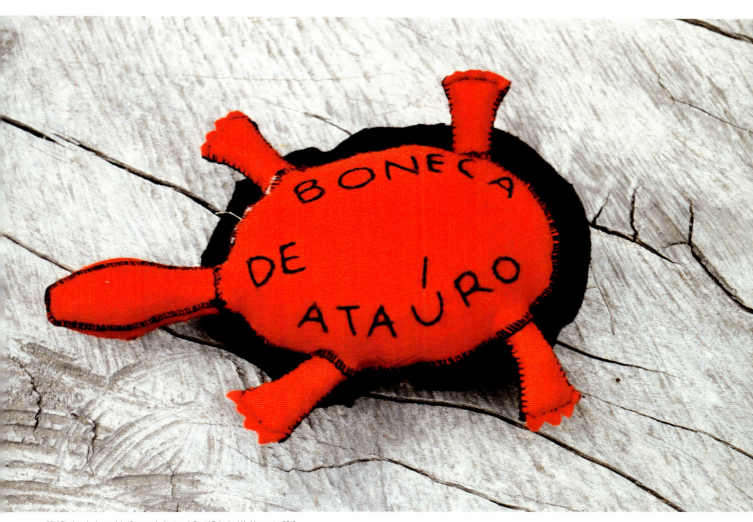
081 | Turtle tails. Artwork by Boneca de Ataúro. © David Palazón. Vila Maumeta, 2010.

082 | Endangered species. Artwork by *Boneca de Ataúro* © David Palazón. Ataúro, 2009.

083 | Casting. © David Palazón. Tasitolu, 2014.

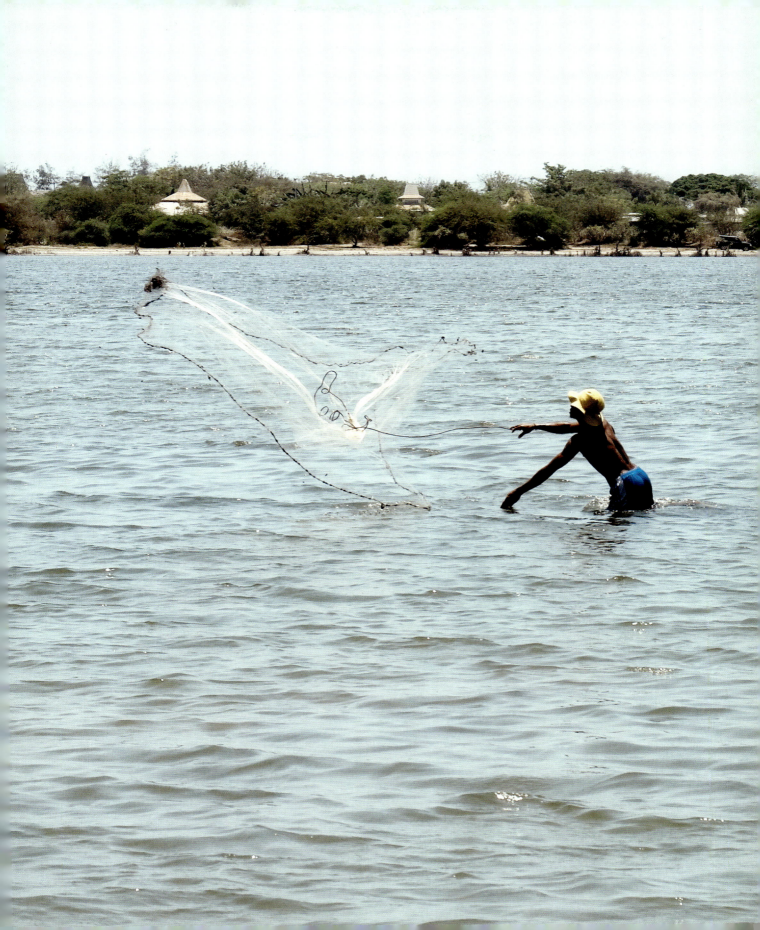

GAUA SURI
Maestro Simão Barreto | Compositor

Uru uatu da'akuru (Deus criou todas as coisas)
Uatu de (Criou o sol)
Uru de (Criou a noite)
Gaua de (Manda vir a aragem)
Ula de (Manda vir o vento forte)
Gaua assar mau (Manda vir o vento fraco)
Ula assar mau (Manda vir a ventania)

Gaua Suri em Makassae, *Bolu Anin* em Tetun, é a cerimónia ritual de chamar vento, na época da ceifa do néli para o limpar dos restos de feno e de farelos.

Como este, existem muitos outros ritos e cerimónias sagradas que, ao longo de muitos séculos, antes da chegada dos portugueses e de numerosas visitas anteriores de outros povos, como os chineses, os persas, os árabes e indus, regem e orientam o dia a dia dos timorenses, na sua vida social e religiosa e consolida o devir das futuras gerações com a herança cultural da moral, dos ensinamentos, das lições e feitos dos antepassados ilustres, narrados nos *dadolin* (poema épico de carácter narrativo) sagrado de cada *uma lulik* (casa sagrada), e exotericamente guardados por *lia na'in* (o guardião da palavra, da tradição).

Às 16.00 horas do dia 20 de Maio de 2002, as vozes do coro de 900 elementos que acompanharam a missa campal das margens de Tasi Tolu, ecoaram solenes, imponentes e comoventes pelas encostas das serras circundantes até ao cume de Tata Mai Lau. Era a missa campal do dia da restauração da independência de Timor-Leste, proclamada em 28 de Novembro de 1975 e interrompida em 7 de Dezembro do mesmo ano pela invasão e tenebrosa ocupação sanguinolenta indonésia. Lembro-me que nesse dia recebi um telefonema de fora que me comoveu até às lágrimas: "nunca se viu celebrar a independência de um país com tanta dignidade e solenidade".

Na verdade, foi um dia grandioso, não só para Timor-Leste, como para a história da humanidade. Não há ditaduras eternas nem escravatura que sempre dure. Foi assim que um pequenino país, indefeso e sem meios bélicos capazes, nos confins do sudoeste asiático, conseguiu vencer o regime tenebroso e moribundo do ditador Suharto, graças à coragem e determinação do seu martirizado e abandonado povo. Contra tudo e contra todos, continuaram a lutar "até à vitória final"—como diz o seu hino nacional—com vontade férrea de conquistar a sua liberdade e independência e manter a sua identidade e cultura herdadas dos seus antepassados.

GAUA SURI (CALL THE WIND)
Maestro Simão Barreto | Composer

Uru uatu da'akuru (God created all things)
Uatu de (Created the sun)
Uru de (Created the night)
Gaua de (Bring the breeze)
Ula de (Bring the strong wind)
Gaua assar mau (Bring the light wind)
Ula assar mau (Bring the gale)

Gaua Suri in Makassae, *Bolu Anin* in Tetun, is the ritual ceremony to call the wind, at the time of the rice harvest to clean hay and bran remains.

Like this one, there are many other rites and sacred ceremonies, that for centuries have governed and guided the day-to-day life of the East Timorese. Long before the arrival of the Portuguese, Chinese, Persians, Arabs and indus, their social and religious life was guided by sacred ceremonies, which bind the duties of future generations to keep the cultural heritage of morals, teachings, lessons and accomplishments of the illustrious ancestors alive, narrated in *dadolin* (narrative epic poems) sacred of each *uma lulik* (sacred house), and esoterically guarded by the *lia na'in* (guardian of the traditional word).

At the 16.00 hours on the 20th of May 2002, the choir voices of 900 elements that accompanied the mass at Tasi Tolu, echoed solemnly and firmly, moving in between the surrounding mountain slopes to the summit of Tata Mai Lau. It was the field mass of the restoration of independence day of East Timor, independence which was proclaimed on the 28th of November 1975 and interrupted immediately after on the 7th December by the invasion and bloody occupation of Indonesia. I remember that day I got a call that moved me to tears: 'you've never seen the celebration of the independence of a country with such dignity and solemnity'.

In fact, it was a great day, not only for Timor-Leste but for the history of mankind. There is no eternal dictatorship and everlasting slavery. That's how a tiny country, helpless and without military means, on the edge of South-East Asia, managed to win over the dark and dying regime of the Suharto dictatorship, thanks to the courage and determination of its martyred and abandoned people. Against all odds and against all, they continued to fight 'until the final victory', as mentioned in its national anthem, with the strong will to conquer their freedom and independence, and maintain its identity and culture inherited from their ancestors.

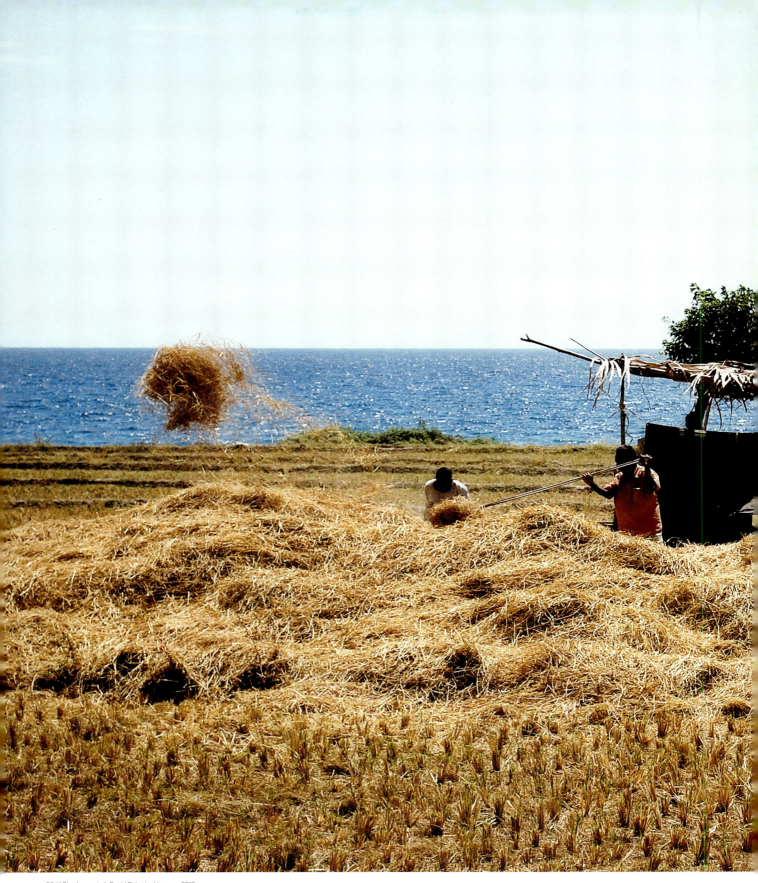
084 | Rice harvest. © David Palazón. Vemase, 2010.

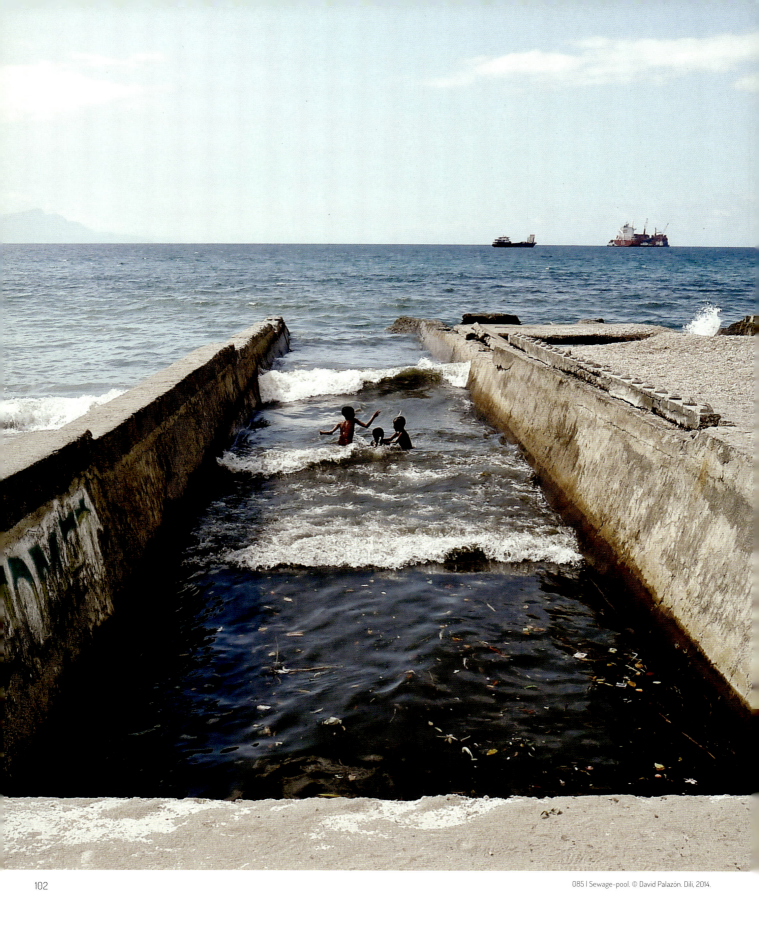

085 | Sewage-pool. © David Palazón. Dili, 2014.

Passados 16 anos sobre a restauração da independência do País —e apesar da abundância do petrodólar—o povo continua na miséria. Não se compreende que ainda se utiliza no ensino curricular das escolas a língua *Bahasa Indonesia* como lingua veicular de comunicação, em vez de utilizar as línguas oficiais de Timor, o Português e o Tétum, como diz a Constituição.

A Administração da ONU depois do referendo elevou o nível da vida dos timorenses a um patamar que eles nunca experimentaram na sua história, transformando a capital do nóvel país, começado do nada, na cidade mais cara do sudoeste asiático, despeito que o salário médio ronda 100 ou 150 USD mensais.

Ruy Cynatti no seu livro de poemas *"Uma sequência Timorense"* dizia:

*O que magoa é ver o pobre
Timorense esquálido beber
Água do pântano,
Onde se escoam lixos,
Comer poeira
E saudar-me, quando
Rodo na estrada,
Deus ocioso.
[…]*

O que encontramos nas ruas poeirentas, sujas, com esgotos a céu aberto, focos de infecção, de propagação de toda a espécie de doenças?

– Crianças mal nutridas, seminuas, esquálidas a nadar nas águas pantanosas dos *kolan* ou dos canos de esgoto partidos. É desolador saber que uma grande maioria da juventude simplesmente vegeta. É uma massa informe sem sal nem rumo, intoxicada pelo consumismo fácil, sem qualidade nem beleza, mergulhada neste marasmo grotesco, sem sentido, sem um mito a que se agarrar. É um comportamento *dantescamente* perturbante, pungente, sem um devir que lhe faça promessa.

É da responsabilidade dos políticos e governantes inverter o rumo da triste realidade em que se encontra a juventude maubere. Sem isso a geração futura estará irremediavelmente condenada a ser autofágica, sufocada pelo inanismo comodista e nihilista.

A acrescentar a tudo isso, a corrupção grassa como uma instituição generalizada, organizada e praticada a nível de quase todo o aparelho do estado, como frequentemente denunciam os diários de Dili.

16 years after the restoration of the country's independence —and despite the abundance of the petrodollar—its people still in poverty. It is incomprehensible that the *Bahasa Indonesia* language is still in use in the school curriculum as a common language for communication and teaching, rather than using the official languages of Timor-Leste, Portuguese and Tetum as established in the Constitution.

After the referendum, the UN Administration raised the Timorese cost of living to a level they had never experienced in their history, transforming the capital of a noble country, which started from nothing, to become the most expensive city in South-East Asia, despite the average monthly wage being around USD 100-150.

Ruy Cynatti mentioned in his book of poems '*Uma sequência Timorense*' (A Timor sequence):

*What hurts is to see the poor
Malnourished Timorese drink
Swamp water,
Where waste seeps,
Eating dust
And greeting me, when
I appear on the road,
God is idle.
[…]*

What do we find in the dusty, dirty streets, with open sewers, the source of infection, spreading all kinds of diseases?

– Children malnourished, almost-naked, squalidly swimming swampy *kolan* waters or broken sewage pipes. It's heartbreaking to know that a large majority of youth just vegetate. It is a shapeless dough without salt or course, intoxicated by the easy consumerism, without quality or beauty, steeped in this grotesque stagnation, without sense, without a myth to hold on to. Such *Dantesque* behavior is disturbing, repulsive, without a promising future.

It is the responsibility of politicians and rulers to reverse the direction of the sad reality of the *Maubere* youth. Without it, the future generation will be hopelessly condemned to autophagy, suffocated by self-indulgency and nihilism.

To add to all of this, corruption grows as a widespread institution, organized and practiced at every level of almost the entire state system, denounced frequently by Dili's newspapers.

086 | Santa Cruz massacre remembrance day. Photograph courtesy of the author. © Sula Sendagire. Dili, 2015.

"*Mehr Licht!*", dizia Johan Wolfgang Goethe no leito da morte. Mais luz, mais ciência, mais instrução, mais educação, mais civismo, mais honestidade!

– *Quo vadis*, Timor?

Pergunta a voz *boriscristofiana* do *rai na'in* vinda das profundezas das grutas de Matebian, à que Timor responde subito:

– Quero um *Gaua Suri*, celebrar o rito do *bolu anin*, para limpar tanto "*dust*" (em toda a amplitude do seu sentido) acumulado sobre mim.

O mito de Sísifo não passa mesmo disso: um mito. Timor não irá ter igual sorte. Acredito que esta terra maravilhosa vai conseguir encontrar o seu destino e ser um país honrado onde os seus habitantes vivem com segurança, dignidade e bem-estar.

Força, Timor!

"*Ad augusta per angusta*"—com as dificuldades às honras—(Victor Hugo, *Hernani*, IV acto), só depois "*carpent tua poma nepotes*"—teus netos colherão os teus frutos (Virgílio, *Eclogas*, IX, 50)

'*Mehr Licht!*', said Johan Wolfgang Goethe on his deathbed. More light, more science, more education, more education, more civility, more honesty!

– *Quo vadis*, Timor?

Questions the *boriscristophian* voice of the *rai na'in* from the depths of the Matebian caves, and Timor responds suddenly:

– I want a *Gaua Suri*, to celebrate the rite of *bolu anin* and clear so much '*dust*' (across all its meaning) accumulated in me.

The myth of *Sisyphus* is nothing but a myth. Timor-Leste will not have the same luck. I believe that this wonderful land will be able to find its destination and be an honourable country where its inhabitants live with security, dignity and well-being.

Go Timor!

'*Ad augusta per angusta*'—through difficulties to honours—(Victor Hugo, *Hernani*, IV Act), only after '*carpent tua poma nepotes*'—your grandchildren will reap your fruit—(Virgil, *Eclogas*, IX, 50).

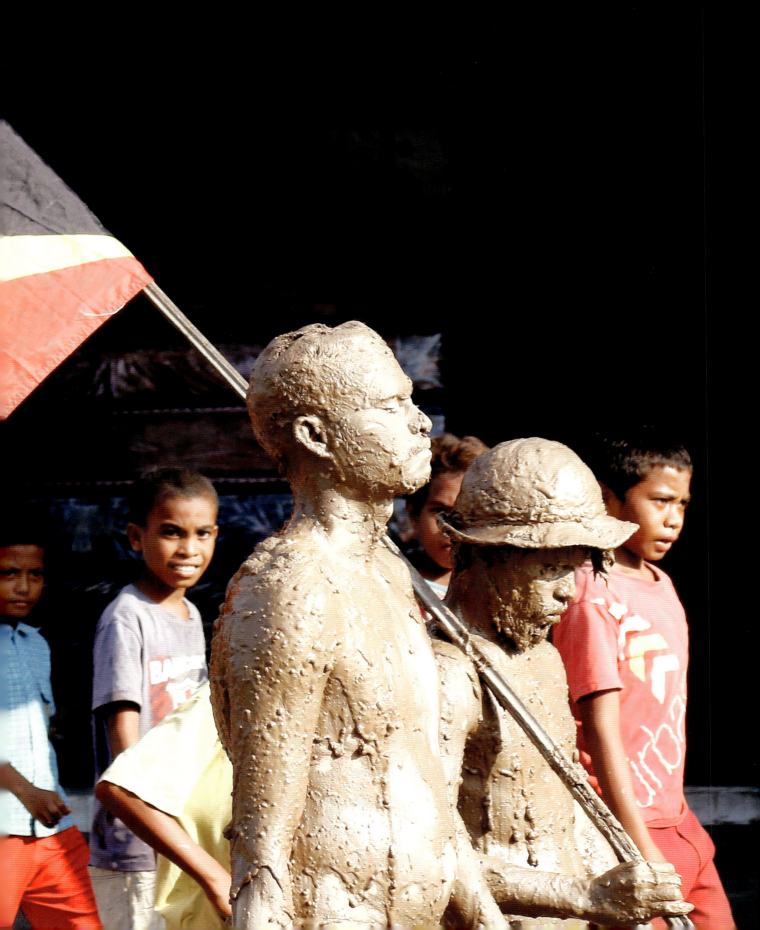

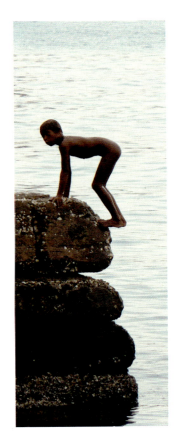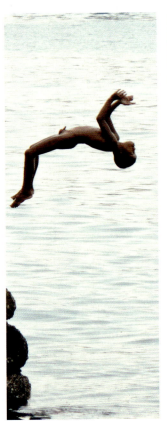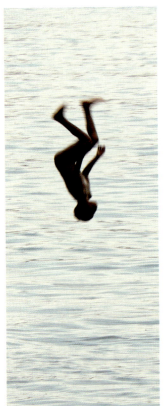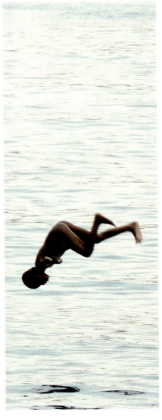

087 | Back flip. © David Palazón. Dili harbour, 2008.

088 | The beauty & the beach. Artwork by Elena Tognoli and David Palazón. © David Palazón. Vila Maumeta, 2009.

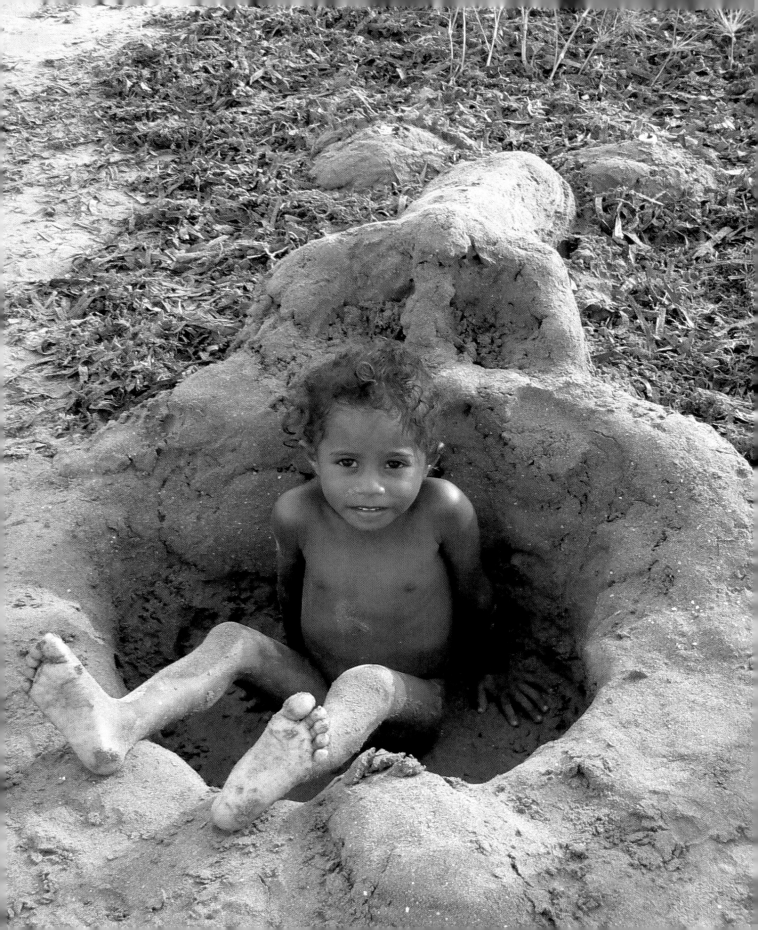

TIMOR OAN
Danilo Lemos Henriques | Child of Timor *(Timor oan)*

What does it mean?
How do I know?
My parents told me that I am
My grandfather told me I am a direct descendant of a wise
and compassionate crocodile.

We were separated through vast seas
Amidst the misty anguish of loss and despair
With the faint, flickering single flame of doubtful but courageous
and always obstinate hope.

I never abandonded you
Although I was unable to be there by your side
When you lost your father
Your child
Your loved one
The tears I shed
Pain I suffered
Despair that could not be vocalized
Were as if we were one.

Beyond all expectations
We achieved our destiny and our dream

Avo, tio, tia, maun, mana, alin
Grandfather/mother, uncle, aunt, brother, sister, younger sibling
So small but intricately woven is the tapestry of our society
So familiar are we with each other
That you could place me directly in society
Through lines of genealogy, marriage,
and familial alliances through the clans of *umane* and *fetosan*

Within approximately thirty minutes of conversation
to decipher which puzzle piece you think I may be
But as I smile at you across the street
Stand behind you in queue
Or pass you on the stairway at work
Do I recklessly read the almost imperceptible wince of the thought that
fleetingly but blazingly crossed your mind?

Mestiço
Malae
China Timor
Otonomista ...

Is my skin shade the wrong tone?
Which should it be?
Perhaps I should change some of my features?
Is my Tetun too *runguranga*?

I've been to that magical rocky outcrop of land
overlooking the sea
Where time seems to have infinitely stood still
And touched the tombstones of the nine generations
of forebears who blessed me with life.

But now
You want to be arbiter
Of who is
And isn't?

Isn't that all a bit too much
Timor *oan runguranga*.

We just defeated our enemies, maun, alin,
Do we really need to create new ones amongst ourselves?

089 | Newborn. © David Palazón, Lacló, 2010.

0901 Out of the pink. © David Palazon. Baucau, 2010.

091 | Staple diet © David Palazón. Fatulia, 2010.

092 | Super malae © David Palazón. Metiaut, 2009.

093 | Roller girl. Photograph courtesy of the author © Karen Reidy, Farol, 2015.

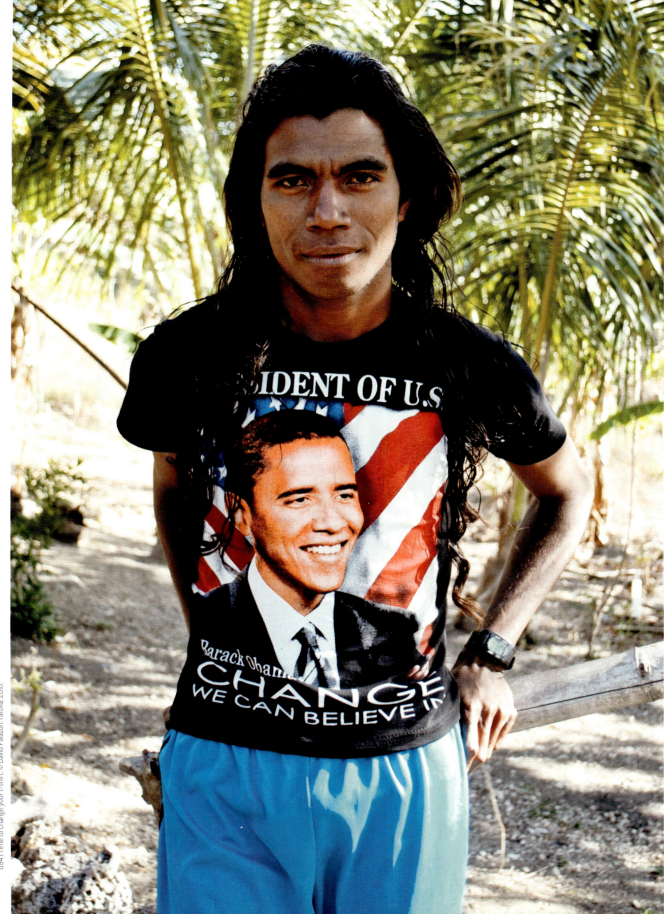

094 | Time to change your t-shirt. © David Palazón. Fatulia, 2010.

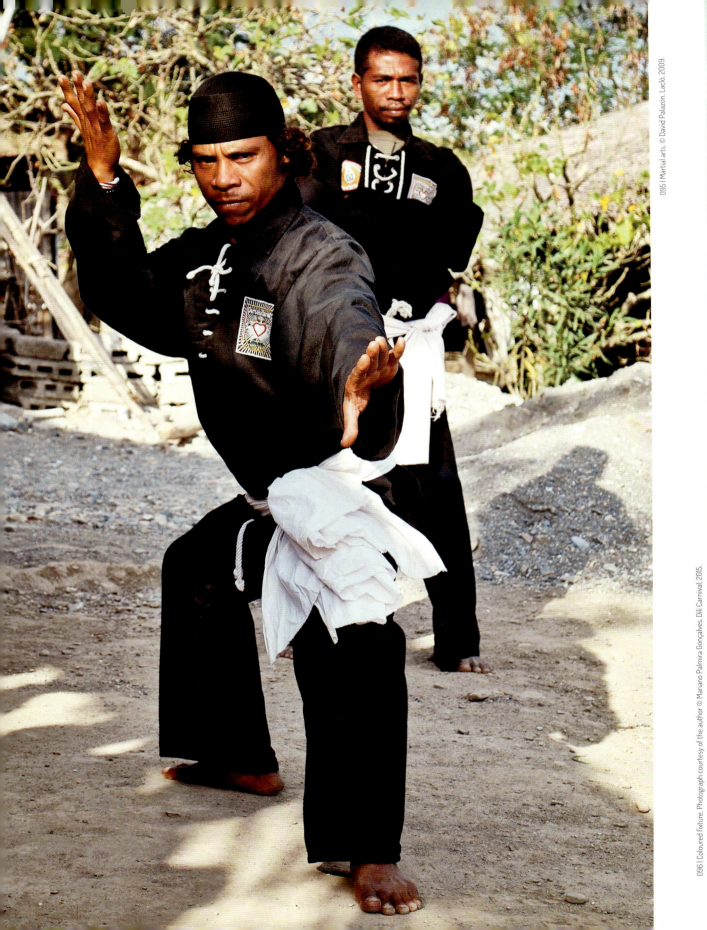

095 | Martial arts. © David Palazón. Laclo, 2009.

096 | Coloured fixture. Photograph courtesy of the author © Mariano Palmira Gonçalves. Dili Carnival, 2015.

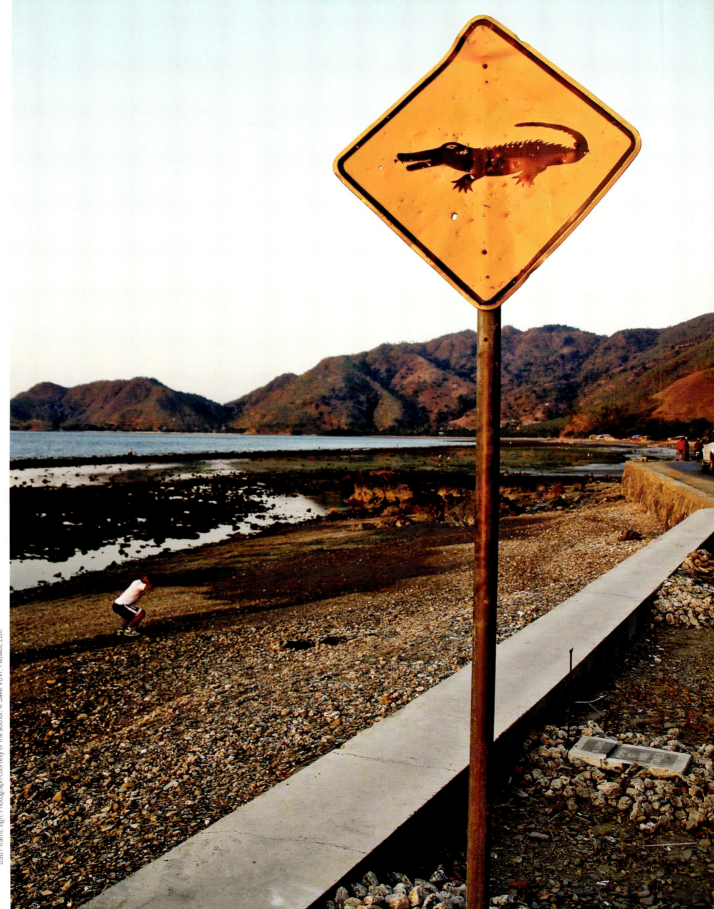
098 | Traffic sign. Photograph courtesy of the author. © Jake VDVF, Metiaut, 2011.

SALT WATER CROCODILES
Alberto Fidalgo | Antropologist

Timor-Leste is one of the countries where the largest living reptile on earth can be found: the saltwater crocodile (*Crocodylus porosus*). The male adult averages from around five meters in length to some records showing up to six or even seven meters. This animal lives mainly in South-East Asia but its habitat ranges from the East coast of India to Northern Australia.

The Tetun[1] word for saltwater crocodile is *lafaek*, which is also used in reference to the Timor Tree Monitor (*varanus timorensis*) known as *lafaek rai-maran* (dry land crocodile) (Kaiser et al. 2011: 61). However, most Timorese use the Portuguese term for grandfather (*avô*) to refer to this animal, because lafaek is considered to be a rude (*kasar*) term to talk about them. In their vision of the world and construction of their environment, most Timorese consider saltwater crocodiles to be *lulik* (sacred) creatures who play one of the most important roles between human and non-human entities.

The importance of crocodiles in Timorese culture can be measured by some expressions where all Timorese people are referred to as 'children of the Crocodile', and the island of Timor as the 'land of the Crocodile'. These expressions are largely based on the narrative of origin that accounts for the formation of the very island of Timor, where a half-submerged crocodile transformed himself into the island in gratitude for the assistance given by a boy (the first Timorese) when the animal was in need. A complete account of this narrative can be found in the book *Textos em Teto da literatura oral Timorense* (Sá 1961), which has been incorporated into the national narrative, as Seixas (2010) pointed out. Nevertheless, there are other narratives of origin—from different sacred houses (*uma lulik*)—that account for human-crocodile relations. Some of them tell stories about crocodiles ascending up the river stream in search for a wife to marry and how, after these accounts, wife giver-wife taker relations were established between them. Other tales talk about the story of a war between humans and crocodiles in a time when a great flood made most of the island submerge under the sea, and when humans—assisted by deities such as the Sun—made the water recede and therefore the crocodiles retreated with it.

The cultural importance of crocodiles can also be found in material culture. It is quite common to find sacred houses (*uma lulik*) carved with crocodile motifs, as well as carved figures of crocodiles. The crocodile motif can also be found in traditional textiles (*tais*), and many other handicrafts made around the country.

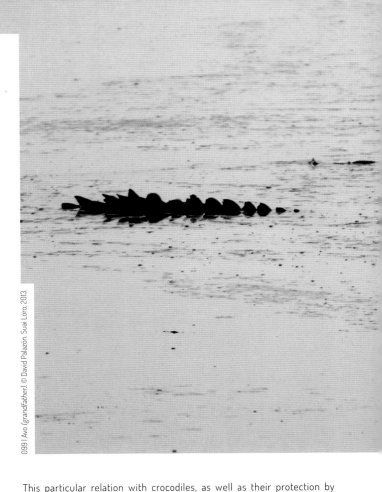

0991 | Avo (*grandfather*). © David Palazón, Suai Loro, 2013.

This particular relation with crocodiles, as well as their protection by traditional law, has made crocodiles a prey which should not be hunted by the population, even when they attack humans.[2] Crocodile attacks are normally blamed on the victim for a variety of reasons, such as disrespect for their ancestry. It is also common to hear that crocodiles do not attack good people, just bad ones. According to Lencastre (1934), crocodiles attacking only criminals or bad people, was an idea used as a local significance for seeking justice. For example, in a traditional justice ceremony, two people would enter the water, therefore exposing themselves to being attacked by a crocodile. If none was attacked, none was guilty, but if the animal attacked either of them, they were found guilty.

There are no records showing crocodile skin exports from the island—at least from 1954[3] to 1975—although some hunting was occurring during that period. According to Portuguese sources (Lencastre 1934), saltwater crocodiles were identified for extermination by governor Celestino da Silva due to the high number of attacks on the local population.

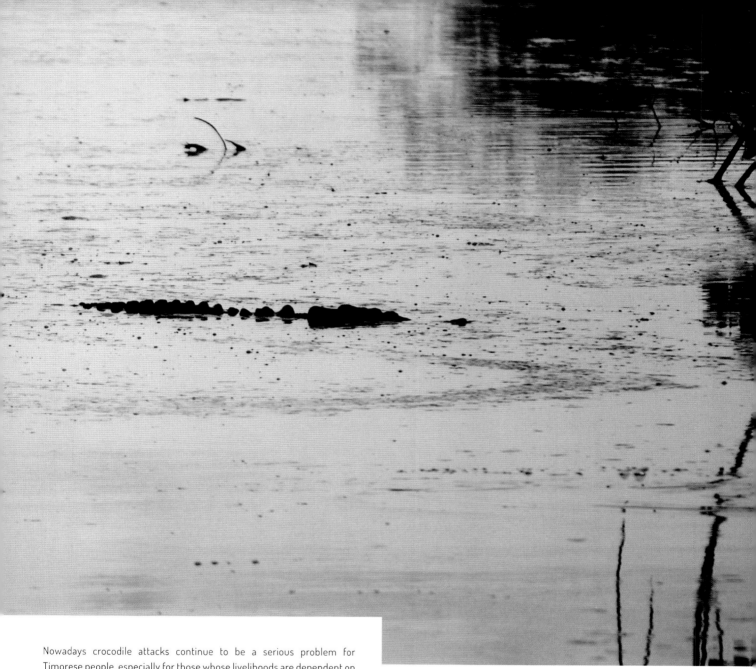

Nowadays crocodile attacks continue to be a serious problem for Timorese people, especially for those whose livelihoods are dependent on coastal activities, such as fishermen. Although many crocodile attacks on fisherman and others go unreported, there are some records that show the importance of this problem.[4] According to Tsujimura et al. (2012) the majority of crocodile attacks occur in the Tasi Mane (Southern Male Sea), where the crocodile population is higher. Despite the fact there has been some initiatives to tackle this problem, there is still much to do about it.

—

[1]. National language of Timor. [2]. Nonetheless, there are some people in the area of Viqueque district that do hunt them. [3]. See "Conselho do Serviço Técnico Aduaneiro. Tabela de valores fiscais dos productos de exportação com discriminação dos destinos, a vigorar no próximo mês de Novembro" in Boletim Oficial de Timor n° 44 (30 de Outubro de 1954), p. 621. [4]. See "Accident report" in http://peskador.org/.

References:

Kaiser, Hinrich et al. 2011. 'The Herpetofauna of Timor-Leste: A First Report'. ZooKeys 109:19–86. Retrieved (http://zookeys.pensoft.net/articles.php?id=2567).

Lencastre, Júlio Garcês de. 1934. 'Lafaic, O Crocodilo Timorense'. O Mundo Português 4:129.

Sá, Artur Basílio De. 1961. Textos Em Teto Da Literatura Oral Timorense. Lisboa: Junta de Investigações do Ultramar. Centro de Estudos Políticos e Sociais.

Seixas, Paulo Castro. 2010. 'Worlds of Translation and Contact Zones in East-Timor'. Pp. 21–33 in Translation, Society and Politic in Timor-Leste, edited by Paulo Castro Seixas. Porto: Universidade Fernando Pessoa.

Tsujimura, Teresa Nao, Enrique Alonso Población, Lourenco dos Reis Amaral, and Pedro Rodrigues. 2012. Safety at Sea Assessment in the Timor-Leste Small-Scale Fisheries Sector. Technical Report. Bangkok. Retrieved (http://www.fao.org/docrep/019/ar291e/ar291e.pdf).

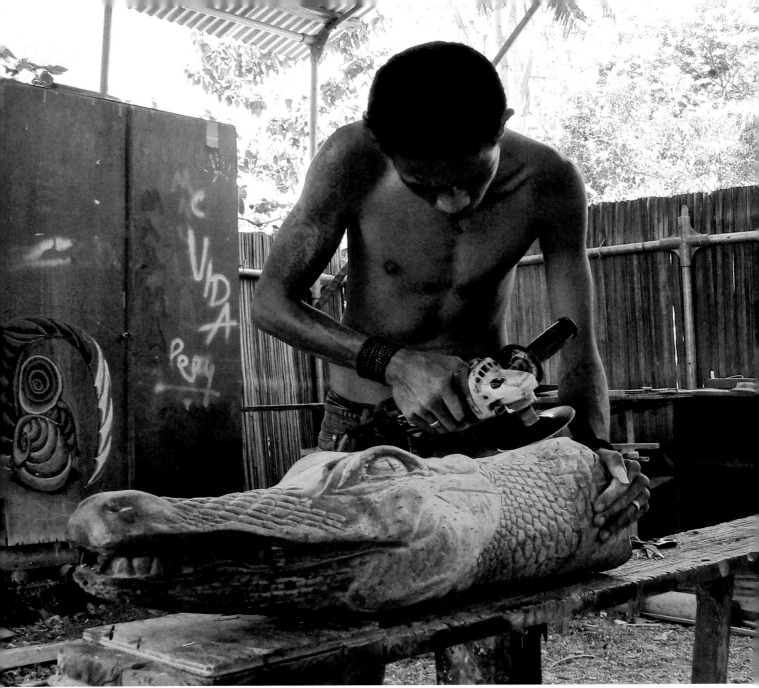

100 | Croc-carving. Artwork by Betino at Arte Moris. © David Palazón. Dili, 2008.

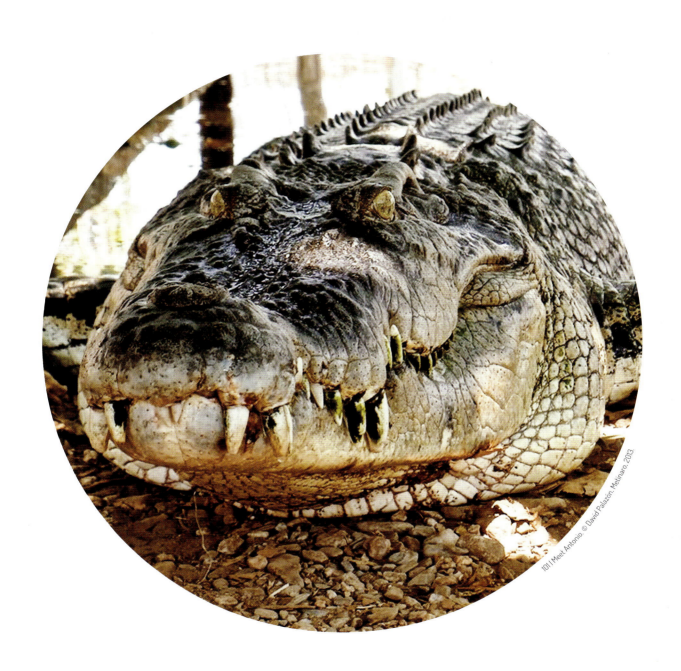

102 | (Crocodile man (Gil Valentim). © David Palazón. Dili, 2008.

104 | Crocodile's head. © David Palazón. Areia Branca, 2013.

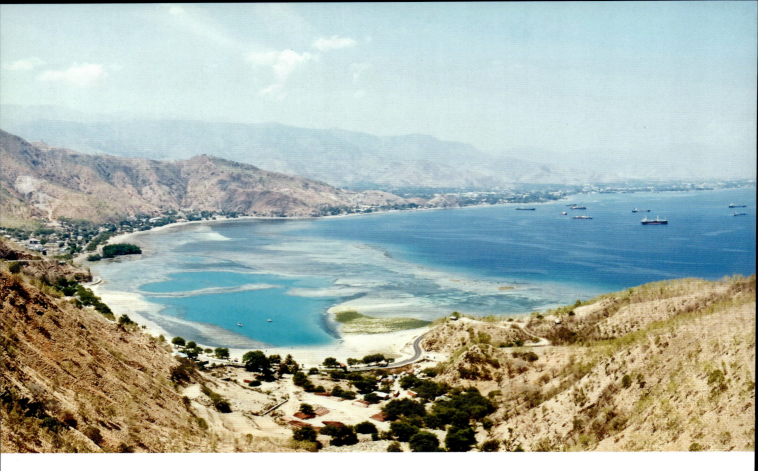

106 | Lonely tree. © David Palazón. Areia Branca, 2015.

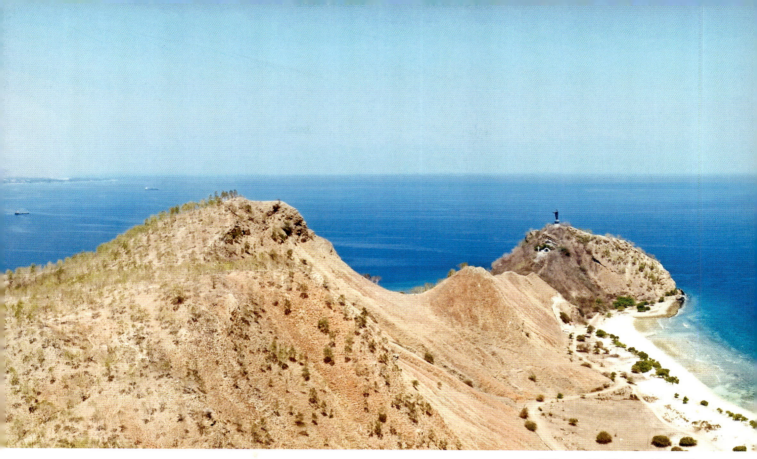

105 | Dry reason. © David Palazón. Areia Branca, 2015.

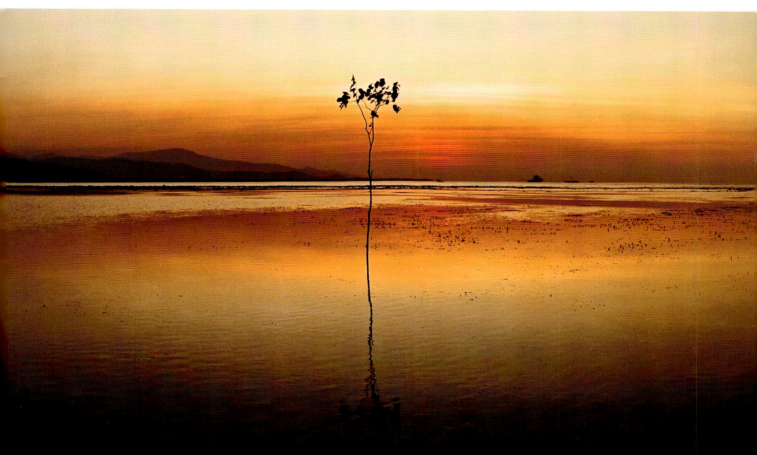

TIMOR-LESTE – PAISAGEM TROPICAL COM GENTE DENTRO[1]
Madalena Salvação Barreto | Antropóloga

Ao longo dos meus tempos em Timor-Leste tenho vindo a alimentar um álbum fotográfico a que dei o título de *"Timor-Leste, paisagem tropical com gente dentro"*. Não são só fotografias de paisagens incríveis e de pessoas bonitas ou exóticas. Com efeito, nesta meia ilha cada vida ou lugar carrega uma história brutal e mística que, felizmente, enquanto pesquisadora social, tenho tido a sorte de ir conhecendo, ainda que todos os dias gere em mim um *runguranga* de sentimentos.

Falo de pessoas que viveram séculos de guerras entre antigos reinos e invasões estrangeiras, havendo ainda hoje, incontáveis questões latentes e traumas por resolver. Por tudo isto, penso que das primeiras lições aprendidas em Timor foi que a expressão facial de um sorriso rasgado, nem sempre traduz tal sentimento, e que não existe tal coisa como respostas diretas. Os acontecimentos históricos por estes lados encarregaram-se de desenvolver a arte da diplomacia, enquanto resistência passiva, e a arte de um sorriso aberto a esconder apreensão ou desconfiança. A minha capacidade de interpretar a reação e o comportamento do outro é posta à prova todo o santo dia e fico com a ideia de que não há um em que eu não ponha a pata na poça.

Ainda assim, a vida por aqui faz-me bem à alma. Sempre que se pergunta *"Diak ka lae?"*, invariavelmente a resposta é: *"Diak mana, sempre diak!"*, com um sorriso sincero estampado na cara. Com efeito, gargalhadas bem altas e genuínas e grandes cantorias são a minha banda sonora de todos os dias. A boa disposição não desaparece desta atmosfera ainda que, segundo o Banco Mundial e apesar dos avultados *incomes* do petróleo, 37.5% do país continua a viver abaixo da linha de pobreza, estipulada a nível internacional. Por diversas vezes, em conversa com amigos timorenses, noto o endurecimento de suas vozes quando se refere este assunto. Refutam determinantemente a autoridade de tais dados, pois acreditam que o conceito de pobreza, em terras de sol nascente, é algo bem diferente do que o do ocidente. Defendem que em Timor, efetivamente nem toda gente tem acesso a mais de 1$ por dia, mas é raro ver-se um sem-abrigo na rua. Um prato de arroz e um tecto para dormir não falta a nenhum timorense, pelo simples facto de que os valores da familia e da comunidade são a essência da cultura e identidade deste país.

1. Título adaptado da obra "Timor: Paisagem tropical com gente dentro" de Rui Feijó.

TIMOR-LESTE – TROPICAL COUNTRY WITH PEOPLE INSIDE
Madalena Salvação Barreto | Anthropologist

Since I arrived in Timor-Leste, I have been building a photography album titled *'Timor-Leste, tropical landscape with people inside'*. It's not only made of photographs of amazing sceneries and beautiful or exotic people. Indeed, in this half-island, each life and place carries a dense and mystique history that fortunately, as a social researcher, I have been lucky enough to get to know, although, every day, it brings me *runguranga* feelings.

I'm talking about people who lived centuries of wars between old kingdoms and foreign invasions, hence the reason for countless latent issues and unresolved traumas. Therefore, one of the first lessons I learned in Timor was that a smile, does not always mean that feeling, and that there is no such thing as a direct answer. The historical events here shaped the art of diplomacy, while passively resisting, it is the art of an open smile hiding hesitation or distrust. My ability to interpret people's reactions and behaviours is tested every damn day and I'm pretty sure I manage to fail at it every single day.

Nevertheless, daily life here brings wonders for my soul. Almost every time I ask a person *'Diak ka lae?'* the answer is: *'Diak mana, sempre diak'* with a sincere and open smile on the face. In fact, genuine guffaws and loud singing are part of the soundtrack of my daily life. Good mood does not leave this atmosphere, even though, according to the World Bank and despite considerable oil income, 37.5% of the country continues to live below the internationally established poverty line. Several times, while talking with Timorese friends, I noticed their voices hardening when referring to this matter. They determinately refute the authority of such data because they believe that the concept of poverty here is something quite different from that in the West. They argue that in Timor, not everybody has access to more than $1 per day but it is rare to see a homeless person in the street. A plate of rice and a roof to sleep is something always available to any Timorese for the simple fact that family and community values are the essence of the culture and identity of this country.

107 | Teaser. © David Palazón. Praia dos Coqueiros, 2014.

De resto, quando falamos de Timor-Leste, falamos de um país com cerca de 15.000 km², não é muito. No entanto, trata-se de um país onde vivem falantes de mais de trinta dialectos diferentes. São inúmeras comunidades, cada uma com traços culturais muito próprios e com um sentido de identidade extremamente vincado. Cada família ou comunidade tem a sua própria história e mito de origem que vão sendo passados de geração em geração, através de tradição oral com um orgulho e um sentimento de pertença incríveis.

Nas minhas vivências por aqui, Timor, é de facto, um país riquíssimo do ponto de vista histórico, cultural e humano, contudo, onde nada se enquadra nas nossas perspectivas "pré-fabricadas" europeias. Em Timor-Leste, pouco se aprende pelos livros, tudo se aprende pela experiência. Das primeiras coisas que me disseram quando aqui cheguei foi *"Primeiro estranha-se, depois entranha-se"*. Efetivamente, é uma relação de amor/ódio da qual não quero prescindir.

When we speak of Timor-Leste, we talk about a country of around 15.000km², not much if you think about it. However, it is a country with speakers of over thirty different dialects. There are numerous communities, each with very specific cultural traits and extremely marked identities. Each family or community has its own history and myth of origin, which are passed down from generation to generation, through oral tradition with an incredible pride and sense of belonging.

In my experience, Timor is in fact a very rich country from a historical, cultural and human point of view, however, little fits into our manufactured European projections. Getting to understand Timor is not something you learn from books, in here everything is learned by experience. One of the first things I was told when I got here was *'First you find it strange, then you can't get enough of it.'* In fact, it is a love/hate relationship, which I do not want to live without.

108 | Transitolu. © David Palazón. Tasitolu, 2013.

109 | Smiling horse © David Palazón. Maubara, 2010.

110 | Galloping boy. © David Palazón. Lospalos, 2013.

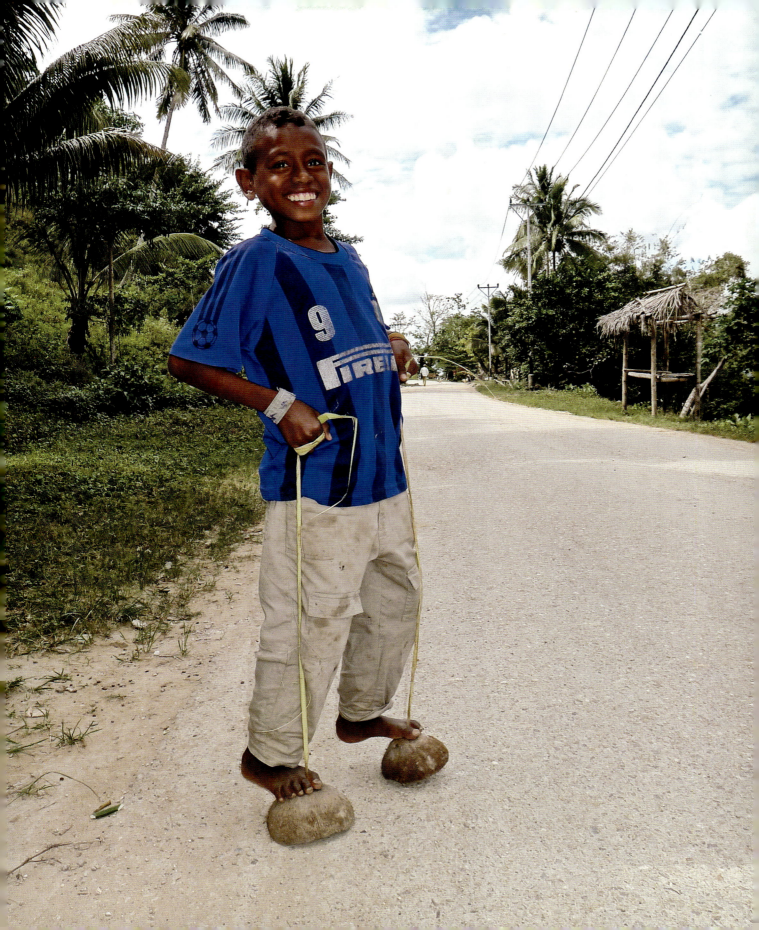

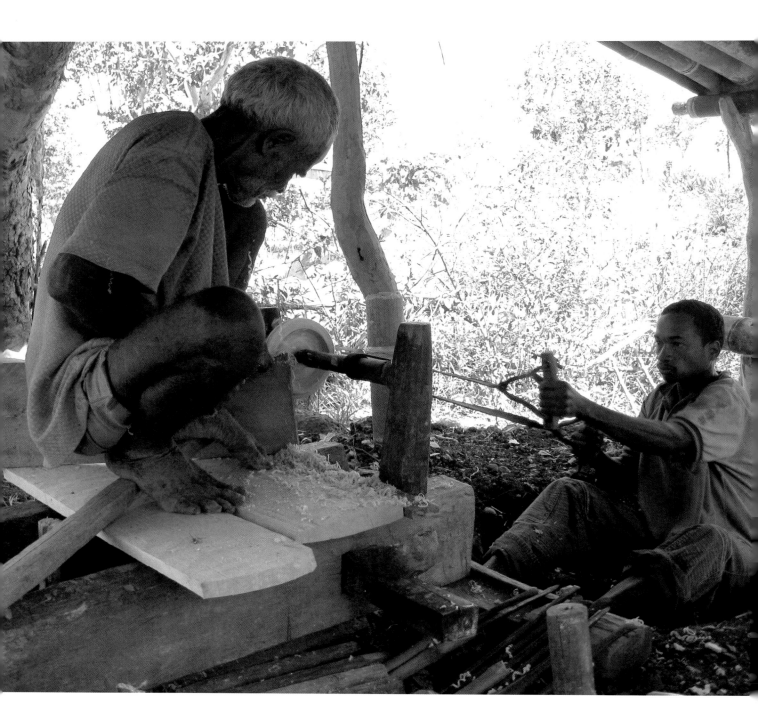

111 | The late Sr Patricio Guterres de Sousa' making *aku kai* (wooden pots, in Midiki language) with a *karau nia kulit* (leather strap powered carving machine). © David Palazón, Kaileitiana (Ossu), 2010.

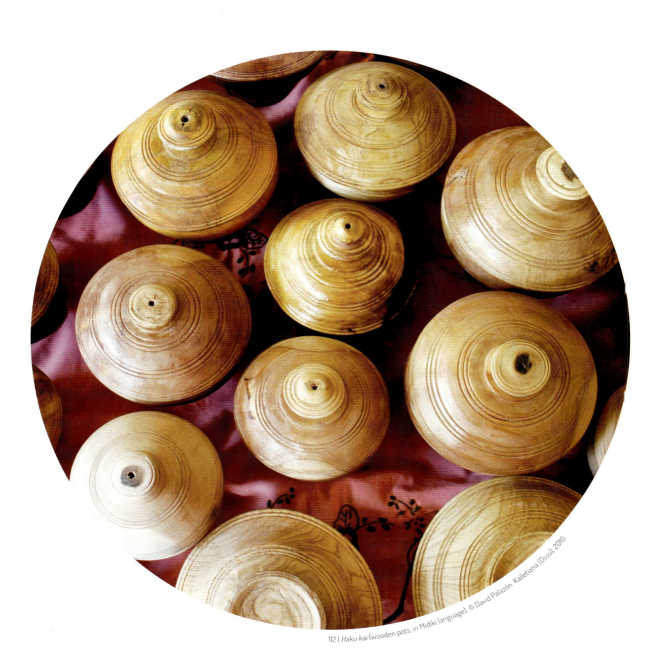

112 | *Haku kai* (wooden pots, in Midiki language). © David Palazón, Kaileitiana (Ossu), 2010.

137

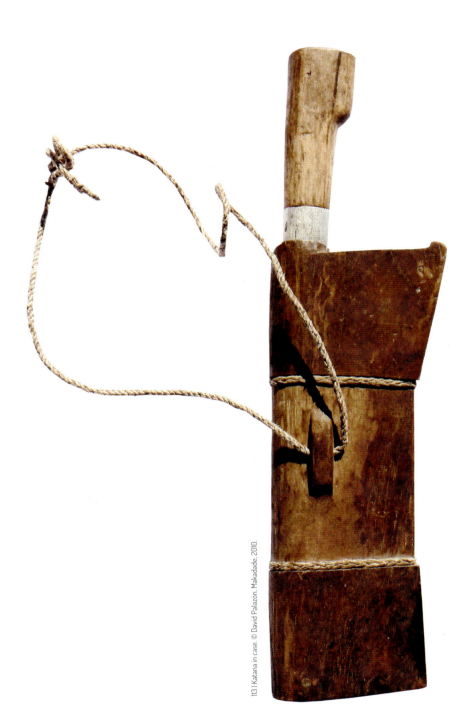

113 | Katana in case. © David Palazón. Makadade, 2010.

114 | Fire breathing. © David Palazón. Viqueque, 2009.

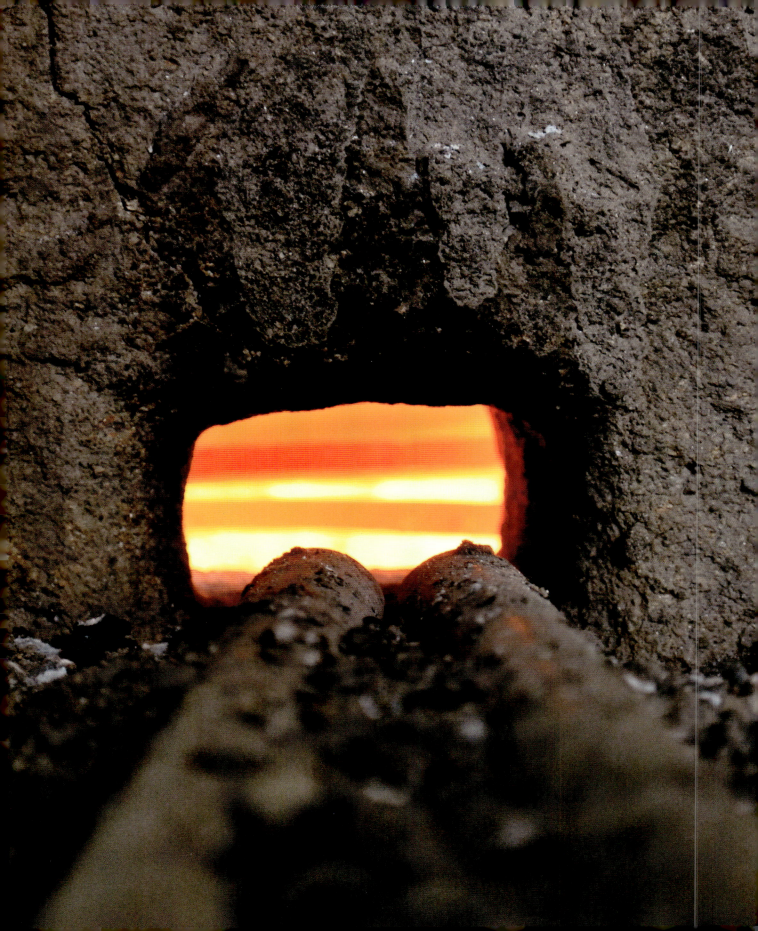

140

115 | Cutlery © David Palazón. Baucau, 2009.

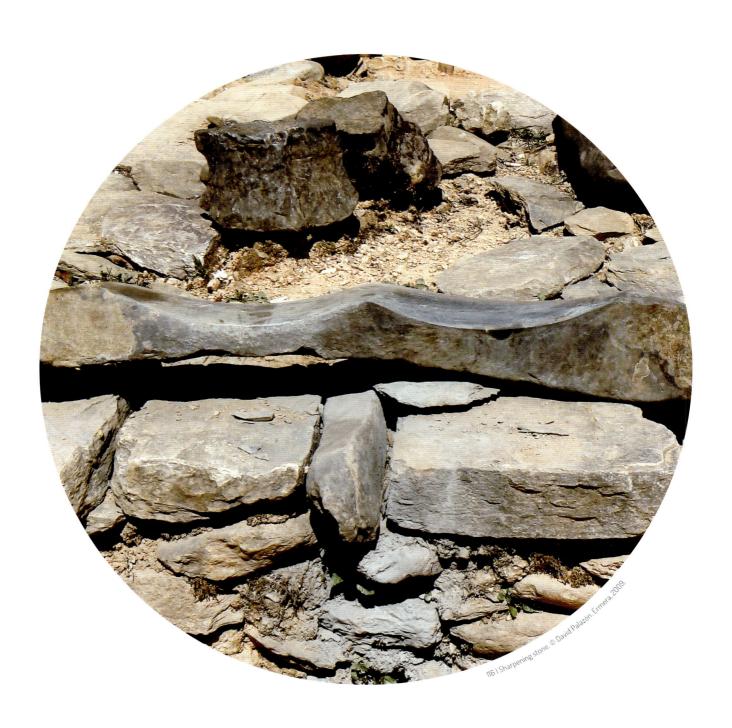
116 | Sharpening stone. © David Palazón. Ermera, 2009.

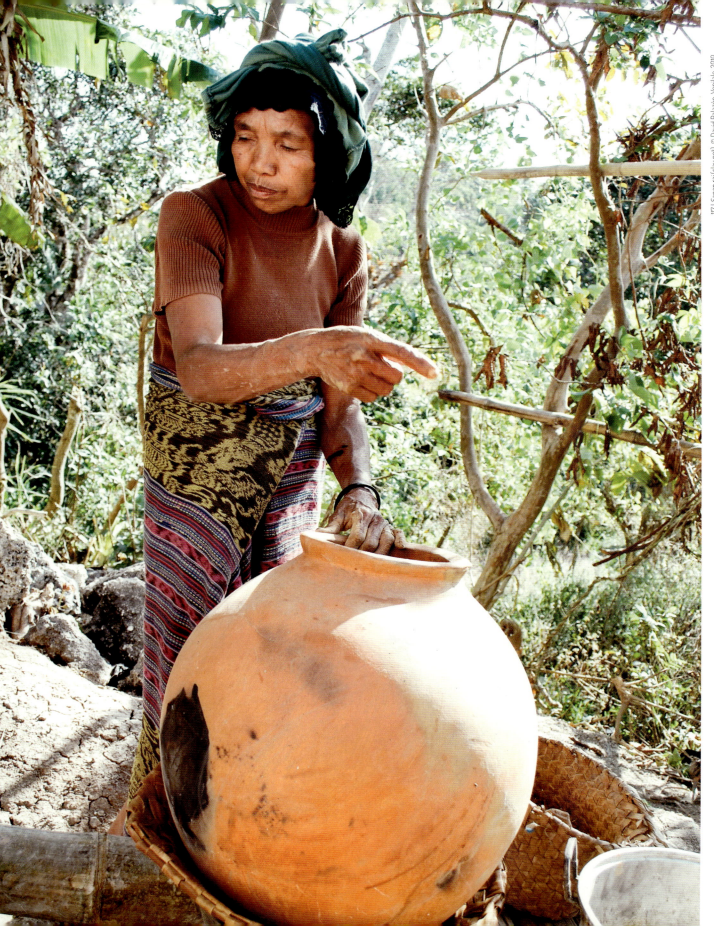
117 | *Sanan rai* (clay pot). © David Palazón. Venilale. 2010.

118 | Hollow. © David Palazón. Dili, 2014

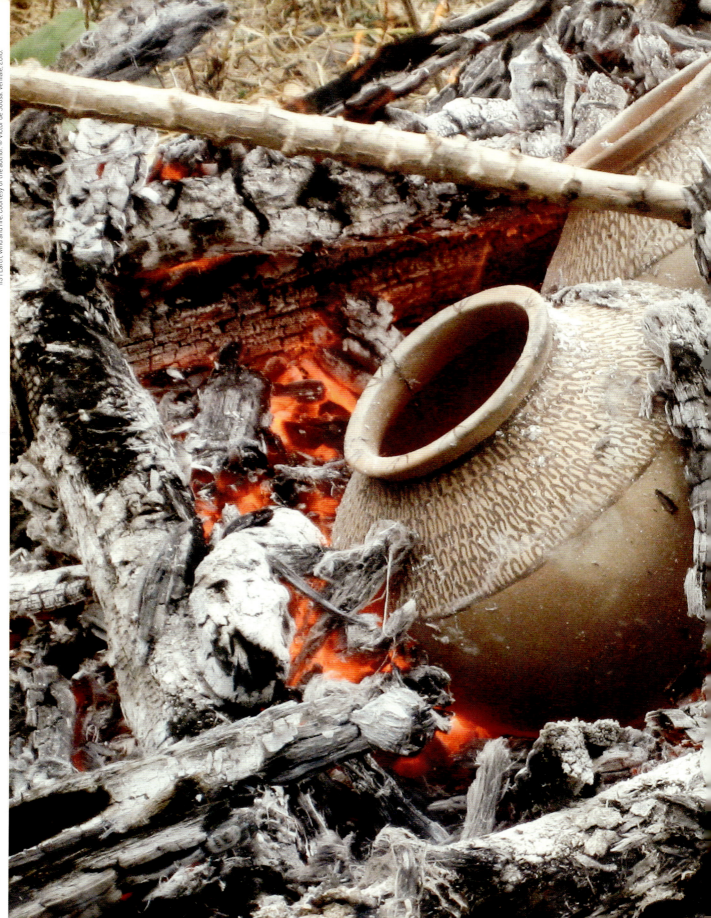

119 | Earth, wind and fire. Courtesy of the author. © Victor de Sousa Venilale, 2010.

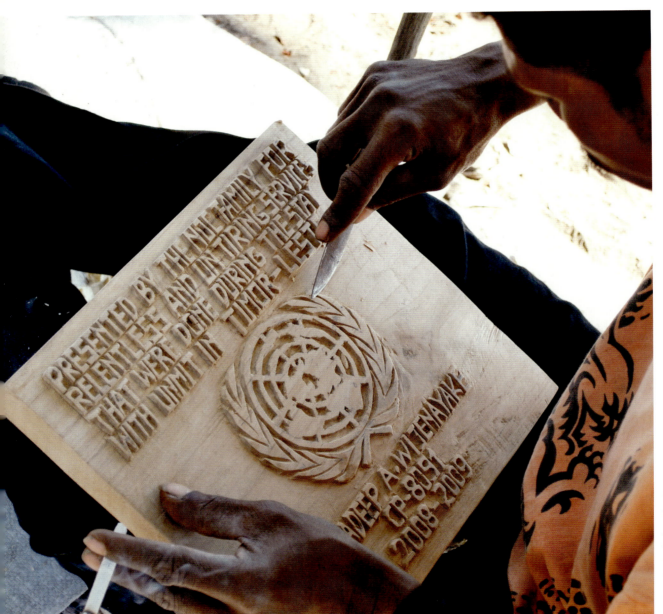

121 | Toolbox. © David Palazón. Baucau, 2010.

SA'ET HEHATA, SA'ET PERANI[1],
SILENT TESTEMUNHAS ATAÚRO NIAN

Maria Ceu Lopes Federer | Art Collector

Oral speech in Timor-Leste exposes a sophisticated runguranga of languages used simultaneously. The natural fluidity of the mixture of languages, enriches dialogue and exchange between Timorese communities. This is the consequence of almost five centuries of colonisation by different foreign powers, in addition to more than thirty local dialects that are spoken daily.

Storytelling is a rich tradition in Timor-Leste. This tradition defies the conventional rule which dictates that a story must have a beginning and an end. Timorese storytelling carries important messages, which are delivered repeatedly through elaborate language, singing and interaction with the listeners, jokes and poetry in a disorderly manner. It's a demonstration of a fantastic runguranga of mind and speech. Arbiru deit.

The following is a Timorese discourse on my 'Silent Testemunhas Atauro Nian' collection to amuse you with an example of the runguranga of languages I speak. It will probably delight the Timorese readers but annoy the foreigners. Mea culpa.

The Atauro silent witnesses representa os ancestros da Ilha e são a evidência do estilo de vida do povo de de Atauro. Aunque se han producido muchos cambios durante los 450 años de colonización portuguesa y los posteriores 24 años ocupación indonesia, parece que todo permanece igual. Ça plus change, ça plus reste le même.

I nostri antenati in Atauro erano illiterati, loro si esprimevano con la scultura in legno ed in questo furoni grandi. Sa'et Hehata, Sa'et Perani adalah ribuan tradisi lama dari Atauro pemahat terampil dalam rekaman sejarah masyarakat dan budaya di Pulau.

Traditional art is a natural force that determines identity, history, and culture of societies, and sustains the economy of artisan communities all over the world.

> "Many intensive forms of environmental exploitation and degradation not only exhaust the resources which provide local communities with their livelihood, but also undo the social structures which, for a long time, shaped cultural identity and their sense of the meaning of life and community. The disappearance of a culture can be just as serious, or even more serious, than the disappearance of a species of plant or animal. The imposition of a dominant lifestyle linked to a single form of production can be just as harmful as the altering of ecosystems. In this sense, it is essential to show special care for indigenous communities and their cultural traditions ..."

Pope Francis. Encyclical Letter 'Laudato Si' of The Holy Father Francis on Care For Our Common Home. 24 May, 2015, paragraphs 145-146.

Iha September 1999, hau hahú sosa estátua Sa'et Hehata no Sa'et Perani ne'ebé fa'an iha Dili, besik tasi ibun. As aquisições continuaram persistentemente tendo, até agora, colecionado cerca de duzentas estátuas de diferentes dimensões para as manter em Atauro, a sua ilha de pertença. Some pieces of Sa'et Hehata and Sa'et Perani are on their way to Charles Darwin University Art Gallery for an exhibition in March 2017. I feel proud of the outcome. Sa'et Hehata, Sa'et Perani, sole hali.

1. *Sa'et Hehata* and *sa'et Perani* stands for female and male statues in Hresuk language. The statues and the language originate from the coastal village of Makili, on the South East of Ataúro island.

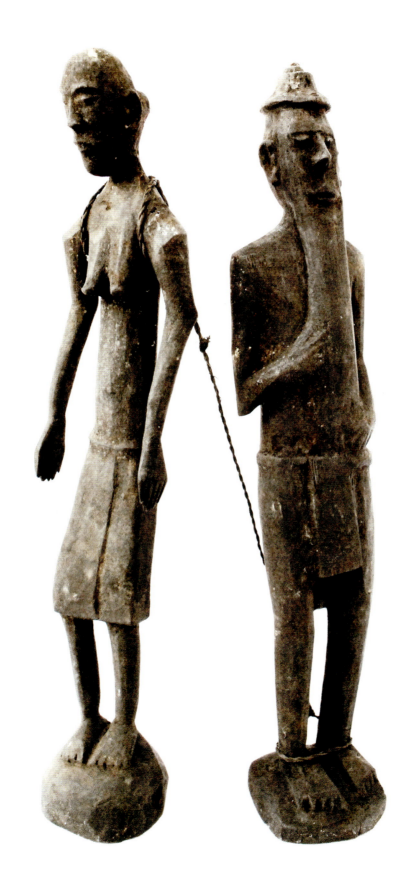

122 | Female and male statue. Courtesy of Maria Ceu Lopes Federer collection. © David Palazon. Dili, 2010

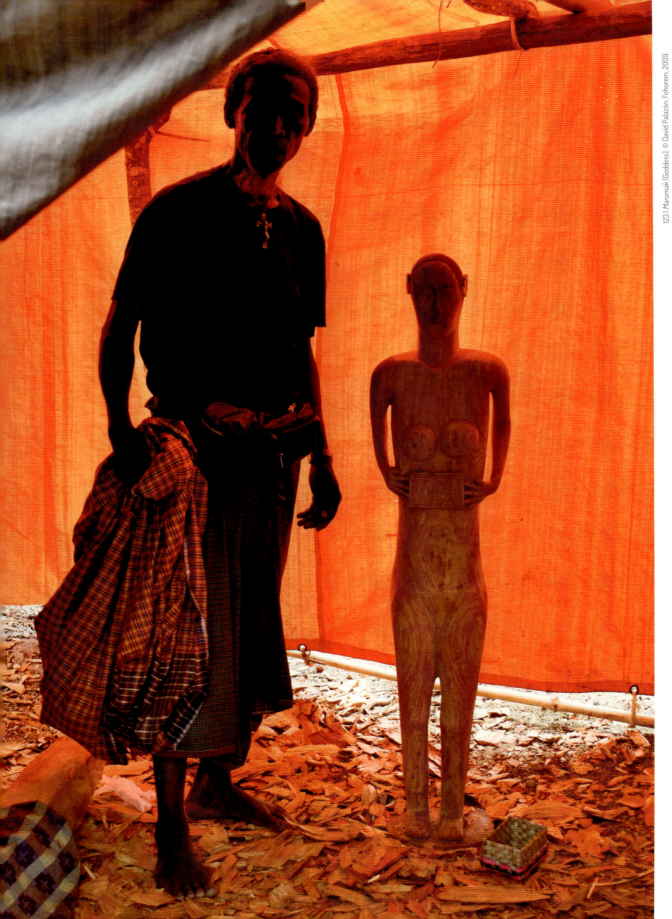

123 | *Maromak (Goddess).* © David Palazón. Fohorem, 2009.

124 | *Trance.* © David Palazón. Baucau, 2012.

125 | The morning after the night before. © David Palazón. Baucau, 2012.

126 | Piped down. © David Palazón. Fatulia, 2010.

128 | Keeping it under your hat. © David Palazón. Laclo, 2010.

127 | Googled. © David Palazón. Dili, 2009.

129 | Personal objects. © David Palazón. Laclo, 2010.

130 | Veteran. © David Palazón. Venilale, 2010.

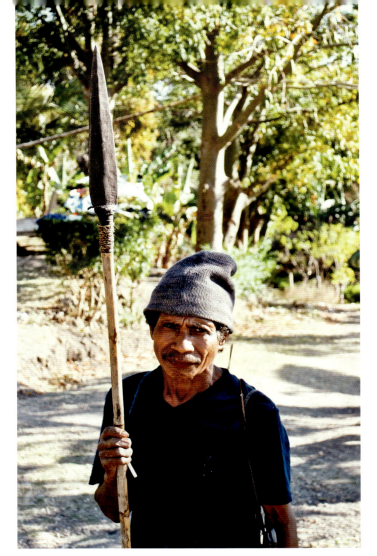

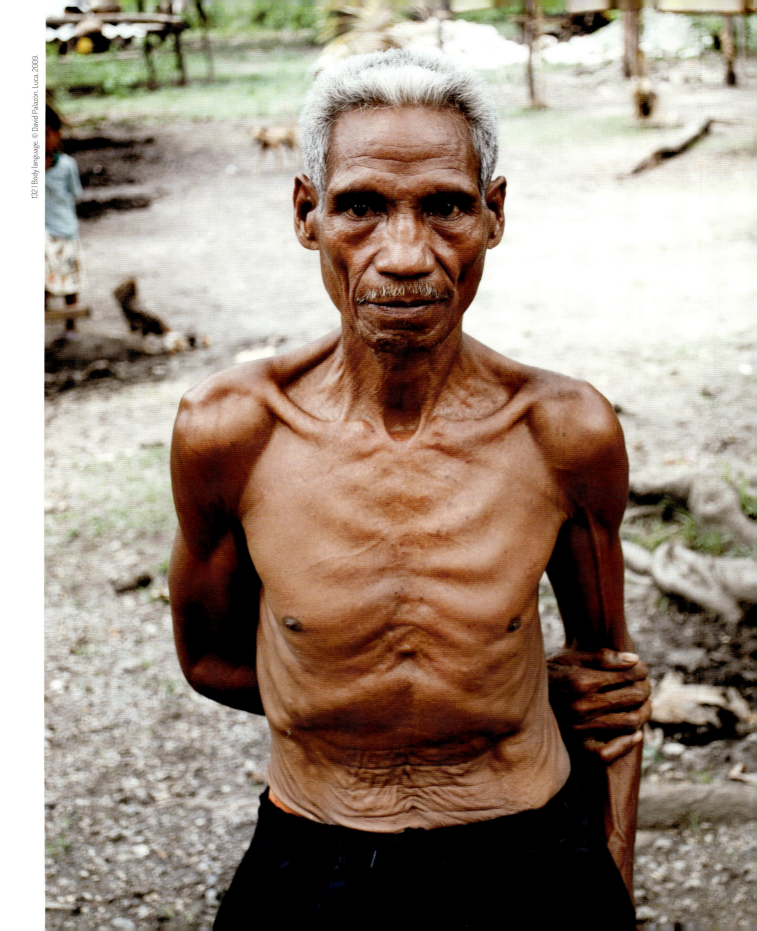

133 | Where is my passport? © David Palazón. Suai Loro, 2013.

135 | Same, same but different t-shirt. © David Palazón. Suai Loro, 2012.

133 | Where is my identity? © David Palazón. Suai Loro, 2013.

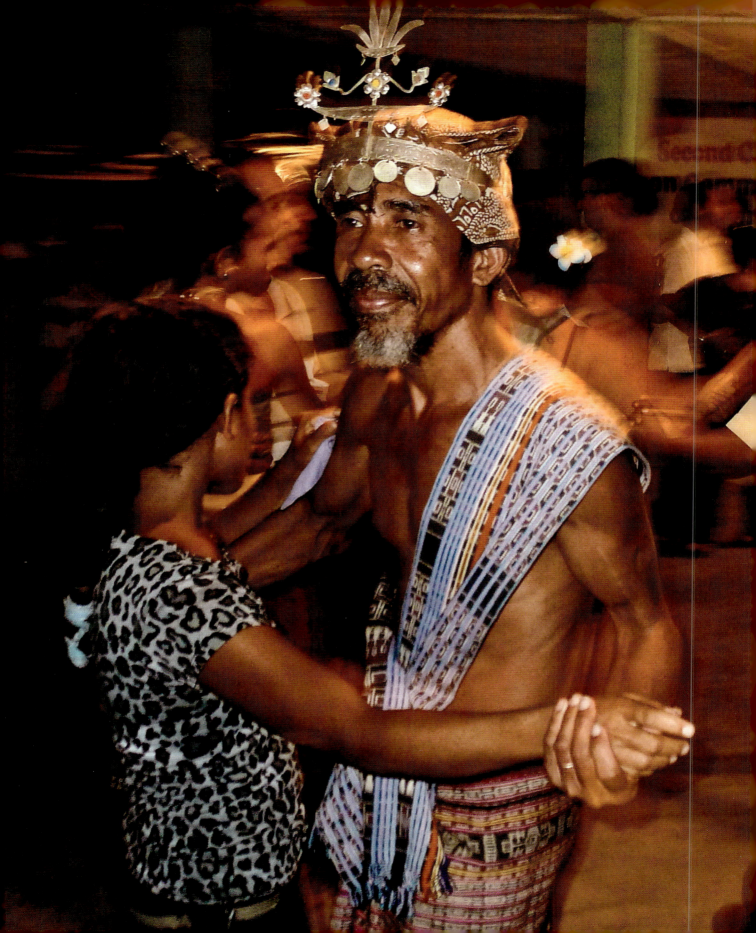

EMA DEHAN SIRA BULAK
Kiki Kakashi | Artista

Ema bulak, ema ne'ebe lao tuir deit nia hakarak, dala balu koalia ou hamnasa mesak mesak, no la preokupa ho ema seluk nomos la preokupa ho nian an rasik, hanesan koalia ho ema seluk ne'ebe ita lahare, maibe nia hare, nia halo deit buat ruma tuir ninia hakarak rasik, bele mos halo tuir deit ema seluk ne'ebe ita lahare maibe nia hare.

Iha hau nia moris, ema bulak ida ne'ebe hau hatene uluk mak naran Kalasa husi Laleno, nia ferik ida ne'ebe sempre hatais kalsa hena mean ida ho kabaya nomos duku sapeu koboi iha nia ulun, iha Sapeu ne'e iha manu fulun, wainhira nia lao liu husi dalan boot ka estrada, nia sempre koalia mesak-mesak ho hakilar *"Soo Lalenu"* iha dalan nia sempre hase ema ne'ebe nia konhese ho diak, dala balu mos ema hase no nia simu ho diak mos, maibe wainhira labarik sira book nia hodi dehan *"bulak ... bulak"* ne'e mak nia foin hirus, tuda e duni labarik sira ne'ebe book nia ne'e.

Iha loron ida, hau sei lembra, wainhira hau sei eskola iha terseiro klase SDN 16 Kauto, besik meudia, hau nia maluk sira husi klase seluk ba iha estrada boot, wainhira ferik kalasa ne'e liu, sira book no goja nune'e ferik kalasa hirus no tuda sira no duni too iha ami nia eskola, ferik kalasa mos mai too iha ami nia eskola, ema hotu halai ba buka fatin hodi subar, hau mos halai ba iha eskola kotuk depois halai ba liu bee matan Papapa iha eskola kotuk no halai ba liu uma.

Liu tiha fulan hirak liu ba, hau ba iha kota, no hau fila ba uma iha besik lorokraik ida, hau lao too iha Motolori, hau hakat liu uituan ponte Lavandaria, husi dook hau hare ferik Kalasa, nia lao mai, lao hasoru hau, hau mos laran tauk-tauk hela, nia keta tuda hau karik, hau lao iha liman karuk, nia lao iha liman loos, nia lao mai besik dadaun, hau nia laran laran mos tauk makaas los, ferik Kalasa lao mai hasoru hau los no hase hau: *"Modo ive a hai la'a inan maran hai fulehe".*

PEOPLE SAY THEY ARE BULAK [1]
Kiki Kakashi | Artist

The *bulak* are those who only do what they want to do, occasionally they speak or laugh alone, and they are not concerned for other people or for themselves. It is as if they talk with other people we cannot see. They do anything they feel like doing. Perhaps they do as they are told by the people we cannot see.

The first *bulak* person I met in my life was called Kalasa who was from Laleno. She was an elderly lady who always dressed in red pants with a red blouse, and wore a rooster-feathered cowboy hat. When I walked down the road, she would always shout *'Soo Lalenu'* (Hey Lalenu!—in Fataluku). She would always greet the people she knew politely and when people greeted her she always responded respectfully. However, when children harassed her calling her *'bulak ... bulak ...',* she would get angry and throw stones or chase after the children that bothered her.

I remember one afternoon, while I was in third grade at the 16 Kauto primary school, my classmates went down to the road. When Mrs Kalasa was passing by, they provoked her into getting annoyed. This led to her throwing stones and following my classmates back to our school. When Kalasa came to the school, everyone fled looking for a place to hide. I ran to the back of the school and continued running down by the Papapa stream until I got home.

A few months later, I found myself in the city, returning home at sunset. I had not yet reached Motolori, just past the Lavandaria bridge and I saw Kalasa from afar. She was walking towards me and saw me. I was scared and afraid that she would throw stones at me. I was walking right past her, the closer I was, the more I feared. When we crossed side-by-side, she greeted me: *'Modo ive a hai la'a inan maran hai fulehe'* (My child! Where have you been walking at these hours?—in Fataluku).

—

1. Bulak: (adj.) quirky, crazy, insane, stupid, silly, clumsy, brave, wild.

136 | Masquerade. Photograph courtesy of the author. © Elena Tognoli. Manatuto Festival, 2010.

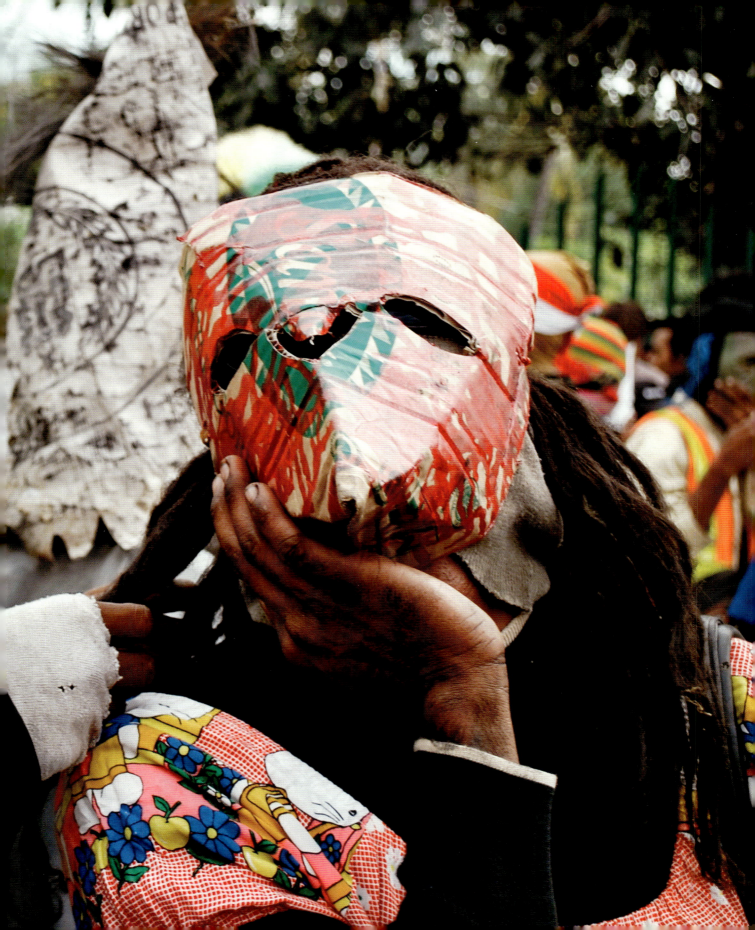

Hau mos la hatan, tamba hau tauk hela, no nia se nia liman mai hau atu fo buat ida, nune hau se hau nia liman no nia fo rebusado haat mai hau, no nia lao nafatin, hau hateke tuir deit, nia kontinua lao, lao mesak-mesak, koalia mesak-mesak e hau mos lao fali no fihir hare hau nia liman, hare rebusado nebe'e ferik Kalasa fo mai hau no hau han ida no lao tuir dalan mai uma. Nune'e iha loron seluk ruma tuir mai mak ami hasoru malu iha dalan, ami sempre hase malu, ami sai belun, maske sai belun iha dalan ninin deit.

Bulak ida seluk naran Paulina ne'ebe iha relasaun familia ho ferik Kasala ne'e, tuir ema konta Paulina ne'e sai bulak tamba nia laen ema oho, no balun dehan sira ne'e gerasaun ema bulak, maibe hau lahatene ne'ebe los no ne'ebe mak lalos. Paulina mos hanesan ferik Kalasa, wainhira ita koalia ho nia ho diak, nia mos sei koalia ho diak mos, wainhira ema book ka goja maka nia sei hirus no tuda.

Bulak ida fali seluk naran Lisino, nia ema Soru, foun-foun nia ema ne'ebe diak, maibe derepente sai bulak no lao lemo-lemo iha Lospalos laran, loron ida hau hare nia iha Igreja Lospalos nia oin, nia hatais kalsa badak ida. Lahatais faru, lao tun sae, halai, koalia no hamnasa mesak-mesak.

Wainhira hau mai iha Dili hau labele hare ona sira, hau bele deit mak rona konaba sira husi ema Lospalos balun ne'ebe dehan katak sira sei bulak, dehan horsida diak, horsida ladiak.

Iha Dili, wainhira hau eskola iha Universidade Dili (UNDIL) hau ho hau nia maluk sira, wainhira iha meudia iha tempo rekreiro, sempre tuur iha baki leten, iha eskola nia oin, tamba iha fatin ne'e mahun, mahun tamba hali hun boot ida moris hamrik iha ne'e. Iha fatin ne'e iha estrada ibun ne'e, ha ema bulak ida sempre lao liu husi fatin ne'e, ema hotu dehan nia ne'e bulak, hau mos lahatene nia naran. Ema bulak ne'e, nia ne'e halai deit dirasaun Taibesi liu UNDIL nia oin halai tun mai iha merkado lama, depois halai sae fali ba iha dirasaun Taibessi nian, nune'e hela deit, nia ne'e, ema bulak ida ne'ebe hakarak halai hela deit.

Tiu ida fali, ne'e mos bulak, ema hotu dehan tiu ne'e bulak, ninia area mak tasi ibun, wainhira ami lao halimar ba iha tasi ibun, nia dala barak lao deit iha tasi ibun, nia lahatais faru ruma ka kalsa ruma, nia hatais deit massa ka plastiko ne'ebe bobar ba nia isin deit, no nonok hela deit, la koalia ho ema seluk, bulak ne'e hakarak los hatais plastiku.

I didn't reply because I was afraid. She stretched forth her hand to give me something, so I stretched mine towards her. She gave me four candies. I looked at her, she continued walking while talking alone. I walked away as I looked in my hand the sweets Kalasa had just given me. I ate one while returning home. From then onwards, every day we crossed each other on the road, we mutually greeted one another and became friends. We were only 'road friends'.

Another *bulak* person I met was named Paulina, she was a family relative of Kalasa. Some people said Paulina became *bulak* because her husband was murdered, but others said her insanity was hereditary. Personally, I don't know what were the causes of her madness. Paulina, like Kalasa, when she was spoke to correctly, she would answer correctly; but if you bothered or annoyed her, she would throw stones at you.

Another *bulak* person I met was called Lisino, who was from Soru. At the beginning he was a normal person, but suddenly became *bulak* and went wandering around Lospalos. One day I saw him in front of the church in Lospalos, dressed in shorts. He had no top, he walked without going anywhere, ran, talked and laughed alone.

When I came to live in Dili, I stopped seeing the three of them. Some people in Lospalos told me that they continued being *bulak*, rapidly changing moods from one moment to the next.

While I was studying at the Dili University (UNDIL), during our breaks, I used to sit with my colleagues on a stone under a large ficus tree because it gave us good shade. At this place, at the beginning of a road, a person always passed who everyone said was *bulak*, although I didn't know what his name was. This *bulak* person would run towards Taibesi passing in front of UNDIL and down towards Mercado Lama, then up again running towards Taibessi. This *bulak* person just wanted to run non-stop.

Another man, also *bulak* according to some people, was always at the beach. When we were walking by the sea shore, he was always strolling around there. He didn't wear any clothes, instead he rolled plastics or plastic bottles on his body. He was always quiet, he didn't talk to other people. This *bulak* person wanted to wear plastic.

[37] Reminiscent. © David Palazon. Viqueque, 2010.

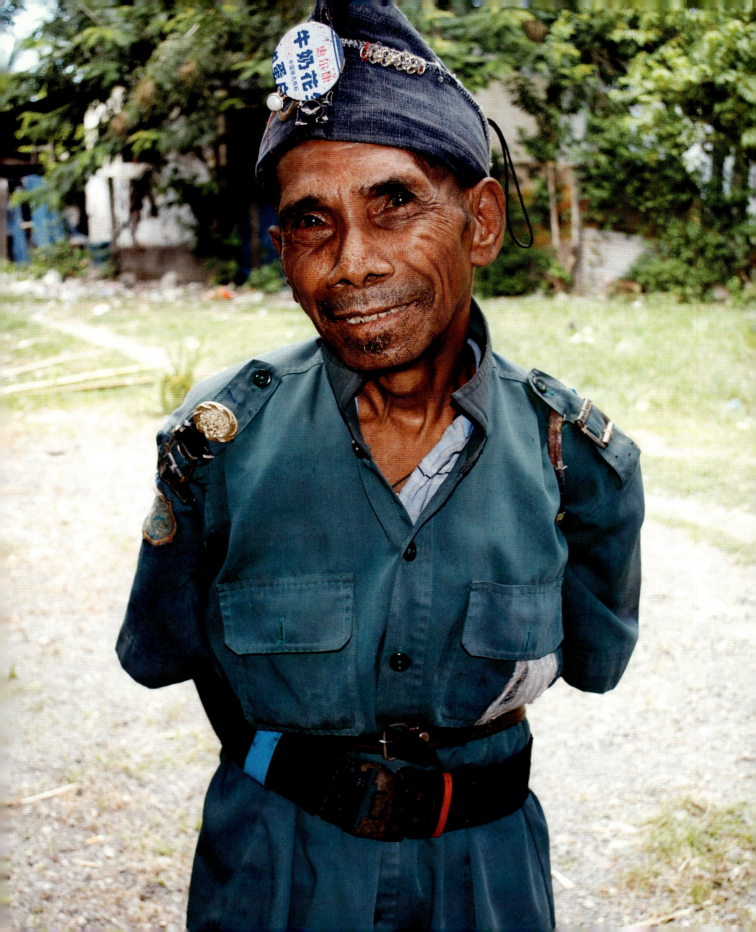

Eulak ida fali nia area mak Bidau too iha Comoro, dala ida hau hare nia hakarek iha rai leten iha Bidau, hau hare no hau liu deit, maibe iha hau nia laran hatete *"saida los mak nia hakerek iha rai leten ne'e"* ema hotu tauk hodi ba besik, e nia mos lakohi koalia ho ema seluk, dala ida hau hein karreta iha lampu merah atu ba Comoro maibe derepente nia mosu ho hatais kalsa badak ida, la hatais faru, nia isin lolon foer los, nakonu ho kosar no rai rahun, nia fuuk mos nakunu ho rai rahun, karik hodi kalan nia kala toba iha fatin ruma iha estrada ninin. Nia tuur iha dalan ninin ne'ebe nakonu ho rai rahun, nia hahu hakerek iha rai leten, hau lao ba besik nia, nia mos lakohi hateke mai hau, nia la preokupa ho ema seluk-seluk iha nia sorin-sorin, ema balun dehan *"bulak, bulak, bulak"* balu hare nia ho hamnasa no lao dook tiha, hau mak lao ba hakbesik nia, atu hare saida los mak nia hakerek iha rai leten, hau lao no hakat ba besik, tamba sei dadersan loron matan mos foin mak atu sae dadauk, nune'e wainhira hau lao hakbesik, hau ninia lalatak kona uluk ona nia isin.

Hau lao ba hamrik besik nia sorin, hau nia lalatak iha ninia oin, nia lakohi hateke mai hau, nia hakete deit rai nebe nia hakerek, nia hakerek nafatin iha rai ne'e hau nia lalatak iha ba, hau fihir ninia letra maibe hau la komprende saida mak nia hakerek, nia lakohi hare hau ne'ebe mak hamrik iha nia sorin ne'e e la kleur nia fila kotuk ba hau nia lalatak ne'ebe iha ninia oin, no hahu hakerek nafatin, hakerek ho letra ne'ebe hanesan, nia hakerek hanesan asinatura deit e repete hela deit, hau hare deit no hau labele komprende, no hau sei labele komprende, karik nia nain rasik mak bele komprende ou bele mos ninia nain rasik mos la komprende buat ne'ebe nia hakerek ba ne'e. Hare kleur tiha ninia asinatura iha rai leten ne'e e hau husik nia mesak iha dalan ninin ne'e, ami labele hase malu, tamba hau hare, nia lakohi atu ema hase nia, maske hase deit ho hamnasa midar, lakleur karreta ida mai para iha dalan ninin no hau lao ba sae mikrolet ne'e e ba iha komoro, e dala barak hau sempre hare nia iha dalan ninin entre Bidau e Komoro, wainhira hau sae mikrolet no hare hetan nian, hau sempre fihir nia, nia ema bulak ne'ebe hakarak los hakerek iha rai leten iha dalan ninin ne'ebe nakonu ho rai rahun.

Iha bulak ida tan seluk, ema hotu dehan nia mos bulak, nia sempre hatais hena mutin ne'ebe foer los ona, hodi bobar ba nia isin, nia isin ne'ebe metan no krekas, lahatais faru, no hodi hela deit boronail ida ne'ebe mos foer los ona, ema hotu lahatene saida mak iha boronail laran ne'e, karik hahan ruma? Ema hotu la hatene, nia ne'e sempre lao hela deit, wainhira hau hatete ba hau nia maun, hau nia maun dehan katak hau nia maun uluk hasoru bulak ne'e iha Kupang, dehan nia lao deit husi Timor mak too iha ne'eba, nia ne'e ema lao rai, ema dehan nia hela iha Metinaro, karik ne'e los tamba wainhira hau fila husi Metinaro ho karreta hau hare nia lao ain iha dalan entre Hera ho Metinaro, dala ida mos hau here nia lao ain iha Fatu ahi wainhira hau fila husi Lospalos ho Bis, hodi bain rua mos hau hare nia lao ain iha Becora ba iha dirasaun Fatuahi, ema dehan nia bulak, bulak ida ne'ebe hakarak lao hela deit, nia ema lao rai, lao ho ain-tanan, n a lao tuir deit nia ain-hakat.

There was another *bulak* person between Bidau and Comoro. One day in Bidau, I saw him writing on the ground. I went near by wondering *'What is he writing on the ground?'*. Everyone was afraid to get close to him, he didn't seem willing to talk to anyone. Another day, while I was waiting for a taxi at the Comoro traffic lights, I noticed he was dressed in shorts and was shirtless. He was dirty all over his body and his hair was full of sweat and soil, perhaps he had fallen asleep somewhere on the edge of the road the previous night. He was sitting at the edge of the dusty road, he began to write on the ground. He didn't notice I was walking towards him. He was not paying attention to the people who were around him. Some people shouted at him '*bulak, bulak, bulak*'. Others were looking at him, laughing, or moving away from him. But I went to see what he wrote on the ground.

I approached him. It was in the morning and the sun was rising, so when I approached him my shadow reached his body. I was standing beside him and my shadow was beyond his head. He didn't look at me, I looked at what he wrote on the ground, he continued writing in the ground now darkened by my shadow. I looked at what he wrote but I couldn't undertand his writing. Shortly after, he turned away from my shadow and continued writing. It seemed as if he were signing, but I couldn't understand what he wrote. Perhaps he was the only one able to understand it, or not. After a long time looking at the scene, I left quietly and left him there at the edge of the road. I could never say hello to him, because he didn't seem to want to say hello to anyone, even if you saluted and smiled at him very politely. The Comoro taxi stopped by the edge of the road, I got in and left. I've seen him many times, always on the edge of the road between Bidau and Comoro. When I travel in the taxi, I always look for him. He is a *bulak* person who just wants to write on the dusty ground by the edge of the road.

There is still one more *bulak* person, or at least everybody says that he is *bulak*, who always dresses with a dirty white cloth. He covers his extremely thin, black body in a white cloth and has no shirt. He always carries a sack, which is also very dirty, and no one knows what is inside. Is he carrying some food? No one knows. He is always walking. When I told my older brother about him, he told me that on one occasion he had found him in Kupang, he said that he had walked all the way from Timor-Leste. He said he was a wandering pilgrim. Some people say he lives in Metinaro, which may be true because I've seen him more than once there, walking between Hera and Metinaro, when I was travelling by car. On one occasion, I saw him walking in Fatu when I was traveling by bus from Lopalos. Yesterday I saw him in Becora, Fatuahi direction. People say he is *bulak*, he is a *bulak* person who just wants to walk, a drifting pilgrim walking barefoot, his path guided only by the stride of his steps.

138 | *Katuas jovem* (young elder). Phtotograph courtesy of the author. © Bernardino Soares. Same, 2014.

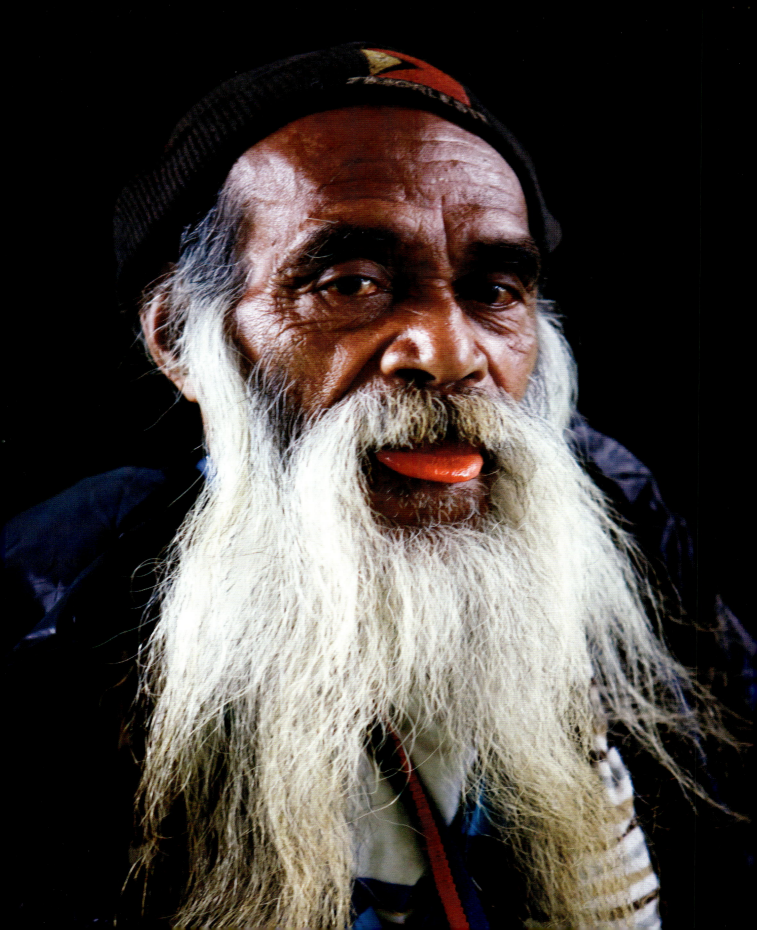

139 | Nut packaging. © David Palazón. Baucau, 2009.

140 | Tongue-cleaner. © David Palazón. Oecusse, 2009.

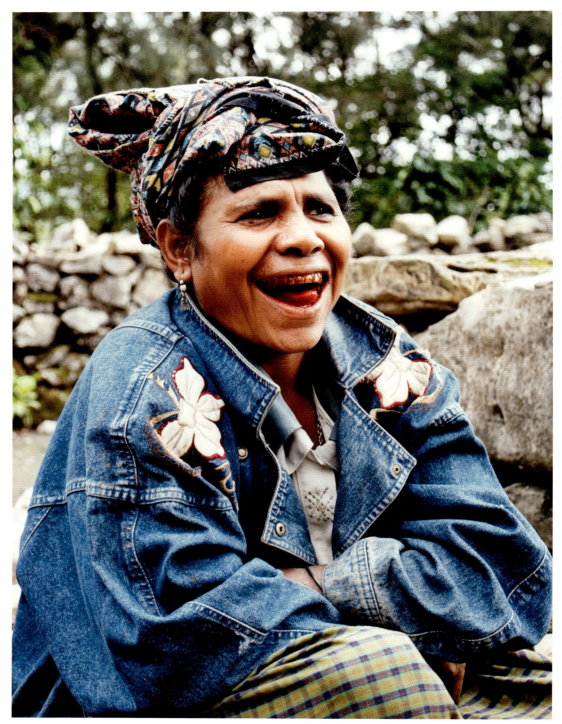

141 | Chewing nuts. © David Palazón. Ainaro, 2010.

142 | Getting high. © Rick Shearman. Atauro, 2011.

FOUND IN TRANSLATION
Daniel Simião | Antropólogo

Chegamos a Díli em novembro de 2002. O país mal tinha completado seis meses de vida, e a presença internacional ainda era incrivelmente marcante no cotidiano da cidade. Díli era uma cidade entre padrões indonésios, portugueses e australianos. Até nos tipos de tomada elétrica, havia os três. Botijões de gás? Tínhamos que observar se o nosso regulador era australiano ou indonésio, caso contrário não comprávamos o botijão, ou comprávamos o errado, como fizemos. Havia placas de lojas que diziam *"Díli – Timor Leste"*. Outras, *"Díli – Timor Timur"*, e outras ainda *"Dili – East Timor"*.

Os restaurantes eram um espetáculo à parte. Estávamos no país havia duas semanas, e fomos a um chamado *Ali Asian Food*, uma lojinha de dez por cinco metros. Na entrada, um balcão tipicamente local, com a comida exposta em vitrine. Passando o balcão estavam as mesas, de madeira, cobertas com toalhas xadrez, estilo cantina italiana. Havia tantas manchas que não precisávamos do cardápio, podia-se escolher o prato pelas manchas da toalha. Mas, havia também um menu em plástico com bem uma centena de pratos, todos identificados com fotos bem feitas. Nas várias sessões do menu, cozinha Malaia, Tailandesa, Timorense e Ocidental ("Western Food"). Tudo em bom inglês, e com os preços riscados. Os novos preços, escritos com caneta hidrocor, eram a metade dos antigos. Sinal óbvio do esvaziamento de internacionais que Díli viveu com a independência.

FOUND IN TRANSLATION
Daniel Simião | Anthropologist

We landed in Dili in November 2002. The country had barely reached six months of life, and the international presence was still incredibly striking in the daily life of the city. Dili was a town between Indonesian, Portuguese and Australian standards. Even in the shape of electrical plugs, the three of them were available. Propane tanks? We had to find out if our regulator was Australian or Indonesian, if we didn't check the tank, it was most likely we could end up buying the wrong one, as we did. There were shop signs saying 'Dili – Timor-Leste'. Others 'Dili – Timor Timur', and some 'Dili – East Timor'.

The restaurants were a world apart. We were in the country for two weeks, and we went to a place called Ali Asian Food, a tiny shop 10 by 5 meters. At the entrance, the food was presented on a typically local window display. Passing the window display were the wooden tables, covered with chess looking tablecloths with an Italian style canteen. The cloth had so many stains that we didn't need the menu; you could choose your dish by the patches on the tablecloth. But, there was also a plastic menu with a hundred dishes, all identified with horrible photos. In the different sections of the menu, Malaysian cuisine, Thai, East Timor and 'Western Food'. All written in good English, and with the prices crossed out. The new prices, written with a marker pen, were half the previous prices. These were obvious signs of the international presence who had lived in Dili with the arrival of independence.

143 | International book store. Photograph courtesy of the author. © Daniel Simião, Dili, 2002.

Uma vez sentados, veio nos atender o dono do restaurante. Rosto moreno, bem escuro, cabelos absolutamente negros e lisos. O estereótipo do indiano. Combinava bem com o filme, também indiano, sucesso recente de *Bolliwood*, a passar, em VCD, na televisão 29 polegadas ao fundo. Como era normal naquelas semanas, nunca sabíamos em que língua nos dirigir às pessoas. Começamos a nos arriscar com um tétum rudimentar para sermos simpáticos. O senhor se atrapalhou. Não falava tétum, e, rápido, faz sinal para um sujeito que ia passando pela porta do restaurante. O sujeito entrou e se ofereceu para ser nosso intérprete. Falava um português perfeito. Perguntou de onde éramos. Do Brasil? Conhecia bem o Brasil, já havia estado em Brasília, no Rio, em São Paulo. Nos espantamos. Ele já havia sido vice-ministro na Administração Transitória, no tempo da UNTAET. Depois de conversarmos um bocado, pedimos explicações sobre um prato. Imaginei que o garçom devesse falar indonésio. Vimos então o vice-ministro virar-se para o garçom e traduzir a nossa dúvida ... em inglês! O garçom falava inglês! E nós a fazer todo aquele espetáculo com um vice-ministro de intérprete, para traduzir uma pergunta simples sobre um prato para o inglês ... Todas as dúvidas tiradas, escolhemos nosso prato. Descobrimos ainda que o vice-ministro, vestido em um jaleco branco, trabalhava na farmácia ao lado. Vamos a um restaurante bastante popular e temos como intérprete um ex-ministro que trabalha no balcão de uma farmácia, fala português, conhece bem o Brasil e nos traduz para um senhor indiano, em inglês. Não é algo que se viva em qualquer lugar.

Once seated, the owner of the restaurant came to greet us. With a dark face, and absolutely black, smooth, dark hair. The Indian stereotype. It matched well with the recent Indian Bollywood movie which was playing in the background in its original version on the 29-inch television screen. During those weeks, we never knew what language to address people in. In order to be nice, we began to take our chances with basic Tetum. However, he didn't speak Tetum so he quickly made a signal to a guy passing by the restaurant door. The guy came in and offered to be our interpreter. He spoke perfect Portuguese. He asked where we were from. From Brazil? How well he knew Brazil, he had been to Brasilia, and Rio, and São Paulo. We were astonished. He had been Deputy Minister in the Transitional Administration during the UNTAET time. We continued to talk in Portuguese for a while and we asked for explanations about a dish. We figured the waiter would probably speak Indonesian. We then saw the Deputy Minister turn towards the waiter and translate our questions ... in English! The waiter spoke English! And we were making all that fuss in the presence of our interpreter the Deputy Minister, to translate a simple question regarding a dish into English ... All questions answered, we chose our plate. We found out the Deputy Minister, dressed in a white coat, worked at the pharmacy next door. We went to a popular restaurant to have our translator, an ex-minister, who worked at a pharmacy counter, spoke Portuguese, knew Brazil very well and interpreted for us in English to an Indian waiter. It's not something you experience everywhere.

144 / Artist's diet © David Palazón. Dili, 2009.

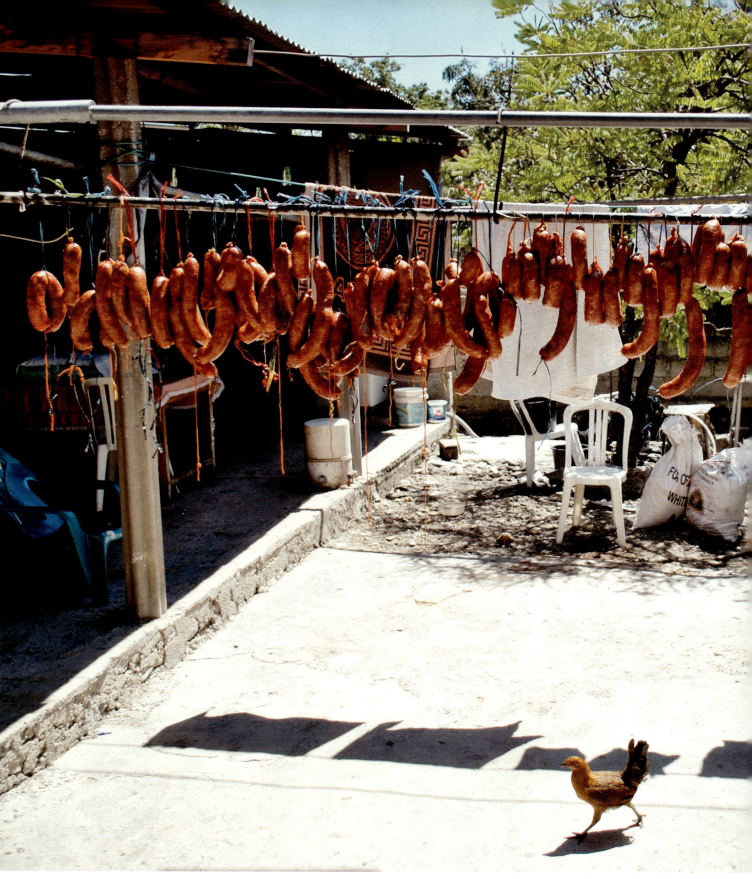

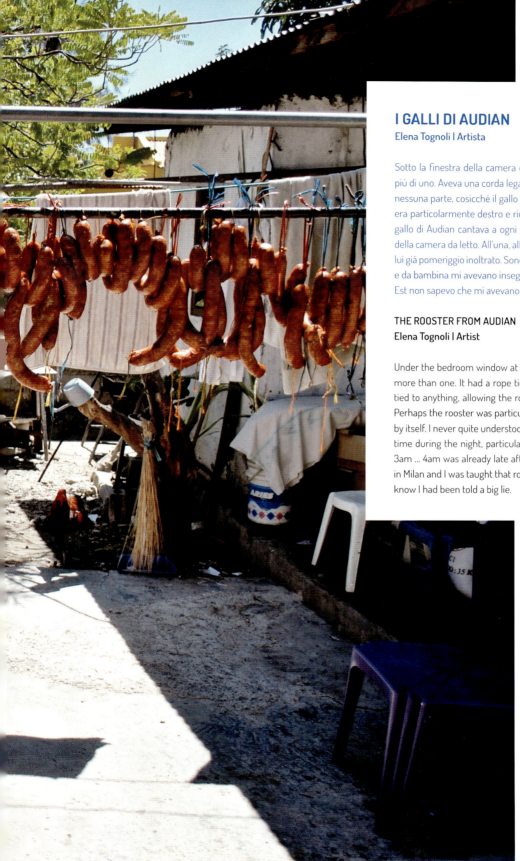

I GALLI DI AUDIAN
Elena Tognoli | Artista

Sotto la finestra della camera da letto di notte passeggiava un gallo, o forse più di uno. Aveva una corda legata a una zampa, ma la corda non era legata da nessuna parte, cosicché il gallo potesse andarsene a passeggio. O forse il gallo era particolarmente destro e riusciva a slegarsi da solo. Non l'ho mai capito. Il gallo di Audian cantava a ogni ora della notte, in particolare sotto la finestra della camera da letto. All'una, alle due, alle tre ... le quattro di mattina erano per lui già pomeriggio inoltrato. Sono cresciuta a Milano in un appartamento di città e da bambina mi avevano insegnato che i galli cantano all'alba. Prima di Timor Est non sapevo che mi avevano raccontato una grossa bugia.

THE ROOSTER FROM AUDIAN
Elena Tognoli | Artist

Under the bedroom window at night there used to stroll a rooster, or perhaps more than one. It had a rope tied around one of its legs, but the rope wasn't tied to anything, allowing the rooster to wander freely around the courtyard. Perhaps the rooster was particularly dextrous and managed to undo the rope by itself. I never quite understood. The rooster from Audian used to sing at any time during the night, particularly under the bedroom window. At 1am, 2am, 3am ... 4am was already late afternoon for him. I grew up in a city apartment in Milan and I was taught that roosters sing at dawn. Before East-Timor I didn't know I had been told a big lie.

147 | *Chorizo galore.* © David Palazón. Audian, 2010.

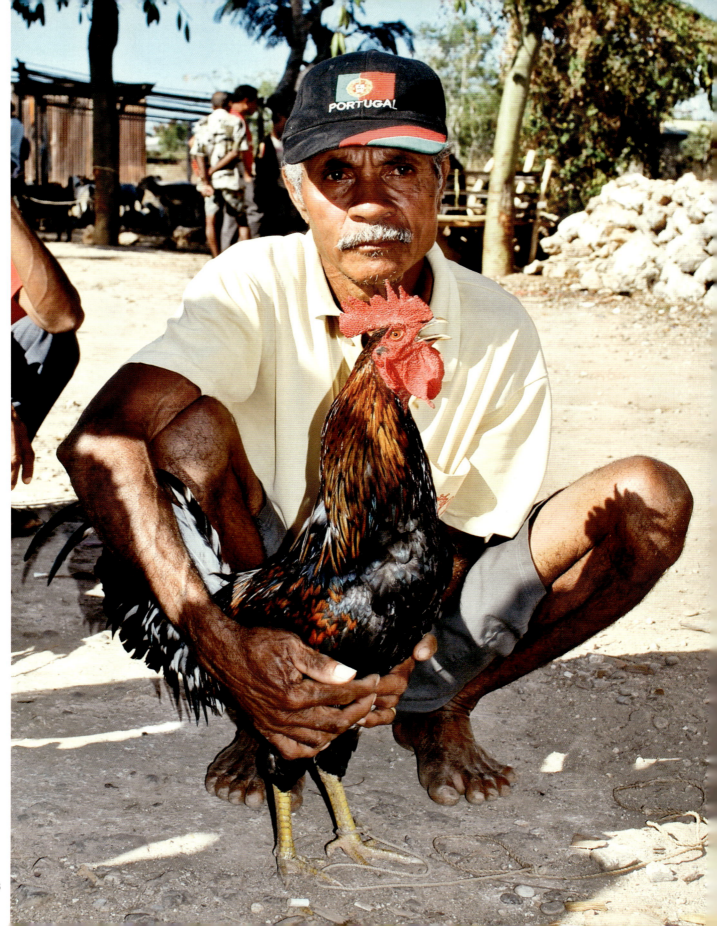

148 | Portugalo. © David Palazón. Baucau, 2010.

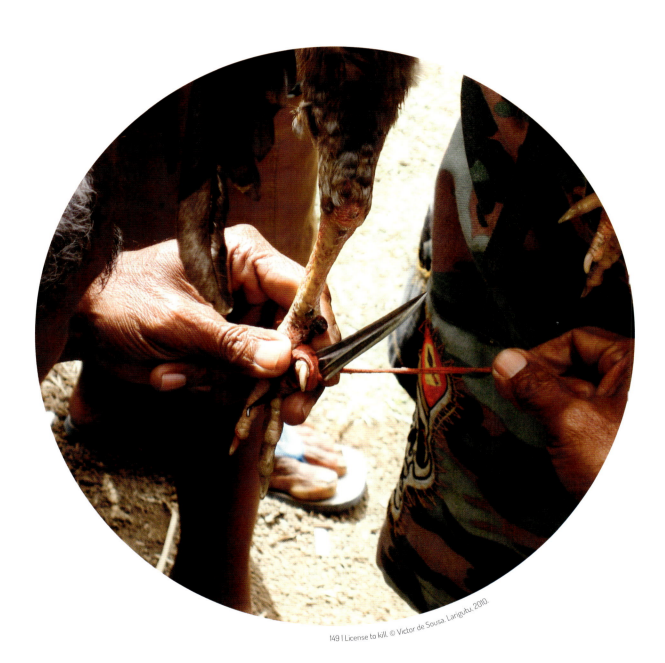
149 | License to kill. © Victor de Sousa. Larigutu, 2010.

179

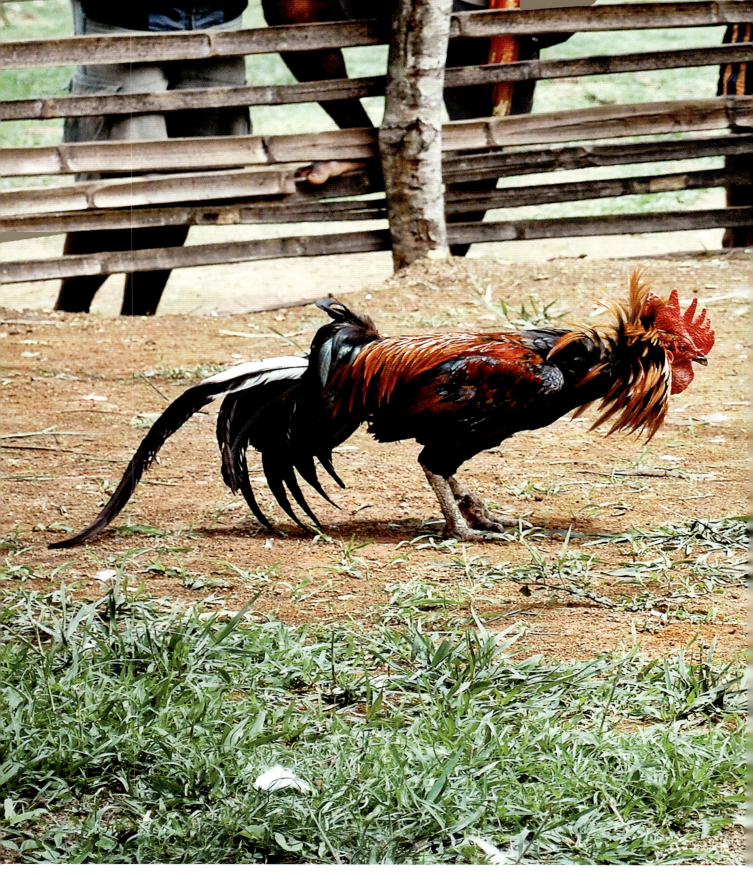

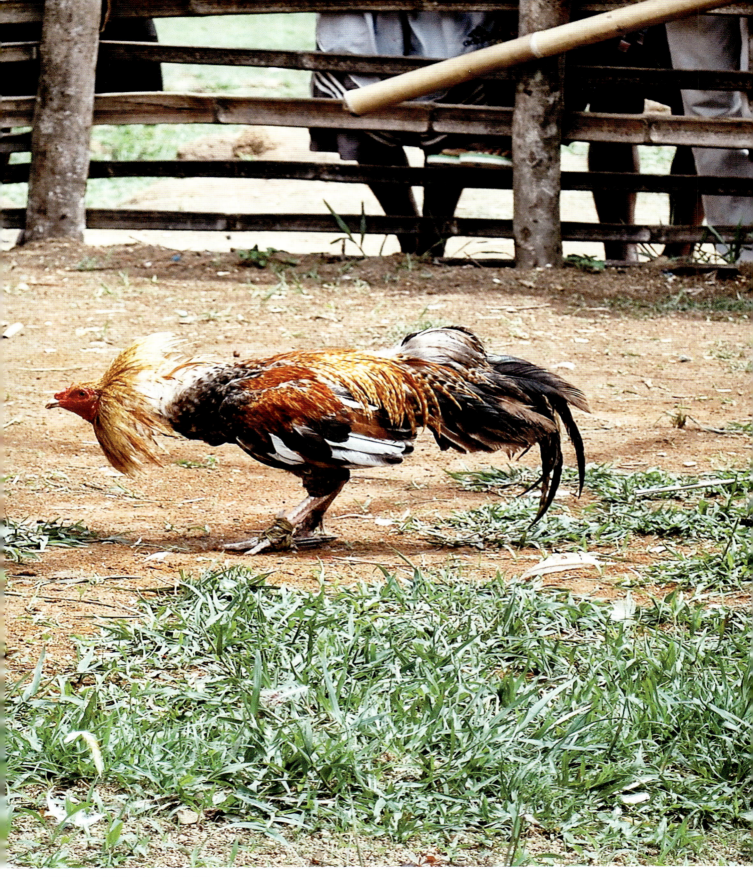

150 | Place your bet. © Victor de Sousa. Larigutu, 2010.

151 | Studio. Photograph courtesy of the author. © Kiki Kakashi. Dili, 2011.

TRADICIONAL COMTEMPORÂNEO
Maria Maderia | Artista

Tinan ba tinan hau nia hanoin kriativu haburas no dezenvolve ho fiar makaas, kona ba hanoin ho lianfuan 'kontemporániu', no 'tempu modernu' nian. Hau la nega no hatun signifikánsia no importánsia do 'tradisionál' no maneiras estabelecidas husi ita nia avós feto no mane sira. Pelo contrário, hau gosta tebetebes idea kona ba 'kazamentu' ou 'hatutan hamutuk' passado/presente; tuan/foun no mós do tradicional/kontemporáriu.

Como disse James Clifford iha *"O Predicamento Kultura nian; Twentieth-Century Ethnografia, Literatura, no Arte":*

> *"Ita nia serviço nu'udar artista maka atu hakat para além de, buat hirak ne'ebé signifika o amor pela mudança, [sempre halaʻo ho] tradisaun na mente, tuir koalia ba katuas no ferik sira dos tribos, no tuir hela com os avós. Istória hirak ne'ebé eles contam são furak tebe tebes. Quando ita são expostos ba sira, tudo sai reflecção desses eventos. Iha satisfação boot tebe tebes para ser artista tradisaun nian."* (Clifford 1988, 251)

Nu'udar artis, edukadora arte nian, konselleira kulturál no pesquizadóra, hau nia objectivo e paixão maka sempre ho nosaun atu ir além de cinta perubahan com tradisaun na mente. Saya haree saya sendiri hanesan "sai nu'udar uma artista de tradição". Hau nia expresaun artistiku vem da perspectiva corrente no contemporário nian, sementara kreatividades contemporários no abstraktus hirak ne'e, tem koneksi ho costumes históricos tradisionál, metódus, imagens, no simbolus que são signifikan no sangat berakar ne'ebé forte iha cultura de Timor Timur.

Mengambil sirih por ezemplu; itu tertanam dalam cara hidup kita no ita uza beibeik iha sehari-hari, se iha pertemuan la-formál no kazuál ou ketika dipraktekkan di tradisional no okaziaun seremoniál suci. Hau menggunakan hanesan dasar untuk ekspresi kreativu saya. Kapan hau uza ida ne'e iha pekerjaan saya no menjelaskan konseitus ou idea balik karya seni, terutama signifikanci kona ba sirih iha ita nia folklore, parese loke dalan untuk pemahaman yang leih baik no simu didia'k ita nia budaya.

TRADITIONALLY CONTEMPORARY
Maria Maderia | Artist

Over the years my creative insight has developed towards the strong belief in the notion of the 'contemporary', and 'modern-day' language. Not disregarding or undermining the significance and importance of the 'traditional' and long established ways of my foremothers. Rather, I cherish the idea of 'marriage' or 'amalgamation' of the past/present; the old/new as well as the traditional/contemporary.

As quoted by James Clifford in *'The Predicament of Culture; Twentieth-Century Ethnography, Literature, and Art':*

> 'Our jobs as artists is to go beyond, which implies a love of change, [always accomplished with] traditions in mind, by talking to the elders of the tribe and by being with your grandparents. The stories they tell are just amazing. When you become exposed to them, everything becomes a reflection of those events. There is a great deal of satisfaction being an artist of traditions.' (Clifford 1988, 251)

As an artist, arts educator, cultural advisor and researcher, my main objective and passion has always been about going beyond a love of change, with traditions in mind. I perceive myself as "being an artist of tradition". My artistic expressions derive from a current and contemporary perspective, while at the same time such abstract and contemporary creativity connects with the traditional historical customs, methods, imagery, and symbols which are significant and deeply rooted in East Timorese culture.

Take the betel nut for instance; it is deeply embedded in our way of life and widely used on a daily basis, whether in non-formal casual meetings or when practiced in the traditional and sacred ceremonial occasions. I have regularly used the betel nut as the base for my creative expression. When I use it in my work and explain the concept or ideas behind the artwork, especially the significance of the betel nut in our folklore, it seems to create a better understanding and acceptance of my culture.

152 | Fingerprint. Artwork *Bei'ala Feto Sira Nia Liman Fatin (foremother's fingerprint)* by Maria Madeira, 2014. © David Palazón, Dili, 2014.

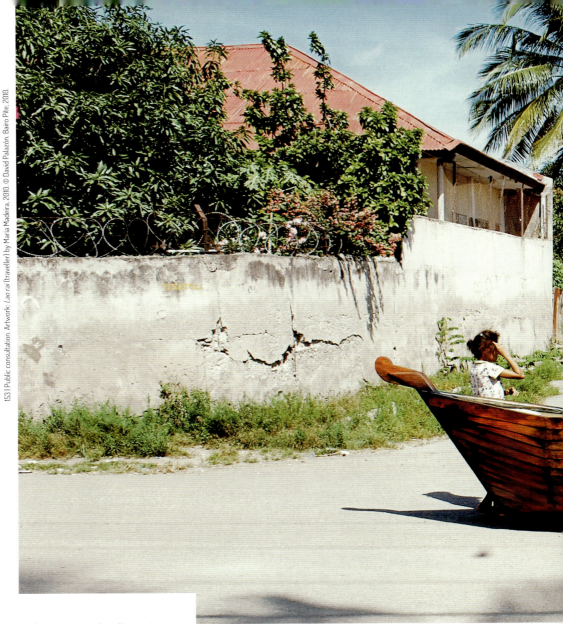

153 | Public consultation. Artwork: *Lao rai* (traveller) by Maria Madeira, 2010. © David Palazón. Bairo Pite, 2010.

Portantu, é muito importante hodi membantu mengembangkan no tane ita nian kaya no beragam arte no identitas budaya; espesialmente nia vizaun kontemporániu. Katak, nós podemos menggabungkan tradicional e o kontemporer, ita dapat membuat buat ne'ebé foun iha bahasa artistico, ne'ebé distintivu e unik Timorense, hodi menyampaikan ba mundu 'uluk se maka ita'; 'agora ita maka se', no 'se maka ita hakarak sai'. Ita bele criar sebuah lingkungan, ne'ebé bele fornese fatin atu hetan tradicional/ contemporánio; tuan/foun, sebaik o passado/presente. Hatutan mós ho noção ba fiar katak casamento no kombinasaun ne'e, sei criar uma nova linguagem, no halo sasán sai di'ak liután, porque buat hirak ne'e sei koalia ba ema hirak ne'ebé mais tradicionalista no mós a nova geração. Adicionalmente, ne'e irá também ser compriendido husi ita e também pela perspectiva internasionál, tanba ne'e sei ajudar muito atu loke mais portas, hodi hetan komunikasaun di'ak liután, e renforsa di'ak liután entendimento entre nações iha nossa kultura ne'ebé diverso no rico iha comidade mundiál.

It is therefore paramount to help develop and nurture our rich and diverse art and cultural identity; especially its contemporary outlook. That we can merge the traditional and the contemporary, we can create a new artistic language, which is distinctively and uniquely East Timorese, to communicate to the world who we were, who we are, and who we want to be. We can create an environment, able to provide room for the traditional/contemporary; the old/new, as well as the past/present. Adding to this notion is the belief that such marriage and combination will create a new language and bring wonders, as this will reach not only the more traditionalists but also the younger generation. Moreover, it will be understood not only by us but also by the western perspective, as it will greatly help to open more doors, allowing for better communication, and build further understanding between nations within our culturally diverse and rich world community.

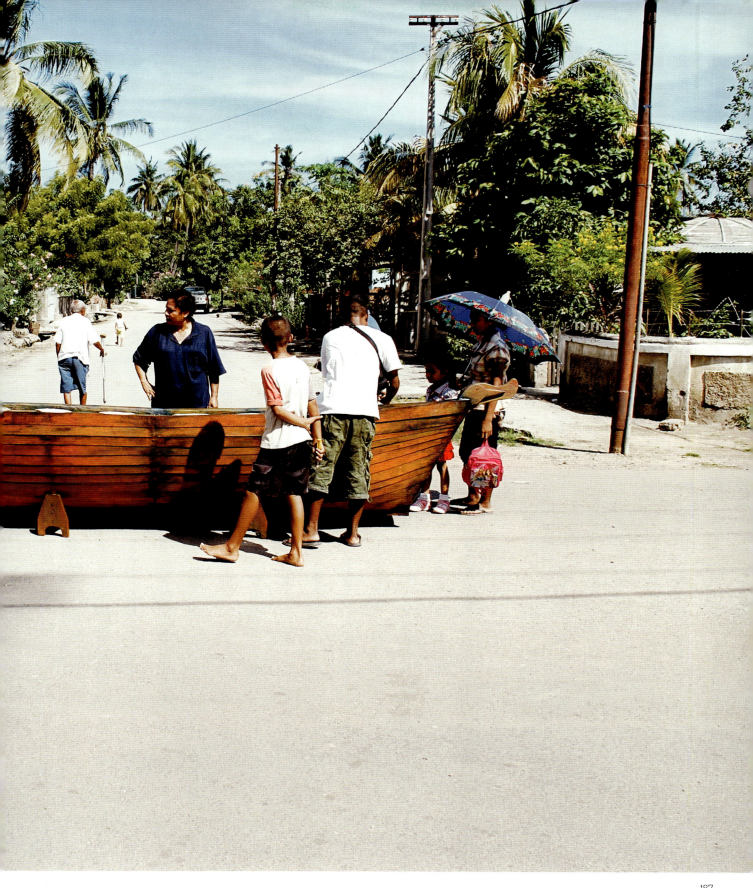

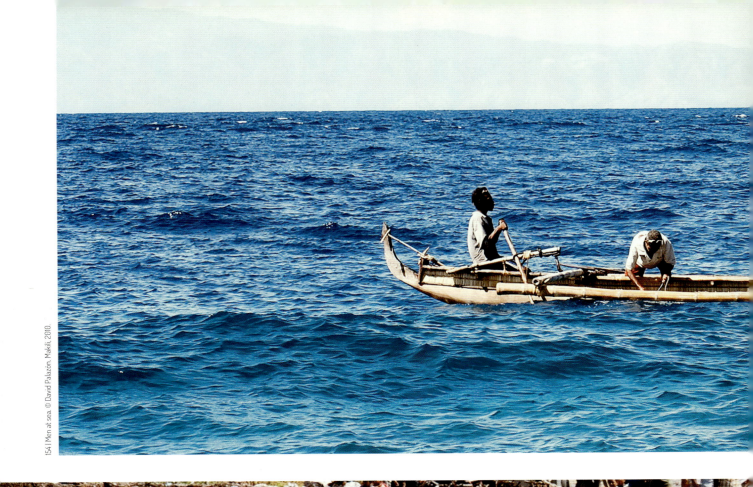

154 | Men at sea. © David Palazón. Makili, 2010.

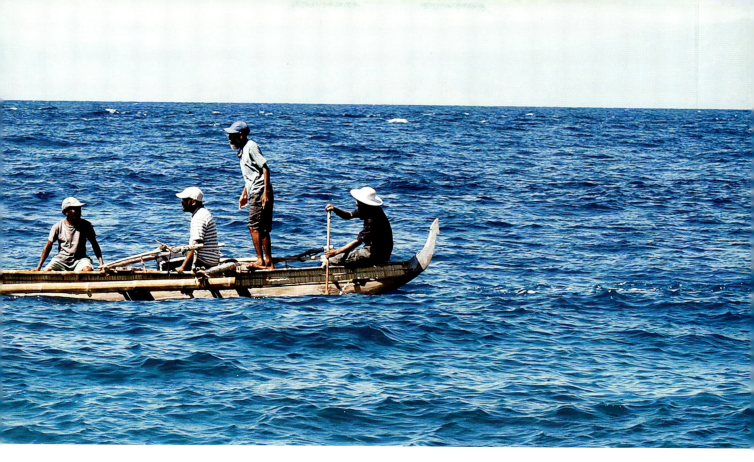

15.1 Stevedore. © David Palazon. Beloi, 2010.

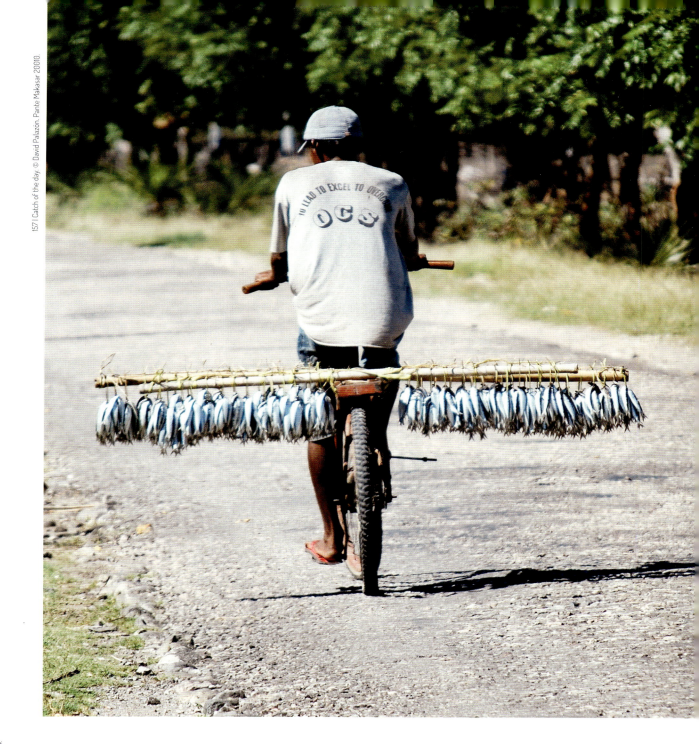

156 | Fresh Fish. © David Palazón. Ataúro 2014.

157 | Catch of the day. © David Palazón. Pante Makasar 20010.

191

THE STORY OF KELBELI & MANU-TASSI

Lucas Serrão Lopes | Community leader

The *Kelbeli* (manta ray) is a unique story from Dair, a small coastal village west of Maubara, in the district of Liquiçá. The story links to an annual event where the nearby community has an opportunity to exchange goods as a means for their welfare. People in the mountains used to bring food and other commodities, in order to barter with the local fishermen for the manta ray's meat.

The story goes that the families in Dair as well as the community around Maubara used to worship the sacred house of Too Wetu-Watu Meta. The ancestral guardian of this sacred house was represented by a red crocodile, average in size and covered with a peculiar red skin that gave him extraordinary power over the salt water crocodiles that also lived in the area.

When a member of any of the households protected by the guardian of Too Wetu-Watu Meta fell victim of theft, the individual had to perform an invoking ceremony involving the throwing of an egg with a small coin to the ocean while praying:

'Oh ... my ancestor from the great ocean. As you know, I am from a poor family, I am a weak person and I have no power to find whoever has taken away my belongings, but I have the confidence and trust in You as the only One in this Earth who knows everything. Please find whoever has taken away my belongings and teach him to respect others as you desire'.

The guardian crocodile would look for the thief and apply the death sentence in its domain, therefore protecting the victim and their family. Then, they would meet with the spokesman of Too Wetu-Watu Meta, who would perform a traditional ceremony so the thief's dead body could be taken out of the sea and given to his family so they could perform a funeral.

The history of *Manu-Tassi* (sea eagle) is considered as a protective charm by the fishermen of Dair. The sea eagle watches over the fishermen and protects them from the dangers at sea, while they go fishing in the ocean. The worship location is the 'growing' sacred stone of Manu-Tassi, located in a tiny old forest close to the seashore of the village. Occasionally, when fishermen used to go missing, fellow fishermen would call Manu-Tassi to the rescue while praying:

'Oh ... sacred place of Manu-Tassi as you might already know our fellow fishermen are located nowhere in the middle of the open ocean. Please help us to bring them safely back to land. We will do a ceremony and sacrifice an animal as our thanksgiving obligation for your Highest One. Manu-Tassi, you are the fishermen's watcher please keep them safe'.

Then, the fishermen would ask their guardian from the sacred house of Too Wetu-Watu Meta:

'Oh ... sacred house Too Wetu-Watu Meta, you are our ancestor, please come and stay with us during the night and we will sacrifice an animal as soon as our fellow fishermen return safely to land'.

The red crocodile would then appear and stay with the fishermen to protect them from bigger crocodiles. At the same time, the tides would change direction bringing the lost fishermen back to land. There are a lot of witnesses who could tell you about the powers of Manu-Tassi and the sacred house of Too Wetu-Watu Meta.

158 | Performance. Photograph courtesy of the author. © Nelson Turquel. Dair, 2010.

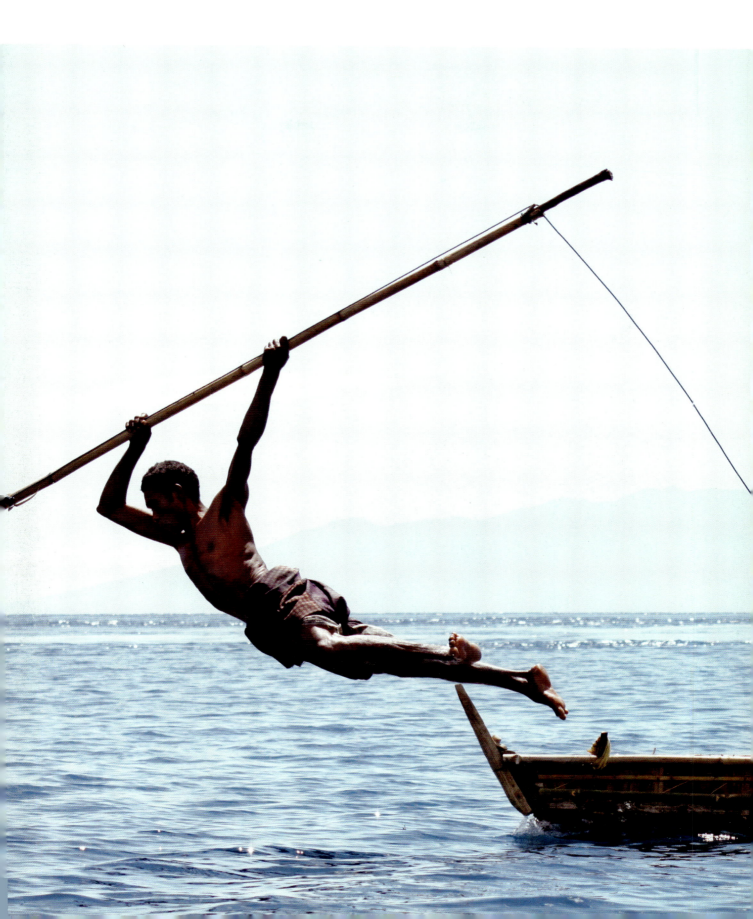

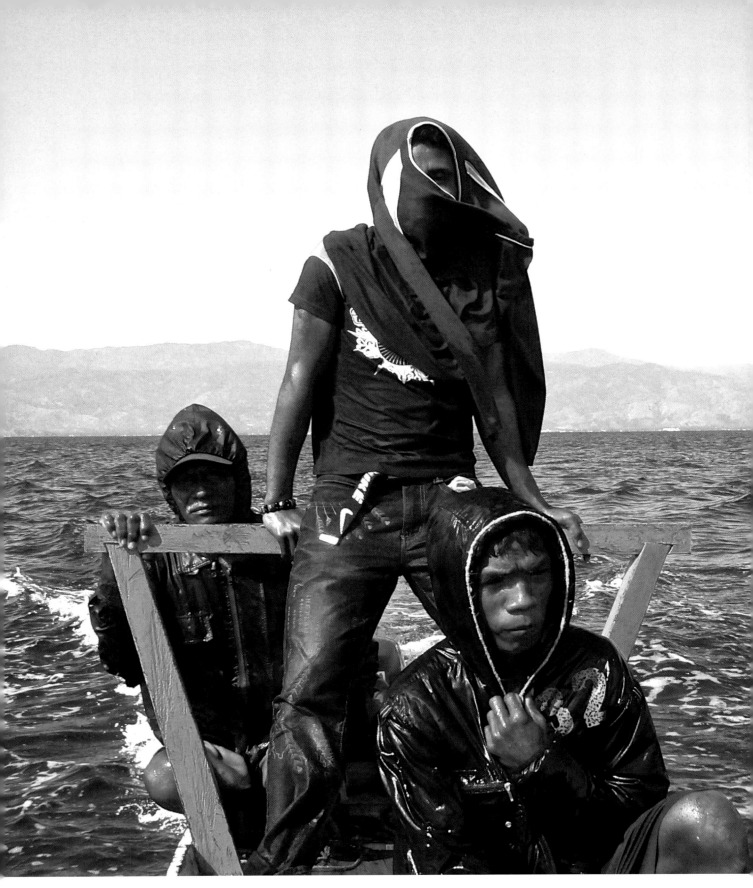

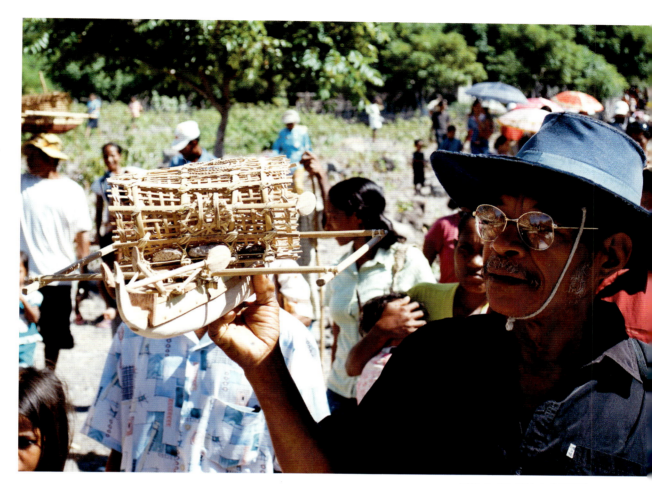

160 | Replica. © David Palazón. Makili, 2009.

159 | The crossing. © David Palazón. Dili, 2009.

161 | Eastern island. © David Palazón. Jaco, 2013.

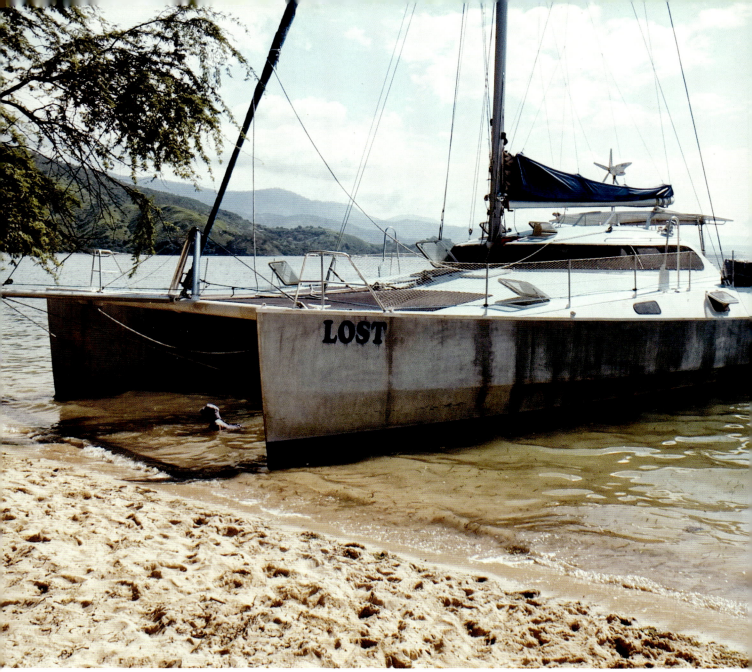

162 | Without a course. © David Palazón. Areia Branca, 2013.

GETTING LOST

Nuno da Silva | Education advisor

I arrived in Timor on my birthday in 2010, carrying a backpack full of ideals and ready made educative solutions, which I thought, could contribute to Timor-Leste's lasting development, supporting its citizen's dreams of a better life. But Timor wasn't willing to embrace my certainties. Four years and a lot of messiness later, I returned to Europe with few certainties left, never-ending doubts and many new questions. I truly felt lost for some time, slowly finding reassurance in not knowing, discovering that without the tyranny of coordinates, falling might also be flying. An African proverb became a life lesson: 'One must get lost to find the way'. After all, not knowing is the beginning of knowing and confusion is the beginning of wisdom.

Timor-Leste is a microcosm of the world we live in, inviting us to embrace the runguranga (messiness) of life instead of resisting it as if we could keep on organizing everything into neat packages and containers—a relic of the deterministic world we inherited. But the world isn't sympathetic with black and white distinctions. It is much more graded than we would like it to be.

In Timor, any attempt to argue our way out of framed dualisms like modernity versus tradition, individualism versus communitarianism, development versus primitive, progressive versus conservative, rich versus poor and men versus women, should be accompanied with an invitation to slow down and embrace doubt. To blatantly take sides, eschews the many ways through which the world is complex and promiscuous and how it shows up in our entangled lives. Life in Timor was full of paradoxes and oxymoronic moments that became the foam of the days. In a country with more than 20 languages spoken by little more than a million inhabitants, runguranga is a way of life. You don't imagine how often, in government meetings, people argued over issues, navigating through Portuguese, Tetum, English or Bahasa, only to reach the end nodding in agreement without knowing exactly on what grounds they are agreeing. Many of these decisions result in impacts that nobody wants and carry an aura of mystery about how they came to be implemented. Things just organically come to life. It is a strange place to be for someone coming from a European context where everything needs to be clearly sorted out before moving to implementation.

In the mist of confusion, Timorese elites, supported by international institutions and many 'developed' nation's aid agencies, have been embracing the neoliberal development model and building an educational system at its service. After years of war and political turmoil, the economy has been steadily growing, fuelled with offshore oil and gas extraction money. On the way, the elite is getting richer while most of the population is kept ignorant and excluded from many benefits while their traditional culture and extended family bonds are irreversibly eroding. The devastation of lands, peoples and diverse ways of co-constituting the world is steadily catching up with Timor.

And while Timor catches up with the developed world, some people start to question the modern notion that economic development and literacy are the answer to all possible questions about how people can frame their lives. Timor offered me an insight that today's multidimensional crises require a re-imagination of development and education—a need to dismantle the narratives and practices that reinforce the continuous exploitation of lands and peoples.

As climate crisis, ecological devastation, deep economic inequality, conflicts between and within people, force us to confront the limits of our imagination, we can come to terms with the ways development and the tired language of progress and technocratic solutions exclude other forms of learning and other material possibilities for reshaping how we live.

As feminist theorist Karen Barad states, 'there are no solutions; there is only the ongoing practice of being open and alive to each meeting, each intra-action[1], so that we might use our ability to respond, our responsibility, to help awaken, to breathe life into ever new possibilities for living justly.'[2]

The pursuit of justice is never a static thing. Justice isn't a destination as such. It is always justice to be/come. And so, it might be a strange invitation to notice the unwanted effects of our actions, the queer and the uncomfortable difference—not to eschew the awkward. Perhaps we are now, more than ever, in need of that in order to really know how entangled we are with the world. Timorese still preserve deeply embedded animist beliefs and practices that invite us to redefine our notions of self to embrace that, in a much larger sense, we are the mountains and the rivers, the skies and the oceans, the familiar and the different and so we need to nurture caring relations with these external organs in the same way we need to care for the internal organs of our body to be healthy and live the good life.

With Timor, I realized that our journey is urgent, and our quest is not for 'new lands' flowing with wealth and power. Our quest is for new ways of noticing. And unlike the old fashioned approach of drawing a line, our form must be a dancing circle where it is possible to unravel new continents beneath our feet, subtle worlds with wild treasures; festivities of love and spontaneous surrender. Between Timor and Portugal, our home lies somewhere in the distance: the kind traversed with an embrace.

1. A neologism introduced by Karen Barad, which challenges the metaphysics of separate, nonrelational entities interacting with one another. Barad insists that things that relate do not precede their relationships; in other words, the world isn't comprised of things but relationships. Everything is entangled, and nothing stands as a given or individual entity, hence the idea of 'intra-acting'. **2.** Meeting the Universe Halfway: Quantum Physics and the Entanglement of Matter and Meaning (p. 10)

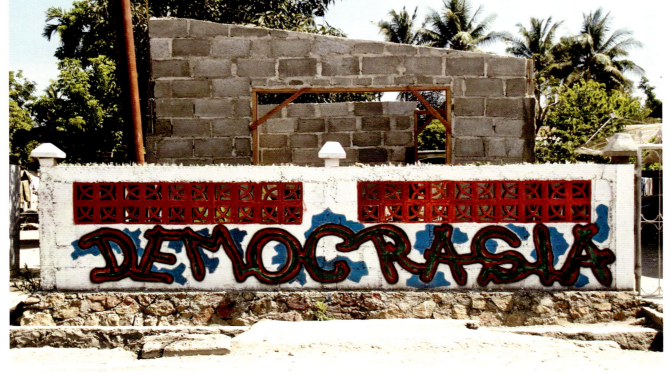

163 | Democracy 1. © David Palazón. Dili, 2009.

164 | Democracy 2. Photograph courtesy of the author. © Gibrael Carocho. Dili, 2010.

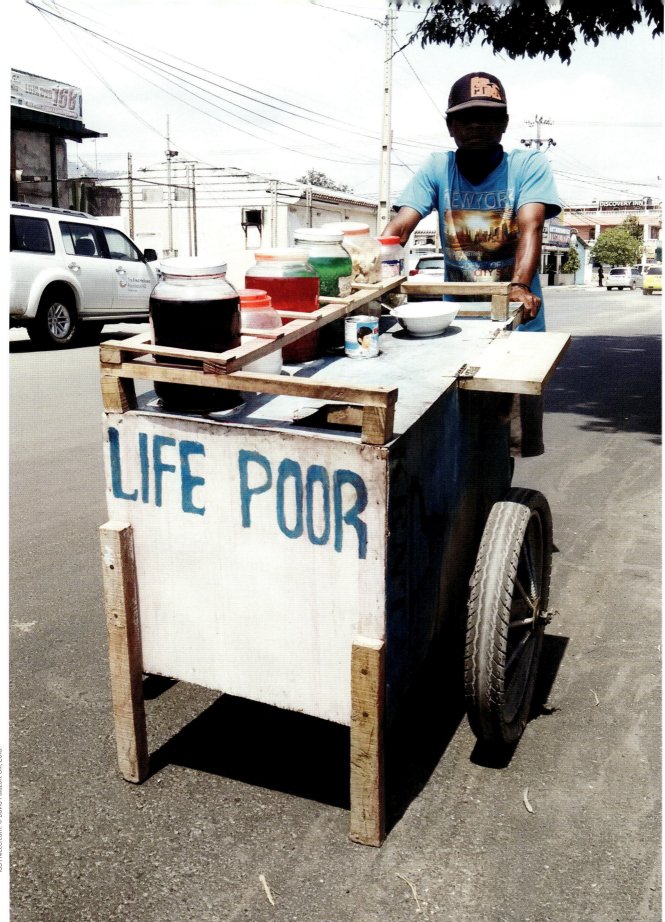

165 | Nicecream. © David Palazón. Dili, 2015.

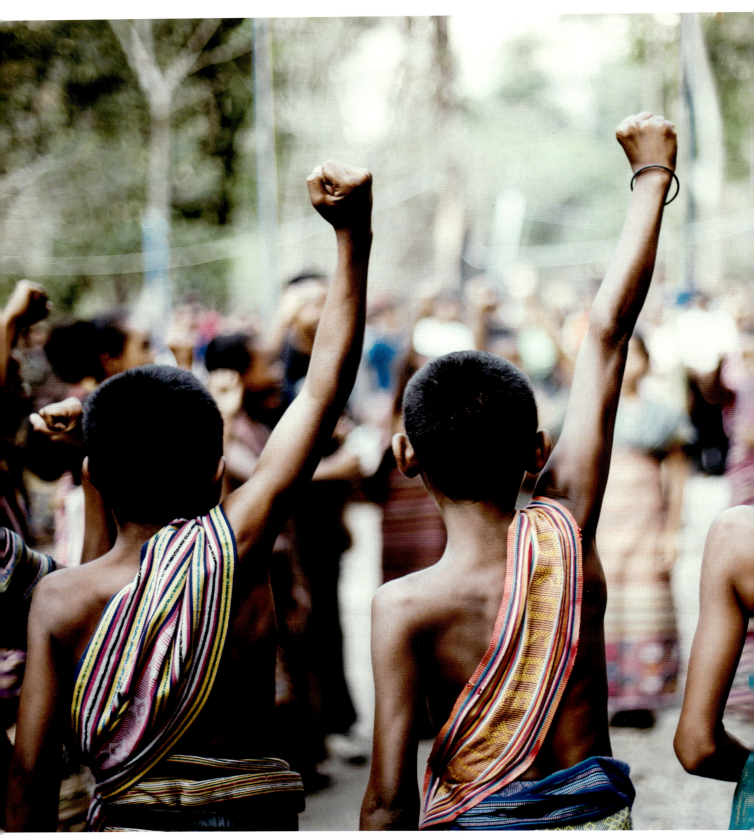

166 | Human's rights. Photograph courtesy of the author. © Bernadino Soares. Dili, 2015.

HAKILAR NUUDAR EMA
Naldo Rei | Hakerek na'in

Tempu lalais liu husi hau nia mehi,
haksolok bá ó nia prezensa iha ami le'et.

Ó hakilar maka'as
ó fanu ema hotu husi toba fatin iha fatin hotu-hotu.

Ó boót lalais husi hau nia mehi
ó hanesan anin boot no laloran tasi nian
mai ho siak no maus.

La kleurtan o' sai klosan
iha ó nia sorin ami hamrik,
hare ó atu sai ema nudar ema.

Ami sei foti ó bainhira o'monu,
Ami sei kaer ó nia liman hodi hamrik.

Bainhira loron too ona
ó sei hamrik mesak nudar ema
ó sei sasin mundo nian

Ó sei simu nia moruk no nia midar, manas no nia malirin
maibe ó labele sente ó mesak tamba ami iha ó nia sorin
iha tempu neébe defisil.

Ó hateke ba oin, haksolok no hananu nafatin
tamba o'sei iha ami nia domin ba rohan laek.

Bainhira ema la trata × hanesan ema,
ó tenki hakilar ho brani no luta hadau fila fali
ó nia direitu nu'udar ema selae

Ó moris la ho dignidade nuúdar ema.
A luta continua!

SHOUT LIKE A HUMAN BEING
Naldo Rei | Writer

Time passes quickly inside my dream,
your presence bringing happiness

Then you shout loudly
waking us up in every sleeping spot

You grow huge in my dream
like a storm wind on the waves of the sea
looming both savage and quiet

Soon you become a young person
and we stand up beside you,
seeing your dignity

We will pick you up when you fall,
holding your hand to raise you up

When the day arrives
you will stand by yourself
and bear witness to your world

You will taste the bitter and the sweet, the hot and the cold,
but don't feel alone because we are beside you
in such difficult times.

Look ahead, stay joyful and sing
because you have our abiding love

If people do not treat you as a human being
you must shout and struggle bravely
to seize back your rights.

Otherwise you live without dignity.
The struggle continues!

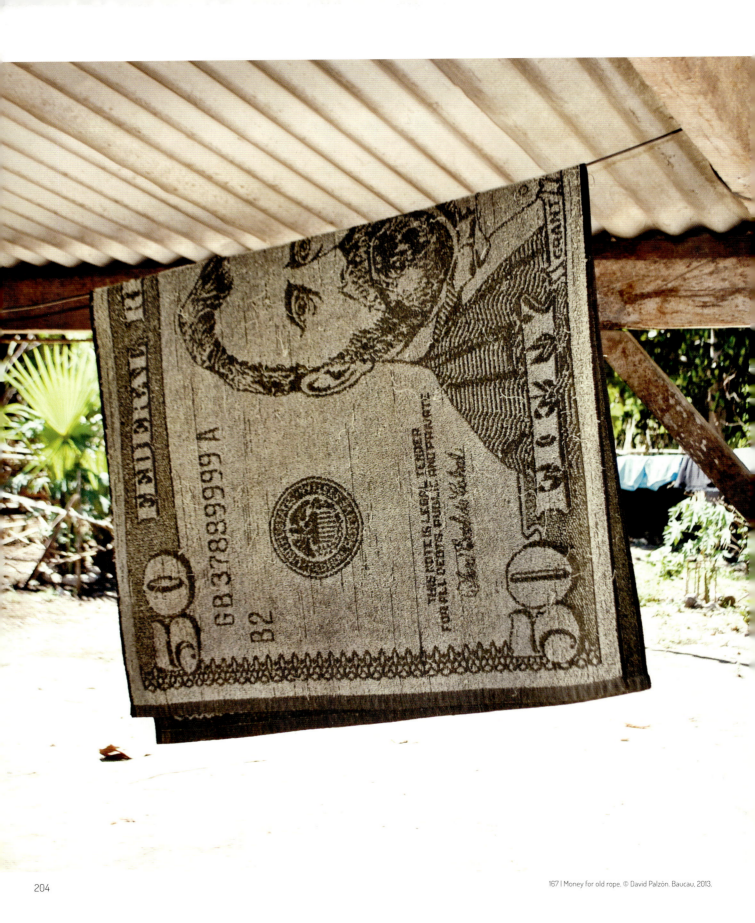

167 | Money for old rope. © David Palzón. Baucau, 2013.

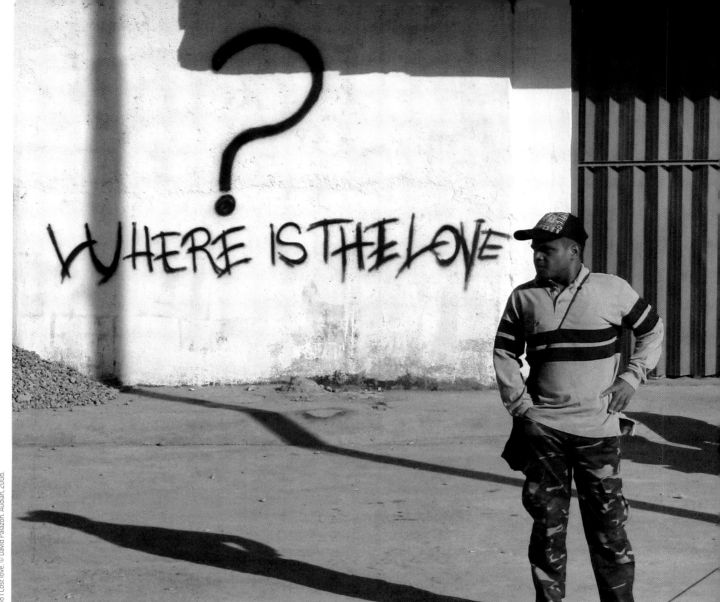

168 | Lost love. © David Palazón. Audian, 2008.

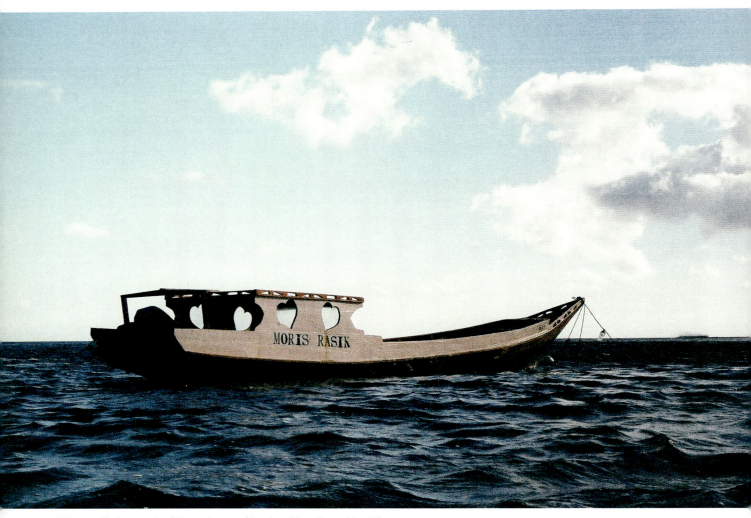

169 | *Moris rasik* (make your own living). Photograph courtesy of the author © Rebecca Kinaston. Adara, 2015.

170 | Love with a view. © David Palazón. Adara, 2015.

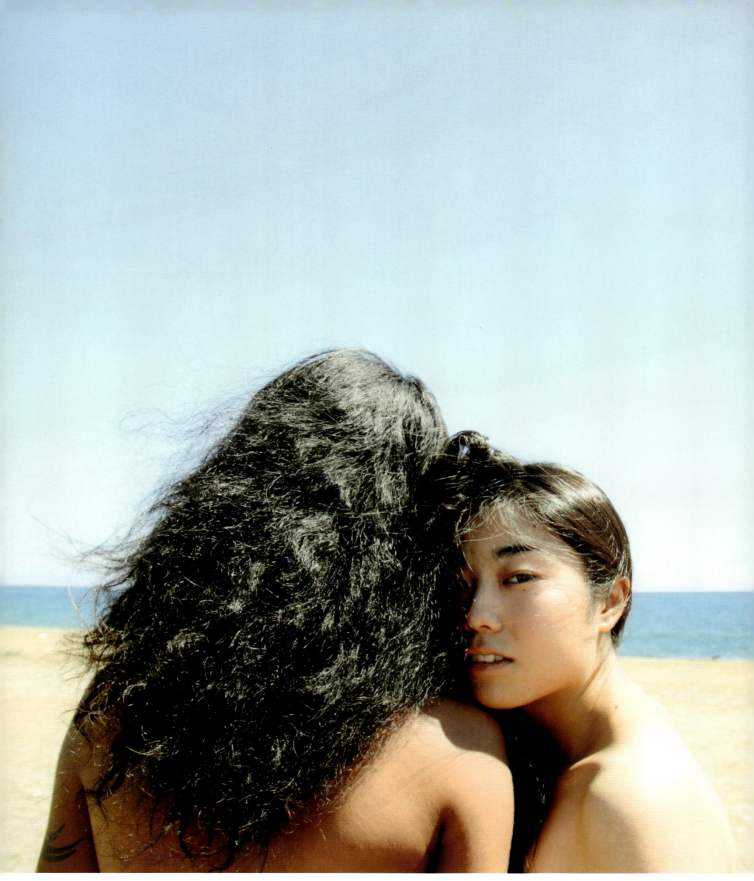

172 | Magic place. © David Palazón. Camansa, 2010.

171 | あおいティモール (Blue Timor). © Megumi Yamada. Dili, 2014.

209

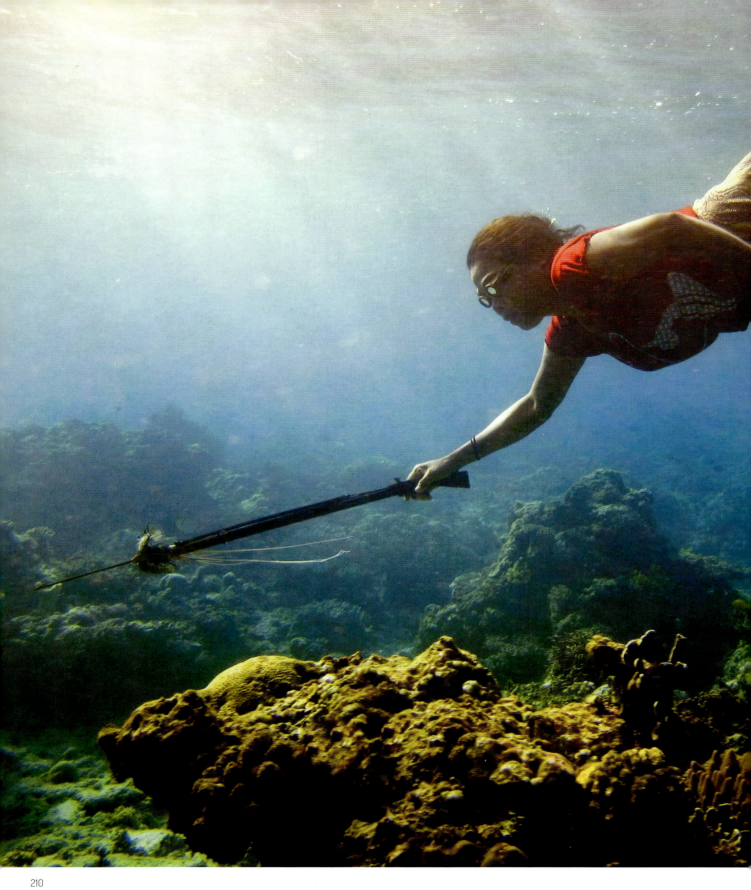

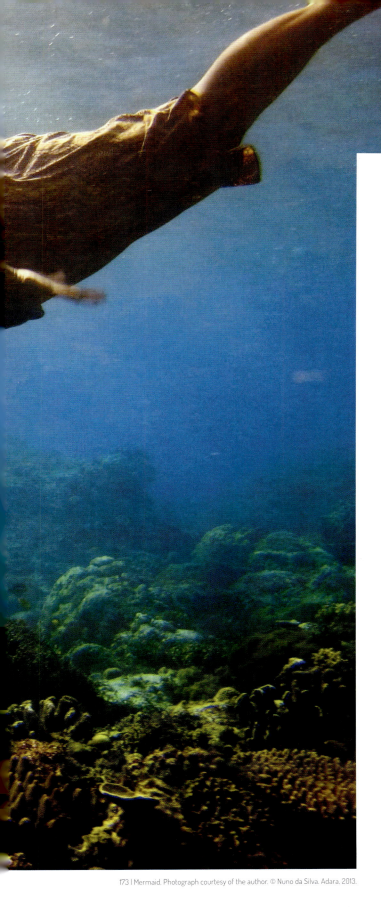

173 | Mermaid. Photograph courtesy of the author. © Nuno da Silva. Adara, 2013.

SIRA FIAR ADAT!
Enrique Alonso-Población | Anthropologist

During the production of our documentary in the Protestat village of Adara (Ataúro island), we thought it could be a good idea to show the community some of the previous films produced by David in Timor-Leste. We installed a white bedsheet in between house walls, placed the projector at an appropriate distance, and plugged all the equipment to an electrical extension fed by a generator only used in special occasions to provide electricity to the community. That night was a special occasion. The films were screened one after the next in no particular order. Some of the films raised giggles and laughter, other specific onomatopoeias of amusement *'oooh'* and dislike *'tsk-tsk-tsk'*. Some situations in the films triggered whisperings between the audience. Sometimes, the audience reacted together as a group, and occasionally a louder voice would trigger a chain reaction of amusement amongst the rest of the community. This variety of spoken responses revealed the exceptional nature of this occasion, happening in a place where access to the internet, mobile network or TV was almost non-existent.

At some point during the night, a short film titled *'tebe dai'* presented the performance of a dancing warrior shaking his sword up to the sky in what appeared to be a traditional ceremony high in the mountains of mainland Timor-Leste. The images triggered intense conversations among the people, the content remained unclear to us until we could hear a clear message coming out from the noisy crowd: *sira fiar adat!* (they believe in traditions!).

The statement drew a clear boundary between the 'we' and the 'others'—those Timorese who believe in traditions. The construction of the 'we' and the 'other' can only be understood in light of the history of those parties who constructed them. These can be interpreted taking into consideration, for example: the contrasting strategies of conversion of the Catholic Church and the Protestant Assemblies of God, the politics of the Academia, inheritance of ideological regimes and state policies from the colonial and occupation period, the indigenous movements, or the interests of today's community leaders, to mention a few.

The concept of *adat* (tradition) is not different to any other concept. All concepts are the outcome of history and the result of social and power relationships[1]. So, which concepts should we use when trying to understand the 'other'? Three main analytical positions can be adopted.

1. *Adat* has been the focus of attention of powerful institutions (academia, state regimes and religious institutions) in their attempt to understand and/or dominate the 'other', for this reason we can trace its evolution.

The first approach consists of trying to overcome society and history—and of course power—by understanding it from the newly developed conceptual setting. An example of this position would be the approach by some artists or even social scientists, whose work is to invent 'power-free' concepts, categories or codes. This attempt, while recognising our concepts as an outcome of power, considers that we can think outside of society and history.

A second perspective, more dominant among social sciences, focuses on an endless 'analysing the analysis' by calling attention to the fact that when people talk, write or create art, they are reproducing historical power relationships, pretending such practice, imbued of moral superiority, is a power-neutral one.

A third approach identifies and recognises the incontestable role of society and history in our conceptual framing. Instead of simulating a potential overcome or a political neutrality, this approach engages in an attempt to boost positive changes in our own—and limited— areas of influence.

The first position can be considered naïve. The second can become conservative, if taken to the limit, for example by a couch critic approach, contributing to the reproduction of the *status quo*. The third position can be considered idealist.[2]

174 | Mamanya (smile in Rasua language). © David Palazón, Adara, 2013

Going back to the film night, we realised the community members didn't seem very interested in seeing the 'others'; instead, we discovered the images they enjoyed the most were the daily underwater unedited shots, in which inhabitants of the village found themselves represented on the big screen.

Our big thanks to the people of Adara for letting us enjoy these images together, and to Timor-Leste for all the lessons we have learned.

—
2. The approaches described here however, should not be deemed as static, as the same person can move from one to the other in the same flux of thought.

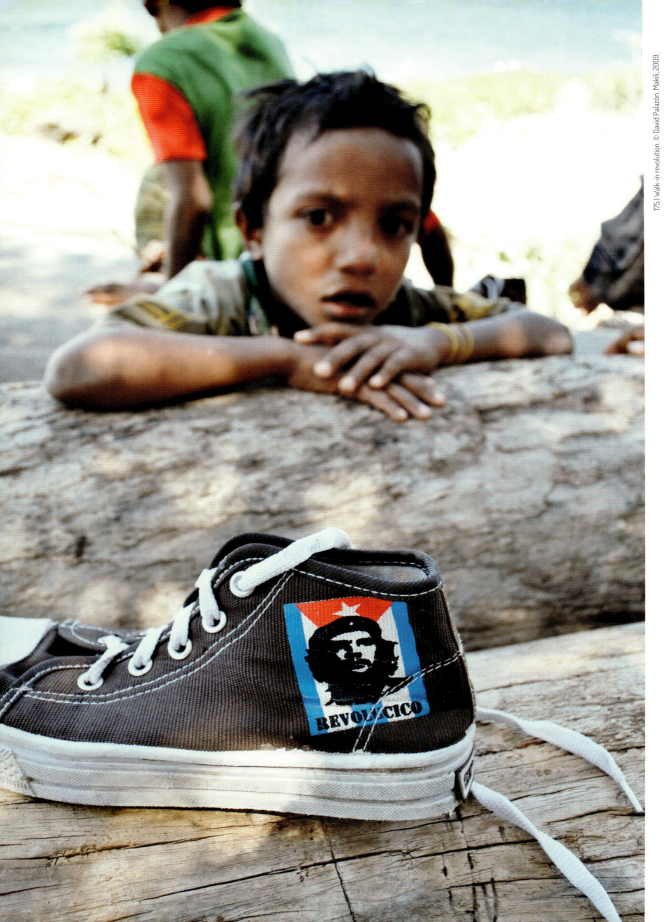

176 | Hard as nails. © David Palazón. Dili, 2010.

177 | Culture champion. Photograph courtesy of the author. © Many Hands International. Lospalos, 2014.

JUSTINO VALENTIM[†] (1954—2014)
KIND MENTOR, COMPASSIONATE LEADER AND CHAMPION FOR CULTURE

Amy Stevenson—with input from Lucia Pichler, Holly Schauble, Kim Dunphy, Nelinha Pereira and Ildefonso da Silva | Many Hands International

Justino often sat on the porch of his modest home in his shirt, pants and rubber sandals, while his family pottered around him preparing the day's meals. From Justino's spot on the verandah facing the main road leading into Lospalos, he would frequently welcome locals as well as many visitors from around the world, including researchers and other cultural experts. Despite the perception of Justino being a humble family man, he, like most older Timorese, had lived a turbulent life, and had a unique and inspiring story to tell. The younger members of his local community tentatively cared for, listened to and respected this kind mentor, compassionate leader and champion for culture. There is no doubt many *ema ki'ik* (little people) made admirable contributions toward their people and the future of Timor-Leste, yet often their stories go untold.

Born in 1954 in Titilari, Lautem District, Justino Valentim spent his early years in search of knowledge, pursuing formal education. He trained as a school teacher, but was only a young adult when Indonesia invaded his country, resulting in rampant poverty, large scale violence, injustice and insecurity overshadowing the prime of his life. Sr. Justino played an important role in Timor-Leste's fight for independence and undertook many risky activities while supporting the resistance. Indonesian military personnel knew of his activities and frequently visited his home during these times, but he managed to survive, with the support of his family and community who cleverly hid him from harm. He was a proud father of 9, as he and his wife Ermelinda Pereira agreed to have six sons together to create their own small resistance army.

After independence, Sr. Justino served in the public sector in various roles including educational and district administration. He was an influential and committed advocate for the promotion and protection of his Fataluku heritage, founding the Council for Fataluku Culture. He played an instrumental role in the ongoing development of Fataluku as a written language, and in his later years, led a research project with NGO Many Hands International, to document endangered Fatakulu cultural knowledge and practice. Justino proudly promoted this heritage to a wide range of audiences, delivering presentations in Lospalos and Dili, sharing research project results and representing Timor-Leste at UNESCO events in Indonesia.

In 2014 the Fataluku community grieved Justino's passing, although they can take comfort in his legacy. As an inspiring teacher, philosopher and gifted orator, he was dedicated to nurturing the younger generations of his people. The benefits of his contributions towards his culture, community, and new generations of Fataluku people will not be forgotten, nor will the many *ema ki'ik* throughout the nation, whose aspirational contributions have had a profound impact on Timor-Leste as we know it today.

This photo provides a glimpse of his character, of the husband, father and grandfather that was Sr Justino; his humour, charm, vitality and wisdom beaming through his smile.

178 | Installation. *'Culture is the memory of a community that doesn't die'.* © David Palazón, Liquiçá, 2012.

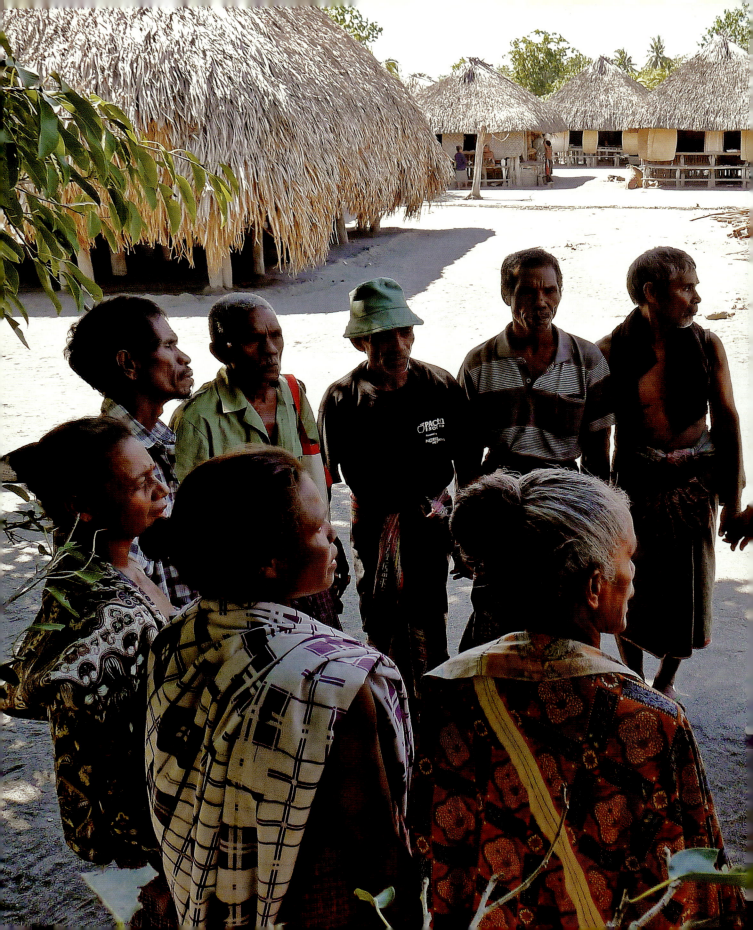

SUNG POETRY IN SUAI
Philip Yampolsky | Musicologist

Among the Tetun-speakers in the southeastern corner of the country, there is a rich tradition of sung poetry. The singing is done in groups, usually by a male chorus answered by a female chorus. People sing at wakes, for two nights before the body is buried; in the ceremony releasing a family from mourning, a year after the death; when engaged in communal work, such as preparing the thatch for a house roof or pounding corn or sago; as accompaniment to certain dances; and when just sitting around in a group.

The poems come from a vast treasury of memorized, unwritten verses called *aiknanuk* (or *kananuk, knananuk, aiknananuk*, etc.). They are always couplets, complete in themselves, sung in ordinary language but often quite metaphorical. They don't seem to have a fixed meter or syllable count, though most lines contain five, six, or seven words. They concern all sorts of topics. The singers choose poems in keeping with the spirit of the event—sad ones for a wake, joking and teasing verses for a work party (or even at a wake, for a change of pace after much solemnity).

Each chorus has a lead singer (or more than one, trading off the lead role), who chooses the verse to be sung. The sequence of verses is not planned out in advance. In fact, there is an element of suspense and competition built in, because when one group begins a poem—this is usually but not always the men's group—then the other group has to choose another poem that will serve as a proper response to it. If the second group cannot think of a good response, then they lose a bit of face (they can gain it back later by stumping the other group in return) and are the butt of jokes and teasing.

Here's an *aiknanuk* I heard in Suai Loro, with a loose translation into English:

Sei lao-lao ba dalan se'es malu
Se'es malu ke basa hiru tuir ona

(When we walk along the road and one of our party
turns off because he has reached his home,
/ We are sad because our friend has left us to go home.)

(Clearly this is a metaphoric reference to a friend's departure in death.)

Suppose the men choose to sing this poem. The lead singer may mutter the words of the first line quietly as a prompt for the other men. Then they all sing the first line of the couplet. Now it is the women's turn to respond to this. The requirement is only that the response be connected in some way to the initial poem. Here is a response that I heard—undoubtedly one of several possibilities—to the men's poem above:

Sei lao-lao ba binan oan kotu
Binan kotu rai nela ina tua dulan

(When we walk a long way we get tired,
/ And we look for a place to rest.)

So the women sing the first line of their couplet, which contains the same image of walking as the men's couplet. By this time the suspense is resolved: the women have a suitable response. Now the men sing the second line of their couplet, which everyone has recognized by now, and they are answered by the second line of the women's couplet. After this, the men choose a new couplet, perhaps continuing the idea of the earlier one or perhaps switching to a new topic. The singing can go on all night at a wake, and then all the next night as well.

What makes a good singer? The answer was always command of *aiknanuk*, the ability to come up quickly with a relevant verse. (Sometimes singers may invent a verse on the spot. I heard one complaining that I was recording them all night but didn't give them any cigarettes. I got the message and sent someone out for some.) Lead singers pride themselves on being able to sing all night and not repeat a verse. Beauty of voice and accuracy of melody are very much secondary.

As for the music: there are a limited number of melodies in any one community. In Suai Loro, I heard four at wakes; there were others for other occasions. All of them use *aiknanuk* as their poetry, and theoretically any *aiknanuk* may be sung to any melody. (The considerations of what verse and what melody are appropriate to a given context still apply.) The melodies are the essential vehicle of the poems—there are few if any occasions when a poem is recited rather than sung.

It is not clear how long this tradition will last. It is largely in the hands of the middle-aged and elderly now, and young people do not seem to be taking it up. One hopes that this remarkable oral treasury of song and poetry will not be lost with the current generation of singers.

179 | Full circle. © David Palazon, Suai Loro, 2013.

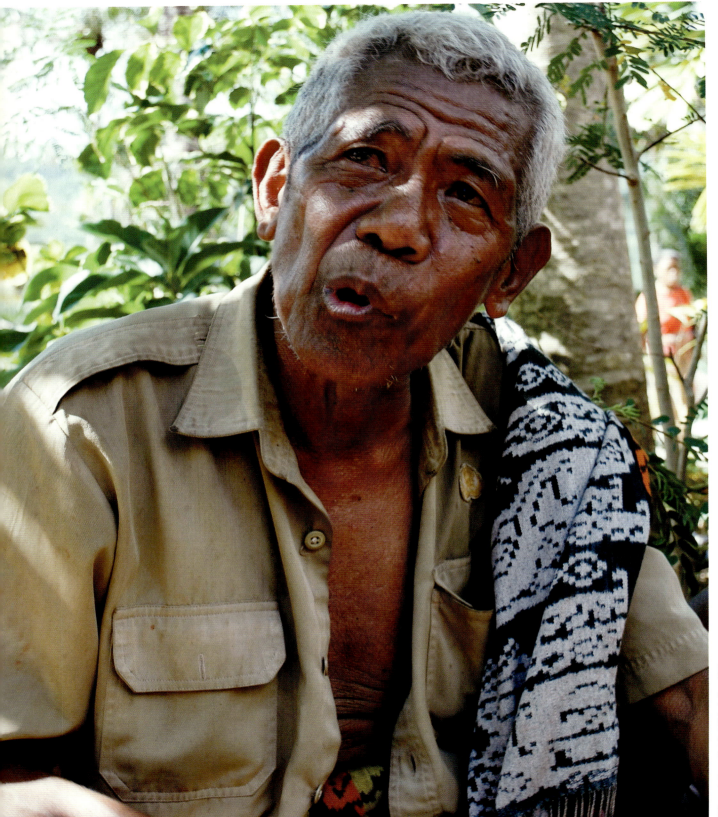

180 | Improvisation artist. © David Palazón, Pope, 2010.

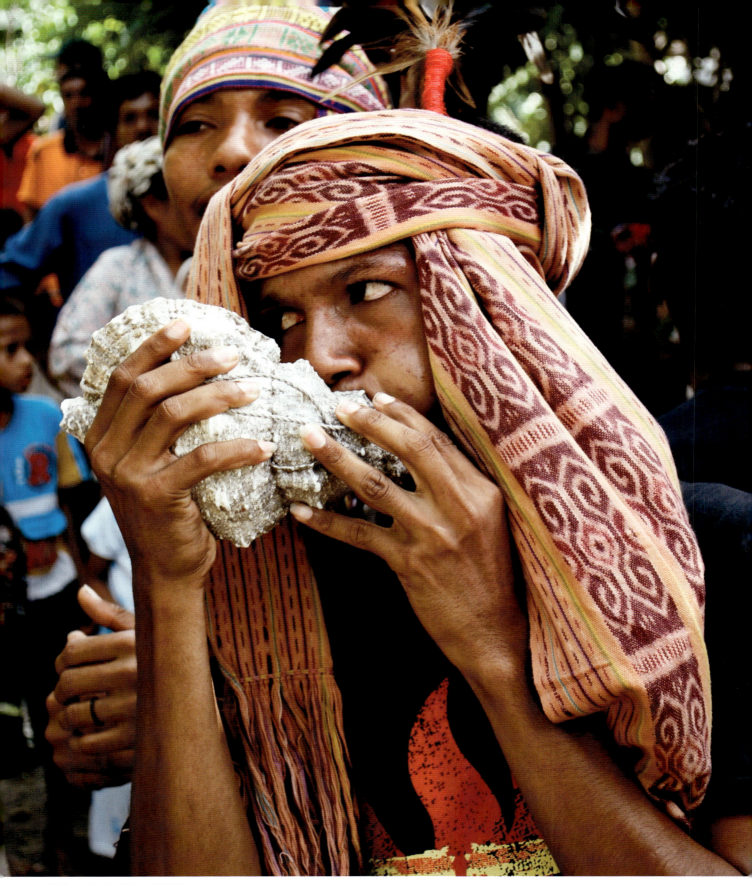

181 | Salty sounds. © David Palazón, Makili, 2010.

182 / Hand eclipse. © David Palazón. Makili, 2010.

183 | Multi-player. © David Palazón, Tumin, 2010

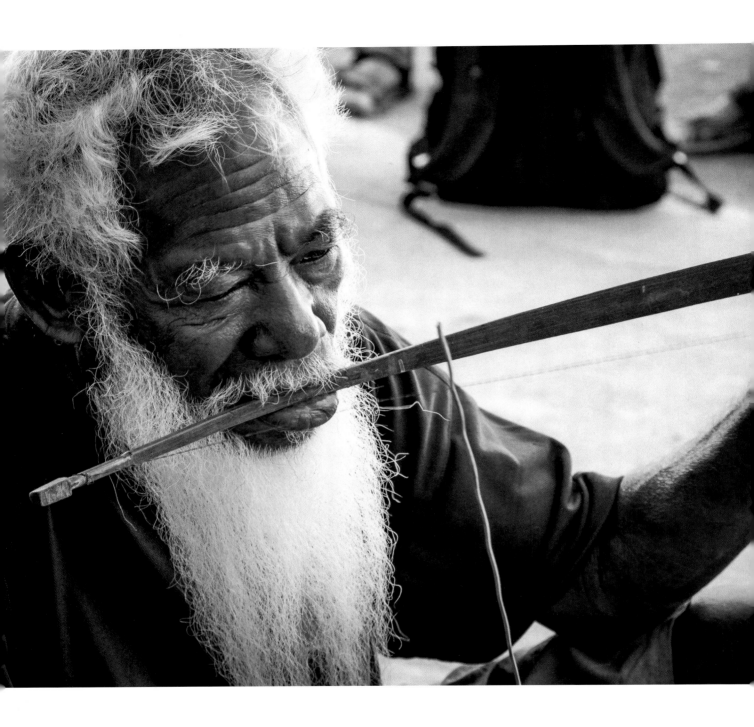

184 | *Rama* (mouth bow). Photograph courtesy of the author. © Luke Monsour, Dili, 2011.

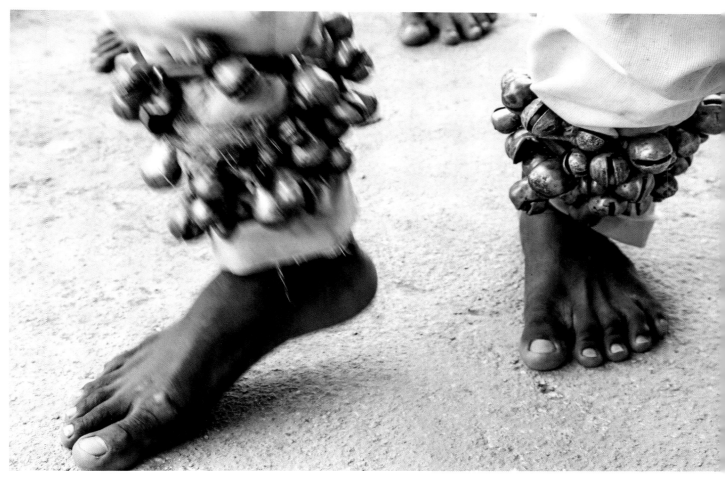

185 | *Kini-kini* (foot bells). Photograph courtesy of the author. © Luke Monsour, Dili, 2011.

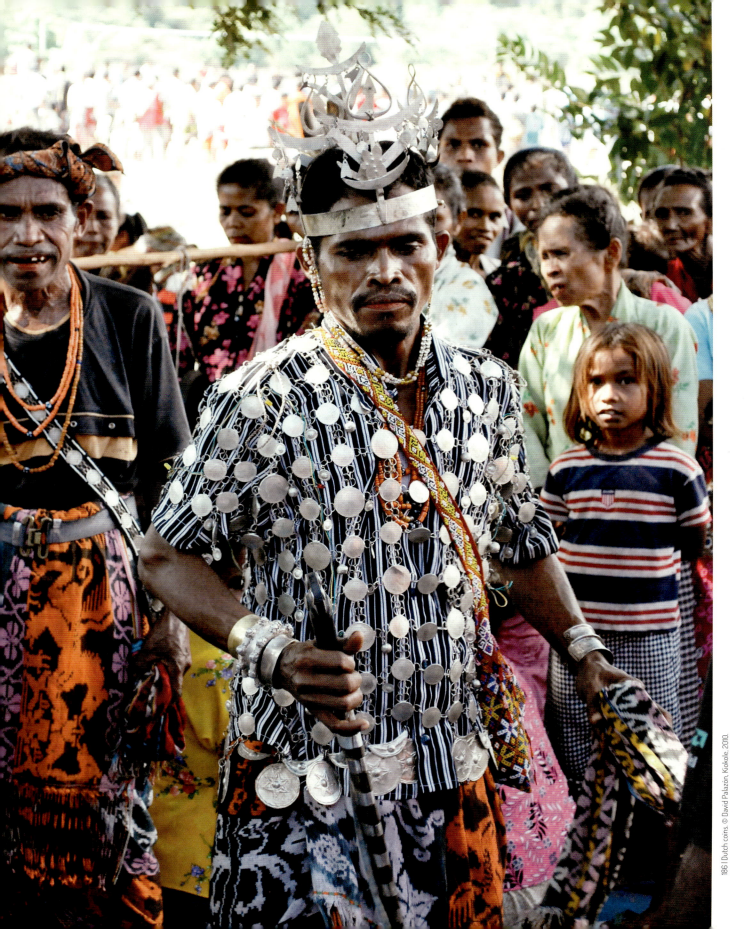
186 | Dutch coins, Kiokole, 2010.

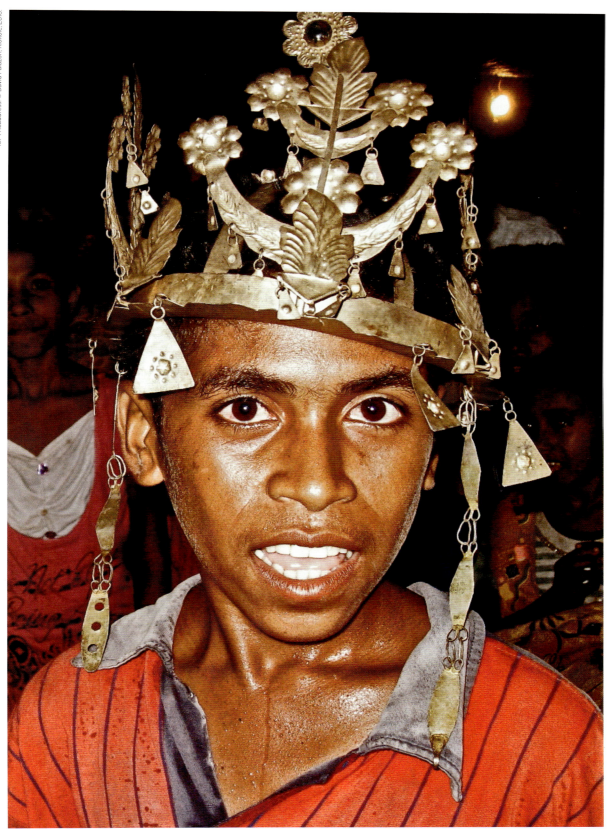

187 | Headdress. © David Palazón, Kiokole, 2010.

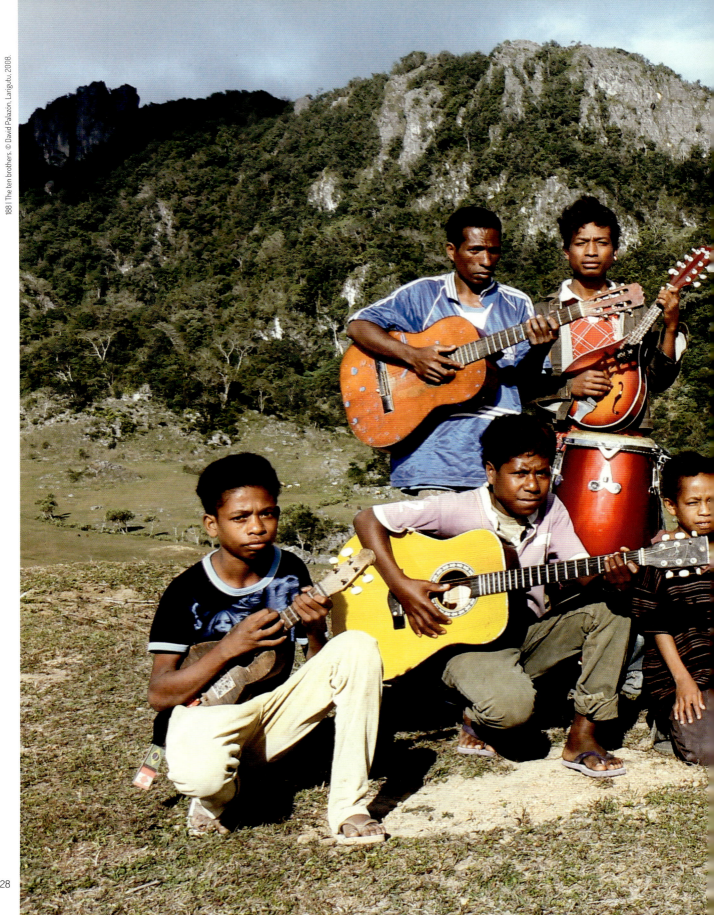

188 | The ten brothers. © David Palazón, Langutu, 2008.

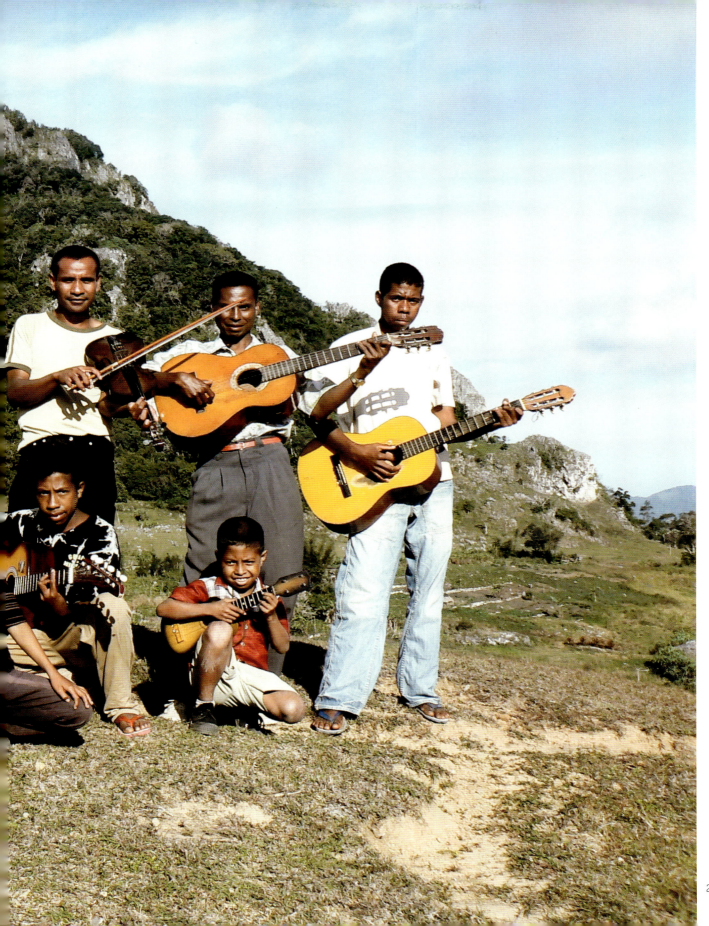

SAFEGUARDING CULTURAL DIVERSITY

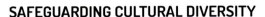
Masanori Nagoka | Chief of culture unit, UNESCO Kabul office

The civil unrest in 1999 and 2006 had a dramatic and negative impact on the people of Timor-Leste and their culture. The violence resulted in the destruction of buildings of all types and ages, many of national importance to the cultural heritage of Timor-Leste, which comprises a rich combination of colonial architecture, cultural landscape with physical evidence of archaeological sites, traditional villages, remarkable vernacular architecture and a variety of crafts and traditional customs, etc.

Today, safeguarding the Intangible Cultural Heritage is a huge challenge in the country, which involves local, national and international co-operation and law enforcement. On the local level, there is a significant lack of awareness about the preservation of their cultural property. On the national level this problem concerns a lack of comprehensive and effective legislation for the protection and management of the broader historical environment, systematic governance of the culture sector, economic poverty, lack of resources of all kinds and uncertain public security. At both local, national and international levels, it will require further years of work to establish conditions under which an adequate mechanism to safeguard the intangible heritage could be introduced. This mechansim should include identification, documentation, research, preservation, protection, promotion, enhancement, and transmission particularly through formal and non-formal education as well as the revitalization of the various aspects of such heritage.

While attempting to preserve cultural resources for future generations, it will be necessary for the cultural heritage of Timor-Leste to be developed sufficiently as a functioning national identity which represents the nation's pride in itself and local ownership of unique Timorese cultural patterns. With such a revived national self-awareness in place, Timorese culture will function as a serious source of local income and a major tourism resource. The income generated by the future growth of the cultural heritage tourism industry will be a major benefit to the local economy, some of which could be reinvested in heritage conservation for the long-term benefit of local communities, in particular those who are marginalized.

During my assignment as Head of the Culture Unit at the UNESCO Office in Jakarta, from September 2008 to June 2014, which supervises five neighboring countries including Timor-Leste, I paid a number of visits to the country where I met numerous friendly and receptive people. One of the UNESCO's projects we carried out, together with the State Secretariat for Culture of Timor-Leste and local community members, was a series of workshops aimed at enhancing the capacities of Timor-Leste to safeguard its intangible heritage through effectively implementing UNESCO's 2003 Convention for the Safeguarding of the Intangible Cultural Heritage.

One of the programmes was conducted in April 2013 in in the rural village of Suai Loro, about 5 kilometers away from the town of Suai, Covalima district, south-western Timor-Leste, where I encountered a variety of intangible heritage that local community group members were still enacting: *Aihan Akar* (the craft of weaving traditional bamboo screens for use in homes), *Bua Malus* (the ingredients, objects, values and rites associated with betel-nut), *Tebe Lilin* (oral history stories), *Koto Tisi* (the preparation of a poisonous bean variety usually considered famine food to render it edible) and *Uma Lisan Soe Mamulak* (ancestral houses as the cultural fibre of the community). I will be back to this unforgettable country in the future to reunite with community people and the rich and diverse culture of the country.

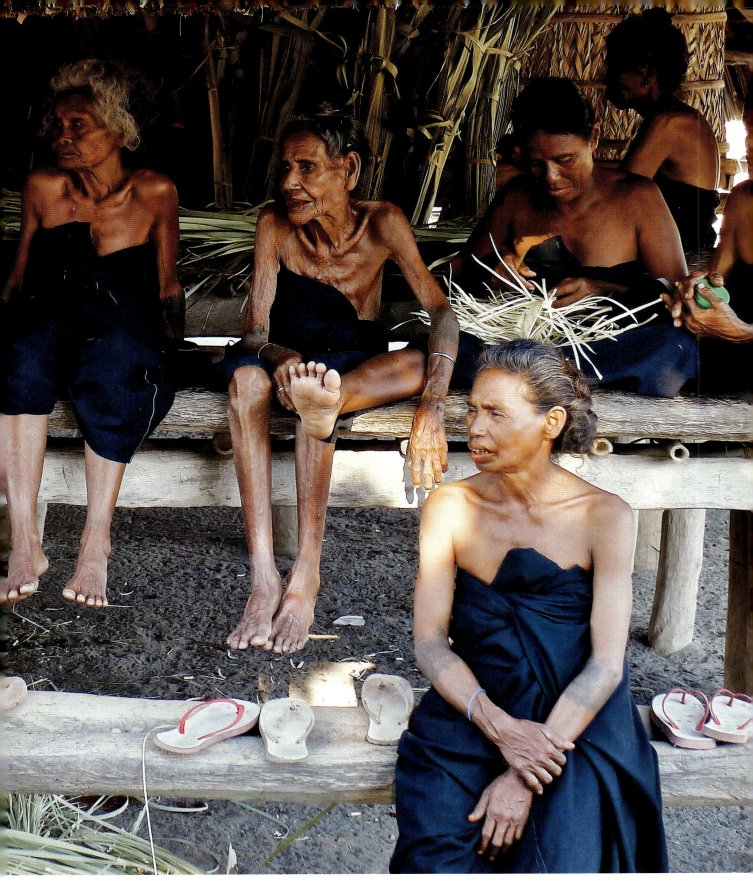
189 | Matriarchal community. © David Palazón. Suai Loro, 2013.

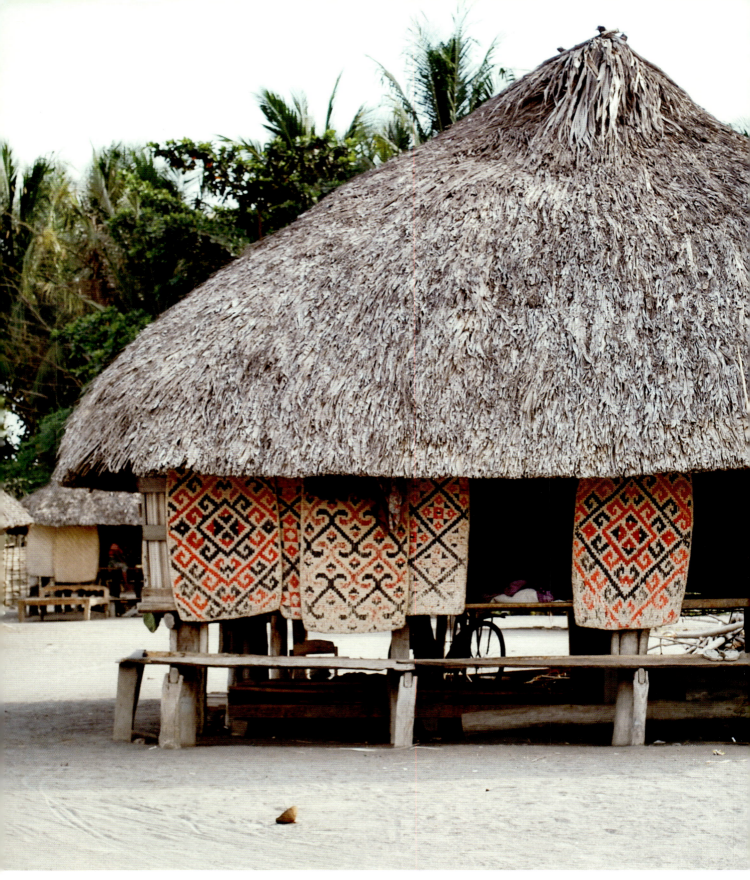

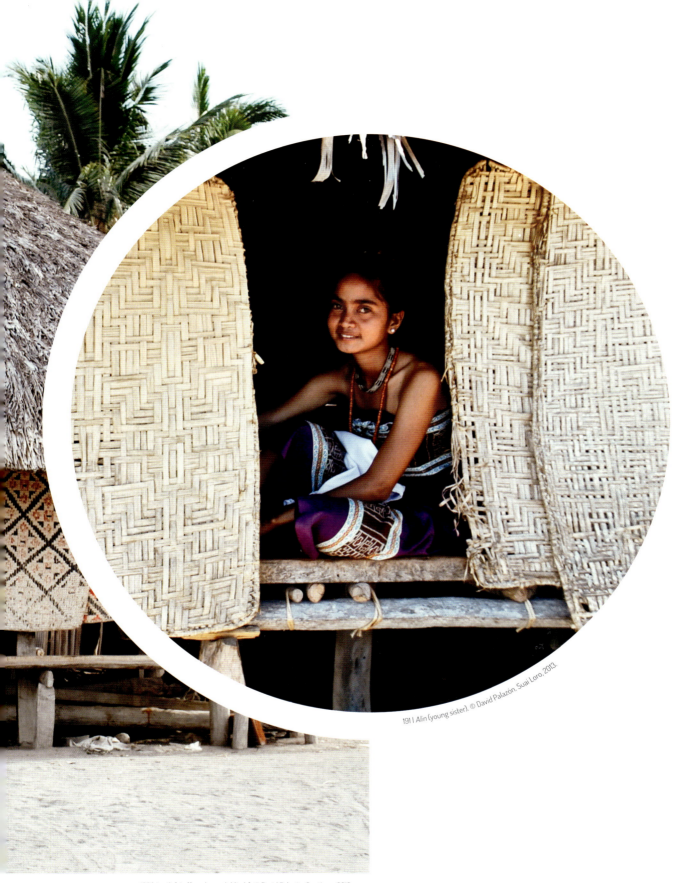

191 | *Alin* (young sister). © David Palazón. Suai Loro, 2013.

190 | *Lenik feto* (female porch blinds). © David Palazón. Suai Loro, 2013.

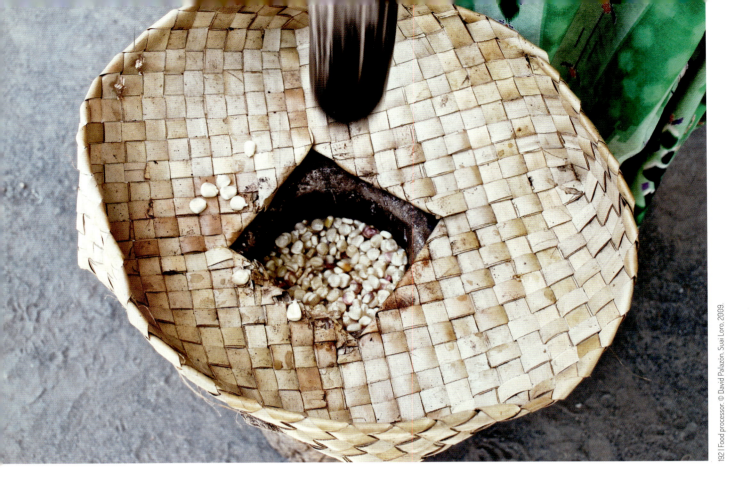

FUHUK IHA BATAR LARAN
Hector Hill | Tradutór

Ular han batar. Ne'e ha'u; ular ne'ebé han batar, hanesan mirain ne'ebé halahuk ai-riin ne'e, han uma ne'e; Fuhuk han auk, halo u'ut mutin ne'e ... hela haas-laran. Ô la haree, ha'u badinas han neineik, han beibeik ... ha'u-nia moris maka ne'e. Loron ida ha'u moris dolar tuir rai, isin-mamar, loron seluk ha'u sai hosi knuan, semo sa'e, isin-toos, nehan kro'at ... Ô la haree, Ô la'o ba ponte lahuk leten, Ô monu ba rai, Ô hatene ha'u.

Fai batar. Baku baku baku to'o rahun.

Kahur ho bee. Halo mahar.

Sona ho mina nu'u. Tau masin.

Fó-han ema.

Natoon de'it ona.

Ha'u bosu.

WEEVIL IN THE CORN
Hector Hill | Translator

Worm eats corn. That's me; the grub that eats corn, like a white ant that weakens that post, eats that house; Weevil eats bamboo, makes white dust ... lives in mango tree. You don't see, Me busy eating slowly, eating always... that's my life. One day I'm crawling on the ground, soft-bodied, another day I come out of my cocoon, fly up, hard-bodied, sharp toothed ... You don't see, You walk on rotten bridge, You fall to the ground, You know me.

Pound corn. Beat beat beat to dust.

Mix with water. Make thick.

Fry with coconut oil. Add salt.

Feed people.

Enough already.

I'm full.

193 | Plate and cup. © David Palazón. Utufalu, 2009.

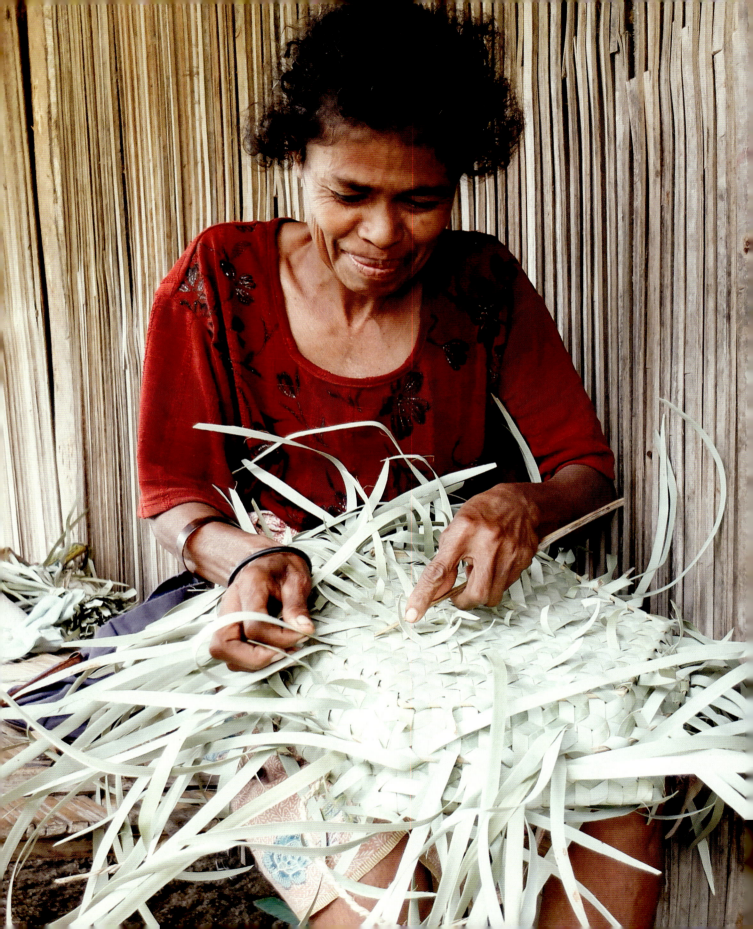

194 | Basket weavers. © David Palazón. Viqueque. 2015.

HOMEWORK

Marcelina Warubua Osolio | Motivational teacher

I come from a big family in Lospalos. I am a teacher of any subject that I feel confident to teach to anybody interested in learning, particularly languages.

I have a big family. I am number 8th out of 18 siblings (8 passed away), a father and two mothers. I come from a non-educated family. In my parents' view, there is no need for a girl to go to school. Men are generally reserved the right to access education. As a woman, you must stay at home and do household work, so you can be recommended for marriage based on your household work skills.

Very early in my life, I resolved myself not to show any confidence at household work, to delay any potentially arranged marriage. I didn't want to get married early. Every time my sisters asked me to do washing, I would always intentionally mess up the clothes. When they asked me to cook, I would add plenty of salt to any meal. I wanted them to believe housework wasn't really my thing, and therefore, they could not arrange my marriage. One day, I decided to escape my family's nest. I looked for a place where I could go to school like the mosque orphanage in my village. In 1983, I was admitted to the orphanage, I converted to Islamic religion and attended grade one. In 1989, I continued to pre-secondary school in Dili until 1992, when I moved to a State secondary school in Jakarta. A year before I finished my high school, a friend of my foster parents told me that if I was admitted at a State University in Indonesia, I would be given a scholarship to continue my studies. In 1995, I was admitted at the Indonesian Islamic State University in Jakarta. My tuition fees and living costs were paid by my foster family. In 1996, I left to continue my studies at the International Islamic University in Malaysia where English was used as the instructional language for 17 months out of the 24 months during the course. I started my Bachelor degree in Psychology in February 1998 and finished it in November 2001. I was then admitted to do a Masters in Educational Psychology at the Faculty of Education at the same university, which I completed in October 2003.

I came back to Timor in December 2003, and immediately after I begun to work with the Ministry of Education as the Scholarship Coordinator organizing scholarships for tertiary education students. During almost 2 years working with the East Timorese Ministry of Education, I was delighted to help my fellow East Timorese increasing their educational prospects by outsourcing international scholarships in countries like Australia, New Zealand and Malaysia. In 2004, I helped organize a group of lecturers across public and private universities in cooperation with the International Institute of Education in Paris and UNDP Indonesia to attend a thesis guideline review training in Jakarta. Thus, in July 2005, five East Timorese were awarded scholarships at UTP in Malaysia in the area of Petroleum. In September 2005, seven more students were awarded with German scholarships to undertake Masters in Agriculture across South-East Asian universities, and two more MTCP scholarships were awarded for Masters Degrees at the State University of Malaysia. At that point, I felt incredibly happy in helping others to continue their educational careers.

Each person has his own view about success. Most people think that success comes in the shape of money, property and wealth. In my experience, successful people are those who like to invest their time and knowledge to help others to grow further ... and beyond their household work.

|95 | Container. *Bote* (basket). © David Palazón. Viqueque, 2015.

|96 | Self-contained. *Katupa* (boiled rice packaging). © David Palazón. Luca, 2015.

239

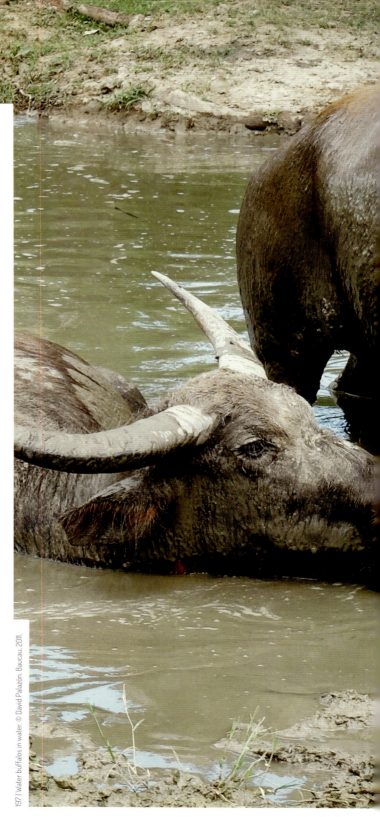

KARAU
Jean-Christophe Galipaud | Archéologue

Karau, un nom bizarre et aux sonorités étranges. Un animal impressionnant qui, croisé au bord des routes, en troupeau, m'a souvent donné l'impression de me promener dans un monde sauvage et inhabité. C'est lui, avec ses cornes démesurées que sculpte patiemment et avec tant de talent le mari de la potière de Manatuto. Ces sculptures merveilleuses dans l'argile réalisées par cet homme si discret me touchent. Elles ont la force des traditions de ce pays. Cet homme réitère pour moi, comme sa femme avec ses pots, la magie de la création. De cette terre rouge sang nait la vie.

En parcourant l'île de Timor, le buffle est partout, dans les champs, le long des routes ou vautré dans la moindre flaque boueuse mais aussi dans les village, bloquant l'espace avec ses cornes démesurées. Ces cornes que nous retrouvons, David et moi, accrochées au poteau central de la maison sacrée de Mau Ulo à Ainaro. Mais d'où vient-il ce buffle et comment est-il arrivé dans l'île? Je l'imagine couché au fond d'une grande pirogue, malade et apeuré tout autant que ces hommes qui venaient tenter leur chance sur ces côtes. Il y a quoi, 3000 ans peut-être. Son cousin est sur mon bureau prêt à m'entrainer à sa suite vers de nouvelles découvertes.

KARAU
Jean-Christophe Galipaud | Archeologist

Karau, what a bizarre and strange-sounding name. Seeing this awesome animal crossing the road in herds, often gave me the impression of leading me into a wild, uninhabited world. There it was, with his disproportionate horns, sculpted patiently with so much talent by the husband of the potter in Manatuto. These wonderful clay sculptures shaped by this discreet man touched me. They hold the strength of the traditions of this country. This man reiterates for me, as does his wife with her pots, the magic of creation. From this blood-red earth life was born.

Traversing the island of Timor, buffalos can be found everywhere, in the fields, along roads or sprawled in any muddy puddle, but also in the village, blocking the space with its large horns. These horns we found, David and me, clinging to the center post of the sacred house of Mau Ulo in Ainaro. But from where did this buffalo come and how did it arrive to the island? I can imagine it lying at the bottom of a large canoe, sick and scared just as much as the men who came to try their luck on these coasts, perhaps around 3000 years ago. His cousin is sitting on my desk, ready to lead me onto new discoveries.

197 | Water buffalos in water. © David Palazon. Baucau, 2011.

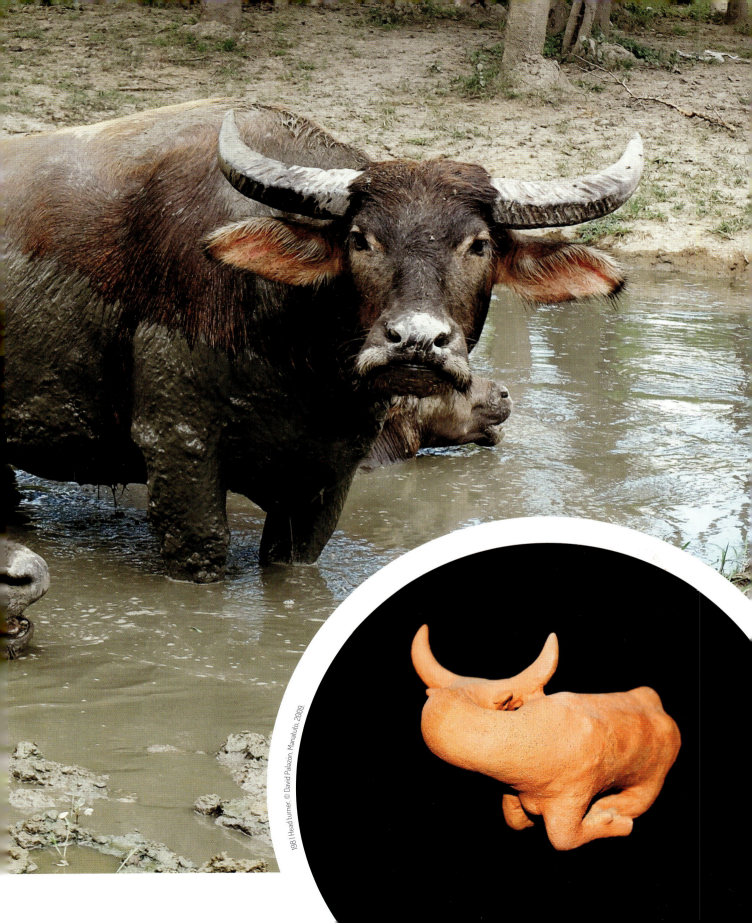

198 | Head turner. © David Palazón, Manatuto, 2009.

199 | Buffalo feast. Photograph courtesy of the author. © Jake VDVF. Loré, 2011.

200 *Kabi'uda* (altar). © David Palazón. Uma Lulik Fad Locar (Hautiol), 2009.

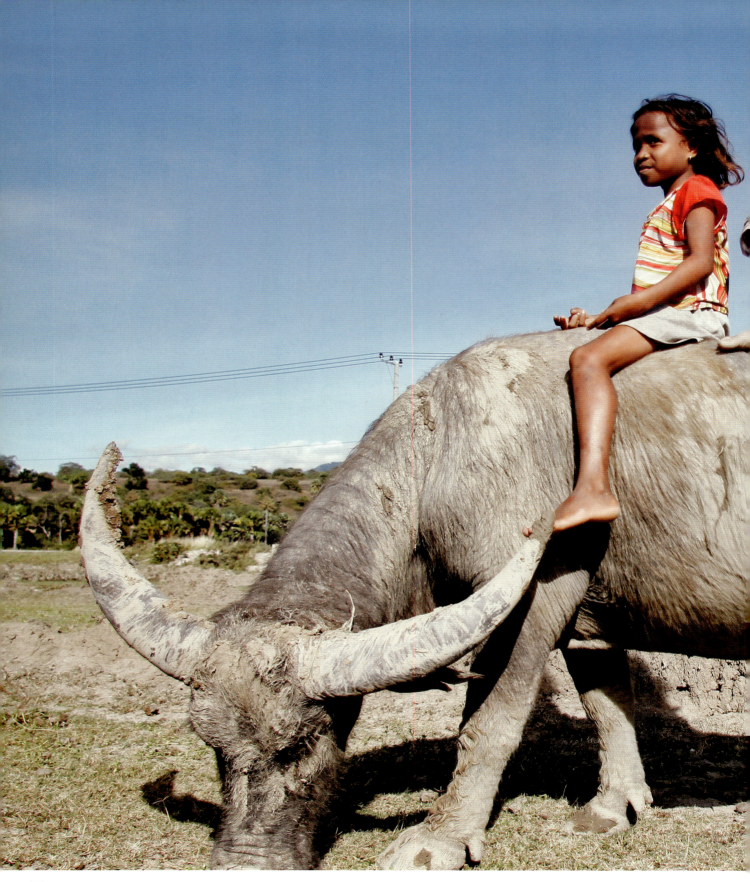

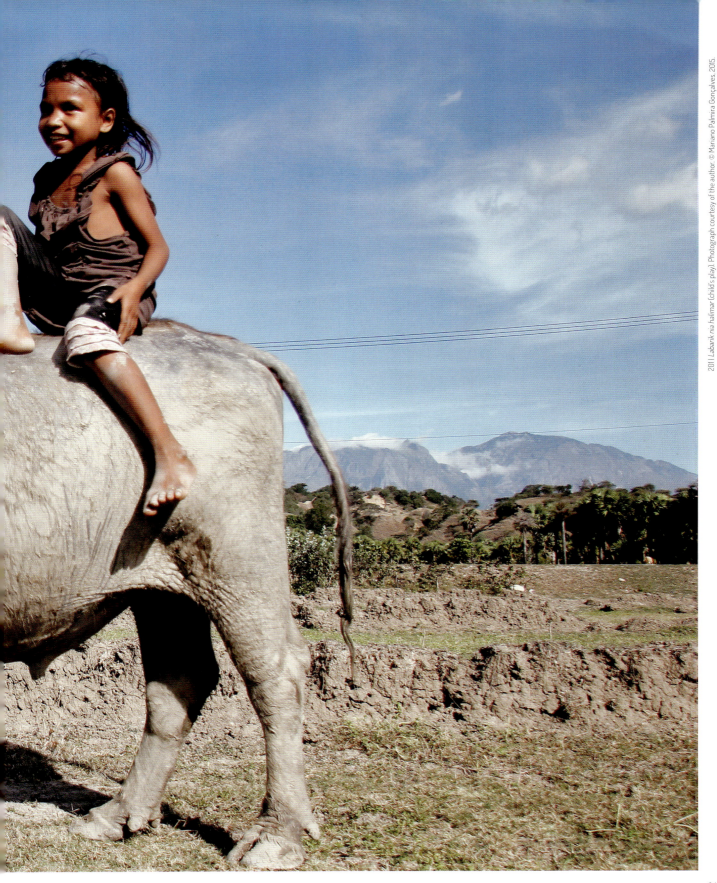

2011 *Labarik nia halimar* (child's play). Photograph courtesy of the author. © Mariano Palmira Gonçalves, 2015.

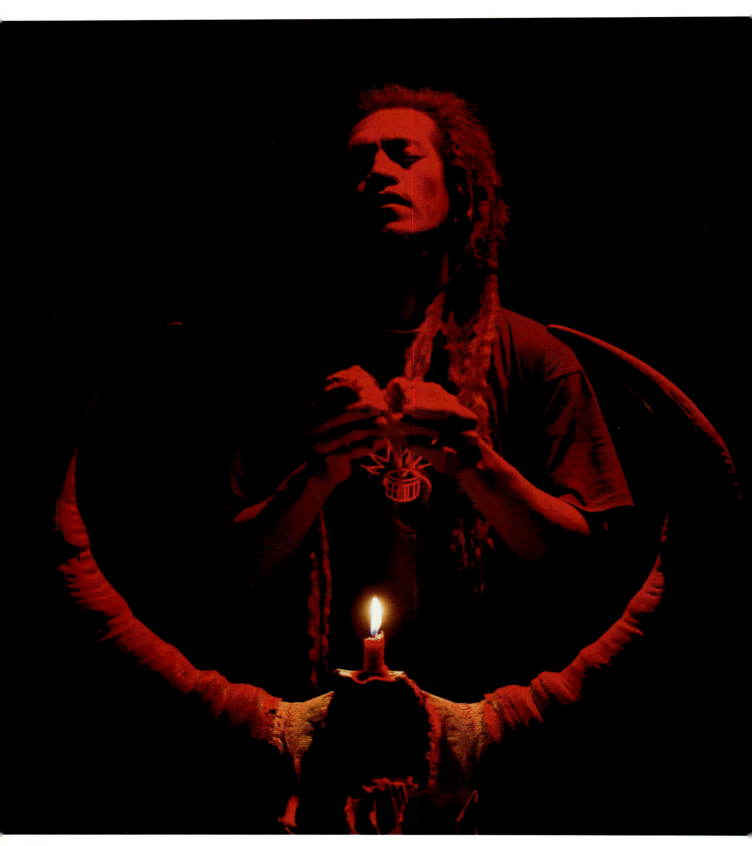

202 | Talking hands. Performance by Etson Caminha. Photograph courtesy of the author. © Sula Sendagire. Dili. 2015.

203 | Architectural drawing. Artwork by Xisto da Silva © David Palazón. One dollar beach. 2008.

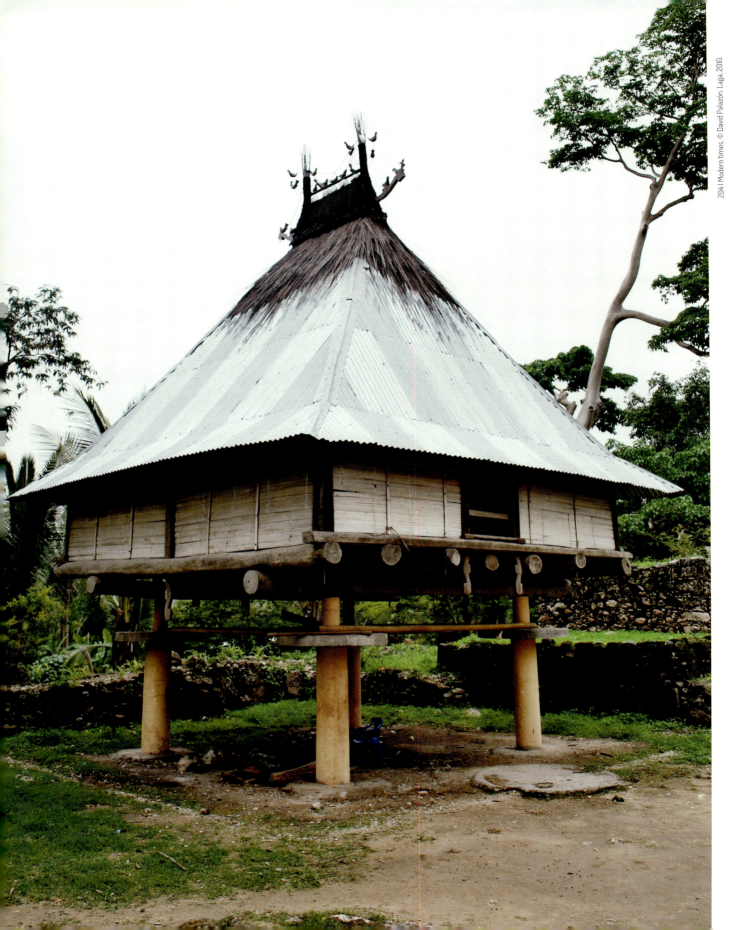

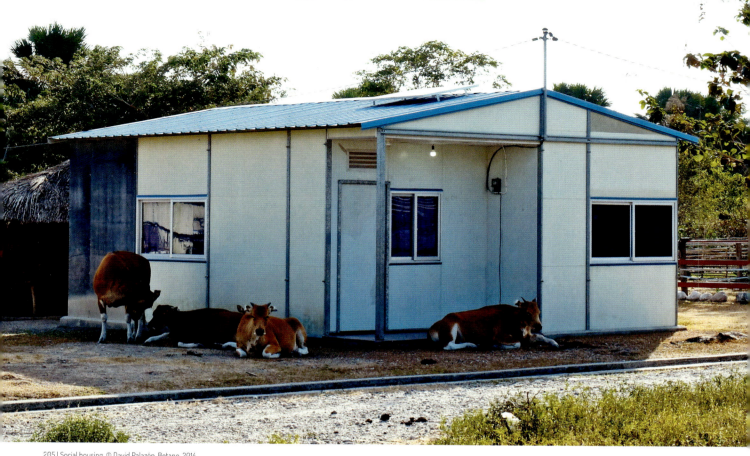

205 | Social housing. © David Palazón. Betano, 2014.

206 | Social housing with character. © David Palazón. Betano, 2014.

207 | Private collection. Photograph courtesy of the author. © Iñigo Ballester. Valencia (Spain), 2016.

208 | Uma Lulik Lia-boo. Photograph courtesy of the author. © Victor de Sousa. Fatulia, 2009.

209 | Doorway. © David Palazón. Hatubuilico, 2010.

210 | Discarded rodent deterrents. © David Palazón. Laga, 2010.

2111 Above the clouds. © David Palazón. Maubisse, 2010.

LULIK: VALOR NUKELO TIMOROAN NIAN
José (Josh) Trindade | Asesór ba peskisa no análisis asuntu sosial-kultural iha Palácio da Presidéncia.

Ita tomak hatene ona kona ba termus Lulik hanesan baibain ita rona, uma lulik, rai lulik, bee lulik, fatin lulik, foho lulik, na'i lulik, amu lulik, nsst. Bainhira Timoroan rona liafuan "Lulik", derepente sira hamriik iha fatin, sira fó atensaun, sira fó respeitu, sira ta'uk, no Lulik dada sira halo tuir no sira la husu buat barak. Sira tuir de'it saida mak lulik haruka.

Lulik hetan ataka makaas hosi ema rai liur ne'ebé mai iha Timor. Ezemplu, Igreja dehan katak Lulik ne'e hanesan fiar animismu ida ne'ebé la di'ak, Portugés sira dehan lulik ne'e *"atrasado"* no ema Indonezia dehan *"terbelakang/ketinggalan zaman"*. Tanba ataka hirak ne'e, Timoroan sira sai moe no lakon fiar an nu'udár sosiedade ida. Sira moe atu ko'alia kona ba lulik, tanba ema hosi rai liur dada sira hodi hanoin katak lulik ne'e buat negativu ida ne'ebé la di'ak. To'o ohin loron, Timoroan barak moe nafatin no ko'alia aat buat hirak ne'ebé sira nia beiala sira rai hela ba sira. Timoroan sira iha konhesimentu no rona kona ba lulik maibé saida loloos mak lulik sira ladún hatene.

Lulik mai hosi liafuan Tetun Terik ne'ebé literalmente bele tradús dehan "labele" no "sagradu". Konseitu lulik ne'e rasik ita bele hetan iha grupu etno-linguistika hotuhotu iha Timor laran tomak. Hodi Bunak dehan *"po"*, ho Naueti ema bolu *"luli"*, ho Fataluku ema dehan *"tei"* no Makasae ema dehan *"phalun"*.

Lulik refere ba mundu espiritual ka mundu kosmos ne'ebé ita labele haree ho matan, iha mundu ne'e nia laran iha na'in ida ka maromak, iha mós espíritu beiala sira nian, mundu ne'ebé mak moris nia hunno abut, no iha laran moos iha lei no regulamentu sira ne'ebé sagradu hodi regula relasaun entre ita ema no relasaun entre ema no natureza.

Iha relasaun entre ema, lulik determina ka regula saida mak Timoroan tenke halo iha sira nia moris sosial iha sosiedade nia laran. Iha momentu ne'e, lulik sai hanesan baze ba moral atu ita bele sukat saida mak di'ak no saida mak la di'ak/sala iha sosiedade. Nu'udár ezemplu, lulik regula relasaun, direitu no obrigasaun entre maun no alin, feen no la'en, fetosan no umane, labarik no inan-aman, feton no nan no ema individual ho ninia sosiedade.

Iha relasaun entre ema no natureza, Lulik regula oinsá ita ema trata natureza (liuliu rai) ne'ebé suporta moris. Iha ne'e, lulik ijiji atu ita ema respeita sasán importante natureza nian hanesan rai, bee, ailaran/aihun, fatuk, nsst. Tanba ida ne'e mak Timoroan sira sempre halo ritual ka seremónia molok ku'uaihan iha toos no natar ka bainhira kuda fini. Seremónia no ritual hirak ne'e maneira ida hosi Timoroan sirahodi fó agredesimentu ba rai nia bokur ne'ebé fó ona rezultadu di'ak ba sira no sira he'in atu hetan kolheita di'ak liu tan iha tempu oinmai. Seremónia "sau batar" molok ku'u batar nu'udár ezemplu ida no ida ne'ehanesan ritual ida ne'ebé importante tebes ba Timoroan sira.

LULIK: THE CORE OF TIMORESE VALUES
José (Josh) Trindade | Adviser of research and analysis of socio-cultural issues at the Presidents' Office.

Each one of us is perhaps already familiar with *lulik* terms such as, *uma lulik, rai lulik, bee lulik, fatin lulik, foho lulik, nai lulik, amo lulik*, etc. When Timorese hear the word *'Lulik'*, it immediately puts them in place for a moment, they pay full attention, they pay full respect, they are afraid, and it makes them obey without hesitation.

Lulik has been labeled as animist by the Church, and 'uncivilized' *(atrasado)* by the Portuguese and *(terbelakang)* by the Indonesian when they colonized Timor-Leste. As a result, Timorese are often ashamed and afraid to talk about the concept of *lulik*, because they have been led to believe that it is a negative animist belief system. This in turn creates a sense of cultural insecurity among the Timorese. Many Timorese today only understand the concept of *lulik* from its surface, what is beyond it they have no idea.

Lulik comes from the *Tetun Terik* word which is literally translated as 'forbidden', 'holy' or 'sacred'. The concept of *Lulik* exists in all languages in Timor-Leste in different terms. In Bunaq they call it *'po'*, in Naueti they call it *'luli'*, in Fataluku they call it *'tei'*, in Makasae they call it *'phalun'*.

Lulik refers to the spiritual cosmos that contains the divine creator, the spirits of the ancestors, and the spiritual root of life including sacred rules and regulations that dictate interpersonal relationships and relationships between people and nature.

In interpersonal relationships, *lulik* determines how Timorese should behave in social interactions within the society. *Lulik* in this case acts as the moral standard. As an example: *lulik* regulates the relationship and the rights and the obligations of younger and older brothers, husbands and wives, *fetosan-umane* (wife giver-taker), children and parents, brothers and sisters, etc. *Lulik* creates social contracts between the Timorese.

In relationships between people and nature, *lulik* regulates how people should interact with nature (especially land) to support their life. In this case, *lulik* demands that nature (such as land, water, trees/forest, rocks/stone) must be respected. That is the reason why Timorese always have ceremonies and/or rituals after harvests and before they plant seeds. This to show gratitude and to value the fertility of the land which gives them good harvest seasons, and to hope for better results in the coming seasons. The *sau batar* ceremony before the corn harvests is an example and is one of the most important rituals for the Timorese.

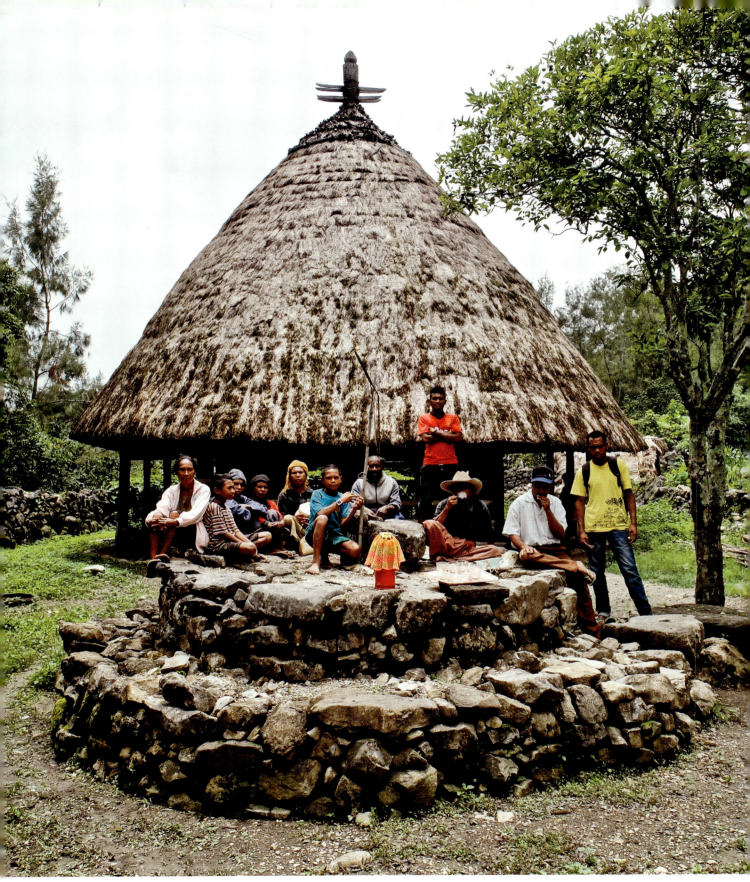

212 | Umbilical cord. © David Palazón. Uma Lulik Mau Ulo (Aitutu), 2015.

Oojetivu hosi Lulik nu'udár filozofia ida mak garantia dame no hakmatek (trankuilidade) ba sosiedade tomak liu hosi mantein balansu entre valor sira ne'ebé la hanesan (ka iha opozisaun ba maluhanesan valor inan/femininu no valor aman/maskulinu). Ezemplu, Timoroan fiar katak, dame no trankuilidade bele hetan liu hosi balansu ne'ebé di'ak entre mundu naroman (mundu ita ema nian) nomundu nakukun (mundu espiritual nian). Iha ne'e, ema iha mundu naroman tenke halo tuir lei no regulamentu sagradu sira ne'ebé beiala sira hamoris tiha ona. Lei no regulamentu sagradu sira ne'e bele hanesan relasaun harmónia entre individual ida ho ninia familia, knua ida ho ninia sosiedade, nsst. Lei no regulamentu sagradu ne'e mós regula relasaun entre fetosan no umane ne'ebé relasaun ida ne'e tenke ihaharmónia nia laran atu dame no hakmatek bele hetan no prosperidade bele buras iha ema nia leet.

Lulik nu'udár sistema ida la'o tuir konseitu "dualizmu" ne'ebé dezenvolve hosi antropolojia na'in ida naran Van Wouden (1968 [1935]). Iha konseitu ida ne'e, sempre iha buat oin rua ne'ebé kontraditóriu maibé sempre komplementa no fó balansu ba malu iha moris. Iha Timor-Leste, ita hatene iha tasi feto-tasi mane, rai ulun-rai ikun, fetosan-umane, belak-kaibauk, loron-fulan, nsst. Estrutura dualistiku ida ne'e antropolojia na'in sira uza barak hodi explika sosiedade iha Indonezia Leste inklui Timor-Leste (Trindade 2008, 178).

Ita uza karik nosaun dualizmu, ita bele obzerva oinsá Lulik nu'udár sistema ida regula relasaunentre elementu/valor sira ne'ebé iha opozisaun ba malu iha moris maibé sira fó balansu no komplementamalu.

Ita tenke nota katak kategozasaun hanesan laos buat ida ke mate iha fatin oustatik. Ne'e signifika katak, sira nebe tama iha area maskulinu bele muda ba iha area femininu ou husifemininu ba iha area maskulinu depende ba okasaun. Nudar familia ou individual ida bele sai hanesan umane ba feto hotu-hotu, no sai hanesan fetosan ba mane hotu-hotu iha ligasaun fetosan-umane. Ezemplu seluk, Timoroan sai rai nain wainhira sira iha sira nia fatin rasik maibe sira sai malae/estranjeiro wainhirasira ba iha fatin seluk. Buat ida la muda an mak Lulik. Lulik hela metin iha ninia fatin.

213 | Interior design. © David Palazón. Uma Lulik Mau Ulo (Aitutu), 2010.

The main objective of *lulik* as a philosophy is to ensure peace and tranquility for society as a whole, in which it can be achieved through the proper balance between differing and opposing elements. As an example, Timorese believe that peace and prosperity can be achieved through a proper balance between the real world and the cosmic world. In this case, people in the real world should follow the rules and regulations set by the ancestors. These rules and regulations can be a harmonious relationship between individuals within family, clan and wider society. Another example would be the relationship between *fetosan-umane* (wife taker/wife giver). It should be as harmonious as possible in order to create peace to achieve prosperity.

Lulik as a system that is in accordance with the concept of 'dualism', developed by Van Wouden (1968[1935]). This is a belief that there is always a balancing of the positive and negative aspects that complement each other in life. In Timor-Leste, there is a wife-giver *(umane)* and a wife-taker *(fetosan)*, there are female values in opposition to male values and there are sacred houses classified into political houses (masculine/foreigner) and ritual houses (feminine/indigenous). This dualistic structure is extensively described in anthropological sources regarding Eastern Indonesia and Timor-Leste (Trindade 2008,178).

Using the notion of dualism, we can observe *lulik* as a system regulating the relationship between the opposing elements/values in life to balance and complement each other.

One should note that the categorization in the Timorese cosmology is not static. By that I mean the opposing elements can change places from masculine to feminine area or the other way around depending on occasion. As an example, a family or an individual can act as a wife giver *(umane)* for all the women in their family and at the same time they are also the wife taker *(fetosan)* for all the male relatives in their clan. Another example, an East Timorese will act as an insider *(rai nain)* within their locality, but they will be acting as an outsider *(malae)* when they leave their village. It is the *lulik*, the core value that is immobile.

—

This article is an extract from the paper presented at: Communicating New Research on Timor-Leste, 3rd Timor-Leste Study Asscociation (TLSA) Conference on 30th June 2011. The paper was also presented at the Academy of Arts & Creative Industries Conference on 16th July 2011.

214 | Malirin (cold). Photograph courtesy of the author. © Karen Reidy. Hatubuilico, 2012.

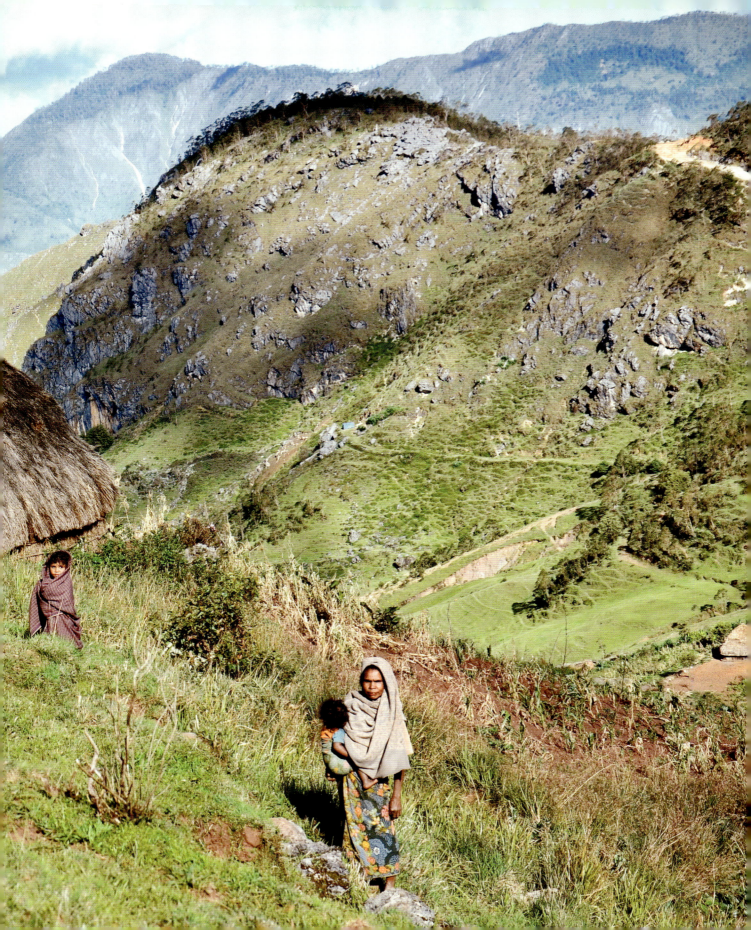

215 | Rainbow's end. © David Palazón. Turiscai. 2010.

216 | Under construction. © David Palazón. Ainaro. 2010.

217 | Sinking ship. © David Palazón. Moro, 2010.

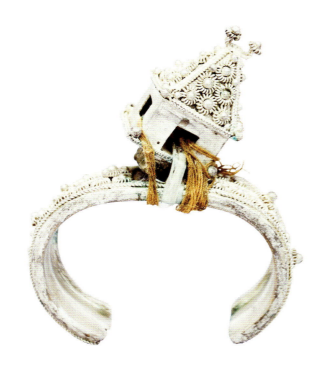

218 | Old jewel. Photograph courtesy of the author. © Gibrael Dias Carocho. Dili, 2011.

218 | The boy with the silver earring © David Palazon, Dili, 2008.

219 | Mini *belak* (medallion). Photograph courtesy of the author. © Risza Lopes da Cruz, Dili, 2015.

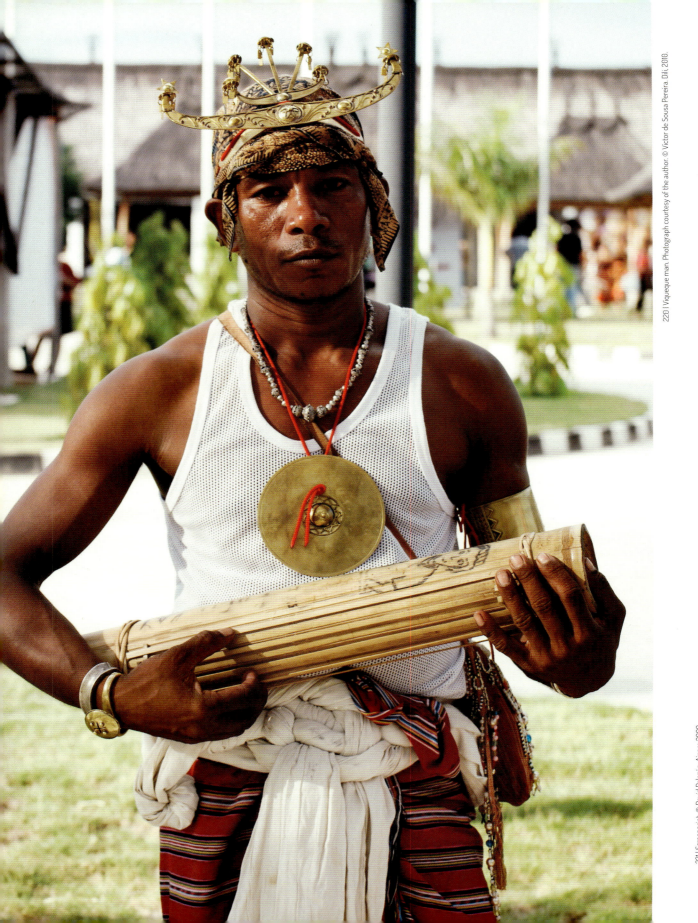

220 | Viqueque man. Photograph courtesy of the author. © Victor de Sousa Pereira. Dili. 2010.

221 | Screenprint. © David Palazón. Ainaro 2009.

223 | Like father like son. Photograph courtesy of the author. © Gibrael Soares Dias Carocho. Dili, 2010.

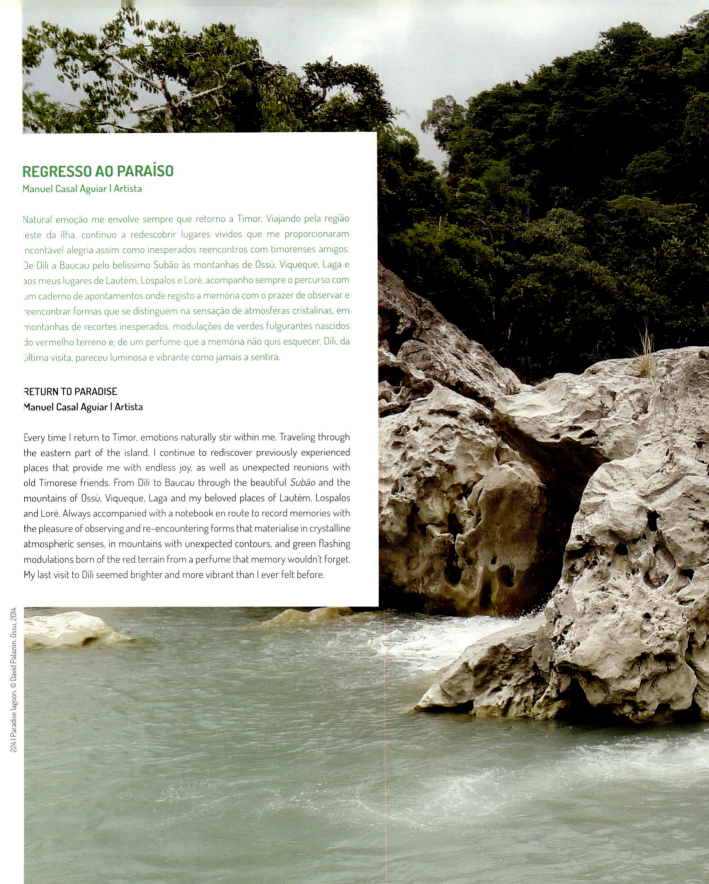

REGRESSO AO PARAÍSO
Manuel Casal Aguiar | Artista

Natural emoção me envolve sempre que retorno a Timor. Viajando pela região leste da ilha, continuo a redescobrir lugares vividos que me proporcionaram incontável alegria assim como inesperados reencontros com timorenses amigos. De Dili a Baucau pelo belíssimo Subão às montanhas de Ossú, Viqueque, Laga e aos meus lugares de Lautém, Lospalos e Loré, acompanho sempre o percurso com um caderno de apontamentos onde registo a memória com o prazer de observar e reencontrar formas que se distinguem na sensação de atmosferas cristalinas, em montanhas de recortes inesperados, modulações de verdes fulgurantes nascidos do vermelho terreno e, de um perfume que a memória não quis esquecer. Dili, da última visita, pareceu luminosa e vibrante como jamais a sentira.

RETURN TO PARADISE
Manuel Casal Aguiar | Artista

Every time I return to Timor, emotions naturally stir within me. Traveling through the eastern part of the island, I continue to rediscover previously experienced places that provide me with endless joy, as well as unexpected reunions with old Timorese friends. From Dili to Baucau through the beautiful *Subão* and the mountains of Ossú, Viqueque, Laga and my beloved places of Lautém, Lospalos and Loré. Always accompanied with a notebook en route to record memories with the pleasure of observing and re-encountering forms that materialise in crystalline atmospheric senses, in mountains with unexpected contours, and green flashing modulations born of the red terrain from a perfume that memory wouldn't forget. My last visit to Dili seemed brighter and more vibrant than I ever felt before.

224 | Paradise lagoon. © David Palazon. Ossu, 2014.

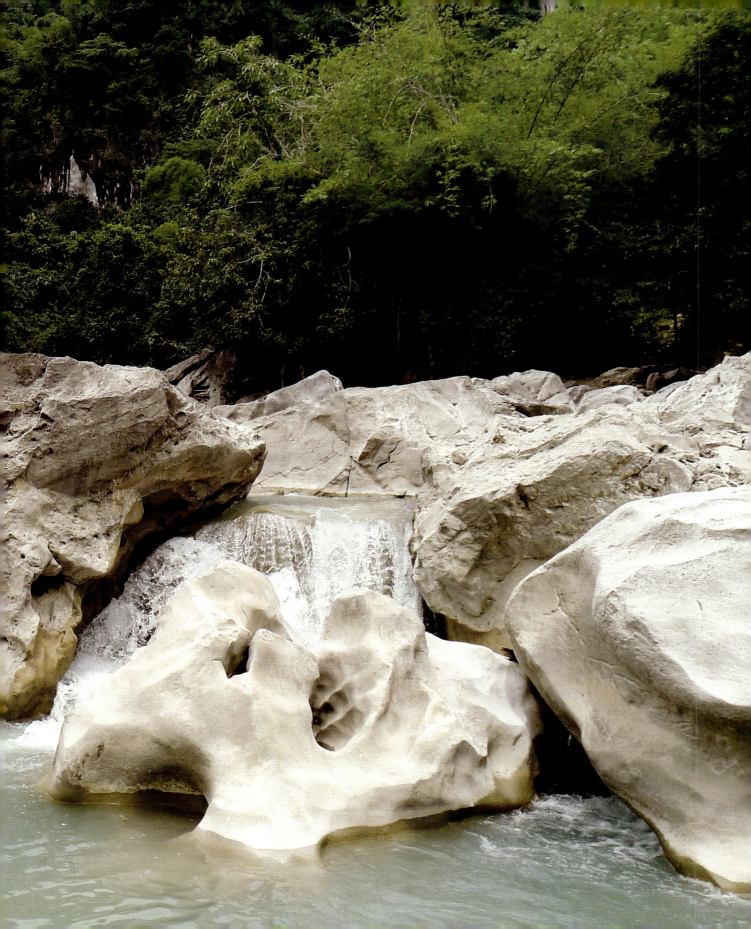

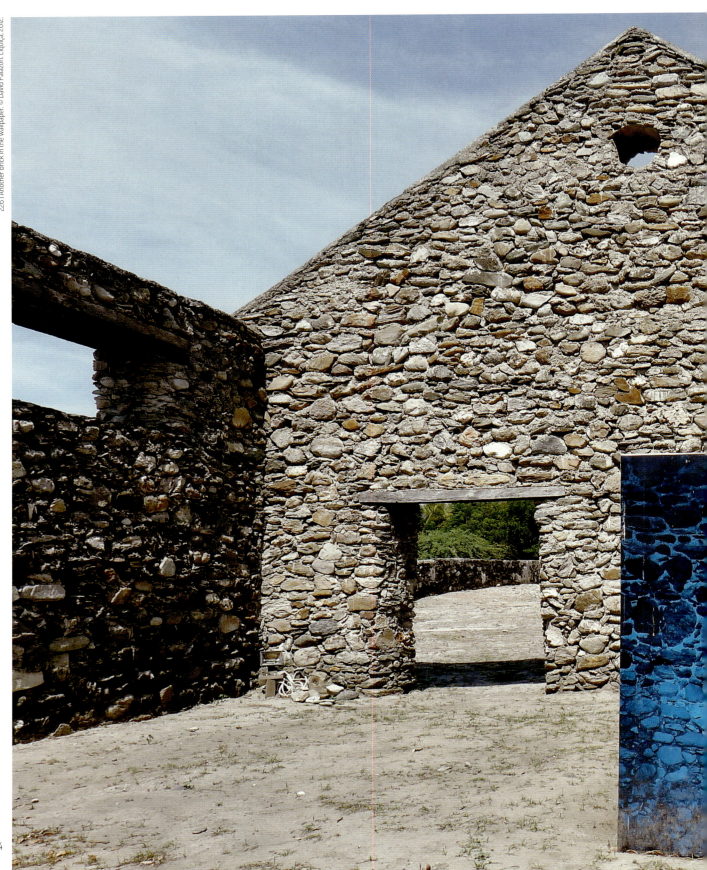

226 | Another brick in the wallpaper. © David Palazón, Liquiçá, 2012.

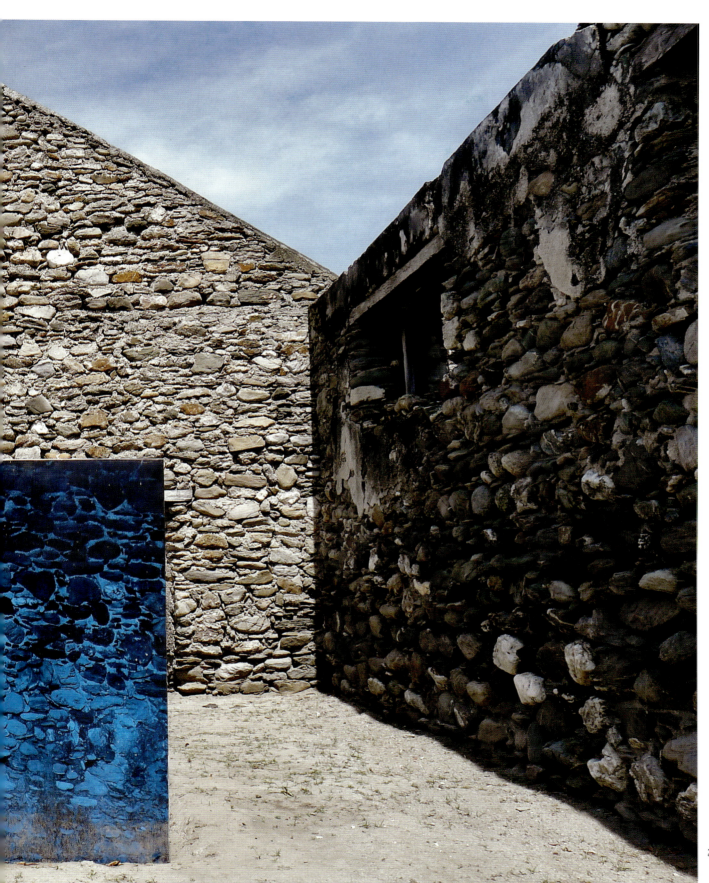

LEGADO DISTANTE E FRÁGIL
Isabel Boavida | Arquiteta

Há algum tempo atrás surgiu, quase como resposta à minha vontade, a oportunidade de ir para Timor, trabalhar naquilo que parecia ser ideal para mim. Parti com receio, pela falta de espírito de aventura, mas cheia de espectativas. Parecia-me perfeito! Ia conhecer a terra das minhas origens, ia trabalhar, e, mais importante, em algo que acreditava ser necessário. Parecia que a minha vontade tinha sido compreendida e que, finalmente, Timor queria receber aquilo que eu queria dar.

Aterrar em Dili foi emocionante. A caminho de casa da família, o Palácio do Governo apareceu de repente e fez-me virar a cabeça. Pareceu-me menos imponente do que eu imaginava. Foi o único edifício que me lembro ter reconhecido nesse primeiro passeio pela cidade. Na verdade, reconheci pouco da cidade à qual me afeiçoei pelas fotografias dos anos 60 que vi vezes sem conta.

Durante os três meses de trabalho de inventário, entre construções de zinco e bloco de cimento, fui redescobrindo partes dessa cidade, arruinadas, abandonadas ou em utilização. Questionei-me muitas vezes se o que fazia era realmente importante, compreendido, aceite e desejado por todos. Com o tempo apercebi-me de que, como em qualquer país, as pessoas não vivem todas da mesma forma, têm necessidades diferentes, e pensam em função disso. Deparei-me com as mais diversas atitudes em relação aos edifícios herdados do período colonial português. Há aqueles para quem os edifícios são apenas um abrigo no qual vivem com medo de ser desalojados; há instituições ou habitantes que os reconstruíram procurando manter, pelo menos na fachada principal, a traça original; há quem os queira, como eu, proteger e preservar, e opiniões mais politizadas a favor da demolição, alegando falta de qualquer tipo de valor. No entanto, a atitude geral é a indiferença.

Apercebi-me de que a minha vontade de proteger e recuperar os edifícios portugueses não era partilhada por todos os timorenses, mas apenas por alguns dos que detêm a voz oficial, que difere muito da voz comum. Tal como a fachada principal, a voz oficial funciona como um cartão de visita que contrasta com a realidade. Enquanto se procura manter a fachada intocada como marca do legado português, tudo o resto foi modificado e tornou-se híbrido devido a acontecimentos violentos e anos de alterações inevitáveis e irreversíveis.

A DISTANT AND FRAGILE LEGACY
Isabel Boavida | Architect

Some time ago, almost as a response to my own will, I was given the opportunity to go to Timor, to work on what seemed like an ideal proejct for me. I left Portugal with fear, because of my lack of a sense of adventure but I was full of expectations. It seemed perfect! I would meet the land of my origins and more importantly work on something I believed to be necessary. It seemed that my dreams had come true and finally, Timor wanted to receive what I was prepared to give.

Landing in Dili was exciting. On the way to my family home, the Government Palace came out of nowhere and made me turn my head. It seemed less impressive than I thought. It was the only building I remembered from that first ride through the city. In fact, I recognised little of the city I was so fond of through the 60's pictures I saw over and over.

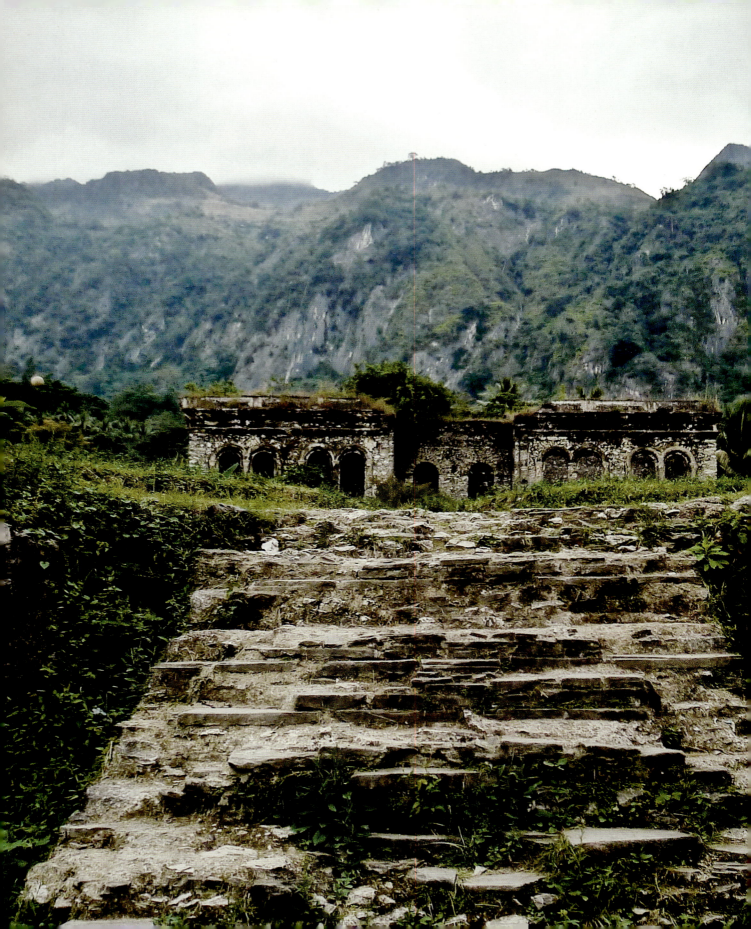

Não teria lógica que também a fachada fosse absorvida pela mudança e a assumisse? Dou por mim a pensar como essa atitude perante os edifícios parece refletir a atual busca de identidade do país. Não será a relação de afetividade com Portugal uma parte superficial da identidade de Timor? Não será inusitado que o português seja lingua oficial quando poucas pessoas o falam corretamente, e quando, por todo o lado, predominam de forma espontânea os *kiosk*, os *warung*, os vendedores de *pulsa*, e tudo custa acima de *satu dolar*?

Voltei de Timor a sentir-me impotente perante o curso natural das coisas, e consciente da fragilidade de um património português que é aclamado por alguns, mas desvalorizado por muitos mais.

During the three months of inventory work, between zinc construction and cement blocks, I rediscovered parts of this city, ruined, abandoned or still in use. I questioned myself many times whether the job I was doing was actually important, understood, accepted and desired by all? Over time I realized that, as in any country, not all people live in the same way, they have different needs, and think based on those needs. I came across many different attitudes towards the buildings inherited from the Portuguese colonial period. For some, these buildings provided shelter to live in for fear of being homeless; there were institutions and inhabitants who rebuilt them keeping, at least, the main façade. Some people like me wanted to protect and preserve these buildings, while other more politicized opinions were in favour of demolition, alleging lack of any value. However, the general attitude was indifference.

I realized that my desire to protect and recover Portuguese buildings was not shared by all Timorese, but only a few of those who had the official voice, which was indifferent to the common voice. As with the main facade, the official voice acts as a business card that contrasts with reality. As it seeks to maintain the untouched building facade as a mark of Portuguese legacy, everything else was modified and became a hybrid due to violent events and years of inevitable and irreversible changes.

Wouldn't it be logical that the facade should also have been absorbed and taken over by change? I found myself wondering how this attitude towards the buildings seemed to reflect the current search for identity within the country. Could it be that the relationship of affection with Portugal is a shallow part of the Timorese identity? Shouldn't it be unusual that Portuguese is an official language when so few people speak it correctly, and when the *kiosk*, the *warung* and sellers of *pulsa*, predominate everywhere, and everything costs above *satu dollar*?

I returned from Timor feeling helpless to confront the natural course of things, and aware of the fragility of Portuguese heritage which is acclaimed by some, but undervalued by many more.

229 | Picture courtesy of Rogerio Lopes, author of the book: *Now and Then: Timor 36 years later*. © Photographer unknown (courtesy of Licinio Martins Lopes, *companhia artilheria ligeira KART 6350* Maubisse, sometime between May 1974 and May 1975.

230 | Picture courtesy of Rogerio Lopes, author of the book: *Now and Then: Timor 36 years later*. © Rogerio Lopes. Dili; 2011.

280

231 | Picture courtesy of Rogerio Lopes, author of the book: *Now and Then: Timor 36 years later*. © Photographer unknown (courtesy of Licinio Martins Lopes, companhia artilheria ligeira KART 6350 Maubisse, sometime between May 1974 and May 1975.

232 | Picture courtesy of Rogerio Lopes, author of the book: *Now and Then: Timor 36 years later*. © Rogerio Lopes. Maubisse, 011.

281

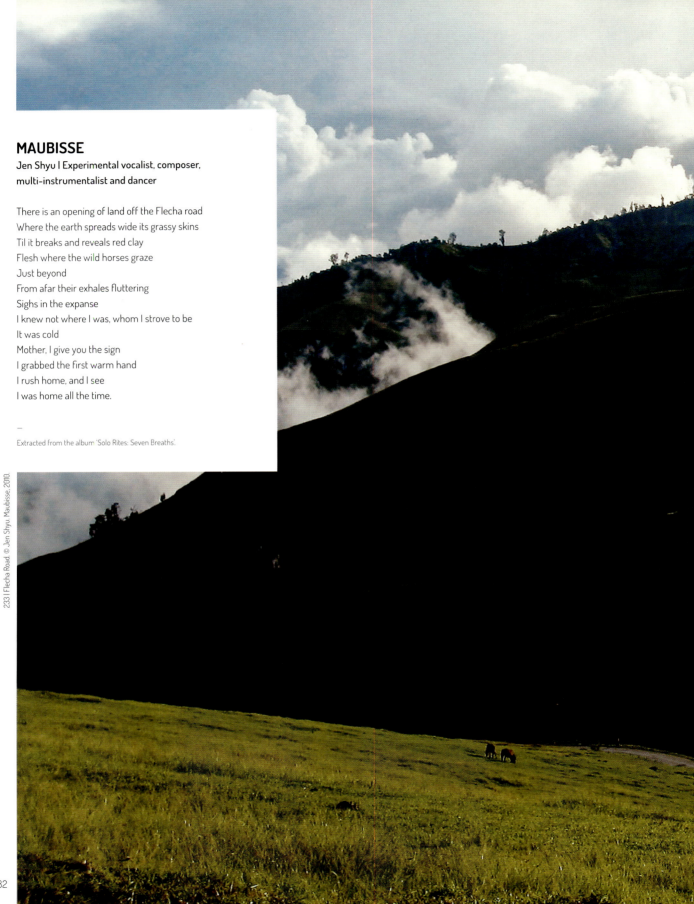

MAUBISSE
Jen Shyu | Experimental vocalist, composer, multi-instrumentalist and dancer

There is an opening of land off the Flecha road
Where the earth spreads wide its grassy skins
Til it breaks and reveals red clay
Flesh where the wild horses graze
Just beyond
From afar their exhales fluttering
Sighs in the expanse
I knew not where I was, whom I strove to be
It was cold
Mother, I give you the sign
I grabbed the first warm hand
I rush home, and I see
I was home all the time.

—

Extracted from the album 'Solo Rites: Seven Breaths'.

233 | Flecha Road. © Jen Shyu. Maubisse, 2010.

234 | Maubisse valley. © David Palazón. Ainaro, 2009.

235 | Centre of Maubisse valley. © David Palazón. Hut-Iel, 2009.

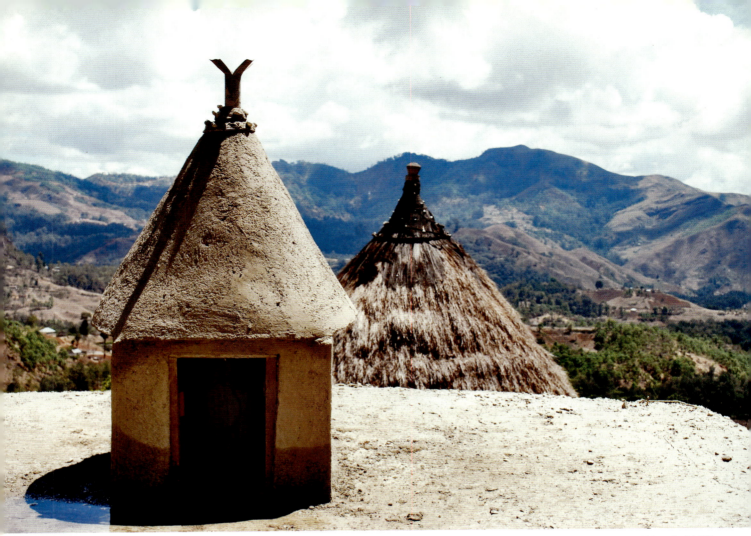
236 | Burial site for the guardian at the centre of Maubisse valley. © David Palazón. Hiut-lel, 2009.

237 | Guardian at the centre of Maubisse valley. © David Palazón. Hut-lel, 2009.

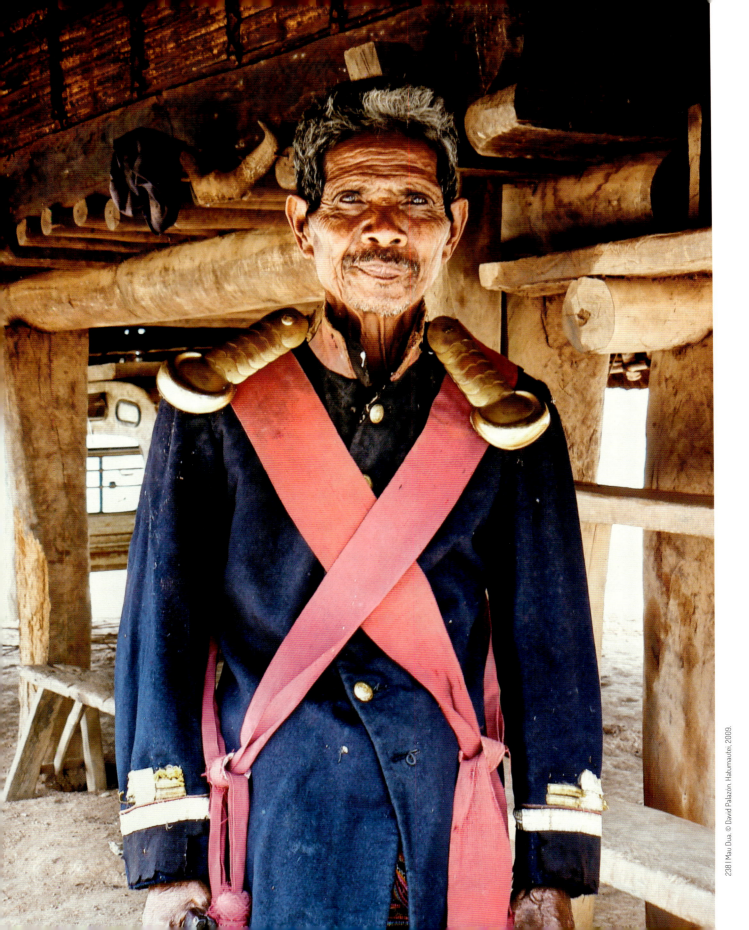

238 | Mau Dua. © David Palazón. Hatumautei, 2009.

240 | Shadow walkers. © David Palazón. Hatumautei, 2009.

239 | Sacred banyan tree. © David Palazón. Hatumautei, 2009.

MAU DUA[†]

John Martires | Estadoist from Hatumautei

These large *epaulettes* weigh heavily on his shoulders; a physical manifestation of the realisation that those times are no longer memorable. The weight made real the moment he was chosen from his clan, by his people, as the keeper of their sacred house. Storyteller and minder of all sacred things, but only to his people, only to his kin. These shoulder pads, resembling an 80's executive woman's power suit, are the last remnants of a time gone by, when heads would roll if anyone questioned a *Liurai's* authority or dared to step in his shadow.

On a cold breezy day, stringy roots dangling from upper branches of the ancient sacred tree, tickle the numerous skulls strewn around the banyan's buttress roots. Once, this grey matter held memories going back centuries in the oral tradition better than a Pentium chip. Now only cold tropical air fills the empty voids with a flash of colour from the occasional lost jewel beetle.

The banyan tree is sentinel to the ups and downs of the Mambai people of Hatumautei. What an insight to their history if we could interview each ring. I would probably interview only the thicker rings. They say when conditions encourage growth, a tree adds extra tissue and produces a thick ring. It always stood alone, on the cutting of a mountain range from a former ancient kingdom. It sprouted roots and shaded those who planted it there. His ancestors, mine too.

The tree and its people changed with the passing of the seasons, ... from the rainy wet and sticky to the dry and cold piercing winds blowing through the valley. This tree has heard the cries of many first born, most of whom are now gone and resting peacefully on the other side of the hill.

When the other people came, they looked different and they did things differently. They brought their God and bedded the women; their children grew up and lived with other Gods. Then they left. The war, the occupation and the joy of independence. All witnessed by the tree. They returned. But history was not the same. He knew it was time. He wanted to go out with a big bang and held on for a while to his three pointed totem resisting the cross, just until this year. Then they say he got baptized and someone read him his last rites. No seven-day mourning, no cattle slaughtering, no pigs or goats, no sign of other rituals. Some said he'd finally seen The Light, and accepted That God.

I think different. To me he will be the last of the Great *Lia-Na'in*. He was the last *Mau Dua*.

I will have to wait for one year to be able to ask at this year's thin ring on the tree: 'What really happened just before his last breath?' ... I will tell you all then!

241 | Bat tree. © David Palazón. Garuai, 2015.

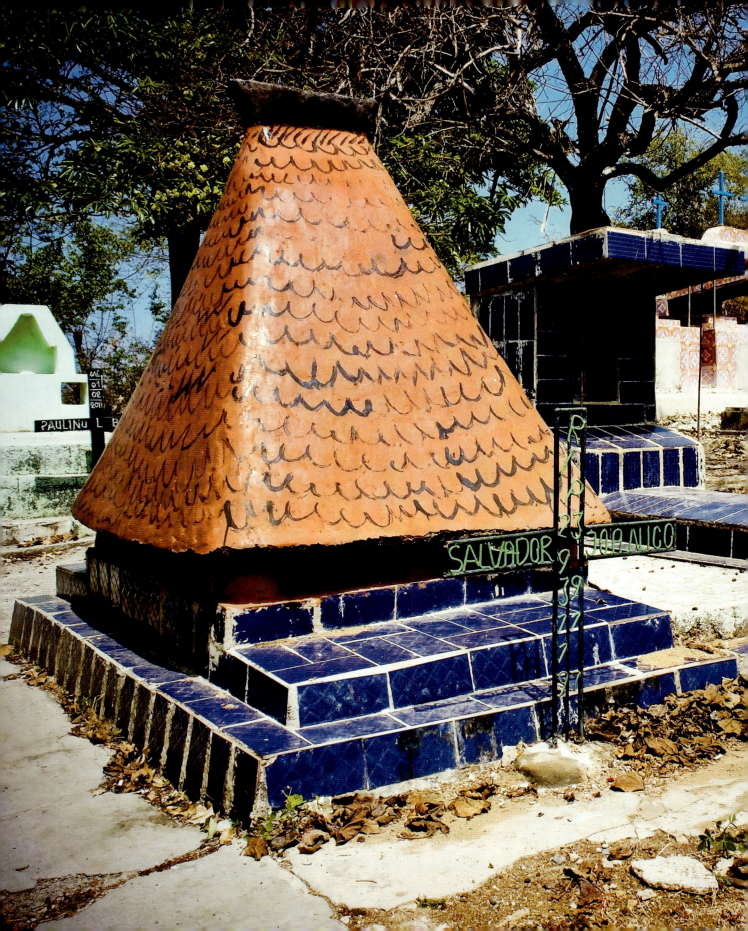

DIMENSÕES VISÍVEIS E INVISÍVEIS
Mara Bernardes de Sá | Attaché cultural

A ilha começou a falar-me através dos sonhos e a contar-me a sua história.

A dimensão do humano amplia e sinto o mundo de forma mais simples e com a intensidade de o ver pela primeira vez.

Na ilha sagrada de antepassados, almas, mortes, sangue, vida e luz ...

Reconheço a linguagem da alma, da minha alma. Pois falo dos sonhos como se falasse do real, e falo do que sinto como se fosse a lei dos humanos.

O meu interior permanece em silêncio e aos poucos desperta-se cada memória futura, passada, presente, o tempo não tem a mesma dimensão real dos corpos. Vivo a união dos tempos e a sua comunhão.

Cada vez ouço mais clara a voz dos mortos e perpetuam a sua existência.

As dimensões misturam-se, aprendi a respirar com os matebian perto de mim, no inicio nem sempre era fácil parecia que perdia a respiração e que o corpo era demasiado pequeno para a alma ... aos poucos fui percebendo o silêncio da sua presença.

A ilha faz-me aproximar mais dos dois mundos (visível e invisível) e ao mesmo tempo estar mais presente neste mundo visível ...

Aprendi a sentir as pessoas sem as julgar, amá-las sem saber dos pecados, perceber que o importante é o momento de partilha, como caminhar nas ruas e sorrir aos dias ...

—

(Texto escrito em 2012)

VISIBLE AND INVISIBLE DIMENSIONS
Mara Bernardes de Sá | Cultural attaché

The island started talking to me through dreams and telling me its story.

The human dimension grows and I feel the world more simply with intensity as if for the first time.

In this sacred ancestry island, souls, death, blood, life and light.

I recognize the language of the soul, of my soul. Because I speak of dreams as if I was speaking about reality, and I speak about what I feel as if it was the human's law.

My interior remains silent and slowly awakens every past, present and future memory, time doesn't have the actual body dimension. I live in the union and communion of times.

I often hear the voice of the dead clearly and perpetuate their existence.

The dimensions blend, I learned to breathe with the spirits near me, it wasn't always easy, at first I seemed to lose breath and my body was too small for my soul ... slowly I realise the silence of their presence.

The island enables me see these two worlds getting closer (visible and invisible) and at the same time to be more present in this visible world ...

I learned to understand people without judging them, to love them without knowing their sins, to realize the most important thing is to be present in the moment, to walk in the streets and smile each day ...

—

(Text written in 2012)

242 | Culture never dies. © David Palazón. Balibo, 2013.

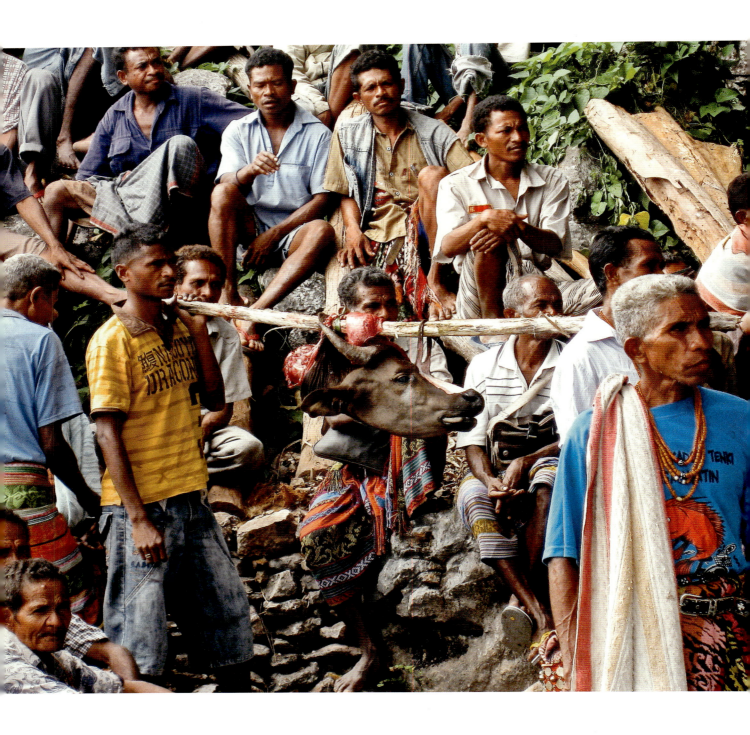

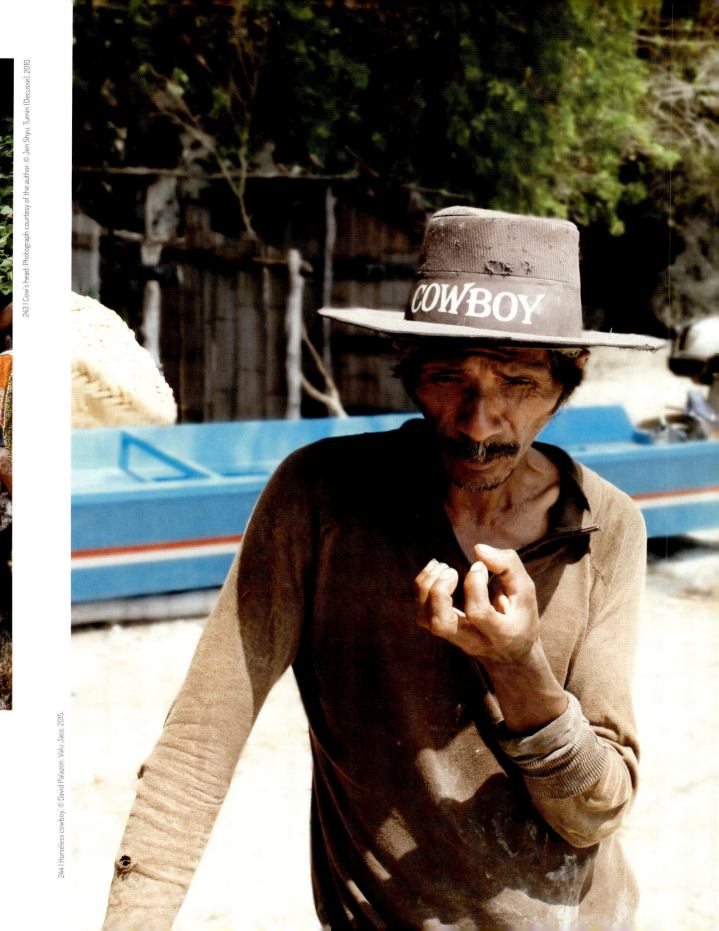

243 | Cow's head. Photograph courtesy of the author. © Jen Shyu. Tumin (Oecusse), 2010.

244 | Horseless cowboy. © David Palazón. Valu Jaco, 2015.

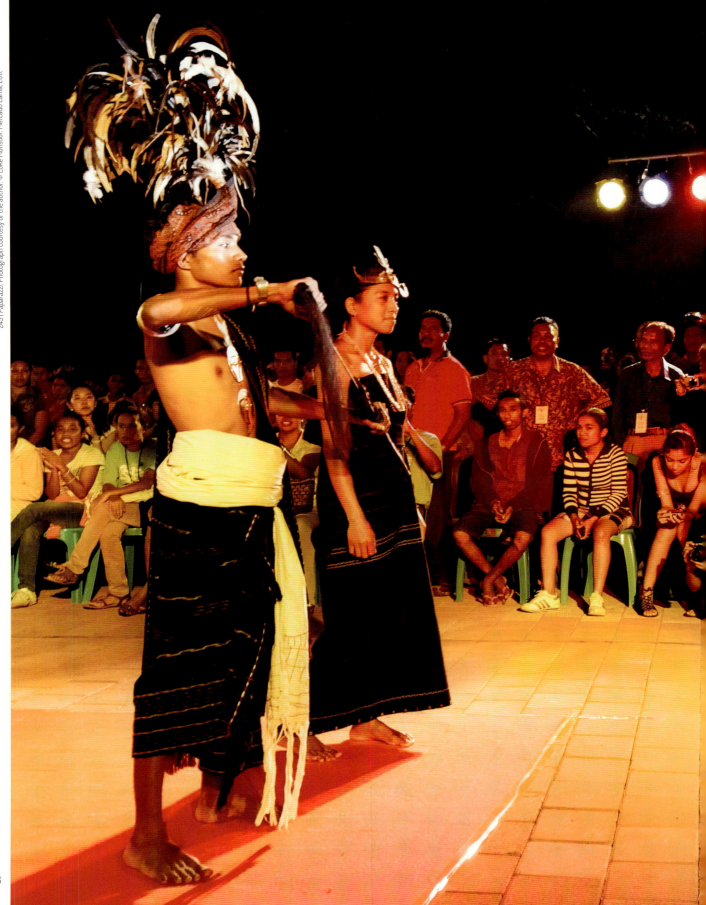

245 | *Paparazzi*. Photograph courtesy of the author. © Luke Monsour, Mercado Lama, 2011.

246 | Tune your channels. © David Palazón. Baucau, 2010.

PEDIR PERMISO
Mireia Clemente | Actriz

John Scott había sido becado para hacer parte de su tesis postdoctoral sobre procesos ecológicos en agricultura sostenible en un país del sudeste asiático hasta entonces con muchas incógnitas para él: Timor Leste. Sabía que laboralmente era una experiencia única, pero también tenía clara una cosa, aprovecharía esta oportunidad, para conocer un país nuevo. Conocer implicaba un amplio número de deberes y obligaciones, cosas que debía hacer y cosas que no. Pero ante todo tenía dos premisas: no ser un turista y pedir permiso, siempre.

Después de los primeros dos meses de estar allí, lo tenía claro, tenía que comprar una cámara fotográfica, así que en el primer viaje que hizo, adquirió una. Todo lo que condensaría las experiencias que estaba viviendo, a parte de su cuaderno de bitácora, sería una buena colección de fotografías. Un año era tiempo suficiente para hacer muchas cosas, pensó.

Después de los primeros seis meses se dio cuenta de que el tiempo … qué era el tiempo? Era un concepto que había cambiado totalmente de sentido para él, y los parámetros y orientaciones por los que se había regido hasta ahora habían cambiado. Seis meses le parecían horas, y cuando vio su maleta en el lugar provisional donde la había dejado al llegar, le pareció que había aterrizado antes de ayer.

Cuando quiso reaccionar se dio cuenta de que le quedaban tres meses de estancia en la isla, que según lo vivido hasta ahora, parecía un soplo. Lo consideró como una cuenta atrás. Necesitaba saber qué se iba a llevar de recuerdo. Prácticamente tenía todo lo que un visitante podía obtener en cuanto a objetos artesanales se refiere; había recibido regalos, … todo le evocaba a algún momento y todo tenía su pequeña historia detrás. Pero necesitaba algo más, algo que reuniera lo que según su perspectiva de aquellos doce meses pudiera ser la esencia del país. Sacó de la caja la cámara que había comprado. Había vivido innumerables momentos de los que no tenía fotografía alguna, pero le quedaban tres meses para capturar la belleza del paisaje que sin duda era uno de los mejores recuerdos que podía llevarse.

No ser un turista y pedir permiso, recordó. Pedir permiso, el consejo que le había dado su buen amigo William, fotógrafo de profesión. Había quien le decía que sus fotos perderían espontaneidad, pero William le había dicho que una de las ventajas de pedir permiso era que entablabas una conversación con la persona en cuestión, y que por tanto se generaba un vínculo que enriquecía la imagen. Para John no había duda, en sus excursiones fotográficas llevaría el zapato adecuado, crema solar y pediría permiso.

ASKING FOR CONSENT
Mireia Clemente | Actress

John Scott received a scholarship to do his post-doc on ecological methodologies in sustainable agriculture in Timor-Leste, a South-East Asian country he didn't know much about. He knew it was a unique work experience, and one thing was certain, for sure he would use this opportunity to discover a new country. To get to know the place would mean having some responsibilities and obligations, what he should or should not do. Above all, he had two principles: avoid being a tourist and always ask for consent.

After the first two months of being there, he decided to buy a camera, so the first chance he had to buy one abroad, he did. In addition to the writings in his notebook, a good collection of photographs would be the best way to condense all his experiences. He thought one year was plenty of time to do so many things.

After six months he realised that time … what about time? Time became a totally new concept for him, the parameters he had used for guidance so far had suddenly changed. Six months seemed like hours, and when he saw his suitcase in the same spot that he had placed it when he arrived, he felt as though he had just landed the day before yesterday.

When he realised he had only three months left on the island, he felt like time had just been blown away. He started the countdown. He needed to know what to take as memorabilia. Basically he already had everything a visitor would gather; crafts, the presents he had received, … everything evoked a personal moment and everything was linked to a short story. He needed something else, something that gathered the essence of his twelve months in the country. He got his new camera out of the box. He had experienced countless moments but he had no photographic record of it, nevertheless he still had three months to capture the beauty of the landscape, without doubt, this was the best he could take with him.

Avoid being a tourist and ask for consent, he recalled. Asking for consent was a piece of advice given to him by his good friend William, the professional photographer. Some people had told him his pictures could lose spontaneity, but William told him one of the advantages of asking for consent of the subject before taking a picture was the establishment of an invisible tie which would enrich the subsequent image. John had no doubt, in his photographic trips he would carry the right shoes, sunscreen and he would ask for consent.

247 | Consent. © David Palazón, Makili, 2010.

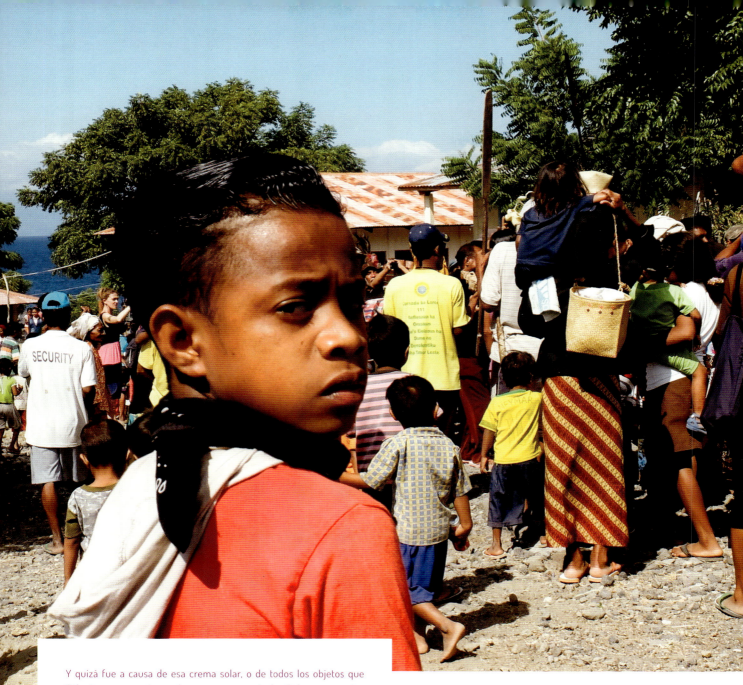

Y quizá fue a causa de esa crema solar, o de todos los objetos que John tuvo que mostrar en los numerosos controles de los aeropuertos sumados a los nervios propios de quien deja la que ha sido su casa por un tiempo, lo que le hizo perder el disco donde había almacenado todas sus fotos. Nunca olvidaría la sensación de vacío cuando se dio cuenta de que ya no tenía todo su archivo de recuerdos. Inmediatamente después revisó su cámara para ver si quedaba alguna fotografía. Había una. No era de ninguna excursión, de ninguna aventura, de ningún paisaje. Era una foto espontánea, que había surgido mientras les mostraba a sus vecinos la cámara que se había comprado y con la que pensaba capturar, archivar y conservar para siempre la esencia de aquel país.

Perhaps it was due to the sunscreen or the rest of the objects John had to show passing the numerous airport control desks, in addition to the distress caused by moving out of what had been his home for a while, he managed to lose the disk in which he saved all his photographs. He will never forget the feeling of emptiness when he realised he had lost all his memory archive. he quickly checked his camera looking for any pictures left inside. There was one. It was not of a trip or adventure, nor a landscape. It was a sudden photograph, taken while showing his neighbours the new camera he had bought to capture, archive and preserve the essence of that country forever.

248 | Public display. Design by David Palazón. © David Palazón, Large de Lecidere, 2014.

249 | National Timorgraphic. Design by David Palazón. © David Palazón. Largo de Lecidere, 2014

250 (Dreams come true. © David Palazón. Uma Lulik Dato Muras Haimoli (Fohorem), 2009.

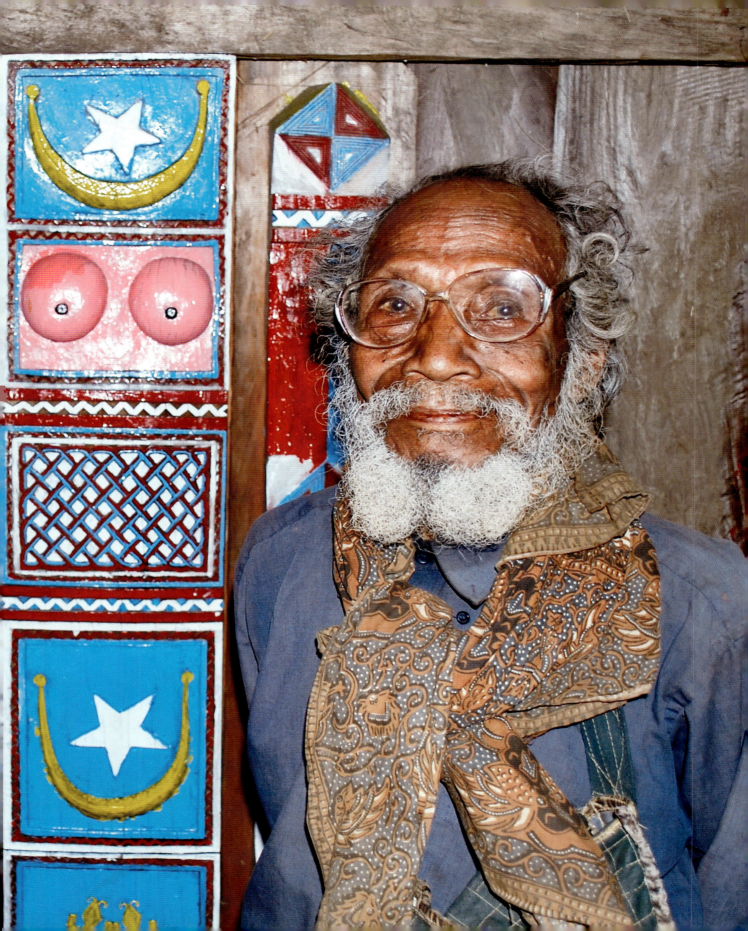

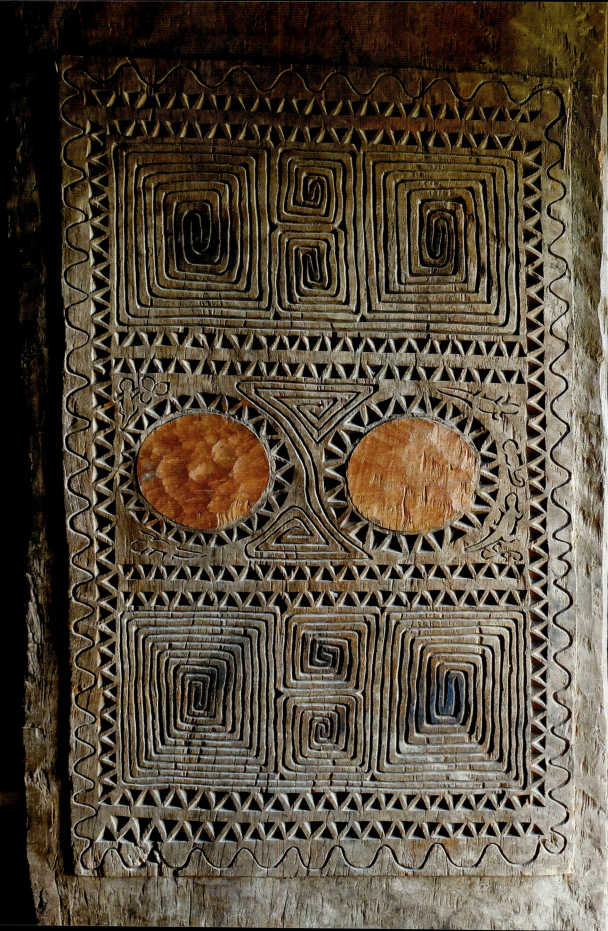

251 | Disembodied door. © David Palazón. Uma Lulik Fad Locar (Hauhol), 2010.

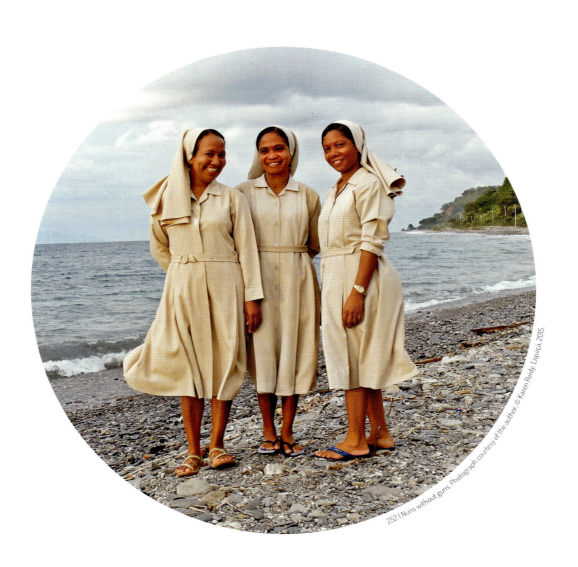

252 | Nuns without guns. Photograph courtesy of the author. © Karen Reidy, Liquiçá, 2015.

307

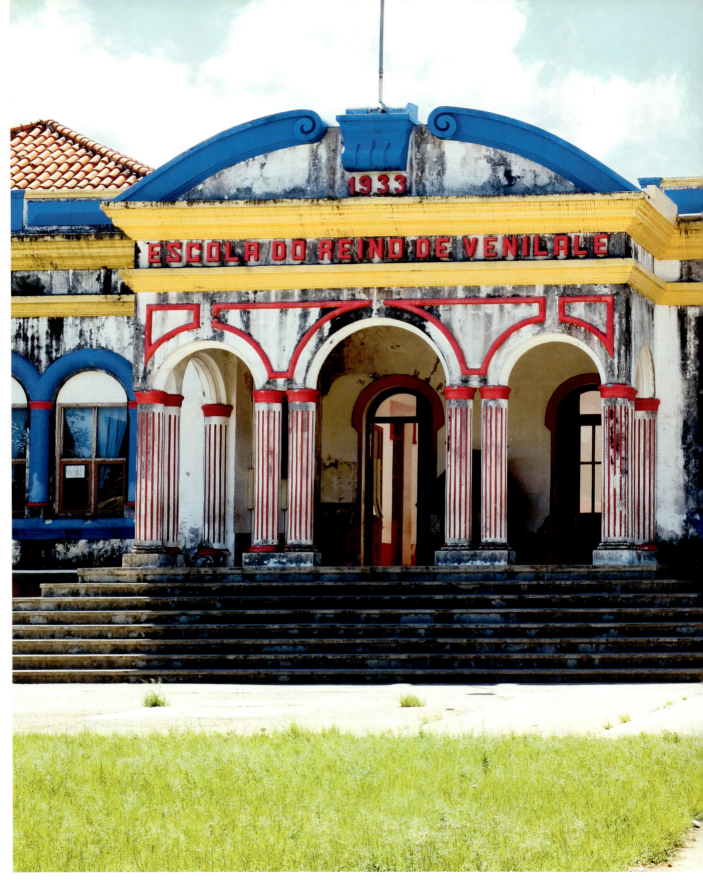

253 | Colonial kitsch. © David Palazón. Venilale, 2015.

s254 | School memories. © David Palazón. Venilale. 2008.

WALKING UP GOLGOTA
Pat Walsh | Human rights activist

There is no train through these stations to the summit
Only a track through an alley of trees that ascends
Sharply over rough ground strewn with loose rocks
Passed grim reminders of the one who struggled and fell
And rubbish tossed in ignorance that defiles
Then up storeys of steep steps that squeeze out sweat like blood
And leave the tortured body questioning this stupidity
But driven by some force within despite the pain
To finish the journey and enjoy the vista unfolding below.

This people has also struggled uphill to a distant summit
Answering a call at first dimly heard then loud and urgent
And trusting blindly in the cunning wisdom of their guides
To stumble betrayed and alone along a way of the cross
Of hot river beds and wild mountain tracks
Lined with grinning jackals and arrogant birds of prey
Through many stations that marked the desperate miles
Towards a vision that beckoned then mocked them like a mirage
Until at last it firmed and they could claim their new Jerusalem.

All conquering the pilgrim stands tall at the top
Hands on hips surveying the pleasing expanse of blue and green
His ego swelled by their applause he waves to those below
Forgetting in the excitement who he is and how he came here
But turning to descend he glimpses to the side
A large white cross dug deep into the rock
A silent echo from the past to this people newly free
That loss and gain defeat and triumph are inseparable twins
And that to give out light the candle must consume itself.

—

Golgota (Golgotha in English) is the name of both the *aldeia* (village) where I once lived in Comoro, Dili, and the mountain above the *aldeia*. It refers to the mount outside old Jerusalem where Jesus Christ was crucified (also known as Calvary). The path to the summit above the *aldeia* is both a popular walking track and a Way of the Cross with fourteen Stations, also known as the *Via Dolorosa* or Way of Sorrows. This poem was first published in Pat Walsh's collection entitled At the Scene of the Crime: Essays, Reflections and Poetry on East Timor, 1999-2010 (2011). See www.patwalsh.net

255 | Sunday outfit (on Easter weekend). Photograph courtesy of the author. © Isabel Nolasco. Road Same-Maubisse, 2015.

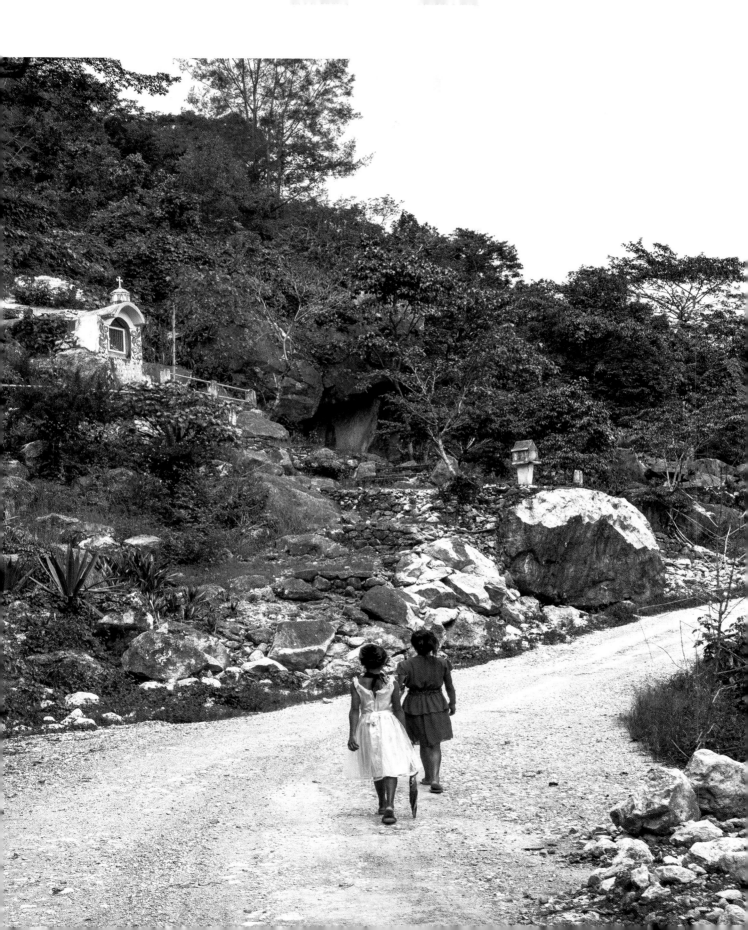

256 | Mt. Matebian's summit. © David Palazón. Quelicai, 2015.

257 | Mt. Matebian. © David Palazón. Venilale, 2014.

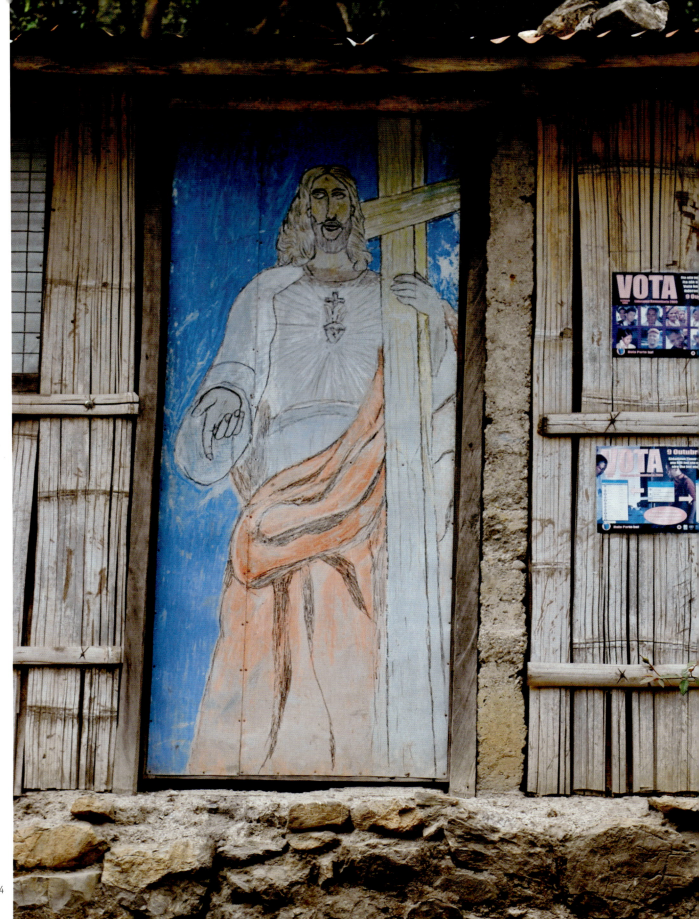

258 | Doorman. Photograph courtesy of the author. © Elena Tognoli. Maubisse. 2009.

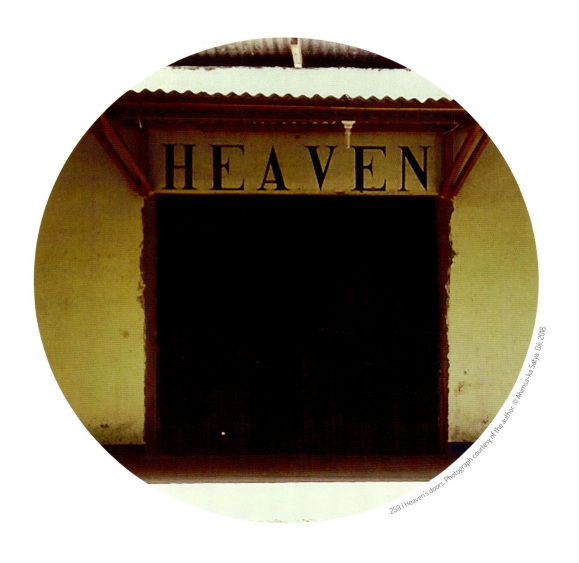

259 | Heaven's doors. Photograph courtesy of the author. © Ahimsa-ka Sabyá. Dili. 2016.

315

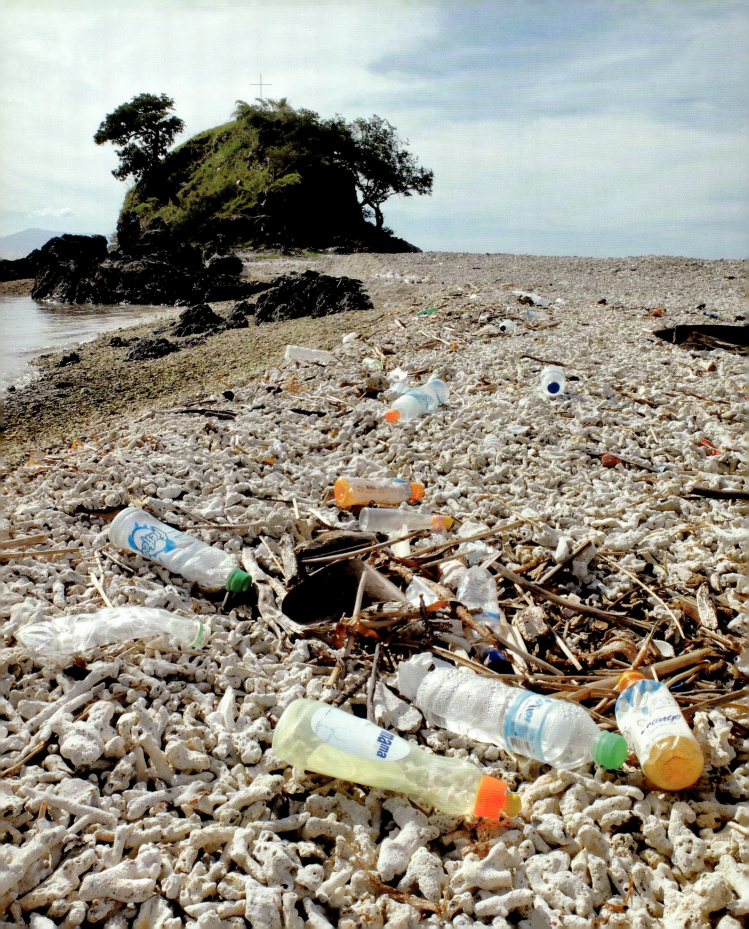

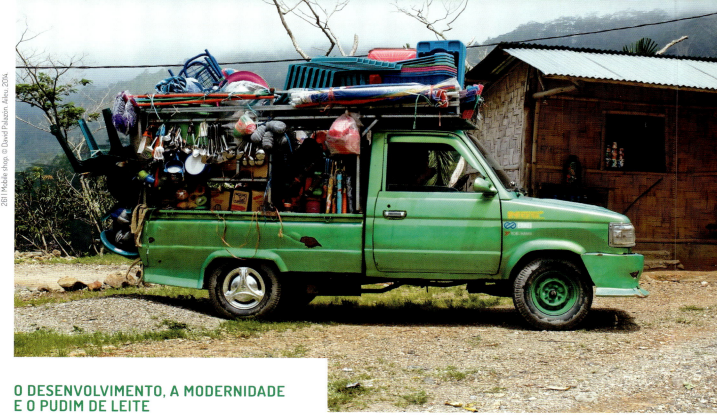

O DESENVOLVIMENTO, A MODERNIDADE E O PUDIM DE LEITE
Margarida Bandeira de Lima | Assessora legal

A globalização é madrasta para os países menos desenvolvidos. Atira-lhes com a modernidade e eles que se aguentem.

O sistema de esgotos a dar os primeiros passos e os canais abertos cheios de latas de refrigerantes, garrafas de plástico, pilhas e baterias de telemóveis.

A modernidade chega, olha com desprezo para o desenvolvimento ainda a calçar os ténis e ultrapassa-o, quero que se lixe que ainda aí estejas, diz ela:

'You're a country in love ... Life is a moment in space when the dream is gone'.

Se há lugar no mundo onde se pode comer um pudim de leite decente é em Timor-Leste. A doce Sonia Soares fá-lo divinamente.

Ali, o pudim de leite, também chamado de pudim de ovos ou pudim flan, mantém-se como era no início, não se adulterou, não há cá invenções de menos açúcar, menos ovos ou caramelo "plástico". Ele é doce, dulcíssimo como deve ser o pudim de leite. Desfaz-se na boca, tem uma consistência firme mas diferente da gelatina, fica, talvez, a meio caminho entre o gelatinoso e o cremoso.

No pudim flan, Timor-Leste não foi em cantigas e manteve a excelência.

DEVELOPMENT, MODERNITY AND MILK PUDDING
Margarida Bandeira de Lima | Legal adviser

Globalization is a bitch to the least developed countries. Toss them with modernity and let them deal with it.

The sewage system taking its first steps and the open canal filled with soda cans, plastic bottles, batteries and cell phone batteries.

Modernity arrives, looks down on the development still putting on its shoes and surpasses it, I don't care if you're still here, she says:

'You're a country in love ... Life is a moment in space when the dream is gone'.

If there is a place in the world where you can eat a decent milk pudding it is Timor-Leste. Sweet Sonia Soares makes it divinely.

Here the milk pudding, also called egg custard or flan pudding, remains as it was at the beginning, not tampered with, there are no inventions of less sugar, less eggs or 'plastic' caramel. It is sweet, very sweet as milk pudding should be. It dissolves in the mouth, has a firm consistency but different from gelatin, it is perhaps halfway between the gelatinous and creamy.

In flan pudding, Timor-Leste wasn't fooled and maintained excellence.

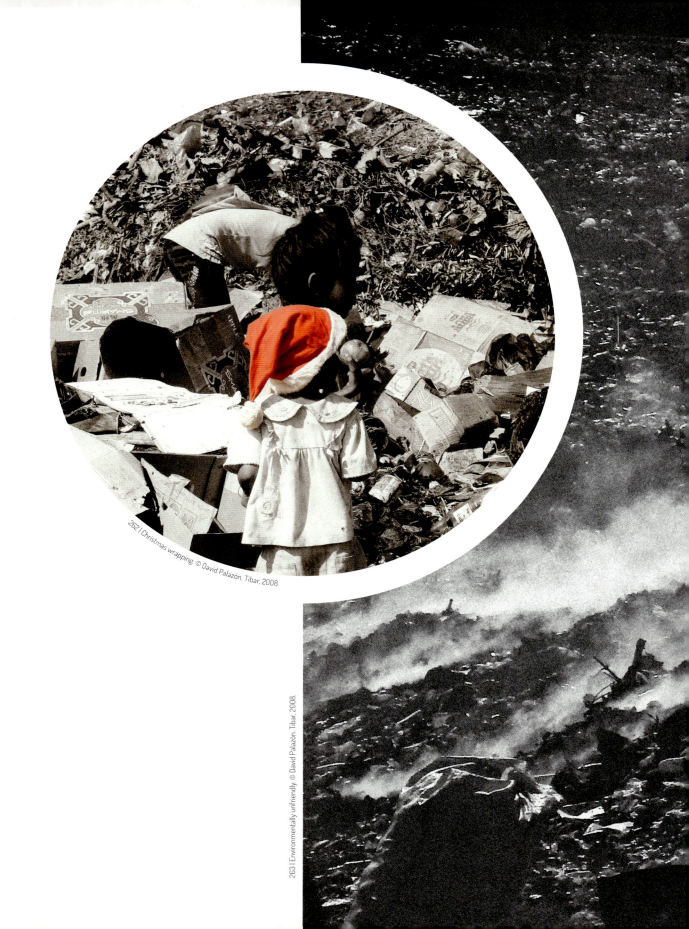

262 | Christmas wrapping. © David Palazón. Tibar, 2008.

263 | Environmentally unfriendly. © David Palazón. Tibar, 2008.

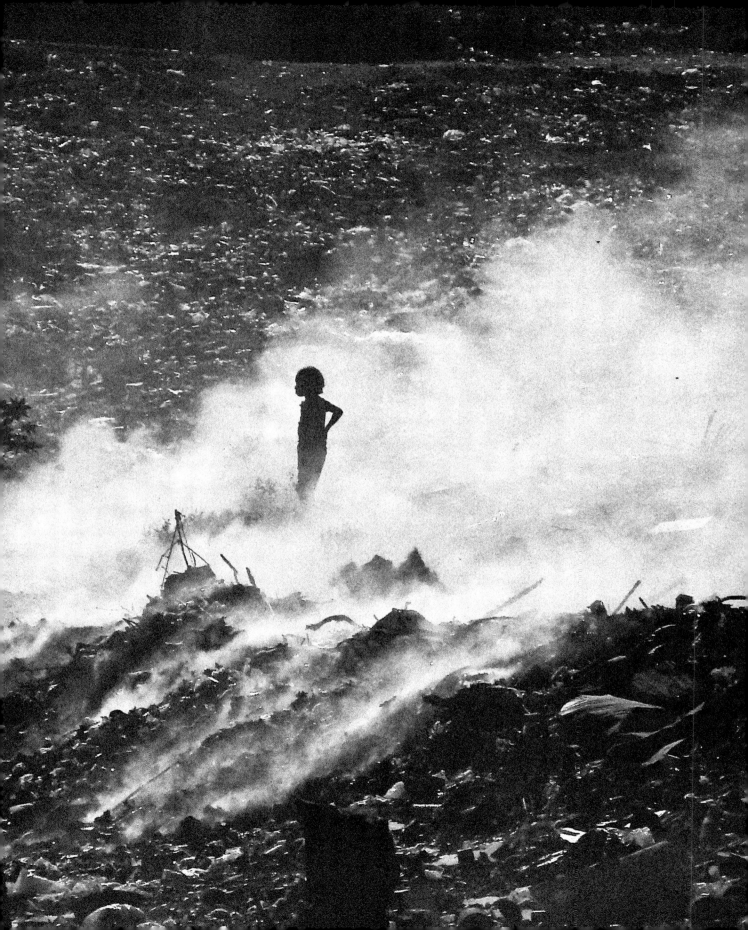

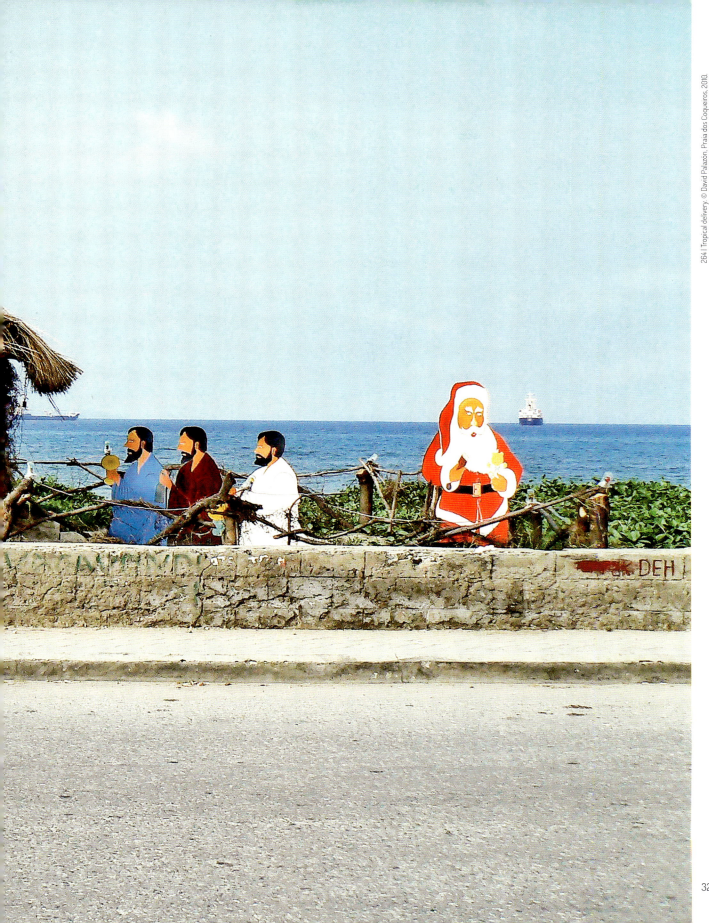

264 | Tropical delivery. © David Palazón, Praia dos Coqueiros, 2010.

266 | Prime banana. © David Palazón. Dili, 2014.

265 | A banana a day will not keep father Christmas away. © Gibrael Diaz Carocho. Dili, 2015.

EMA BO'OT
Leilana Quinger | English teacher

My friendships have always been based on mutual heckling; on friends who call me out on my failings, half in jest, who imitate me when introducing me to strangers. One friend and I teased each other so much that we had to come up with a 'safe word', a signal to stop when we were hitting real nerves. We deliberated which words would we never use in any context and agreed upon 'fiscal responsibility.' Both the terminology and the concept being alien to us.

Timor-Leste, like my favourite humans, challenged me and mocked me and generally highlighted my failings in a way I wasn't always ready for. There was the relentless dust, the sea apparently full of crocodiles, the roads—long, bumpy and devoid of gas stations at crucial junctions.

On my final night in Dili my Temporary Flatmate (TF) did everything he could to make it memorable. He took me to a sea-side bar which, amazingly, I'd never been to before, and we sipped cocktails on beanbags. He told me his enviable story; a childhood in Angola, an elite boarding school in the Ghat mountains of India.

He was economically minded; everyone around me was and they all invited me to spend my last night at the Ministry of Finance ball. The idea of it made me laugh but, of course, I wanted to go. Absurdity is seductive.

Under a giant tarpaulin, we were plied with food and booze and speeches. The women were all in their finest; the men swaggered. I was seated at a huge table of people, all relentlessly kind and understanding of my fish-out-of-water status. We scanned the crowd for famous faces, until we noticed the ultimate famous face —Prime Minister Xanana Gusmão. I fanned my face in exaggerated excitement and told everyone present:

'Oh my god, oh my god, my last night in Timor and I get to see Xanana!'

TF looked up and announced: 'well, I guess you better get a *selfie* with him.'

I looked at him sideways and said 'no, no way.' The idea of approaching this legendary figure for a *selfie* was humiliating in the extreme, even if I could see that's what more and more people were in fact doing. TF scoffed, then told my tale to the various people sitting with us – who unanimously agreed that it wasn't my decision to make and that, yes, I must get a *selfie*.

They literally dragged me until I was standing in front of the man, sweaty and apologetic. Umm. Can I get a photo?

He smiled, put his arm around me and in a moment it was over. My heart was knocking on my ribs. My hand was shaking after I sat down; waves in my wine.

Like a schoolgirl I checked my phone, only to immediately note that the photo hadn't taken – the cheapest smartphone on the market is not to be relied upon in life defining moments like this. I didn't mind; I don't like photos of myself in any case and the memory of the moment was more important than anything else. I didn't mention it to the others.

TF was beaming; he'd succeeded. 'Show me!' he insisted. I winced.

'I'm really sorry' I said, for absolutely no reason, 'but it didn't work. Never mind though, it was wonderful to meet him!'

'What?? Nooo!' He relayed the story to the 12 other people sitting at our table and they all agreed that I must ask him again.

Asking a Prime Minister for a *selfie* once is bad enough, but asking again is beyond the pail. However, once again, my physical strength did not stand up next to four people pushing me across the dance floor.

Xanana, God bless him, laughed and played along. And then it happened again. And like a saint on earth, he kept laughing.

After three attempts I finally had a *selfie* with the Prime Minister, in which I was dripping with sweat from nerves and heat and burning shame. I ate with the others, myself in near silence, and threw back my glass of wine.

I took my empty glass and wandered around, lost, desperately seeking a refill to kill off any trace of human consciousness. The wine table I'd been frequenting had been drunk dry and I was looking around, like a lost deer, when a small man stood behind me and repeated: 'Miss! Miss!'

Feeling like an ant, I didn't assume he was speaking to me. I don't know anyone here; I don't know anything about finance. 'Miss' he insisted. I looked at him quizzically, but in a way which could be read as 'blank' in case he wasn't directing his inquiry at me.

He locked eyes with me and pointed in the direction of the Prime Minister, who was gesturing frantically for me to come over to his table. I went over, bowing my head and mumbling gratitudes, which he brushed off. He held out his glass of wine—and I, thinking he wanted to cheers me—showed him my empty one. He shook his head and pulled my glass over, replacing it with his, full glass. He gestured for me to drink.

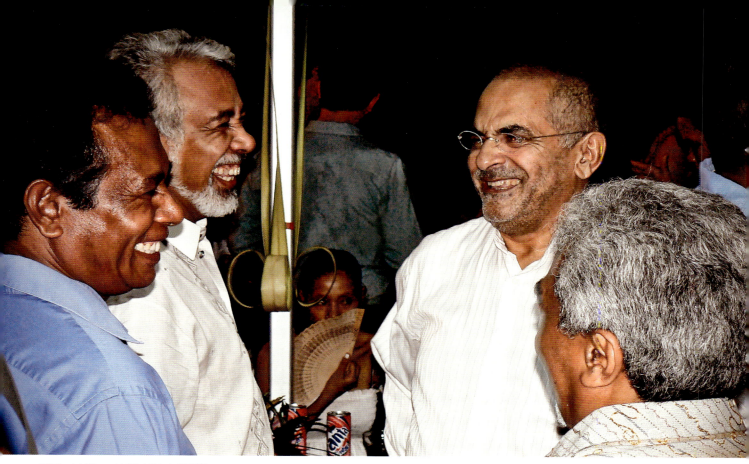

2E7 | *Ema bo'ot* (big people). © David Palazón, Dili, 2008.

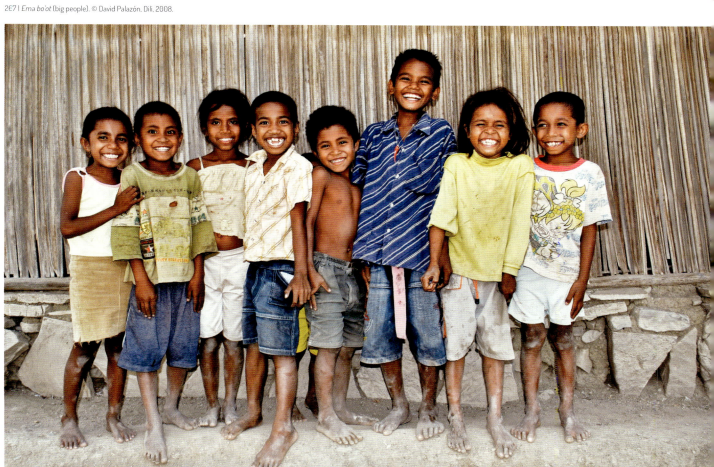

2E8 | *Ema kiʼik* (small people). © David Palazón, Laclo, 2009.

269 | Little white lies. © David Palazón. Areia Branca, 2015.

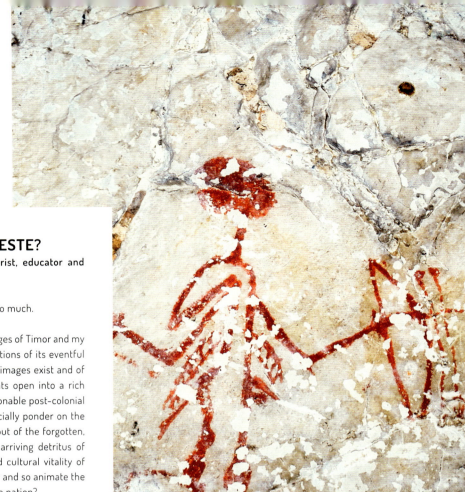

270 | Unidentified object. © David Palazón. Tutuala, 2010.

SO WHAT IS IT ABOUT TIMOR-LESTE?
Tony Fry | Designer, design and cultural theorist, educator and author

I am wary of the image. It reveals a lot but hides so much.

Asking myself about the relation between my images of Timor and my memories of the place I find myself lost in reflections of its eventful and tempestuous distant past of which only few images exist and of which I have written. Nonetheless these thoughts open into a rich imaginary that pre-colonial, colonial and a questionable post-colonial history of images equally hide and reveal. I especially ponder on the future: how can it be imagined? What can arise out of the forgotten, the passing of memories, the present and the arriving detritus of globalisation, as well a still and not extinguished cultural vitality of the nation's people? What can capture this vitality and so animate the spirit, music and colour of the young people of the nation?

The young are of 'the in-between': a place to make another kind of future. It's an environment of poverty, conformity, the mess of the everyday, continued Eurocentric imposition together with the power of place, damaged traditions and creative energy. In this making there are de-colonizing messages and practices out there in the world to find and use. In contrast, there are also farewells to be made to the carriers of residual colonial influence.

I now hear the thunder of village drumming. Then not only do I see a rebuilt *Uma Lulik* but the beauty of its crude craft also captivates me.

Next the memory of a photograph of the tools and workbench of a jewellery maker arrives. What I see is so basic and so at odds with elegance of the objects that this craft person creates. The skill and seemingly unending beauty of *tais* also arrive to mark memory and place.

Now I'm looking at a copy of an engraving from a French Atlas of 1824. It is commanding my gaze and I see in the bottom left corner a canoe with outriggers. It is familiar: such canoes still remain in use. But what is illustrated appears to be of a better quality than those now made. It has a cleaner line, is decorated, and sits higher in the water.

My mind now drifts. It rests on images exhibited in Dili a few years ago. They reproduce those on painted rocks from caves in the Eastern tip of Timor-Leste which are from 6,000 to 35,000 years old. Streams of questions continue to spill from these memories. The images remembered are of course open to contemporary expert interpretation, but modern systems of classification and meaning (including of 'art') may have no correspondence with those employed by their creators. Thus whatever we are told about what we see in no way has the ability to actually tell us 'the first truth'. Questions like: who were these people, what did this imagery mean to them, what were they trying to communicate (if at all), and what happened to them all come to mind?

271 Japanese cave. © David Palazón, Veniale, 2009.

272 | Lene Hara cave. © David Palazón. Tutuala, 2010.

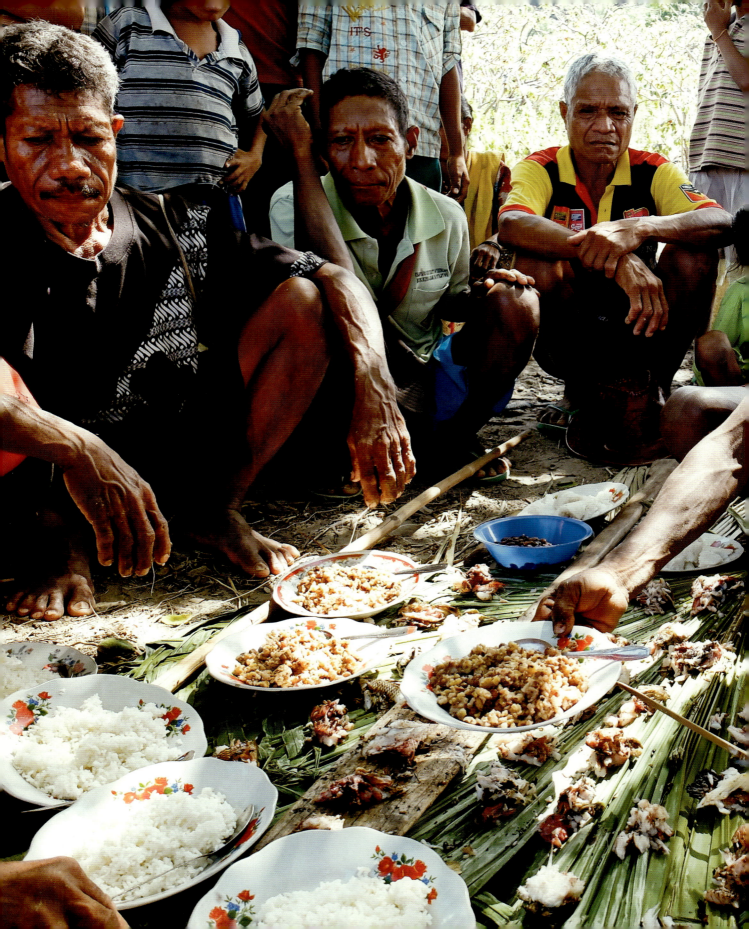

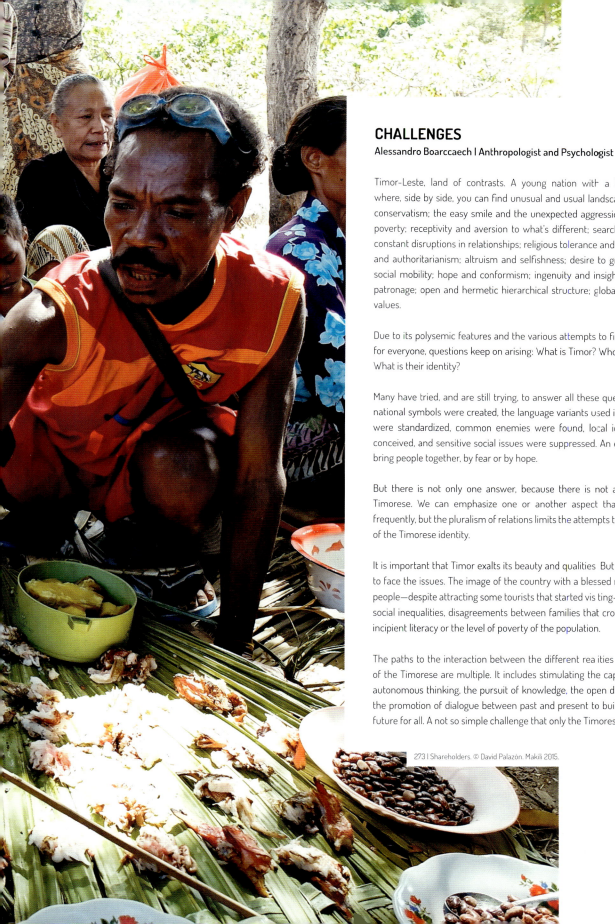

CHALLENGES
Alessandro Boarccaech | Anthropologist and Psychologist

Timor-Leste, land of contrasts. A young nation with a long past. A place where, side by side, you can find unusual and usual landscapes; pluralism and conservatism; the easy smile and the unexpected aggression; ostentation and poverty; receptivity and aversion to what's different; search for harmony and constant disruptions in relationships; religious tolerance and prejudice; dialogue and authoritarianism; altruism and selfishness; desire to grow and almost no social mobility; hope and conformism; ingenuity and insight; meritocracy and patronage; open and hermetic hierarchical structure; globalized and ancestral values.

Due to its polysemic features and the various attempts to find a common path for everyone, questions keep on arising: What is Timor? Who are the Timorese? What is their identity?

Many have tried, and are still trying, to answer all these questions. Heroes and national symbols were created, the language variants used in formal education were standardized, common enemies were found, local idiosyncrasies were conceived, and sensitive social issues were suppressed. An effort was made to bring people together, by fear or by hope.

But there is not only one answer, because there is not a single way to be Timorese. We can emphasize one or another aspect that can occur more frequently, but the pluralism of relations limits the attempts to bring the essence of the Timorese identity.

It is important that Timor exalts its beauty and qualities. But it is also important to face the issues. The image of the country with a blessed nature and friendly people—despite attracting some tourists that started visiting—does not diminish social inequalities, disagreements between families that cross generations, the incipient literacy or the level of poverty of the population.

The paths to the interaction between the different realities and ways of being of the Timorese are multiple. It includes stimulating the capacity for empathy, autonomous thinking, the pursuit of knowledge, the open display of ideas, and the promotion of dialogue between past and present to build a more inclusive future for all. A not so simple challenge that only the Timorese can win.

273 | Shareholders. © David Palazón. Makili 2015.

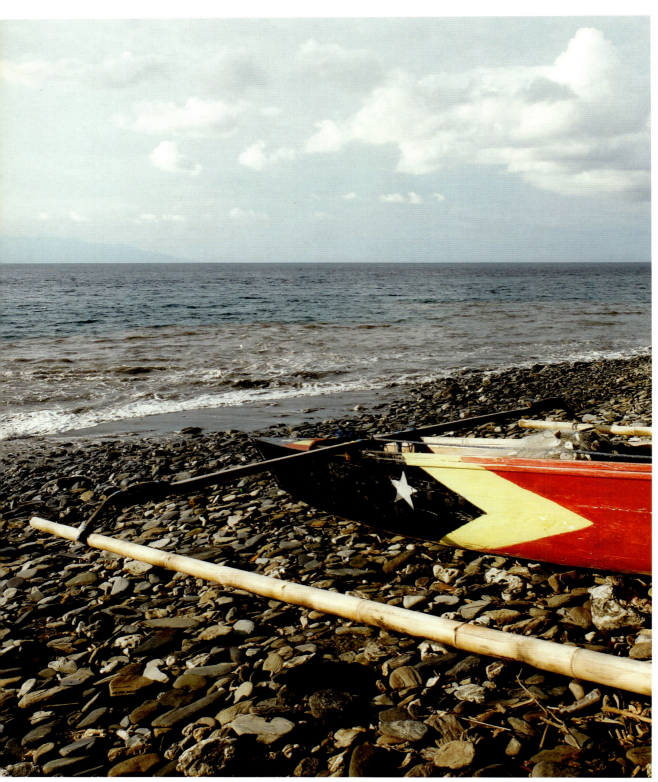

274 | Paddle your own canoe. © David Palazón. Liquiçá, 2015.

275 | Atelogu (see you later). © David Palazón. Cristo Rei, 2015.

OBRIGADA, EM TIMOR-LESTE E A TIMOR-LESTE
Kelly Silva | Antropóloga

Em diferentes ocasiões, amigos em Dili lembraram-me que em Timor-Leste a palavra obrigada/o não existia antes da colonização portuguesa. Avô André, um *matan dook* (curandeiro) de Manatuto que encontrei em Dili algumas vezes, foi quem primeiro me explicou porque: por se saberem mutuamente dependentes, as pessoas não diziam obrigada. Estavam desde sempre obrigadas umas às outras porque a vida é um contínuo fluxo de trocas: dar, receber e retribuir. A circulação e a troca de bens, serviços e direitos sobre pessoas (essa é uma tradução minha, claro) era obrigação em ato e era algo tão natural (Pierre Bourdieu diria tal fenômeno está no domínio da doxa), que sequer era preciso expressá-la, verbalizá-la. A inobservância destas condutas, contudo, era objeto de crítica social. Não por acaso, adjetivos como mau pagador/a ou ingrato/a são insultos morais dos mais potentes no país, atribuídos a quem não reconhece suas dívidas para com os outros e que, portanto, não as honra.

Em outra circunstância, tomei conhecimento do modo como alguns leste-timorenses dão sentido às noções de riqueza e pobreza. Pobre é aquele que não tem família, parentes, com os quais relações de dívida são alimentadas. Por oposição, rico é aquele que tem uma vida abundante de relações e, portanto, de relações de troca e dívida.

Meus amigos em e de Timor-Leste têm generosamente me ensinado o valor e a importância das relações, da dependência e das dívidas. Em contraponto, fazem-me ver os limites do individualismo. As sensações de tranquilidade e segurança que experimento fazendo trabalho de campo em Dili (apesar do calor) são índices desses aprendizados. Talvez porque em campo, mais do em qualquer outro contexto, torno-me totalmente dependente das pessoas; de sua generosidade em me acolher e compartilhar parte de suas vidas comigo. Dessas relações afloram profundas conexões afetivas; dessas relações, minha humanidade cresce (como diria Caetano Veloso). Por esta e por outras razões, sinto-me obrigada a Timor-Leste e escrevo sobre dívida e dádiva entre populações que sempre nos ensinam o quão preciosas são nossas relações e os nossos vínculos. Existimos, pois, por meio e através daqueles com os quais nos relacionamos.

THANK YOU, IN TIMOR-LESTE AND TO TIMOR-LESTE
Kelly Silva | Antropologist

Friends in Dili have reminded me on different occasions, that in Timor-Leste the word *'obrigada/o'* (thank you) did not exist before the Portuguese colonization. Grandfather André, a *matan dook* (healer) of Manatuto I encountered in Dili a few times, first explained to me why: if people were mutually dependent, they didn't have the need to say 'thank you'. They were forever bound to each other because life is a continuous flow of exchanges: giving, receiving and repaying. The circulation and exchange of goods, services and rights of people (of course, that's my translation) was an obliged act and it was something so natural (Pierre Bourdieu would say this phenomenon is in the area of doxology), that it was not necessary to express it and verbalize it. The lack of observation on these matters, however, was an object of social criticism. For instance, adjectives like 'indebted' or 'ungrateful' are some of the strongest moral insults in the country, assigned to those who do not acknowledge their debts to others and therefore, are not honored.

In another situation, I understood how some East Timorese give meaning to notions of wealth and poverty. Poor is the one who has no family, or relatives, with whom debt relations are nourished. In contrast, wealthy is the one that has a life of abundant relationships and therefore, relations of trade and debt.

My friends in and of Timor-Leste have generously taught me the value and importance of relationships, of dependence and debt. In contrast, it makes me see the limits of individualism. The feelings of calmness and security that I experienced while doing fieldwork in Dili (despite the heat) are indexes of these learnings. Perhaps because in the field, more than in any other context, I become totally dependent on the people; their welcoming generosity and sharing part of their lives with me. Deep emotional connections flourish from these relationships; it is from these relationships, (as Caetano Veloso would say) that my humanity grows. For this and other reasons, I feel obliged to Timor-Leste and to write about debt and gift between people who always teach us how precious our relations and links are. We exist therefore, through those with whom we deal and have relationships with.

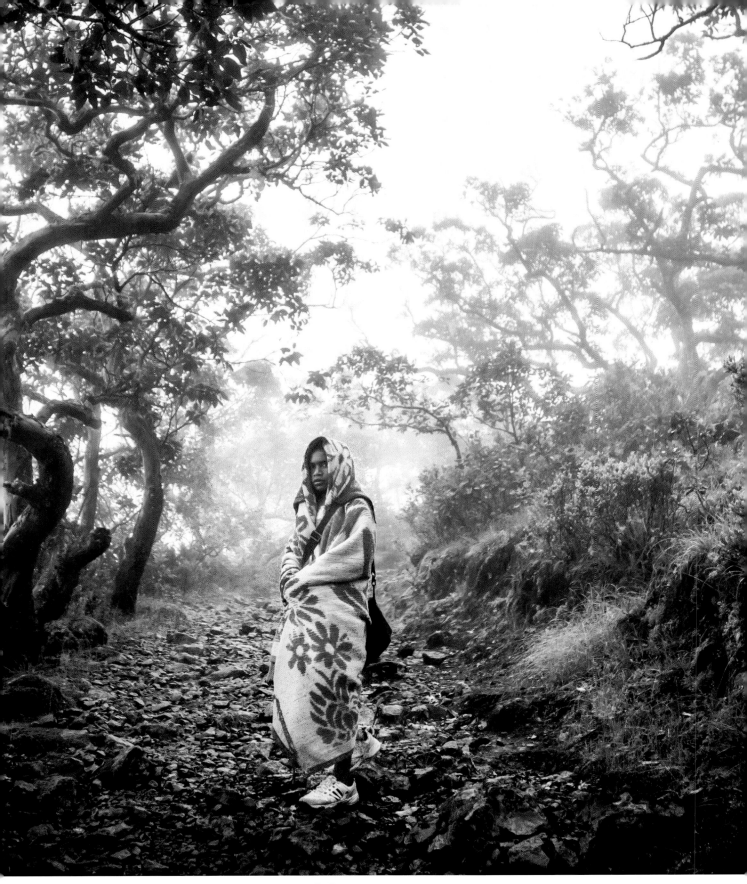

276.| *Tuir mai* (follow me). Photograph courtesy of the author. © Bernardino Soares. Mt Ramelau, 2014.

276 | *Lorosa'e* (East sunrise). © David Palazon. Mt Ramelau, 2015.

277 | Loromonu (sun sets in the West). © David Palazón. Mt Ramelau, 2015.

278 | The future is to be written. Artwork by Arte Moris students. © David Palazón. Dili, 2008.

279 | Designation of origin. Artwork by Boneca de Ataúro. © David Palazón. Ataúro, 2014.

I would like to express my gratitute to the following people, without whom my overall experience of Timor-Leste would have not been the same: (in alphabetical order) Abe Barreto, Abe Cancio Silva, Abilio da Conceição Silva, Abilio dos Santos†, Abino, Agio Pereira, Ahimsa-ka Satya, Alain Georges Matton, Alana Hayes, Alberto Fidalgo, Alessandro Boarccaech, Alexander Meillier, Alfeo Pereira, Alin Bela, Amanda Wimetal, Ana Rego, Anata, Andrea Pires, Andrew Henderson, Antonio de Vivo, António Gil Lobit, Antony Crean, Arte Moris, Aurélie Seguin, Barry Hinton, Beatriz Marciel, Beto Timur, Bernardino Soares, Bernie McEvoy, Bety Reis, Bishop don Basílio do Nascimento, all the women at the Boneca de Ataúro, Bosco, Bruno Lencastre, Carlos Costa, Carlos Freitas, Cecilia Assis, Celestino da S. Mendes Sarmentu, Cesario, Charline Bodin, Christine Cabasset, Clara Gonzalez, Claudio Savaget, Colleen Coy, Coral Gillet, Cosme Viegas, Cristina Rocha, Dália Mesquita, Daniel Adriaens, Daniel Simião Schroeter, Danilo Afonso-Enriques, Dac Anh Khanh, Desmond Lee, Dez Irmaõs, Diamantina Araujo, Diana Borges, Dili Expats Facebook Group, Dulce Felicio Turquel, Dylan Gelard, Eduardo Flores, Efrén Legaspi, Elena Giachetti, Elena Tognoli, Ella Medley-Whifield, Emmanuel Braz, Endericos Fahi, Enrique Alonso, Ester Piera Ester Züecher, Estudio Candonga, Etson Caminha, Eugenio Sarmento, Fabrizio Cesaretti, Fanny Vilardebó, Fátima Almeida, Fatinha, Fernando Encarnação, Fernando Madeira, Fidelis Magalhaes, Flávio Miranda, Florentino Sarmento, Fong-Fong, Francisca Maia Gonçalves, Francisca A. Soares, Francisco López Assís, Fredrick Stürmer, Gabriela Gansser, Gabrielle Samson, George Ereu, Gembel Arts Collective, Giacomo Mencari, Gibrael Dias Carocho, Gil Valentim, Graça Viegas, Kay Rala Xanana Gusmão, Kiki, Haburas Juventude, Hamar Baptista Alves, Hector Hill, Helder Pereira, Honorio Ximenes, Iliwatu Danabere, Ina Varella, Iñigo Ballester, Ino Parada, Irene del Olmo, Isabel Abric, Isabel Boavida, Jake VDVF, Jan-Patrick Fisher, Janak Rogers, Jason Grant, Jean-Christophe Galipaud, Jen Shyu, Joana Custódias, Joana Franco, Joanna Barrkman, João Felipe Gonçalves Tolentino, João Ferro, João Paulo Esperança, Joaquim Campbell de Brito, Joaquim de Brito, Joaquim Sutamalik, Johanna Struthman, John Martires, John Miller, John York, John-Paul Gural, José Sequeira 'Somotxo', José Alberto Simões, José Alberto Sousa, José Amaral, Jose Luis Sousa Santos, José Monis Ximenes, José Ramos-Horta, Josh Trindade, Juan Carlos Rey, Justino Valentim†, Karen Myers, Karen Reidy, Katia Petrunia, Kelly Cristiane da Silva, Kelly Warner, Kim Dunphy, Kirsty Sword Gusmão, Kristina Escorza, Larissa Almeida, Latrini Nengah, Leandro Fernández Jardon, Leilana Quinger, Leito Capucho Smith, Licinio Martins Lopes, Liliana Pires, Lina Hinton, Leocadia de Araujo, Luca Gansser, Lucas Serrao Lopes, Luis Aguilar, Luis Gárate, Sra Luisa, Luke Monsour, Lutzia Pitcher, Madalena Barreto, Mafalda Marchioro, Maite Monnereau, Mana Alicia, Manuel Casal Aguiar, Manuel Smith, Mara Bernardes de Sá, Marcelina Osolio, Margarida Bandeira de Lima, Margarida Madureira, Maria Amado, Maria Bermudez, Maria Ceu Lopes Federer, Maria da Costa, Maria Isabel XImenes, Maria Madeira, Mariana Groba Gomes, Mariana Nobre Vieira, Mariana Pinto, Mariano Gonçalves, Marie Claire Sweeney, Mario Gomez, Mário Spencer, Mark Vaughan, Marqy, Martine Perret, Masanori Nagaoka, Massimo Riva, Master Lee, Matteo Bezzi, Maturina de Araujo, Mau Dua†, Max Mikhail Ryleev, Max Stahl, Mayumi Hayashi, Megumi Yamada, Melly, Miguel Caldeira, Mireia Clemente, Mr Blue, Naldo Rei, Nando, Natália Carrascalão, Nazario Salvador, Nelson Turquel, Nick Hayes, Niina Kylliäinen, Nika Elena Ryleeva, Noam Chomsky, Nogueira Mendes, Nuno Costa, Nuno da Silva, Nuno Vasco Oliveira, Osme, Ozorio, Pablo Barrera, Padre Luis, Padre Xico, Patrick Walsh, Paulino, Pedro Rosa Mendes, Pele, Philip Yampolsky, Pia Kranz, Rebecca Kinaston, Rick Shearman, Rio Gandara, Risza Lopes da Cruz, Rita Peixinho, Robbie, Rogerio de Sá, Rogerio Lopes, Ronny Suhendra, Rosa Gomes, Rosália Madeira Soares, Ross Dunlop, Rowena McNaughton, Sara Montes, Sabom Julio, Sandra Tilman, Sara Martin, Satorlina da Silva, Sanggar Masin, Sanggar Matan, Sean Borrell, Sebastião da Silva, Seday Ganefabra, Séverine Giroud, Sierra James, Maestro Simão Barreto, Simaun C. Pereira, Simon Fenby, Simone Tomazela, Sofia Miranda, Sonia Lobato, Soumitri Varadarajan, So Young Lee, Nuno Bianco de Araujo, Rui Amaral S. Serrani, Steve Tickner, Sula Sendagire, Tania Bettencourt, Tatoli ba Kultura, Teresa, T. C. Aluk, Theresia Susanto, Thomas Nehrmann, Tiago Guerra, Timor-Leste Post Office front desk staff, Tony Fry, Timor Telecom front desk staff at Hotel Timor, Vasco Leitão, Vera Silva Costa, Victor de Sousa, Vina Barahman, Virgilio Simith, Virginia Soares, Vitorino Santos, the Wawata Topu ladies, Will Tobalima, Xabier Erkizia, Xavi Arasa, Xisto Silva, Yann Franc de Ferriere, Yara Menéndez, Yusvani Roque, Zaida Barreto and everyone else that I have possibly, probably forgotten.

—

THE GOD OF ILIMANU by Jean-Christophe Galipaud

I was in Laclo recently to organise a survey trip in some Ilimanu caves with my colleagues from the archaeology department in Dili. We were discussing with our future guide, Jeremias, a thin middle aged man, in a military jacket and kaki shirts, wearing proudly a cow boy leather hat. While I was looking at the village and dreaming about this future exploration, the conversation in tetun shifted to Jeremia's previous experiences. A few *malaes* had already made the trip over the years, in search of these out of the world inhabitants of Ilimanu, sleeping in caves, wearing penis wrapping and keeping away from any form of civilisation. The conversation was mostly about a couple, that Jeremias was convinced I would know, as they also were *malae*. Were they Australians? Not sure. Perhaps Portuguese? No he would not think. They spent several days up there, was he explaining, doing all sort of extraordinary things and seemingly enjoying to share food and life. One day the man put an apple on a stone and ask some people to shot at it with their bows while he was filming. At this stage we were all trying hard to figure out who they were, even if it sounded like an impossible coincidence to know of them. Especially for me who had been in this country for such a short time. One other day, he went on, they draw on paper the faces of the old men and women and the results was so real, added Jeremias, that we were all convinced that they were *Maromak* (God). And you still don't remember their names, I asked asked Gil? I think the women was called something like Ilina, replied Jeremias. He had not finished pronouncing the name that everybody in the group started to shout: it was David, David Palazón!

280 | Message in a t-shirt. © David Palazón. Ataúro, 2014.